Welcome to:
AroundEurope
Promotion
We recive Post from:

Aarhus
Amsterdam
Antwerp
Barcelona
Berlin
Bern
Birmingham
Bordeaux
Borgerhout
Brighton
Bristol
Carignans
Copenhagen
Evergem
Fontaines / Saone
Frankfurt am Main
Gartenhaus
Geneva
Genzano di Roma
Gothenburg
Groning
Innsbruck
Karlsruhe
Lille

London
Lermont
Madrid
Matosinhos
Milan
Mougins
Munich
Nice
Oslo
Papinster
Pforzheim
Porto
Rennes
Rotterdam
Stockholm
Stuttgart
The Hague
Toulouse
Verviers
Vienna
West Sussex
West Uorkshire
Wiesbaden
Zurich

Around Europe Promotion

another way of travelling around europe

About the Book

All Contents are selected by
Juland BarcelonaVienna
Author and Art direction Andrés Fredes
www.julandscape.com
andres.fredes@julandscape.com

For any questions about the
Around Europe edition:
everything@aroundeuropeonline.com

Publishing

INDEXBOOK. SL
Concell de Cent 160 Local 3
08015 Barcelona
phone +34 93454 55 47
fax +34 93 454 84 38
email: ib@indexbook.com
www.indexbook.com

The captions and artworks in this book are based on material supplied by the designers whose work is included. While every effort has been made to ensure their accuracy, neither Index Book nor the Author does under any circumstances accept any responsibility for any errors or omissions.

ISBN: 978-84-96774-22-3
Printed in China

100% EuropeanDesign

Acknowledgements.

I'd like to thank our collaborators. All the participants in the book come first ...
You will find all their names in the index and also a portrait.
The good vibes between all of them deserve my most sincere gratitude.
You all are great professionals and, of course, I hope to have you around in future
publications.... thanks alot!!.

Also thanks to:
Claudia, for her collaboration in this publication.
Toni from Index, for his constantly good willingness to help me.
Julia, because she know how dificult is manage everything with two childrens.
Mia Filipa, for her smile and her love for the books she have now with 3 1/2 years old.
To our new member of the Juland Republic Titus León for his sweet caracter and
his big, big smile!
My mother, for her love and big support.
Hannes, my brother in law for be ever ready!!!.
My parents in law, for the big support in our constants trips around the world.
To Isabel, Pamela, Elvira and the team of Indexbook, for their constant support
and interest in our work. You are a great team!!.
To our friends of Unfolded design studio in Zurich, for the interview.
My special acknowledgement to all designers paticipants with the envelops (mailart)

To all thank you very much!
Enjoy the book.

And be ready for the AroundEuropeConference soon in Barcelona.
Always check @ aroundeuropeonline.com

Hi Friends and Design lovers!!

Welcome to Around Europe Promotion. Browse these 629 pages and you'll find a wide range of samples for promotion: t-shirts, posters, catalogues, flyers, packaging, exhibitions and many different promotional elements.

Actually, what is promotion?

It is a form of corporate communication that uses various methods to reach a targeted audience with a certain message in order to achieve specific organizational objectives. Nearly all organizations, whether for-profit or not-for-profit, in all types of industries, must engage in some form of promotion.
Such efforts may range from multinational firms spending large sums on securing high-profile celebrities to serve as corporate spokespersons to the owner of a one-person enterprise passing out business cards at a local business person's meeting.

Promotion is an activity designed to boost the sales of a product or service. It may include an advertising campaign, increased PR activity, a free-sample campaign, offering free gifts or trading stamps, arranging demonstrations or exhibitions, setting up competitions with attractive prizes, temporary price reductions, door-to-door calling, telemarketing, personal letters.
Well, the best way to point up what these definitions say is by illustrations. We hope you enjoy the graphical journey through Europe. In this case we allow ourselves to travel via mails and postal packages, oftentimes employed as promotional elements, too.

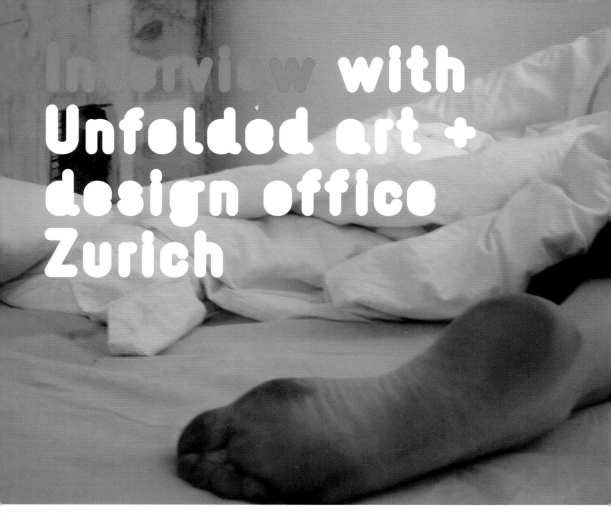

Interview with Unfolded art + design office Zurich

***Introduce your self to those that don`t know you are a designer? unfolded, a small graphic design studio from zürich. officially 3.5 years old/young.

extra:
***can you define what kind of work you do a little more in two or three sentences?
we are doing art: art direction, graphic and design. analog and digital, timebased and timeless. most importantly, no matter whether it is print or digital: interactive.

***a little bit of history: where do the members of the team all come from? how did unfolded start and when?
our various backgrounds of fine art, graphics and design, new media and paedagogy influence our work. nadia gisler and friedrich-wilhelm graf (the founding members) started to work together on some projects 4 years ago. we figured out that we liked working together and that we complemented each other perfectly. as we became more committed to the development of our projects, we founded unfolded in winter 2003. we enjoy working with our wonderfully patient freelancers. depending on the project, they are trained photographers, media artists, programmers, editors, etc.

***does the company have a philosophy? if so what is it?
passion, for work, process and output. love for the details / sidestories and while maintaining an eye for the big picture.

***what are the strong points of your work? what keeps you going?
we are perpetually brainstorming and developing from scratch. every project is a kind of blank canvas. our approach is to develop the optimal embodiment of a project. unfolded endeavors to find the most appropriate concept, instead of relying on the easiest solution. the coordinates for realisation come into being not only out of analysis, but flourish through perseverance

and reflection.

***What did you want to be when you where little?
E: „I only hope that we don't lose sight of one thing - that it was all started by a mouse." (Walt Disney)
extra D: Denkt immer daran:/ Mit einer Maus fing alles an. (Walt Disney)

***What inspires you?
E: Idleness is the inspiration of the spirit?
extra D: Müßiggang ist allen Geistes Anfang. (Franz Werfel)

***How do you work? Alone, or with more people? Researching a lot beforehand? Explain us your methodology
We do not believe in cold calling. normally we are contacted by clients and discuss the ideas of the project during out first meeting. thereby, we then try to work with the expectations and ideas of our clients. it takes a moment until we have a picture, a vision that we are thoroughly convinced about, that will be a good solution for our duties at hand. Often times the solution appears as questions are being answered, or as a small detail in a briefing, or as our interest is piqued, by our own perceptions, and then we use these as a foundation. Unfolded sometimes works as a pair or a group of three. we try to assess the needs of our clients and depending on the size and nature of the project, we do work with specialists from a small network that is based not only in zürich, but also worldwide. there are a couple of individuals we like a great deal, who we work well with together. To sum it up, that the end result is more than what we started out with. 2 + 2 can sometimes equal more than 4.

***When is design simply good in your perception?
more than four arguments are not appropriate on paper, so away with the other two. (steffan heuer über powerpoint)

***If you had to give an advice to

emerging designers, what would it be?
one must not be liked by everyone.

***If you would have not become a designer, what do you think you would be doing today? in my next life? perhaps a musician or a filmmaker

***How much time do you spend working on your designs per day?
E: repetition deepens the relationship betweeen the different centers in the brain, which measures on brain activity show. (stefan klein)
extra D: wiederholung festigt die verbindungen zwischen unterschiedlichen zentren im hirn, wie messungen der gehirntätigkeit zeigen.

***Describe as one typical day in your life?
a great deal happens, until you can see an internet site. Every time when you click on something, then the whole cycle begins again. (die sendung mit der maus)

**Your favorite designer or design studio?
E: It is a curse to live in an interesting time.
extra D: Es ist ein Fluch, in interessanten Zeiten zu leben.(Hannah Arend)

***Your favorite design city
a place, where only the lights are extinguished at night.

***What is happening design wise in your town? to keep things short, we would like to stay realistic in reference to Switzerland, and not expound lessons. (Idea contest, Swiss Pavillion Expo, 2005 Aichi)

***Your favorite project? The one that makes you proud of yourself!? And Why?
those with the most blood, tears and processes

***Which is the project that was mostly celebrated?
carol: computers says no

***Is money a rather positive or

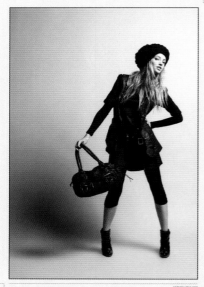

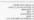

AUTUMN/WINTER 07/08

ABCDE
FGHIJK
LMNOP
QRSTU
VWXYZ

negative issue?

ladies and gentlemen, you have yet to receive information about financial assets; how to recieve the highest yields. for all your hard work, you don't want peanuts. As André Kostolany already said, „There are a hundred Marks (in reference to the Deutsch Mark, the old German currency prior to the Euro) here and a hundred Marks to earn, and there is undoubtedly business." And with a smirk, he told a story about the hobo, who was in standing in front of the judge in Hungary. „Aren't you ashamed of yourself?" admonished the judge. „ You have a murdered a human being, just to rob him of two Gulden (a former type of coin)?" „But your honor", said the defendent with the utmost confidence, „Two Gulden here, two Gulden there.." (unknown source)

***Who was the worst client in your designer-life? And why?
the devil's work is never done. the devil is always busy. (the good reverend doctor purify)

***Who was the client you liked most?
clients who have had trusted in our vision

***What do you hate?
not trust, bad decision-making abilities

***What is the coolest thing about your design studio?
ask our neighbors

***What is your favorite object in your studio?
?

***What´s your answer to everything?
computers says no

***On which things do you spend your money?
hopefully for the right ones

***You can´t live without....
our daughter

***Are you a design victim?
yes and no, probably yes but only

the good gadgets...

***What is your opinion on "fame"? ruhm? 15 minuten, we have to find them somewhere first, Sic transit gloria mundi! („Thus passes the glory of the world")

***What is your opinion on designers with attitudes like pop stars?
:-) yeah, rockstars, we personally don't know any rockstars, but the couple rock stars that are around, are always good for a whimsical smile.

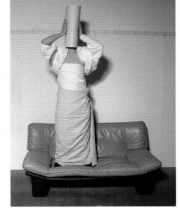

SOMETHING ABOUT THE TOPIC OF THE BOOK:

***Define a promotion:
true conveyance of contents. smart. convincing, detailed, credible

***Which criteria should a good promotional campaign feature?
see above

***You need to promote your self, how do you do it?
we don't have an idea on how to do that. maybe we should continually update our website with all of our recent works and clever texts.

***Which is the best campaign you ever saw?
carol: computers says no

SOMETHING ABOUT ZURICH:

***Favorite places in Zurich we have now, but we would like to ask every one we know
sihlfriedhof (cemetery), lindenhof (park), somewhere at the lake, somewhere at the sihl or letten (two rivers)

*Clubs, resturants shops,museums buildings, places in general something nice.
this month: kunstgriff, bildwurf bar, samurai (a japanese restaurant), dachterassen/rooftops (in general), firma, some secret places we don't wanna see in a book ;-=

Disclaimer: Our knowledge is based on a dangerous smattering of thoughts and ideas

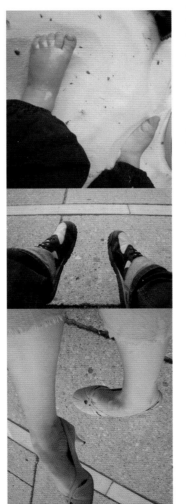

The Countries

Austria

Belgium

Denmark

England

France

Germany

Iceland

Italy

The Neth

14	75
76	113
114	129
130	161
162	203
204	247
248	
324	
362	
406	441
442	463
510	

Austria Belgium Denmark England France Germany Iceland It

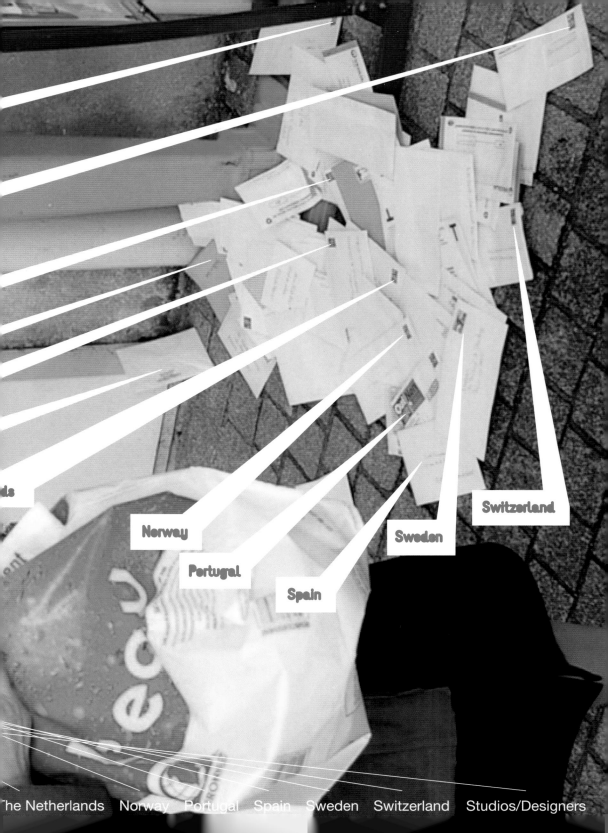

Norway

Portugal

Spain

Sweden

Switzerland

The Netherlands Norway Portugal Spain Sweden Switzerland Studios/Designers

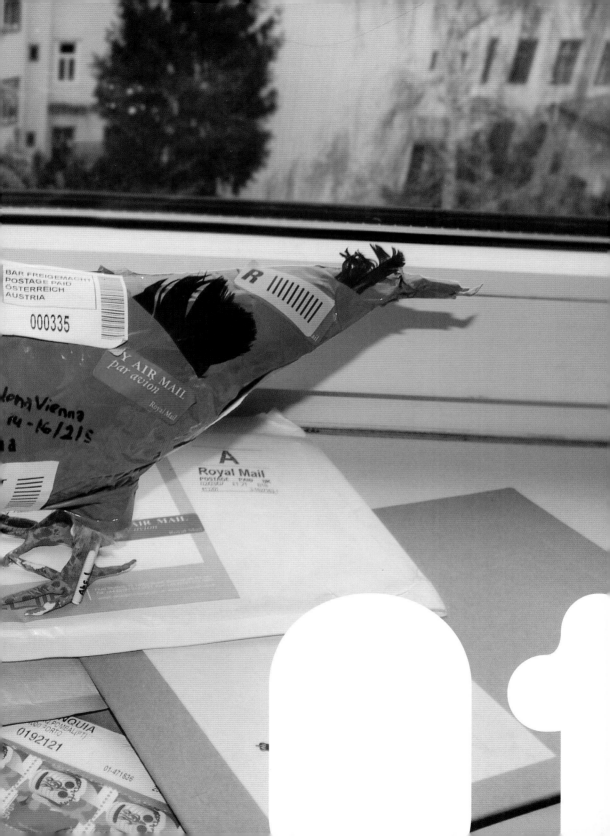

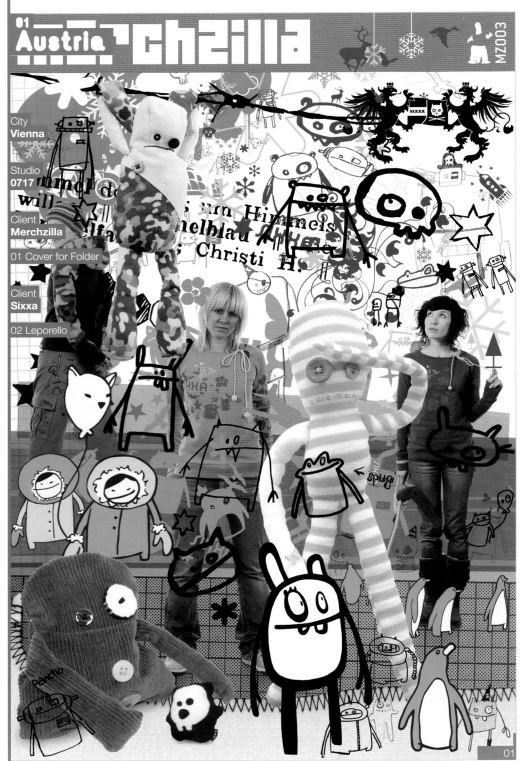

City
Vienna

Studio
0717

Client
Merchzilla

01 Cover for Folder

Client
Sixxa

02 Leporello

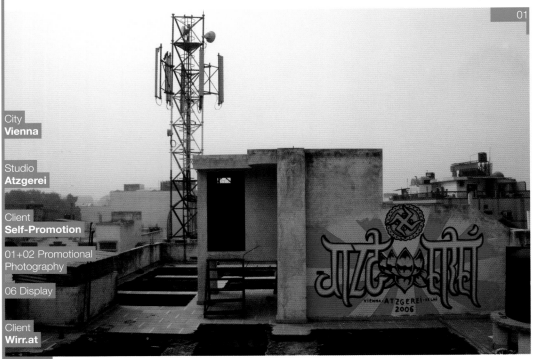

City
Vienna

Studio
Atzgerei

Client
Self-Promotion

01+02 Promotional
Photography

06 Display

Client
Wirr.at

03 Poster

Client
The Sprmrkt

04 Flyer

Client
COR

05 T-Shirt

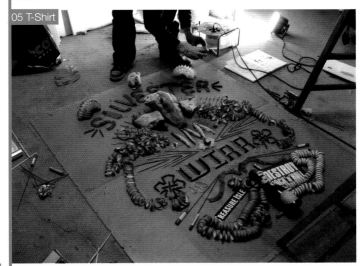

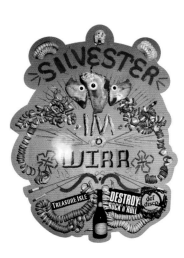

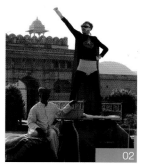

02

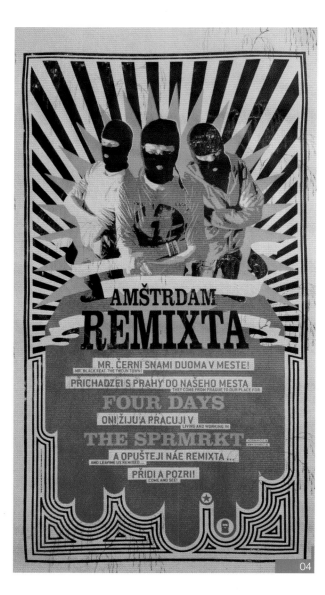

AMŠTRDAM
REMIXTA

MR. ČERNI SNAMI DUOMA V MESTE!
MR. BLACK FEAT. THE TWO ZI TOWN!

PRICHADZEI S PRAHY DO NAŠEHO MESTA
THEY COME FROM PRAGUE TO OUR PLACE FOR

FOUR DAYS

ONI ŽIJU A PRACUJI V
LIVING AND WORKING IN

THE SPRMRKT

A OPUŠTEJI NÁE REMIXTA ...
AND LEAVING US REMIXED

PŘIDI A POZRI!
COME AND SEE!

04

05

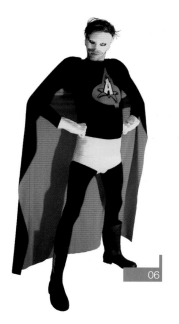

06

City
Vienna

Designer
Christof Nardin

Client
**Univesity of Applied
Arts Vienna**

01+02 Booklets

03 Poster/Media
for a Lecture Series

Client
trits.ch

04 Posters

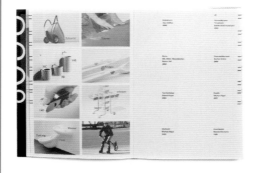

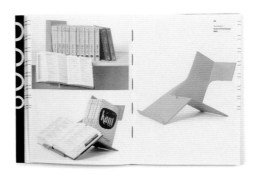

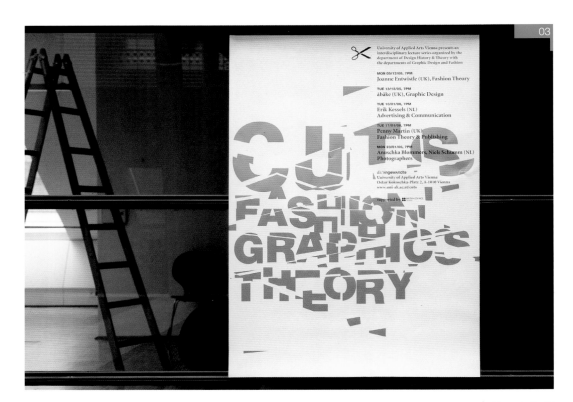

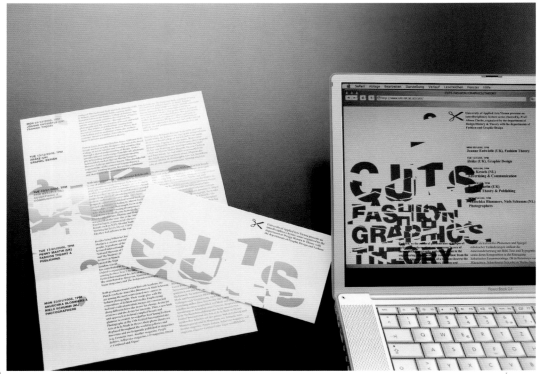

Club 2

Kreuzigung der Vernunft

mit Fetz, Feurstein, Matt, Nardin, Rüf, Waldner
26.12.2005, 21 Uhr, Tritsch

26.12.06, 21.00

—A**MOR**
E
TRITSCH

Club2

MIT
HAAKIEL
FETZ
FEURSTEIN
INNAUER
MATT
NARDIN
RÜF
WALDNER

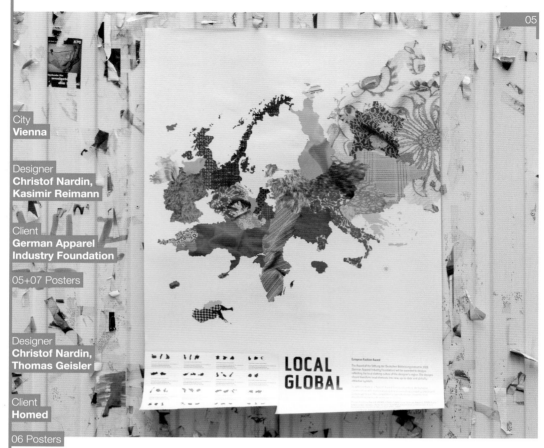

City
Vienna

Designer
**Christof Nardin,
Kasimir Reimann**

Client
**German Apparel
Industry Foundation**

05+07 Posters

Designer
**Christof Nardin,
Thomas Geisler**

Client
Homed

06 Posters

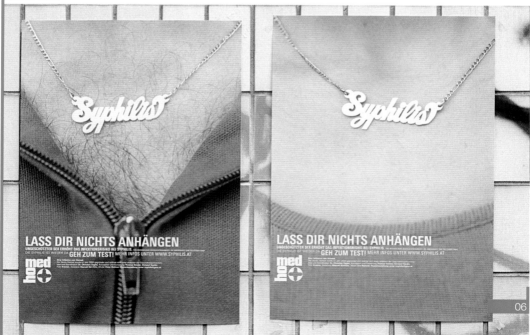

THE FINE ART OF TRAVELLING is the topic of the Award of the Stiftung der Deutschen Bekleidungsindustrie 2007 (German Apparel Industry Foundation). Regardless of whether business trip or sports vacation, first class or economy, we are looking for travel fashion that meets the multifaceted demands of travellers.

In addition, there is a Special Award Fashion Branding, attributed in collaboration with the world's leading brand consulting company Interbrand Zintzmeyer & Lux.

The competition is open to design students of all disciplines in the fourth semester or higher. Registration deadline: December 8th, 2006.

THE FINE ART OF TRAVELLING
EUROPEAN FASHION AWARD

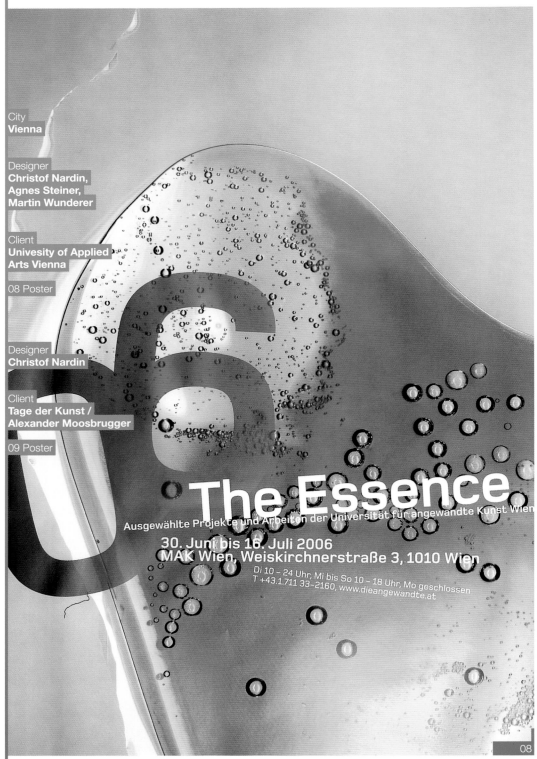

City
Vienna

Designer
**Christof Nardin,
Agnes Steiner,
Martin Wunderer**

Client
**Univesity of Applied
Arts Vienna**

08 Poster

Designer
Christof Nardin

Client
**Tage der Kunst /
Alexander Moosbrugger**

09 Poster

The Essence

Ausgewählte Projekte und Arbeiten der Universität für angewandte Kunst Wien

30. Juni bis 16. Juli 2006
MAK Wien, Weiskirchnerstraße 3, 1010 Wien

Di 10 – 24 Uhr, Mi bis So 10 – 18 Uhr, Mo geschlossen
T +43.1.711 33–2160, www.dieangewandte.at

08

City
Vienna

Studio
cmod

Client
Self-Promotion

01 Promotional
Photography

02 Toy

03 Poster

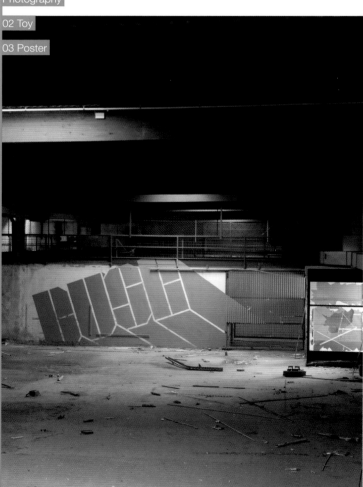

Foto: Kramar
Text: Sabine Dreher



01

02

03

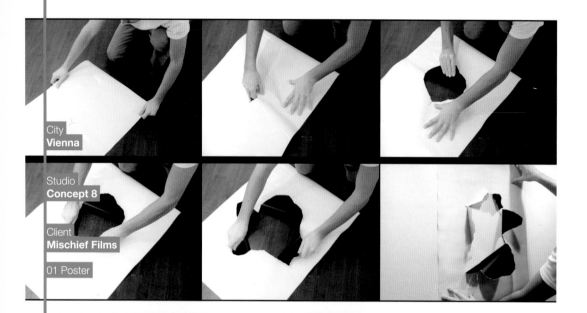

City
Vienna

Studio
Concept 8

Client
Mischief Films

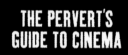

01 Poster

THE PERVERT'S
GUIDE TO CINEMA

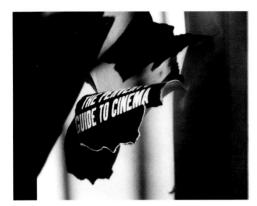

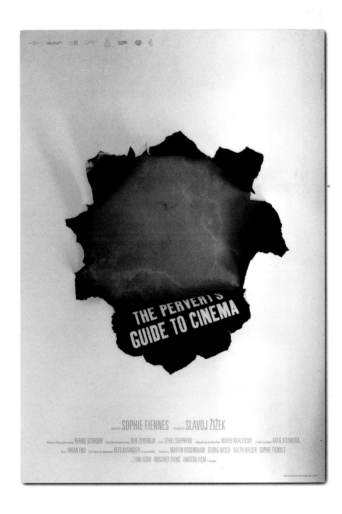

THE AGE OF SIMULATION

FORSCHEN und LERNEN

im 21. JAHRHUNDERT

SIMULATION and EDUCATION

Lernen durch Erfahrung. Simulationen eignen sich für die Konstruktion von informellen Lernumgebungen und bieten vielgestaltige Möglichkeiten zur Expedition in unterschiedlichen Wissensumgebungen.

SIMULATION and EDUTAINMENT

Die Bedeutung der emotionalen Involvie Möglichkeiten der Weltgestaltung für die von Lernprozessen am Beispiel vo

001

City
Vienna

Designer
Daniel Hammer

Client
Student Project
«The Age of Simulation»

01 Poster

SIMULATION /// EDUCATION 001

BEREICH der maximalen Steigung

3,548h
2,365h
1,523h

GIPFELpunkt
38,4578 m

Steigungsverhalten in Fall x aus 3 // vgl. Pkt. 85.20

B

SIMULATION /// SCIENCE 002

BEREICH der maximalen Steigung

4,985h 5,056h 5,398h

GIPFELpunkt GIPFELpunkt GIPFELpunkt
92,568 m 98,65 m 93,987 m

C

SIMULATION /// EDUTAINME

BEREICH der maximalen Steigung

0,566h

GIPFELpunkt
28,3625 m

SELECT HERE 0 5 10 20 30 40 50 60 70 80 90 100
nominale Entwicklung in Jahren
1990-1995 ■ Bevölkerung

SELECT HERE 0 5 10 20 30 40 50 60 70 80 90 100
nominale Entwicklung in Jahren
1995-2000 ■ Bevölkerung

MEERESNIVEAU

MEERESNIVEAU
0

MEERESNIVEAU

D00
x=0,3569
y=3,514588
z=126,441588
T=9,46917
s=4,9
s=unbekannt

D02
x=0,1588
y=63,4815584
z=15,19013
T=2169,196
s=2,19
s=unbekannt

D04
x=12,5687
y=149,196134
z=19,1016
T=56,1685
t=1,23945
s=1645,1856

D03
x=0,1813646
y=2,6891
z=12,18363836
T=916,1946
s=12,491h
s=9

N
NW NO
W O
SW SO
S

30
31

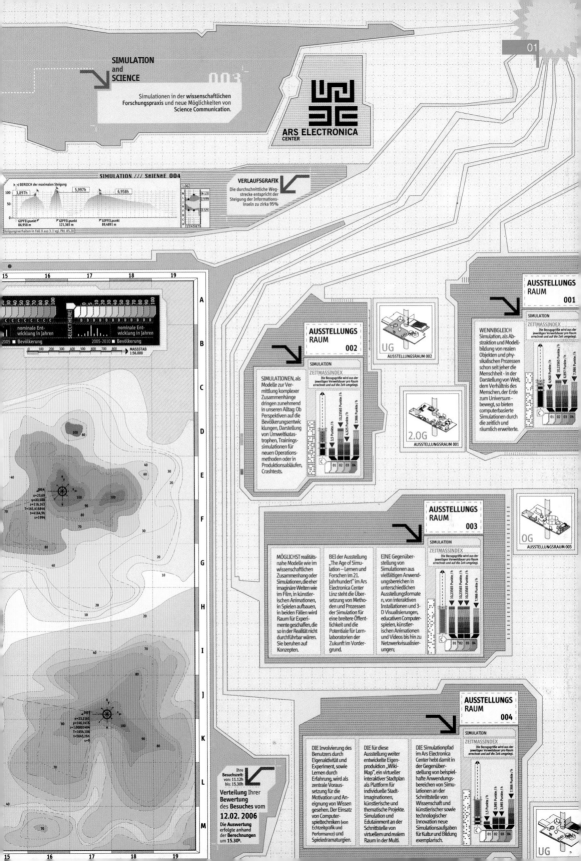

SIMULATION and SCIENCE

Simulationen in der **wissenschaftlichen** Forschungspraxis und neue Möglichkeiten von Science Communication.

ARS ELECTRONICA
CENTER

SIMULATION /// SnIEnnE 004

BEREICH der maximalen Steigung

3,897h 5,997h 6,958h

GIPFELpunkt II° GIPFELpunkt I° GIPFELpunkt
86,958 m 121,365 m 89,4891 m

Steigungsverhalten in Fall X aus 3 // vgl. Pkt. #5.20

VERLAUFSGRAFIK
Die durchschnittliche Wegstrecke entspricht der Steigung der Informationsinseln zu zirka 95%

nominale Entwicklung in Jahren nominale Entwicklung in Jahren
2005 Bevölkerung 2005-2010 Bevölkerung

MASSSTAB
1:56.000

SELECT HERE!

AUSSTELLUNGS RAUM 001

SIMULATION
ZEITMASSINDEX
Die Bezugsgröße wird aus der jeweiligen Verweildauer pro Raum errechnet und auf die Zeit umgelegt.

WENNBGLEICH Simulation, als Abstraktion und Modellbildung von realen Objekten und physikalischen Prozessen schon seit jeher die Menschheit - in der Darstellung von Welt, dem Verhältnis des Menschen, der Erde zum Universum - bewegt, so bieten computerbasierte Simulationen durch die zeitlich und räumlich erweiterte.

AUSSTELLUNGS RAUM 002

UG
AUSSTELLUNGSRAUM 002

2.0G
AUSSTELLUNGSRAUM 001

SIMULATION
ZEITMASSINDEX

SIMULATIONEN, als Modelle zur Vermittlung komplexer Zusammenhänge dringen zunehmend in unseren Alltag: Ob Perspektiven auf die Bevölkerungsentwicklungen, Darstellung von Umweltkatastrophen, Trainingssimulationen für neue Operationsmethoden oder in Produktionsabläufen, Crashtests.

AUSSTELLUNGS RAUM 003

SIMULATION
ZEITMASSINDEX
Die Bezugsgröße wird aus der jeweiligen Verweildauer pro Raum errechnet und auf die Zeit umgelegt.

MÖGLICHST realitätsnahe Modelle wie im wissenschaftlichen Zusammenhang oder Simulationen, die eher imaginäre Welten wie im Film, in künstlerischen Animationen, in Spielen aufbauen, in beiden Fällen wird Raum für Experimente geschaffen, die so in der Realität nicht durchführbar wären. Sie beruhen auf Konzepten.

BEI der Ausstellung „The Age of Simulation — Lernen und Forschen im 21. Jahrhundert" im Ars Electronica Center Linz steht die Übersetzung von Methoden und Prozessen der Simulation für eine breitere Öffentlichkeit und die Potentiale für Lernlaboratorien der Zukunft im Vordergrund.

EINE Gegenüberstellung von Simulationen aus vielfältigen Anwendungsbereichen in unterschiedlichen Ausstellungsformaten, von interaktiven Installationen und 3-D Visualisierungen, educativen Computerspielen, künstlerischen Animationen und Videos bis hin zu Netzwerkvisualisierungen;

OG
AUSSTELLUNGSRAUM 003

AUSSTELLUNGS RAUM 004

SIMULATION
ZEITMASSINDEX
Die Bezugsgröße wird aus der jeweiligen Verweildauer pro Raum errechnet und auf die Zeit umgelegt.

DIE Involvierung des Benutzers durch Eigenaktivität und Experiment, sowie Lernen durch Erfahrung, wird als zentrale Voraussetzung für die Motivation und Aneignung von Wissen gesehen. Der Einsatz von Computerspieltechniken (von Echtzeitgrafik und Performance) und Spieledramaturgien.

DIE für diese Ausstellung weiter entwickelte Eigenproduktion „WikiMap", ein virtueller interaktiver Stadtplan als Plattform für individuelle Stadtimaginationen, künstlerische und thematische Projekte. Simulation und Edutainment an der Schnittstelle von virtuellem und realem Raum in die Multi.

DIE Simulationpfad im Ars Electronica Center hebt damit in der Gegenüberstellung von beispielhafte Anwendungsbereichen von Simulationen an der Schnittstelle von Wissenschaft und künstlerischer sowie technologischer Innovation neue Simulationsaufgaben für Kultur und Bildung exemplarisch.

Ihre Besuchszeit:
von: 11.12h
bis: 15.30h

Verteilung Ihrer **Bewertung** des **Besuches** vom **12.02. 2006**
Die Auswertung erfolgte anhand der **Berechnungen** um 15.30h.

UG

15 16 17 18 19

A B C D E F G H I J K L M

wonderland

City
Vienna

Studio
Drahtzieher

#1 'Getting Started'

ABCDEFGHIJKLMNOPQRSTUVWXYZ ÄÖÜ
abcdefghijklmnopqrstuvwxyz äöü 0123456789
.,-;:!?&8()+-*/·#@[\]_ ¶«»¡¿®©™%„"",'
§¢$€¥àçéîñøûÅÇÈÎÑØÛÆŒæœ

Client
Wonderland

the quick brown fox jumps over the lazy cat.
the rabbit jumps over the lazy fox.
THE QUICK BROWN FOX JUMPS OVER THE LAZY CAT.
THE QUICK BROWN FOX JUMPS OVER THE LAZY CAT.
the quick brown fox jumps over the lazy cat.
the quick brown fox jumps over the lazy cat.

01 Poster

02 Postcards

Follow the white rabbit!

'Getting Started'

About
POACHING!

A10

(opposite)

Studio
ICHIBAN

Architects pay more attention to sneaker brands than to marketing literature.

Client
Microsoft

01 XBox-Design

NEW MAGAZINE

wonderland
Platform for Architecture

Where, how and with what means can I make myself independent as an architect?

51 hours/week
is the average working time for the architects surveyed.

wonderland

wonderland

#1 ISSUE RELEASE

Real Vienna
31. Mai – 2. Juni 2006
Messezentrum Wien Neu

Wonderland in Vienna
7. Juni – 19. Juni 2006
Architekturzentrum Wien

GOOD (quality)
FAST
CHEAP

www.drahtzieher.at

'Getting Started'
Follow the white rabbit…

'Getting Started'
Follow the white rabbit…

·OUT OF EUROPE·

SKY EUROPE

BUNDESKANZLERAMT KUNST

Education and Culture
Culture 2000

CityOf Vienna
Vienna is special.

#1 wonderland

Arch_Ing

A10 #1 wonderland
Platform for Architecture

A10 #1 wonderland
Platform for Architecture

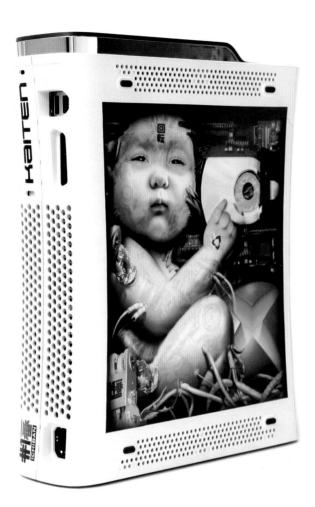

01

02

Studio
ICHIBAN

Client
Microsoft

02 Promotional Pack,
Stickers

Client
Nike

03 Advertisement

Client
Self-Promotion

04 Clothing

KAITEN 回転

(jap. für 回 Kai = Kreis , 転 Ten = Wiederholung)

Die Gestaltung der X-Box Konsole hat Ichiban auf eine meditative und fast schon philosophische Reise geführt.
Es ist nicht genug die Konsole als optisch ansprechendes Äusseres zu gestalten, die visuelle Darstellung musste nicht
nur dem Thema entsprechen sondern inhaltlich weiterführen, anbieten und zum Teil auch irgendständig wachsen.
Im Grunde sind es zwei verschiedene Interpretationen eines Themas, auf in einer Seite der x-Box offensteen.
Zum einen die Zen-Inspirierte, weisse, klare und minimalistische Wirkende Linie, auf der anderen Seite die
"Überraschungseffekt", das Innenleben der X-Box, voll dem "Bereichise" Kaiten.

Die offensichtliche Assoziation Kaiten – wiederholender Kreis, ist mit der Rotation der CD oder DVD verbunden, die
Sanfterbegende Gedanke in der permanente Versuch etwas Immer und Immer wieder zu wiederholen, bis das
gewünschte Ergebnis erreicht ist.
Das Baby symbolisiert auch den Menschen, geworfen an Mittelpunkt, nicht gefangen, sondern häufig fortschend
und lernend.
Ein Baby muss auch behutsar werden, es muss umsorgt werden und es nehmgt seine Aufmerksamkeit.
Die X-Box als Tür zu einer virtuellen Welt, dem Betrachter ist es überlassen zu unglein.

KAITEN

(jap. for 回 kai = circle, 転 ten = repetition)

With the design of the X-Box console, Ichiban started a meditation and almost philosophical journey.
It is not enough to design the console just to look good, the visual effect has to offer a message, some sort of guidance.
There are two different interpretations of one theme, each visualized on each side of the x-box.
First, there is the Zen inspired, white, clear and clutz line, on the other side there is the "surprise" effect, the life inside
the console, with its innardum the baby Kaiten.
The obvious association to Kaiten is the rotating circle, the CD or DVD, but behind this thought lies the permanent and
the repeat something over and over again to reach the proper result.
The baby symbolizes also the human centered, always in the midpoint, not held to capture, but voluntary searching and

Handling Exattention: Kaiten wants to be taken care of.
The betrachter has to make his own opinion.

HANDLE WITH CARE
DO NOT TOUCH WITHOUT GLOVES!

034
035

02

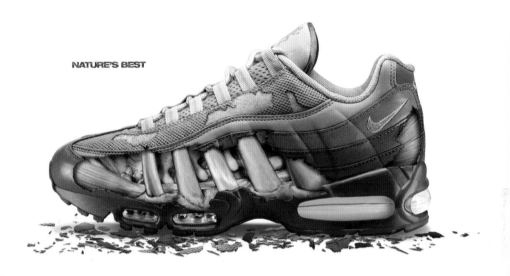

NATURE'S BEST

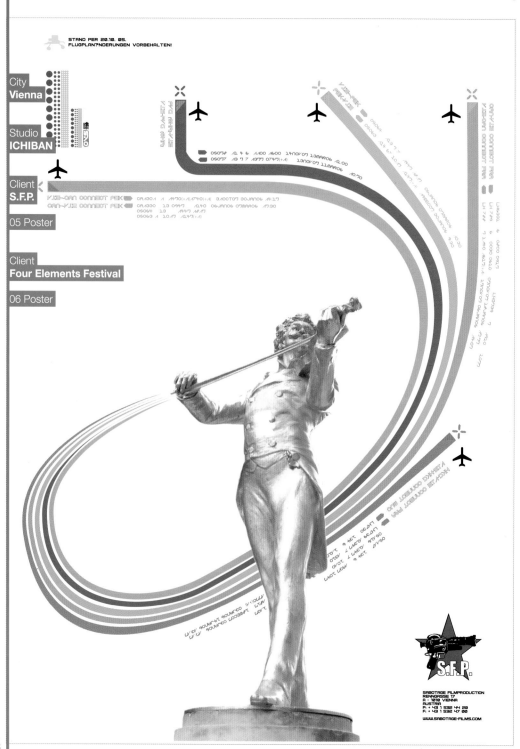

STAND PER 20.10. 05.
FLUGPLAN?NDERUNGEN VORBEHALTEN!

City
Vienna

Studio
ICHIBAN

Client
S.F.P.

05 Poster

Client
Four Elements Festival

06 Poster

SABOTAGE FILMPRODUCTION
RENNGASSE 17
A - 1010 VIENNA
AUSTRIA
P: + 43 1 532 44 20
F: + 43 1 532 47 20
WWW.SABOTAGE-FILMS.COM

City
Vienna

Studio
isebuki

Client
KAIA.Licht

01 Leporello

02 Brochure

Client
Bernhard Loibner

03 Press CD

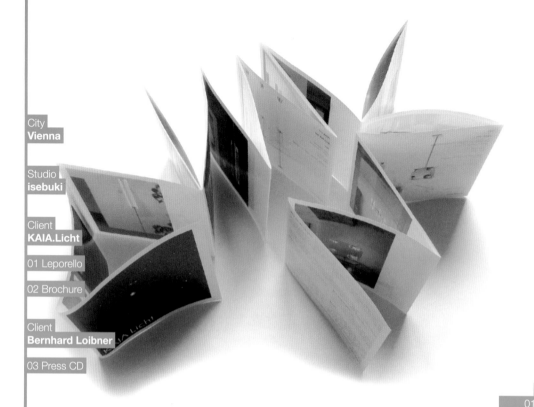

01

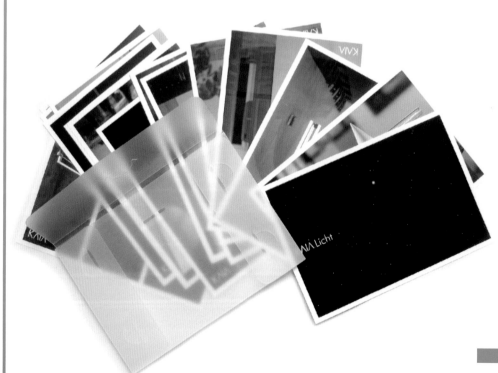

02

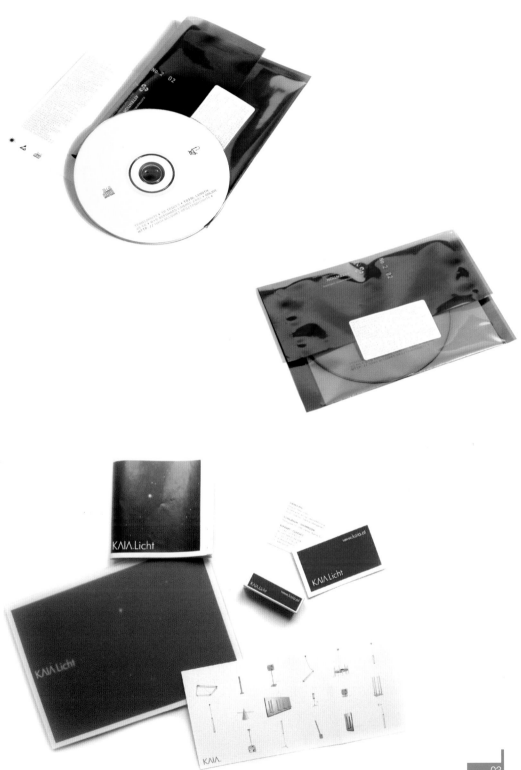

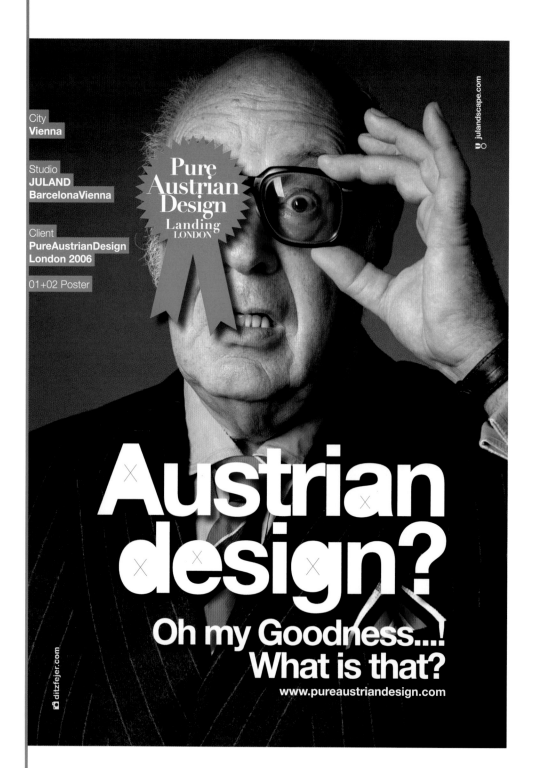

City
Vienna

Studio
JULAND
BarcelonaVienna

Client
PureAustrianDesign
London 2006

01+02 Poster

Pure
Austrian
Design
Landing
LONDON

Austrian
design?
Oh my Goodness....!
What is that?
www.pureaustriandesign.com

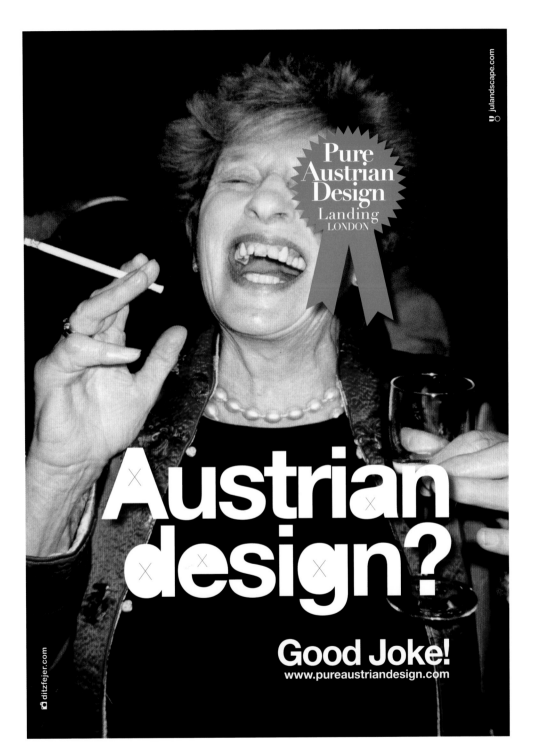

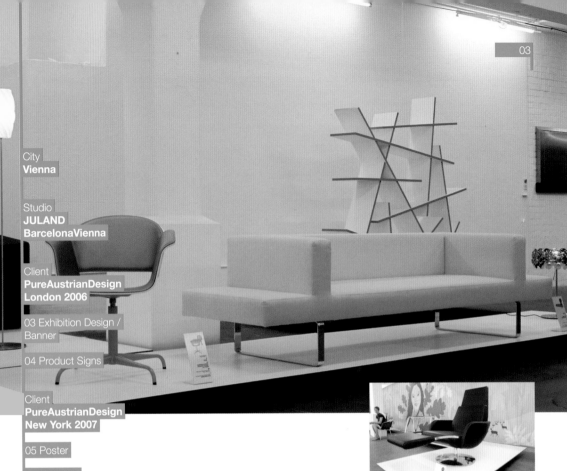

City
Vienna

Studio
JULAND
BarcelonaVienna

Client
PureAustrianDesign
London 2006

03 Exhibition Design /
Banner

04 Product Signs

Client
PureAustrianDesign
New York 2007

05 Poster

06 Invitation

07 Advertisement

Client
PadFinder Magazine

08 Advertisement

PLUS
D*
SEBASTIAN
MENSCHHORN
P*
–
M*
wood, foam, fabric, chromed steel
I*
www.pureaustriandesign.com/showroom/
sebastian_menschhorn
www.sebastianmenschhorn.com

RONDO
P*
BENE
D*
CHRISTIAN HORNER
JOHANNES SCHERR
KAI STANIA
M*
maple plywood, beech or cherry veneered,
fabric or leather, steel
I*
www.pureaustriandesign.com/showroom/bene
www.bene.com

04

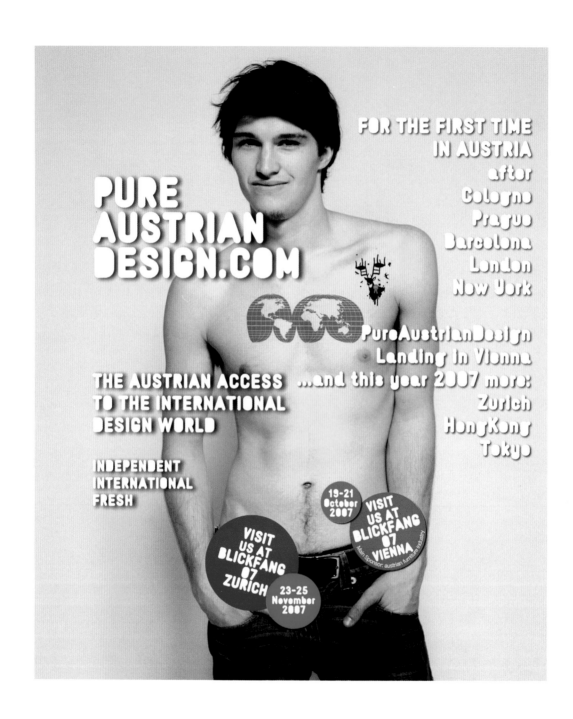

PURE
AUSTRIAN
DESIGN.COM

FOR THE FIRST TIME
IN AUSTRIA
after
Cologne
Prague
Barcelona
London
New York

PureAustrianDesign
Landing in Vienna
...and this year 2007 more:
Zurich
HongKong
Tokyo

THE AUSTRIAN ACCESS
TO THE INTERNATIONAL
DESIGN WORLD

INDEPENDENT
INTERNATIONAL
FRESH

19-21
October
2007

VISIT
US AT
BLICKFANG
07
VIENNA
Main Sponsor: austrian furniture industry

VISIT
US AT
BLICKFANG
07
ZURICH
23-25
November
2007

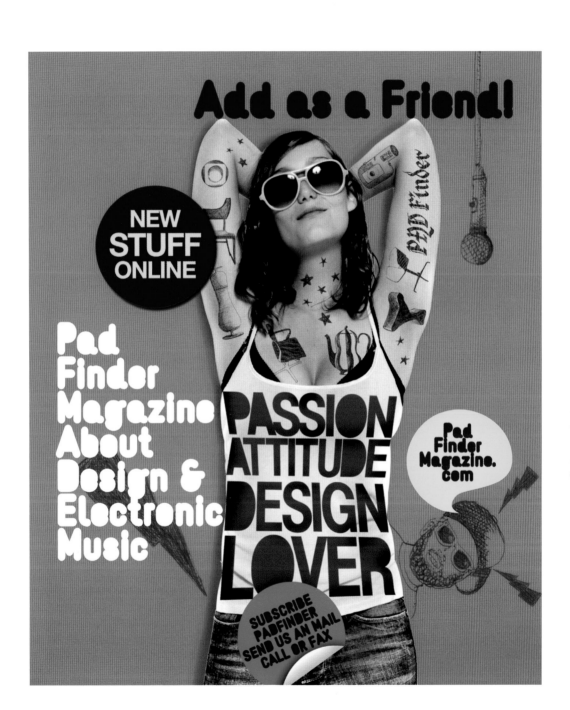

City
Vienna

Studio
JULAND
BarcelonaVienna

Client
PureAustrianDesign
New York 2007

09 Poster

10 Catalogue

11 Badges

12 Bag

13+14 Invitations

15 Cup

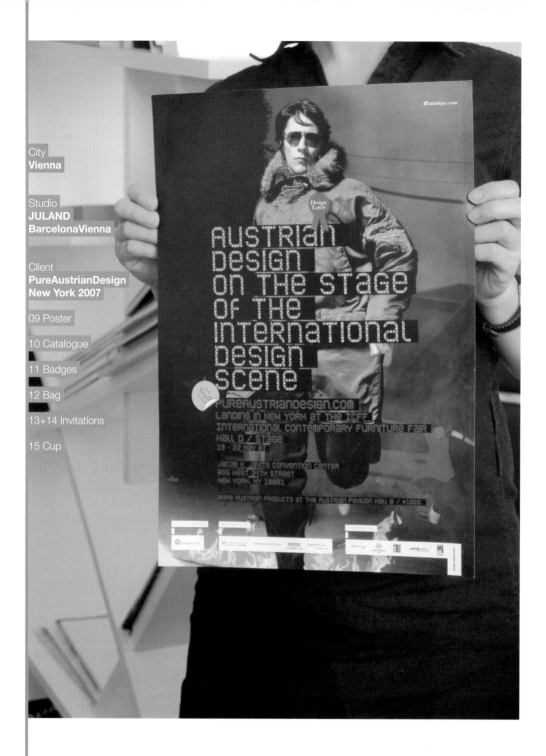

creative industrial objects

Pure Austrian Design

ICFF Show

The "Pure Austrian Design Landing" – the exhibition is a high profile design exhibition of the contemporary Austrian design landscape. The selected exhibits range from furniture and product design to lighting and tableware. The show introduces the up-coming design generation to established manufacturers. Thirteen objects from Vienna are awarded the "Vienna Selected Design" button. The announced design objects will be presented in an official Austrian landmark. The exhibition by Austrian CIO will accompany the "landing aspirations".

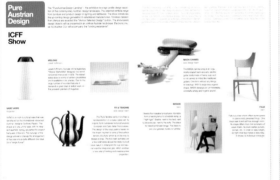

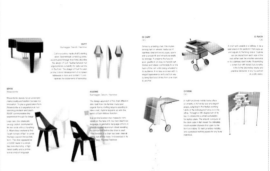

11

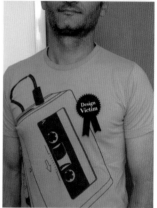

12

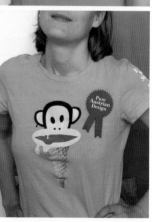

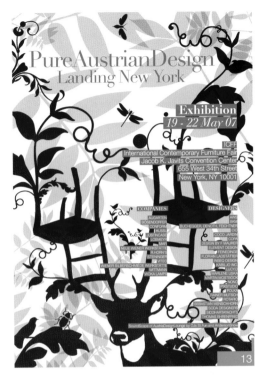

PureAustrianDesign
Landing New York

Exhibition
19 - 22 May 07

ICFF
International Contemporary Furniture Fair
Jacob K. Javits Convention Center
655 West 34th Street
New York, NY 10001

13

14

15

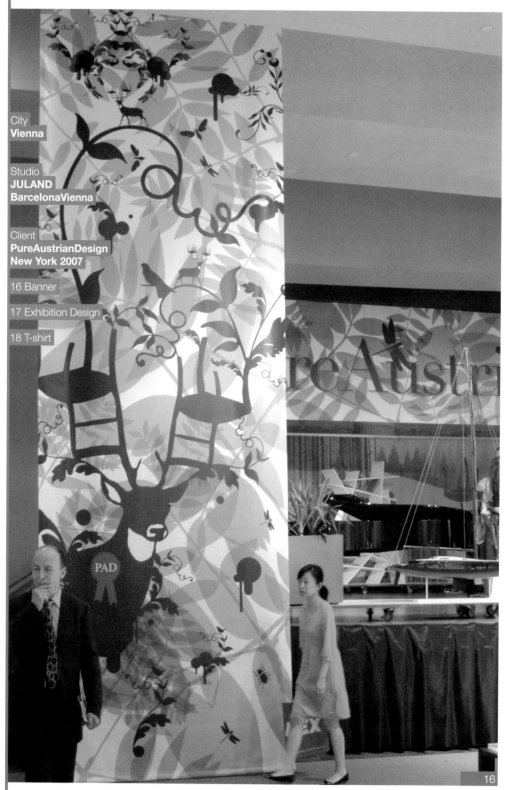

City
Vienna

Studio
**JULAND
BarcelonaVienna**

Client
**PureAustrianDesign
New York 2007**

16 Banner

17 Exhibition Design

18 T-shirt

16

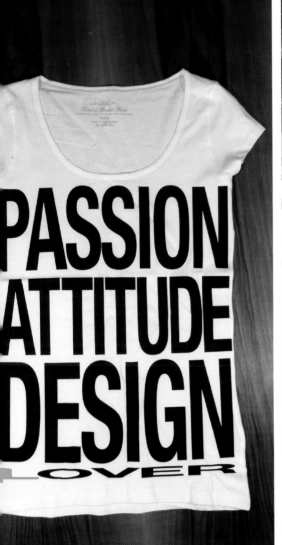

PASSION
ATTITUDE
DESIGN
LOVER

City
Vienna

Studio
Peach

Client
Couch Records

01 Poster

02 CD Artwork+Flyer

Client
Wien Museum

03 Posters

Client
ORF

04 Bus Signage

05 City Light Poster

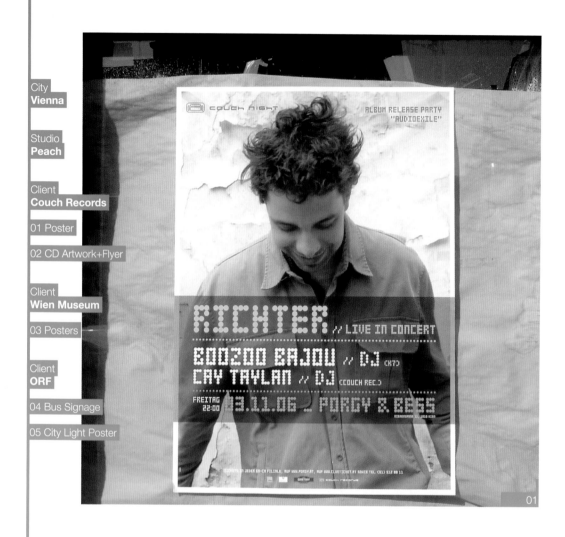

01

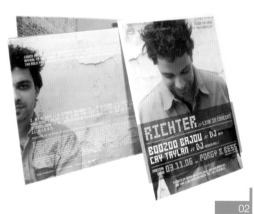

02

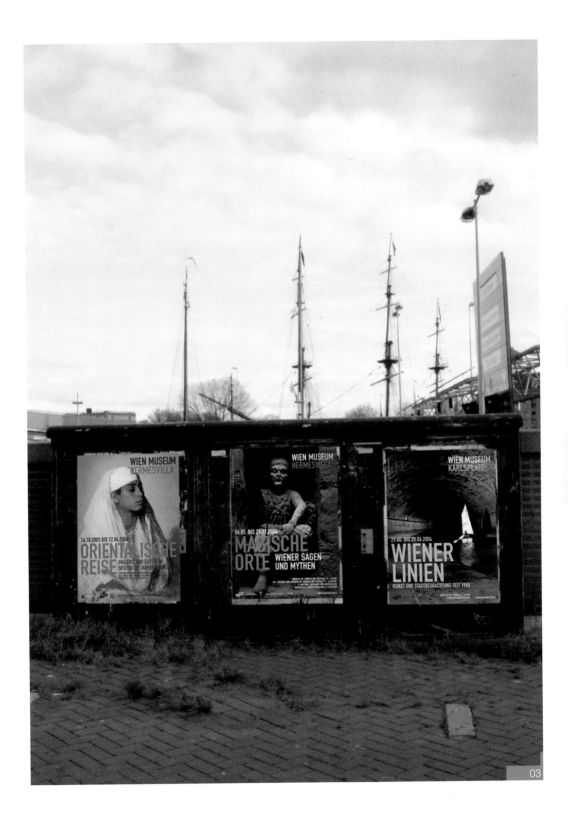

03

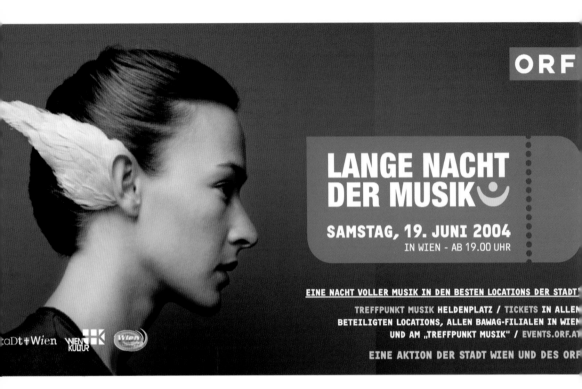

ORF

**LANGE NACHT
DER MUSIK**

SAMSTAG, 19. JUNI 2004
IN WIEN - AB 19.00 UHR

EINE NACHT VOLLER MUSIK IN DEN BESTEN LOCATIONS DER STADT

TREFFPUNKT MUSIK **HELDENPLATZ** / TICKETS **IN ALLEN**
BETEILIGTEN LOCATIONS, ALLEN BAWAG-FILIALEN IN WIEN
UND AM „TREFFPUNKT MUSIK" / EVENTS.ORF.AT

EINE AKTION DER STADT WIEN UND DES ORF

04

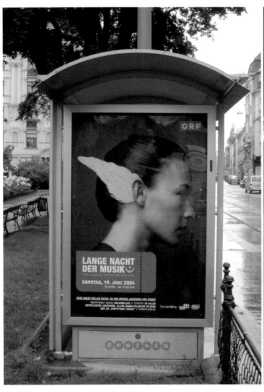
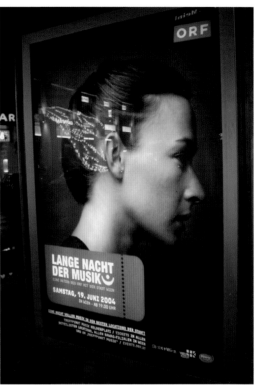

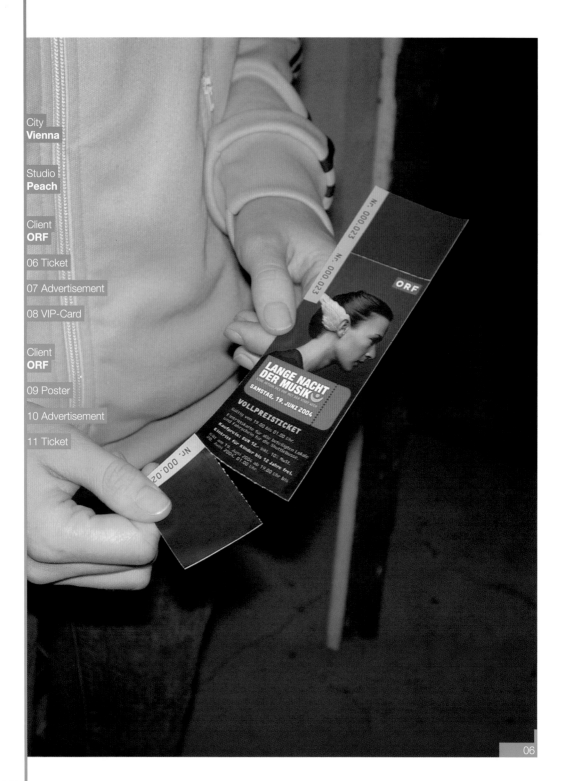

City
Vienna

Studio
Peach

Client
ORF

06 Ticket

07 Advertisement

08 VIP-Card

Client
ORF

09 Poster

10 Advertisement

11 Ticket

06

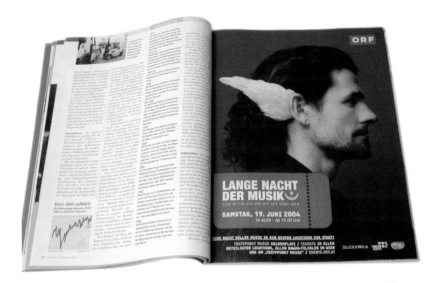

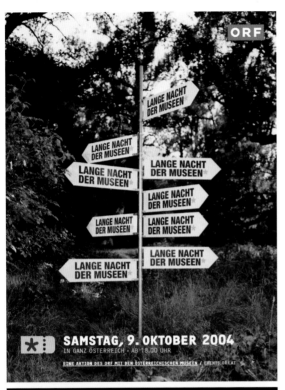

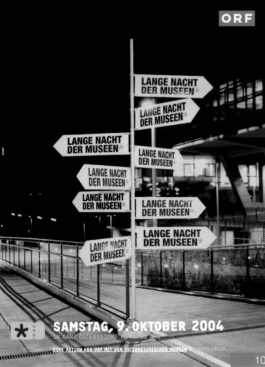

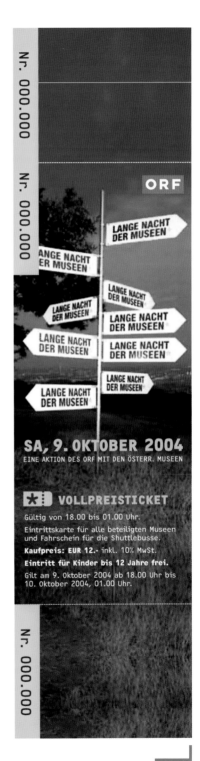

10

11

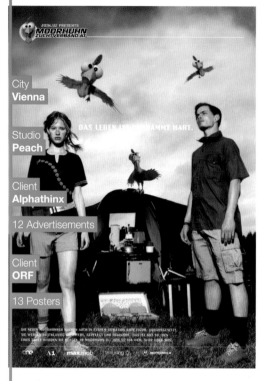

City
Vienna

Studio
Peach

Client
Alphathinx

12 Advertisements

Client
ORF

13 Posters

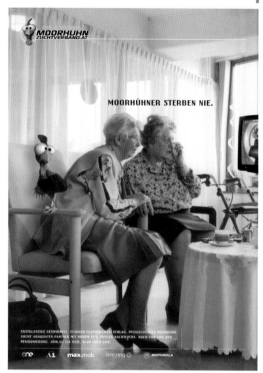

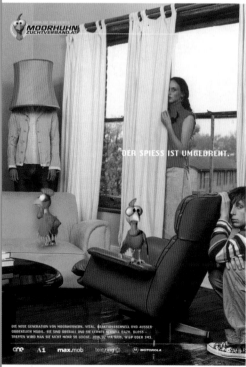

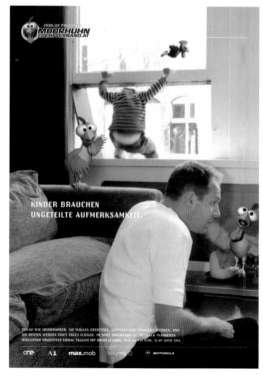

13

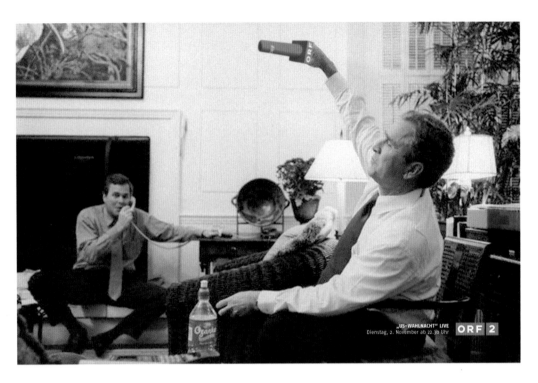

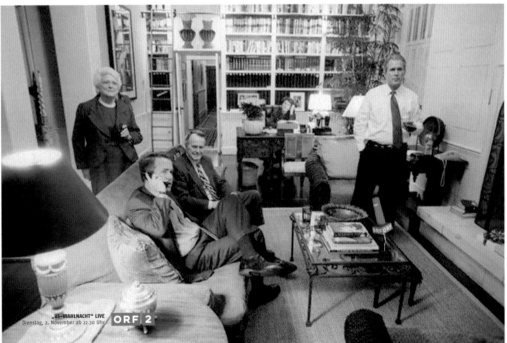

City
Vienna

Designer
Sabine Lorenz

Client
**Verein zur Förderung
der Filmkultur**

01 Card
front / inside / back

02 Flyer

03 Badges

04 Flyer

05 T-Shirts

FLIM
Zeitschrift für Filmkultur

FLIM ist ein idealistisches Zeitschriftenprojekt, das sich intensiv und hintergründig mit dem bewegten Bild beschäftigt. Ganz persönliche Emotionen und Erkenntnisse haben dabei ebenso Platz wie analytische Gedanken. Durchdachtes Design unterstützt die Texte, die sich mit Themen aus der großen Weite des Films auseinandersetzen. Handgezeichnete Illustrationen, fotografische Arbeiten und das offene Layout, das den Texten Platz zum Atmen gibt, gehören zum Gesamtkonzept von FLIM.

FLIM ist der Versuch, der professionellen Stromlinienförmigkeit in der Filmberichterstattung ein innovatives und individuelles Gegenstück zu bieten. FLIM erweitert die Landschaft der deutschsprachigen Filmzeitschriften um eine neue Nische. FLIM verwischt Genregrenzen der Textproduktion und regt zu einer ernstzunehmenden Betrachtung der Einflüsse und Auswirkungen, die Film auf unser Leben hat, an.

Die aktuelle Ausgabe 01/2006 widmet sich unter anderem dem selten behandelten Themenkomplex Filmmusik und Ton und nähert sich ihm aus verschiedenen Richtungen an. Ein Versuch, Hörbares zu fotografieren, Gedanken zu ordnen und Gefühle zu Papier zu bringen. Außerdem in FLIM 01/2006: Texte über Blaxploitation, Puppenanimation, Lady Snowblood, Kurt Kren, Bollywood in Barcelona und vieles andere mehr.

FLIM erscheint zweimal im Jahr und ist im Buchhandel, in Programmkinos und Musikläden erhältlich.

FLIM online bestellen unter order@studienverlag.at

FLIM – Zeitschrift für Filmkultur
www.flim.at

01

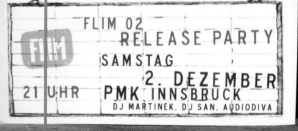

02

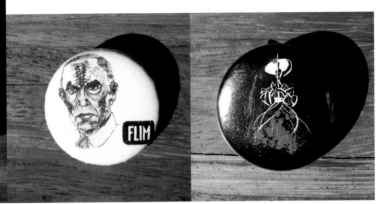

03

04

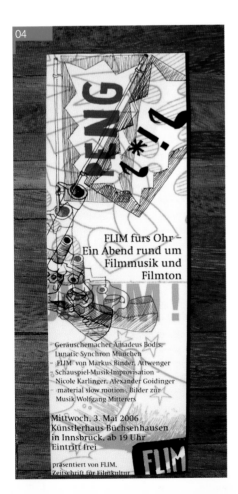

FLIM fürs Ohr –
Ein Abend rund um
Filmmusik und
Filmton

– Geräuschemacher Amadeus Bodis,
Lunatic Synchron München
– FLIM von Markus Binder, Attwenger
– Schauspiel-Musik-Improvisation –
Nicole Karlinger, Alexander Goidinger
– material slow motion, Bilder zur
Musik Wolfgang Mitterers

Mittwoch, 3. Mai 2006
Künstlerhaus Büchsenhausen
in Innsbruck, ab 19 Uhr
Eintritt frei

präsentiert von FLIM,
Zeitschrift für Filmkultur

05

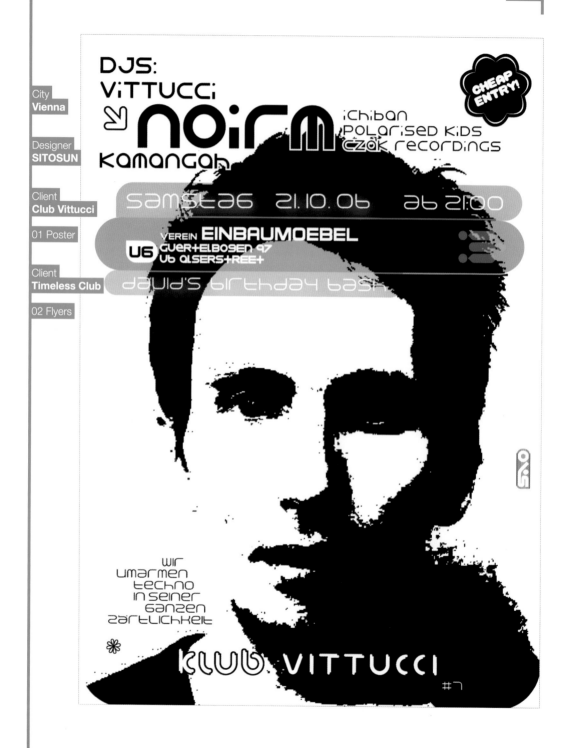

City
Vienna

Designer
SITOSUN

Client
Club Vittucci

01 Poster

Client
Timeless Club

02 Flyers

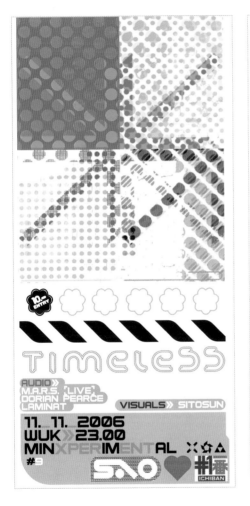

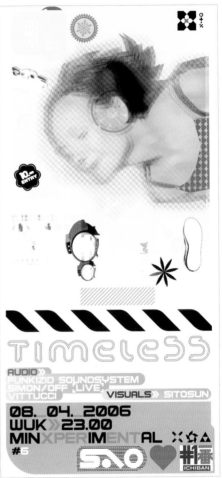

TIMELESS

AUDIO »
M.A.R.S. 'LIVE'
DORIAN PEARCE
LAMINAT

VISUALS » SITOSUN

11. 11. 2006
WUK » 23.00
MINXPERIMENTAL X☆△
#9

TIMELESS

AUDIO »
FUNKIZID SOUNDSYSTEM
SIMON/OFF 'LIVE'
VITTUCCI

VISUALS » SITOSUN

08. 04. 2006
WUK » 23.00
MINXPERIMENTAL X☆△
#6

BÆTTLE RESEARCH

Innsbrucks freie Kulturszenen

City
Innsbruck

Studio
transporter werbeagentur
fabrizi.höller.reiter oeg

Client
BÆTTLEGROUP FOR ART

01 Poster
front / back

Client
beaufort Architekten

02 Close-up

03 Invitation Card

04 Personal Card

...tektur und tirol
...zer AutorInnen Autorenversammlung Regionalgruppe Tirol
...nen Autoren Tirol
...heaterbeirat Tirol
...lattform mobile Kulturinitiativen
...nstlerschaft
...tur Kulturinitiativen – IG Kultur Tirol]

...beschäftigt sich mit der „Kulturstadt" Innsbruck. Ihr Anliegen ist es zusammenzu-
...nsbrucker freien Szenen stärker sichtbar zu machen, die existenzielle Lage der
...zu thematisieren, auf kulturpolitische Probleme und Anliegen aufmerksam zu
...konzepte zu entwickeln, die den künstlerisch/kulturellen Potenzialen dieser Stadt
...sent geben.

...SUM

...RCH – INNSBRUCKS FREIE KULTURSZENEN

...EPTION/PROJEKTLEITUNG
...or art

...N
...TKI

...MSETZUNG/RECHERCHE gefördert von

...PROGRAMMIERUNG
...ncept.Print.Web.

...SSE
...or art
...gasse 6
...RI
...nat
...PBI

ETTLE RESEARCH
brucks freie Kulturszenen

...KT DER BÆTTLEGROUP FOR ART
...STADTPLAN

MIT EIGENEM ORT
Kulturinitiativen, Künstlerinnengruppen und Plattformen mit eigenem Ort
(Vereinslokalgruppen, Ausstellungsräume, regelmäßig besetzte Büros, Ateliers, Probenräume ...)

02 AUT. ARCHITEKTUR UND TIROL → //
03 KUNST & → 08 // 47, 37
09 DIE BÜHNE INNSBRUCK (Wagner) → 09 // 47, 104
14 EVERSEEL → 14 // 33, 65, 104
18 FREIRAD 105.9 MHZ → 18
20 GALERIE NOTHBURGA → 20
28 INITIATIVE MINDERHEITEN → 27 // 129, 131
30 INNSBRUCKER KELLERTHEATER → 30
33 JUGENDZENTRUM Z6/CAFÉ SUB → 33
36 KULTURCAFÉ PROPOLIS → 36
37 KULTURGASTHAUS BIERSTINDL → 37
38 KUNST UND DRÜBER → 38
39 KÜNSTLERHAUS BÜCHSENHAUSEN → 39
40 KUNSTRAUM INNSBRUCK → 40
41 LITERATURHAUS AM INN → 41
42 LIVE STAGE → 42
46 OTTO PREMINGER-INSTITUT
 // A CINEMATOGRAPH → 46A
 // B LEDKINO → 46B
47 P.M.K → 47
48 PLANKTON LABS → 39 // 47
48 PLATTFORM KUNSTÖFFENTLICHKEIT → 58 // 01, 126
50 THEATER AN DER SILL → 58
60 THEATER VERBAND TIROL → 37 // 129
63 TIROLER KÜNSTLERSCHAFT:
 // A KUNSTPAVILLON → 63A
 // B STADTTURMGALERIE → 63B
 // 39 KH BÜCHSENHAUSEN → 39
64 TKI Tiroler Kulturinitiativen – IG Kultur Tirol → 37, 39, 47, 107
65 TREIBHAUS → 65
66 TÜFTLER → 66 // 42, 72
67 TURMBUND → 67
68 V.A.R.U.U.M. CONTAINER → 68 // 37, 47, 65, 102
69 WERKSTÄTTE HASPINGERSTRASSE → 69
70 WESTBAHNTHEATER → 70
72 WORKSTATION → 72 // 37, 40, 47, 65

OHNE EIGENEN ORT
Kulturinitiativen, KünstlerInnengruppen, Plattformen ohne eigenen Ort, die
KünstlerInnen, Büros u. Räume gemeinsam mit anderen nutzen
bzw. fallweise anmieten, in früheren diversen Kulturinitiativen und
Interessenvertretungen haben eigene Orte außerhalb Innsbrucks

02 AUT.ARK. KV → // 33, 42, 72
03 BLICK IM WINKEL → // 106
04 CHOKE MEDIA EMPIRE → // 33, 47
05 CLUB FLAMINGO → // 47
06 COGNAC & BISKOTTEN → // 37, 42, 65, 102
07 CON VERSE → // 65, 101, 110
10 DIE IGLER ART → // ALL OVER IGLS
11 DIRTY DANCING CREW → // 47
12 DJ KAFFEE UND KUCHEN → // 37, 47, 105, 110
13 DJS AUS MITLEID → // 47
14 FAULZAHN → // 33, 47
16 FIREFLY CONCERTS → // 33, 36, 47
17 FILM (// Verein zur Förderung der Filmkultur) → // 01, 37, 39, 117
19 FULL CONTACT → // 47, 104
21 [GALERIE ST. BARBARA] → // 101, 110, 111
22 GAV (// Grazer Autorinnen Autorenversammlung) → // 47
23 GRAUZONE/ACTION NET → // 33, 47
24 HIDDEN MUSEUM → →
25 IG AUTORINNEN AUTOREN → // 37
26 IGFT (// Interessengemeinschaft Freie Theaterarbeit T) →
27 [IGNM TIROL] → →
29 INNPOLS → // 33, 37, 47, 65
31 IRK – WOCHENENDGESPRÄCHE → // 106, 111
32 IMNTEXT → // 37
34 K.U.U.G.E.L. → // 33, 39, 40, 47, 72
35 [KLANGSPUREN SCHWAZ] → // 110, 110, 126
43 LOS GURKOS PROD. → // 47, 72
44 MOZI BREWS FILM → // 47
45 MLK - KULTUR → // 36, 37, 47, 65
50 PREMIERENTAGE → // ALL OVER TOWN
51 QUIRLIG → →
52 RADIKALES NÄHKRÄNZCHEN → // 47, 72
53 RODIM ACADEMY → // 47, 72
54 STARTTHEATER → // 37, 65, 101, 106, 113
55 STRUCTURE RESEARCH → // 37, 40, 47, 102
56 SUBSDANCE → // 47, 104
57 TAK (// Tiroler Autorinnen und Autoren Komp →
59 THEATER MELONE → // 65, 70
61 THEATERGRUPPE GRENZENLOS → // 58
62 TIROLER DRAMATIKERFESTIVAL → // 37, 65, 70, 106
71 WETTERLEUCHTEN → // 108
73 WOZU GRENZEN?! → // 37
74 ZZAPP.TV → →

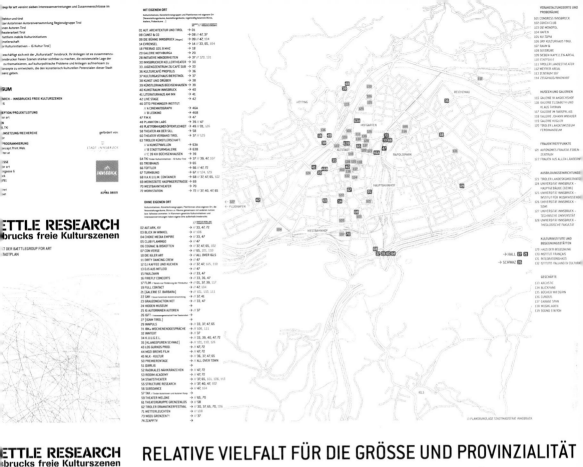

// PLANGRUNDLAGE STADTMAGISTRAT INNSBRUCK

VERANSTALTUNGSORTE UND
PROBERÄUME
101 CONGRESS INNSBRUCK
102 COUCH CLUB
103 DIE MONOPOL
104 HAFEN
105 NO TOPIA
106 ÖMT KULTURHAUS TROGL
107 RAUM &
108 SEEBÜRG
109 SIEBEN KAPELLEN-AREAL
110 STADTSALE
111 TIROLER LANDESTHEATER
112 WEYHER-AREAL
113 ZENTRUM 107
114 ZEUGHAUS/INNHOF

MUSEEN UND GALERIEN
115 GALERIE IM ANDECHSHOF
118 GALERIE ELISABETH UND
 KLAUS THOMAN
119 GALERIE IM TAXISPALAIS
119 GALERIE JOHANN WIDAUER
119 GALERIE KUGLER
120 TIROLER LANDESMUSEUM
 FERDINANDEUM

FRAUENTREFFPUNKTE
121 AUTONOMES FRAUENLESBEN-
 ZENTRUM
122 FRAUEN AUS ALLEN LÄNDERN

AUSBILDUNGSEINRICHTUNGEN
123 TIROLER LANDESKONSERVATO
124 UNIVERSITÄT INNSBRUCK -
 HAUPTGEBÄUDE (GEWI)
125 UNIVERSITÄT INNSBRUCK -
 INSTITUT FÜR MUSIKWISSENS
126 UNIVERSITÄT INNSBRUCK -
 SOWI
127 UNIVERSITÄT INNSBRUCK -
 TECHNISCHE UNIVERSITÄT
128 UNIVERSITÄT INNSBRUCK -
 THEOLOGISCHE FAKULTÄT

KULTURINSTITUTE UND
BEGEGNUNGSSTÄTTEN
129 HAUS DER BEGEGNUNG
130 INSTITUT FRANÇAIS
131 INTEGRATIONSHAUS
132 ISTITUTO ITALIANO DI CULTURA

GESCHÄFTE
133 AROSTIC
134 BLICKFANG
135 BÜCHEL WIEDERIN
136 CURIOUS
137 GARAGE SPAN
138 MOBKLAGEN
139 SOUND STATION

ETTLE RESEARCH
brucks freie Kulturszenen

...KT DER BÆTTLEGROUP FOR ART
...STADTPLAN

...vorliegende Stadtplan ist der erste Teil
...ættle research, einem Rechercherpro-
...das die bættlegroup for art innerhalb
...nsbrucker freien Kulturszenen durch-
...und das die bestehenden Netzwerke,
...edingungen, unter denen Kulturarbeit
...sbruck geschieht, sowie die Wünsche,
...hen und Ziele der Kulturtreibenden dar-
...Der Stadtplan bildet die in Innsbruck
...en autonomen Kulturinitiativen, Künst-
...engruppen und Plattformen ab, die als
...rschaffende, KulturveranstalterInnen
...der Interessenvertretungen in einem
...ulturellen Kontext arbeiten und so das
...elle Kulturleben der Stadt wesentlich
...alten. Neben den grundlegenden Daten
...dressen und Telefonnummern liegt der
...erpunkt im Stadtplan auf der Verortung
...itiativen und Gruppen (räumlich und
...ell), ihrer Vernetzung untereinander so-
...uf den ihre Kulturarbeit bestimmenden
...en und der Darstellung wesentlicher
...gspunkte der freien Szene in der Stadt.

...n Gruppierungen und Institutionen verbirgt sich eine unüberschaubare Anzahl an
...lenschen. Es würde den Rahmen von bættle research leider bei weitem sprengen, all
...lichkeiten, die sich für die Kultur in Innsbruck engagieren, und besonders jene Einzel-
...eiten, die künstlerisch tätig sind, alle Architekten und ArchitektInnen, die bildenden
...und KünstlerInnen, alle Musiker und MusikerInnen, die Komponisten und Komponistin-
...nds, die DJs und DJanes, die MedienkünstlerInnen und -künstlerinnen, alle TheoretikerInnen
...innen, alle SchriftstellerInnen und SchriftstellerInnen, alle SchauspielerInnen und Schauspielerin-
...e Regisseure und Regisseurinnen einzeln anzuführen.

...n rund 70 auf dem Stadtplan vertretenen Kulturinitiativen, KünstlerInnengruppen und
...gibt es selbstverständlich auch einige, die am Rechercheprojekt nicht beteiligt sind –
...n nicht zugehörig fühlen, keine Zeit zur Teilnahme fanden, nur über ihre inhaltliche
...die Öffentlichkeit treten wollen oder einfach weil wir einzelne nicht erreicht oder mög-
...verübernehmen haben. Auf die Darstellung der Archive, [Print]Medien und vielerlei En-
...eschaftlichen der Didaktik und Kulturvermittlung widmen, mussten wir leider verzichten,
...te die Kapazität des Projektes gesprengt. Deshalb zeigt bættle research zwar mög-
...auf den Innsbrucker freien Kulturszenen auf, erhebt jedoch keinen Anspruch auf
...keit.

...ort und vertieft werden sollen die Recherchen zu bættle research in zwei weiteren
...her **Netmap** im Internet, die auf der Basis des zum Stadtplan zugrunde liegenden Fra-

RELATIVE VIELFALT FÜR DIE GRÖSSE UND PROVINZIALITÄT
DER STADT // FAKTOR URBANEN LEBENSGEFÜHLS // NULL
MEDIENPRÄSENZ // WEITBLICK AUGENMASS KOMPETENZ
// WIDERSTÄNDIGE GRÜNDUNGEN // ALLES, SOLANGE ES
NICHTS KOSTET // ENTGLITTENE RELATIONEN // DIE STEI-
NERNEN STRUKTUREN DER NORDKETTE // BEHARRLICH-
KEIT // KUNST ALS LUXUSPRODUKT // WIR SIND DIE
PEANUTS // INNSBRUCK IST UND BLEIBT EINE LÄNDLICHE
GEMEINDE // EHRLICH WOLLEN STATT AMTLICH MÜSSEN //
UNSCHARF BIS PLANLOS // DAS STÄRKT // VERSCHWINDEN
POTENZIELLER KULTURRÄUME // KULTUR STADTSTRUK-
TURELL MITDENKEN // DAS STADT-LAND-BUND-SPIEL //
IMMER NUR GESTOPPELTE NOTLÖSUNGEN // NEUGIERIGES
PUBLIKUM // UNERHÖRTES // UNBEDINGT WÜNSCHENSWERT
// LÄSST ZU WÜNSCHEN ÜBRIG // MEHR MUT

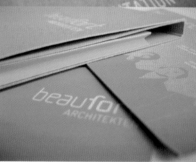

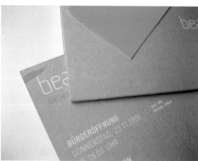

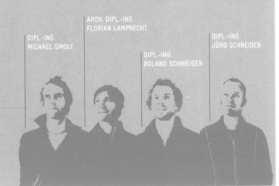

beaufort

ARCHITEKTEN

BÜROERÖFFNUNG
DONNERSTAG, 23.11.2006

ELISABETHSTRASSE 3
INNSBRUCK

PRÄSENTATION
19.30 UHR

DIPL.-ING.
MICHAEL SMOLY

ARCH. DIPL.-ING.
FLORIAN LAMPRECHT

DIPL.-ING.
ROLAND SCHWEIGER

DIPL.-ING.
JÖRG SCHNEIDER

beaufort
ARCHITEKTEN

DIPL.-ING.
JÖRG SCHNEIDER

DIPL.-ING.
ROLAND SCHWEIGER

ARCH. DIPL.-ING.
FLORIAN LAMPRECHT

DIPL.-ING.
MICHAEL SMOLY

beaufort

DI JÖRG SCHNEIDER
SCHNEIDER@BEAUFORT.AT
T +43 (0)512 560276 -15. M +43 (0)699 11069503

GEBOREN 1971 Innsbruck

AUSBILDUNG 1990-1998 TU Innsbruck
1998-1999 École d´Architecture
Languedoc-Roussillon (Montpellier/F)
1999-2000 Diplomarbeit
„Architekturzentrum Causse du Larzac"
bei Prof. Gilles Perraudin
2000 Diplom bei Prof. Volker Giencke
2005 Ziviltechnikerprüfung

PRAXIS 2000-2006
Peter Lorenz Architekten Projektleitung
2000 Saunahaus Casser Natters
2002 Umbau Alpinschule Innsbruck
2003 Sanierung Augen Miller
2003 Sanierung Theresia
2004-2005 MPREIS Niederndorf
2005 Wettbewerb Chirurgie
2006 Wettbewerb Swarovski Headquarters

PROJEKTE

1993 Dachbodenausbau Dr. Hiltmair / Innsbruck
2001 Haus Farbmacher / Sistrans
2002 Büroeinrichtung Rosaton / Innsbruck
2003 Buchbinderei Sanders / Innsbruck
2005 Doppelhaus Riepler / Ampass

ELISABETHSTRASSE 3 A-6020 INNSBRUCK
WWW.BEAUFORT.AT OFFICE@BEAUFORT.AT

T +43 (0)512 560276
FAX DW -13

City
Vienna

Studio
Treibhaus Wien

Client
Kopf Hoch

01 Postcards

Client
Self-Promotion

02 Direct Mailing

Client
FF Company

03 Direct Mailing

Client
Hertzflimmern

04 Flyer

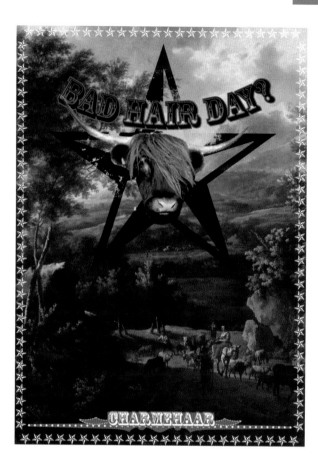

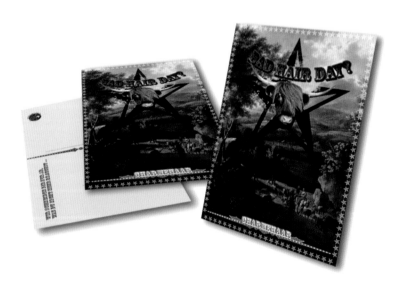

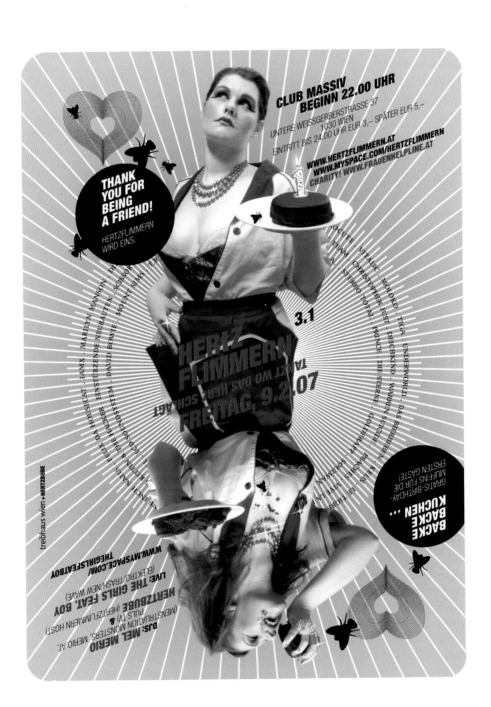

City
Vienna

Studio
Treibhaus Wien

Client
Die Kalendermacher

05 Advertisement

06 Application

07 Flyer

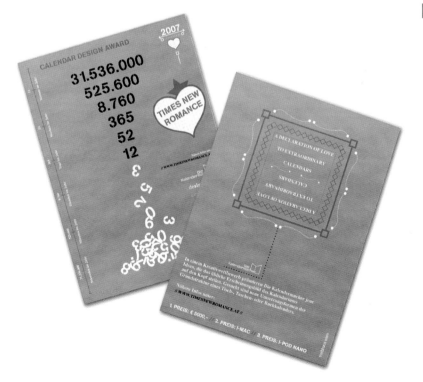

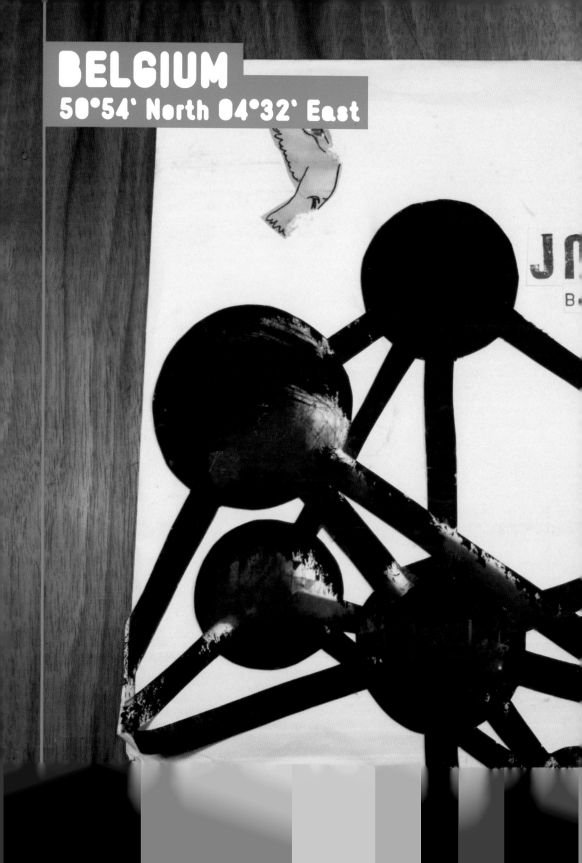

ANTWERPEN
09.VIII.07
200

BELGIQUE
B
L
E
G €0240
72MX

ND Barcelona Vienna

ggasse 14/16 / 2 / 5

0 Vienna

USTRIA

02

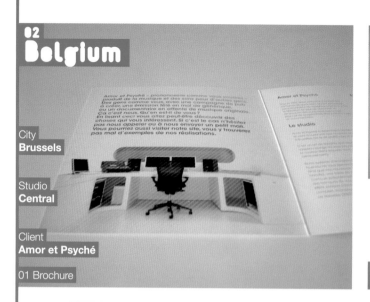

City
Brussels

Studio
Central

Client
Amor et Psyché

01 Brochure

01

Client
Infinitskills

02 Guerilla Advertising
(CD Artwork, Scotch Tape)

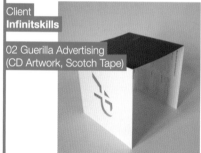

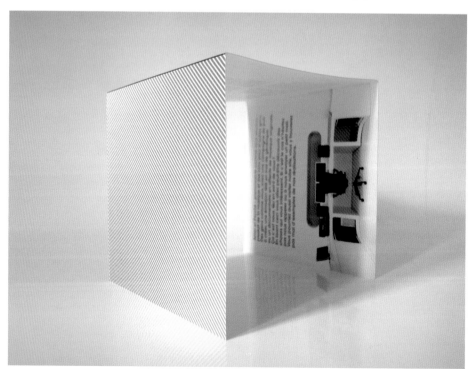

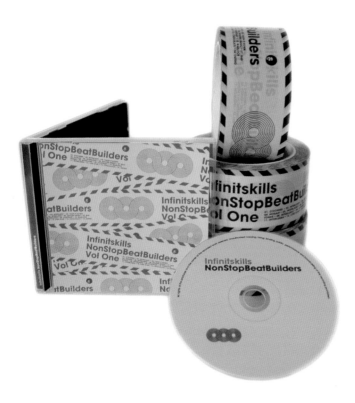

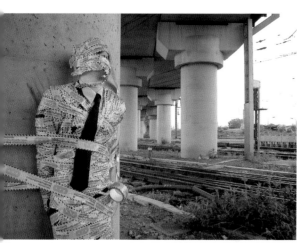

City
Borgerhout

Studio
Dikke Neus Verbond

Client
Beleg van Schoten 3

01 Poster

02 Sticker / Flyer

03 T-Shirt

04 Wall Painting

Client
Magik

05+07 Flyer

06 Badges

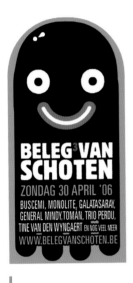

02

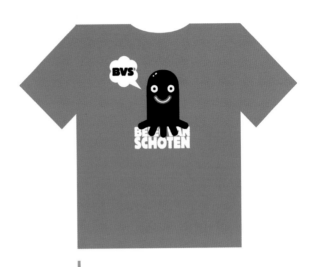

03

04

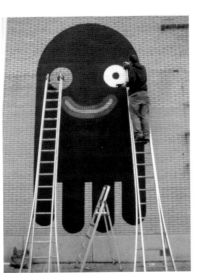

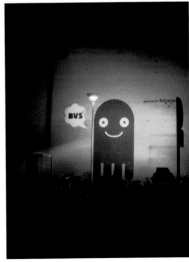

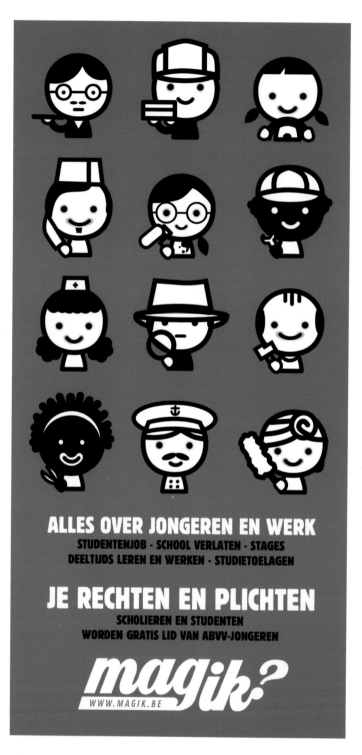

06

JOBSTUDENTEN CAFE

ALLES OVER JONGEREN EN WERK !

07

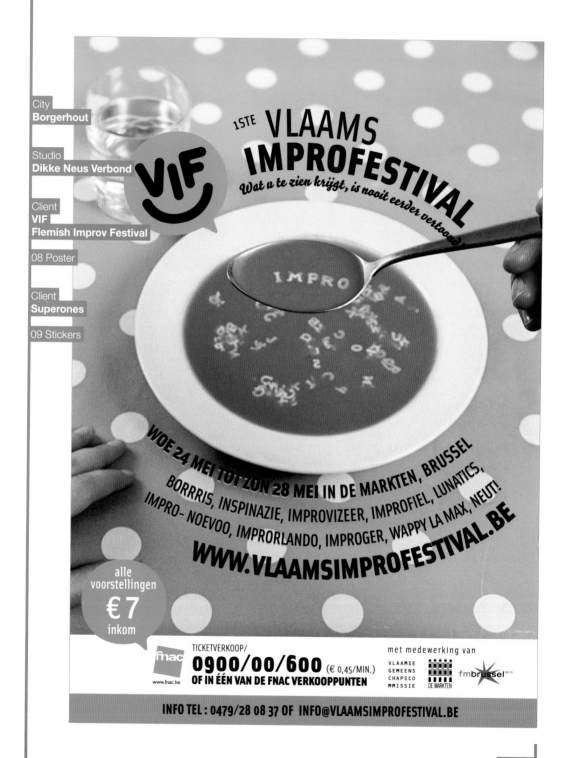

City
Antwerp

Studio
Flink

Client
AWDC

01+02 Poster

Client
Self-Promotion

03 Poster

04 Newspaper

ANTWERP
WORLD
DIAMOND
CENTRE

ANTWERP
CAPITAL OF DIAMONDS

LOREM IPSUM DOLOR SIT AMET, CONSECTETUER ADIPISCING ELIT. MORBI COMMODO, IPSUM SED PHARETRA GRAVIDA,
ORCI MAGNA RHONCUS NEQUE, ID PULVINAR ODIO LOREM NON TURPIS. NULLAM SIT AMET ENIM. SUSPENDISSE ID
VELIT VITAE LIGULA VOLUTPAT CONDIMENTUM. ALIQUAM ERAT VOLUTPAT. SED QUIS VELIT. NULLA FACILISI. NULLA
LIBERO. VIVAMUS PHARETRA POSUERE SAPIEN. NAM CONSECTETUER. SED ALIQUAM. NUNC EGET EUISMOD ULLAM-
CORPER, LECTUS NUNC ULLAMCORPER ORCI, FERMENTUM BIBENDUM ENIM NIBH EGET IPSUM

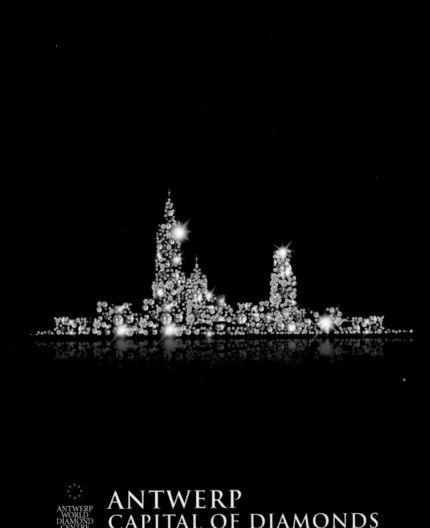

ANTWERP
CAPITAL OF DIAMONDS

ANTWERP WORLD DIAMOND CENTRE

LOREM IPSUM DOLOR SIT AMET, CONSECTETUER ADIPISCING ELIT. MORBI COMMODO, IPSUM SED PHARETRA GRAVIDA, ORCI MAGNA RHONCUS NEQUE, ID PULVINAR ODIO LOREM NON TURPIS. NULLAM SIT AMET ENIM. SUSPENDISSE ID VELIT VITAE LIGULA VOLUTPAT CONDIMENTUM. ALIQUAM ERAT VOLUTPAT. SED QUIS VELIT. NULLA FACILISI. NULLA LIBERO. VIVAMUS PHARETRA POSUERE SAPIEN. NAM CONSECTETUER. SED ALIQUAM. NUNC EGET EUISMOD ULLAM-CORPER, LECTUS NUNC ULLAMCORPER ORCI, FERMENTUM BIBENDUM ENIM NIBH EGET IPSUM.

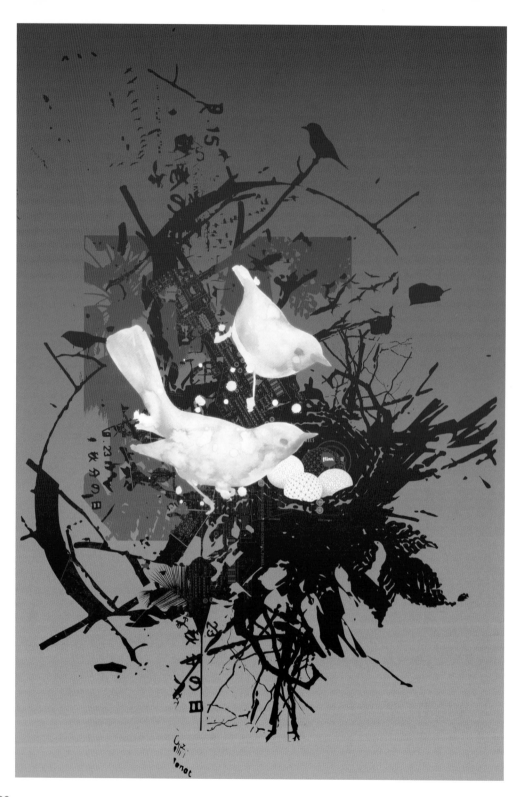

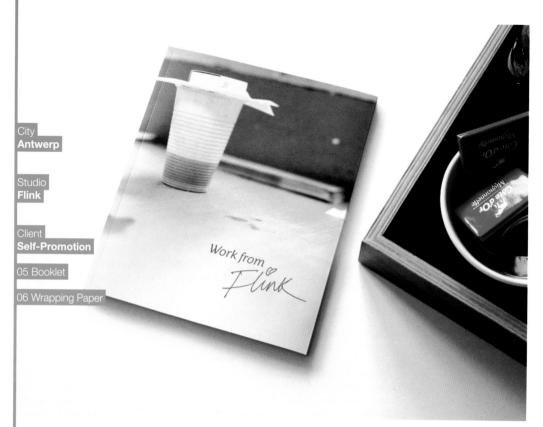

City
Antwerp

Studio
Flink

Client
Self-Promotion

05 Booklet

06 Wrapping Paper

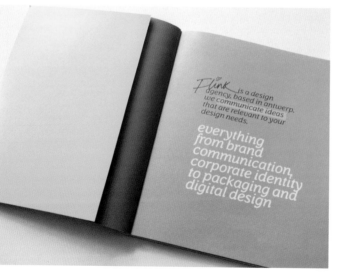

Flink is a design
agency, based in antwerp.
we communicate ideas
that are relevant to your
design needs.

everything
from brand
communication,
corporate identity
to packaging and
digital design

05

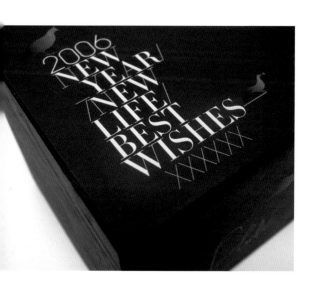

2006
NEW YEAR
NEW
LIFE
BEST
WISHES

AGAIN PAYS OFF
DESIGN PAYS OFF
MAY THE NEW YEAR
INSPIRE YOU TO
GREATER THINGS

2005_
IT'S
A
WRAP
2006

City
Brussels

Designer
Ingeborg Schindler

Client
IEFH

01+02 Annual Report

Client
FH Mainz

03 Poster

04 Programm Card

05 Invitation Card

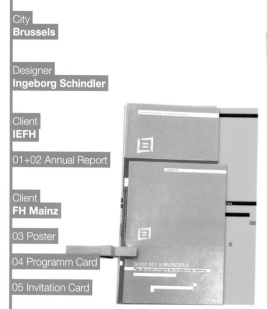

RAPPORT D'ACTIVITÉS 2004-2005
Insitut pour l'égalité
des femmes et des hommes

RAPPORT GENDER MAINSTREAM
Rapport final d'évaluation de la cellule
« gender mainstreaming » mise en place
au sein du gouvernement fédéral

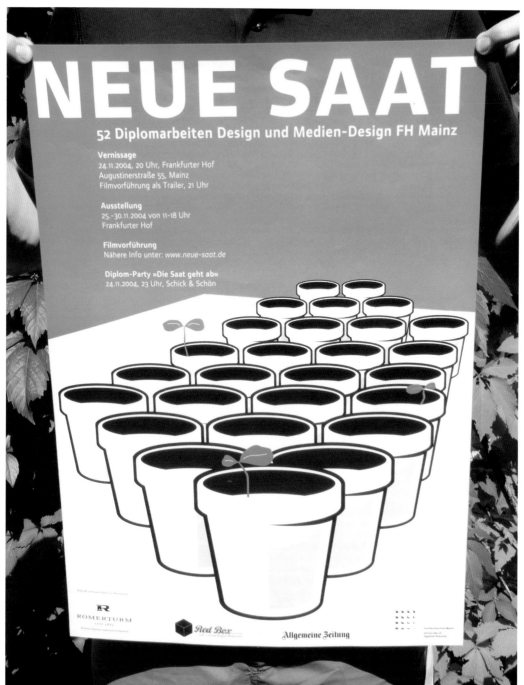

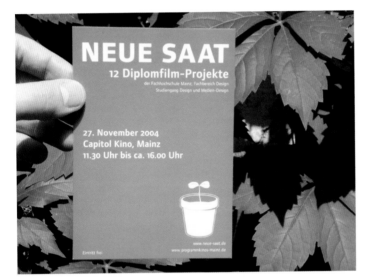

04

05

City
Antwerp

Studio
Kiokarma

Client
beyondsnow

01 Brochure

02 Sticker

03 Exhibition Design

04 T-Shirts

05 Flyer

01

02

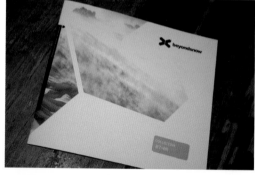

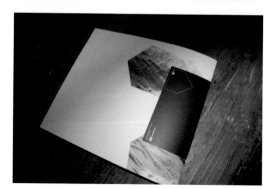

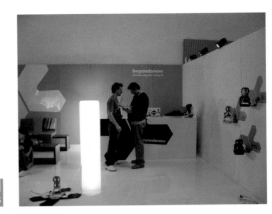

03

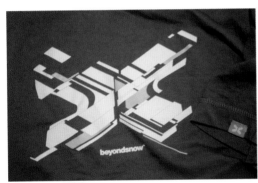

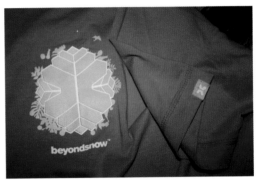

04

05

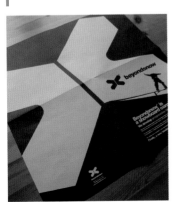

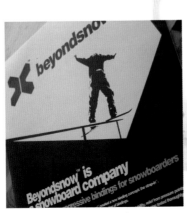

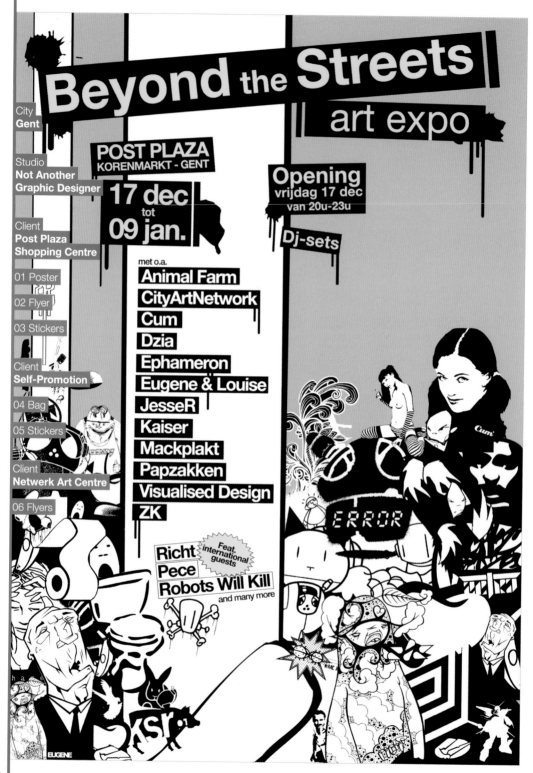

Beyond the Streets
art expo

City
Gent

Studio
**Not Another
Graphic Designer**

Client
**Post Plaza
Shopping Centre**

01 Poster

02 Flyer

03 Stickers

Client
Self-Promotion

04 Bag

05 Stickers

Client
Netwerk Art Centre

06 Flyers

POST PLAZA
KORENMARKT - GENT

17 dec
tot
09 jan.

Opening
vrijdag 17 dec
van 20u-23u

Dj-sets

met o.a.
Animal Farm
CityArtNetwork
Cum
Dzia
Ephameron
Eugene & Louise
JesseR
Kaiser
Mackplakt
Papzakken
Visualised Design
ZK

**Richt
Pece
Robots Will Kill**
and many more

Feat.
international
guests

ERROR

Cum

EUGENE

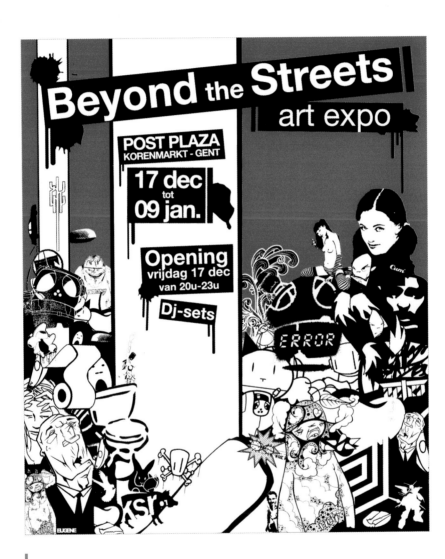

02

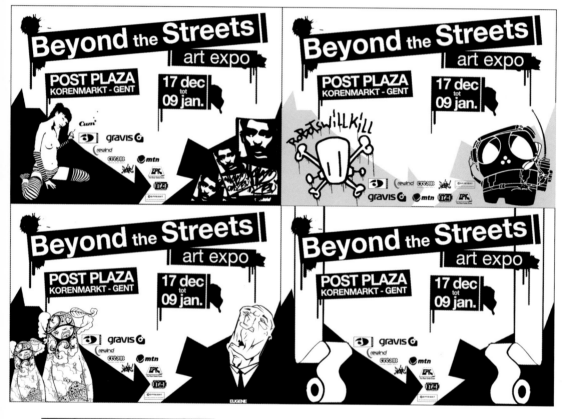

not another graphic designer *nagd*

NETWERK
CONCERTEN 005

PRAM [UK] [Domino Records]
vr 18/02/05
"Uniquely cinematic brand of fractured electro-pop"
www.dominorecordco.com
€ 10 - 7

aLOSTaSOULS #10
za 19/03/05
AMATEUR ATHLETICS ft. GULATI/GASH/GULATI [UK], NEUBARTON [UK],
COMA SPORT [UK-B], DARDADROME [B], PHIORIO [DJ-Minimal] + surprise act
www.alostasouls.be
€ 7,5 - 5.5

SWOD [DE] [City-centre-Offices]
vr 25/03/05
"Think Erik Satie, Pole and Murcof, Than think again"
www.swod-music.de
€ 10 - 7

EMPHASE label-night
za 16/04/05
ANNE LAPLANTINE [FR]
GOTTSCHAU & MÖBIUS [DE]
FS BLUMM [DE]
"Berlin based electronic label & friends"
www.emphaserecords.com
€ 10 - 7

COLLEEN [FR] [The Leaf label]
za 07/05/05
"Dreamlike, Haunting, Enigmatic", "The Golden Morning Breaks"
SUPPORT: HALF ASLEEP [B] [Matamore]
"Half between sadcore and freak folk"
www.colleenplays.org
www.half-asleep.tk
€ 10 - 7

Kunstencentrum Netwerk
Houtkaai z/n
B-9300 Aalst

info & tickets: 053/70 97 70
E info@kunstencentrumnetwerk.be
S www.kunstencentrumnetwerk.be

NETWERK
CONCERTEN 005

EMPHASE label-night
za 16/04/05
ANNE LAPLANTINE [FR]
GOTTSCHAU & MÖBIUS [DE]
FS BLUMM [DE] [Morr Music]
"Berlin based electronic label & friends"
www.emphaserecords.com
vvk via Fnac: 0900/00600
€ 10 - 7

TRIOSK [AUS] [The Leaf label]
za 23/04/05
"A fascinating exploration of the shadowground between acoustic jazz and electronics"
"Soundslikes - Tortoise, Cinematic Orchestra & Jan Jelinek"
+ support
www.triosk.com
vvk via Fnac: 0900/00600

DONATO WHARTON [UK]
[City-Centre-Offices]
ANITA LEIB
za 30/04/05 - za 04/06/05 [wo - za / 14:00 - 18:00]
Installatie in het kader van de groepstentoonstelling "Sugar Free"
www.city-centre-offices.de
www.netwerkgalerij.be

COLLEEN [FR] [The Leaf label]
za 07/05/05
"Dreamlike, Haunting, Enigmatic", new album: 'The Golden Morning Breaks'
SUPPORT: HALF ASLEEP [B] [Matamore]
"Half between sadcore and freak folk"
www.colleenplays.org
www.half-asleep.tk
vvk via Fnac: 0900/00600
€ 10 - 7

aLOSTaSOULS #11
za 25/06/05
www.alostasouls.be
€ 7,5 - 5.5

Kunstencentrum Netwerk
Houtkaai z/n
B-9300 Aalst

info & tickets: 053/70 97 70
E info@kunstencentrumnetwerk.be
S www.kunstencentrumnetwerk.be

City
Antwerp

Studio
Stip

Client
Markus Wormstorm

01+02 Postcards

Client
Self-Promotion

03 Notepads

01

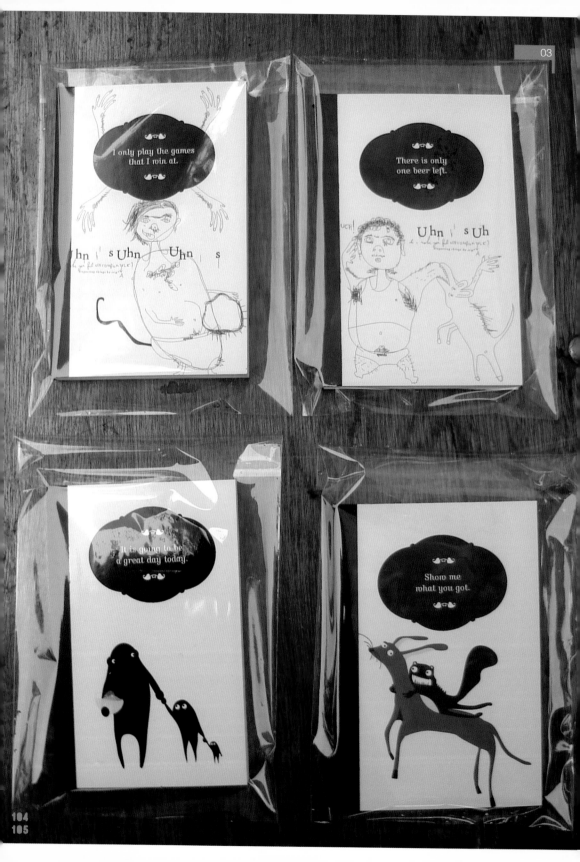

City
Evergem

Studio
Studio Rufus

Client
Limits

01 Invitation Card

Client
Self-Promotion

02 Mailing

03 Matchbook

Client
Cream

04 Newspaper

05+06 Advertisement

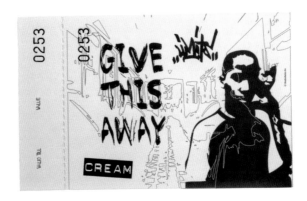

20
06
JAAR ANNÉE

Studio Rufus, *Uw licht in de duisternis*, wenst U
een Zalig Kerstfeest en een Gelukkig Nieuwjaar.

Met vriendelijke groeten,
Jens Versprille – *Creatief Directeur*

Nº 007! /250 EXPL.

STUDIO RUFUS

www. studiorufus. be

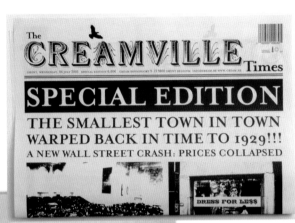

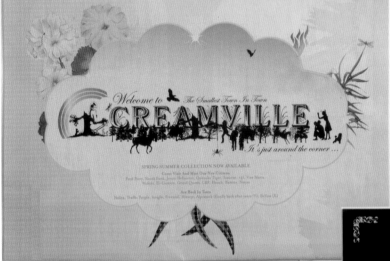

City
Evergem

Studio
Studio Rufus

Client
Kate

07 Birthday Card

08 Stickers

Client
Cream / Oh Deer

09 Postcard

10 Price Card

Client
Self-Promotion

11 Greeting Card, Sticker

Greetings from ...

25 JAN. 2006

KATE

Hane made by Franceska & Iris

Versprille

08

Een titelloze tentoonstelling met Jessica Lamote, Karen Vermeren, Lotte Huyghe, Nathalie Vanheule en Ole Stragier Opening: vrijdag 17 maart om 20u00

City
Ghent

Studio
Tigrafik

Client
Budabox

01 Poster

02 Flyer
back / front

Client
**City Primary School
Klavertjevier & Klimop**

03 Poster

a 21u00 danssolo

Karen Lotte Nathalie Ole

Openingsuren Budabox: zaterdag & zondag telkens van 14u00 tot 18u00
Maart 18, 19, 25 & 26 en April 1 & 2

Budabox, Budastraat 58, 8500 Kortrijk

01

Een titelloze tentoonstelling met **Jessica Lamote, Karen Vermeren, Lotte Huyghe, Nathalie Vanheule en Ole Stragier**

Opening: vrijdag 17 maart om 20u00

Openingsuren Budabox: zaterdag & zondag telkens van 14u00 tot 18u00
Maart 18, 19, 25 & 26 en April 1 & 2

Budabox, Budastraat 58, 8500 Kortrijk

02

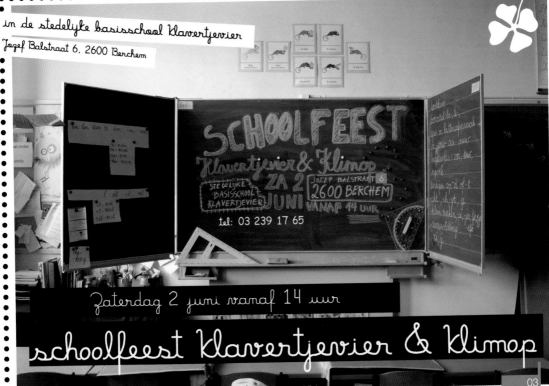

in de stedelijke basisschool Klavertjevier

Jozef Balstraat 6, 2600 Berchem

SCHOOLFEEST
Klavertjevier & Klimop
STEDELIJKE BASISSCHOOL KLAVERTJEVIER
ZA 2 JUNI
JOZEF BALSTRAAT 6 2600 BERCHEM VANAF 14 UUR
tel: 03 239 17 65

Zaterdag 2 juni vanaf 14 uur

schoolfeest Klavertjevier & Klimop

03

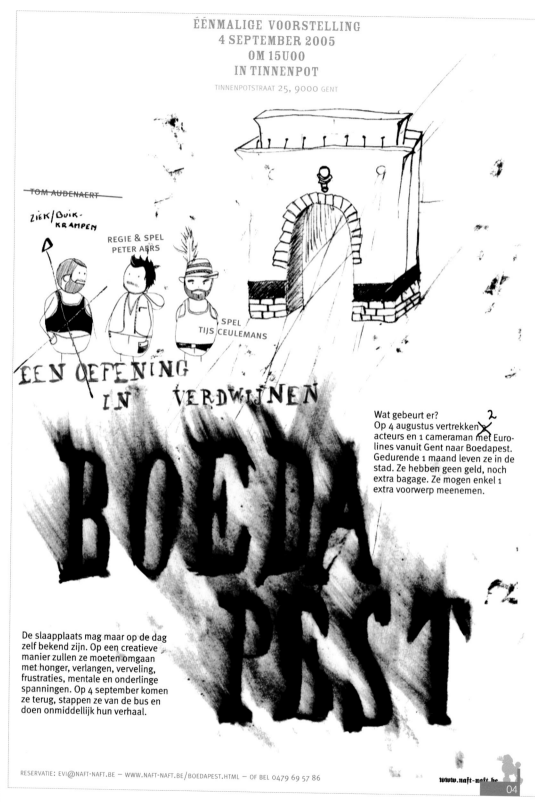

ÉÉNMALIGE VOORSTELLING
4 SEPTEMBER 2005
OM 15U00
IN TINNENPOT

TINNENPOTSTRAAT 25, 9000 GENT

TOM AUDENAERT

ZIEK/BUIK-
KRAMPEN

REGIE & SPEL
PETER AERS

SPEL
TIJS CEULEMANS

EEN OEFENING
IN VERDWIJNEN

BOEDA PEST

Wat gebeurt er?
Op 4 augustus vertrekken 2
acteurs en 1 cameraman met Euro-
lines vanuit Gent naar Boedapest.
Gedurende 1 maand leven ze in de
stad. Ze hebben geen geld, noch
extra bagage. Ze mogen enkel 1
extra voorwerp meenemen.

De slaapplaats mag maar op de dag
zelf bekend zijn. Op een creatieve
manier zullen ze moeten omgaan
met honger, verlangen, verveling,
frustraties, mentale en onderlinge
spanningen. Op 4 september komen
ze terug, stappen ze van de bus en
doen onmiddellijk hun verhaal.

RESERVATIE: EVI@NAFT-NAFT.BE — WWW.NAFT-NAFT.BE/BOEDAPEST.HTML — OF BEL 0479 69 57 86

www.naft-naft.be

04

មិនអនុញ្ញាតអោយចូលក្នុងបន្ទប់នេះ
លើសពីពីរនាក់ឡើយ !
ពេលអ្នកជំងឺម្នាក់ចេញ ទើបអ្នកជំងឺ
ដទៃទៀតអាចចូលបាន !

* **សំគាល់ ៖** ក្នុងករណីដែលមានអ្នកជំងឺធ្ងន់ ផ្ដល់អាទិភាពចូលមុនអ្នកជំងឺទៃ។

មានអ្នកជំងឺពីរនាក់ក្នុងបន្ទប់
សូមរងចាំ !

អ្នកជំងឺម្នាក់ចេញ

អ្នកជំងឺបន្ទាប់ទៀតចូល

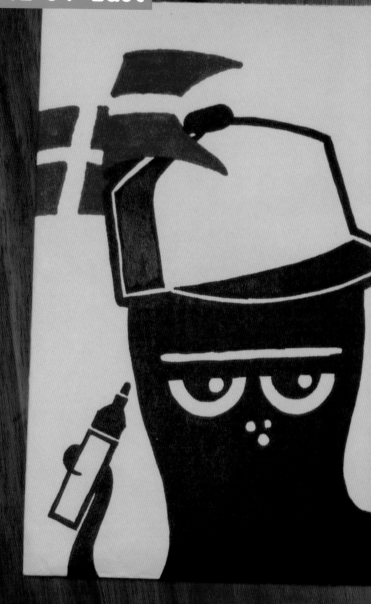

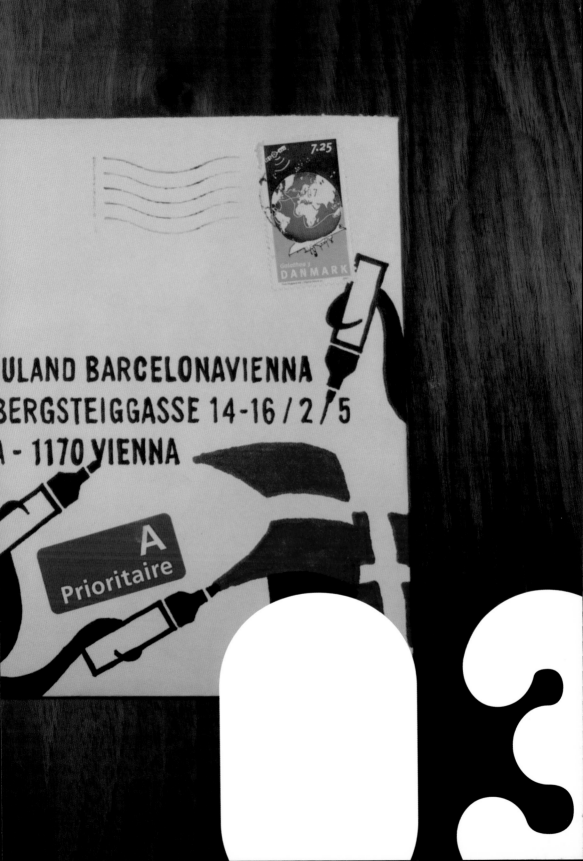

City
Copenhagen

Studio
DeadVoltage Designs

Client
Self-Promotion

01 Toys

02 Shoes

03 Stickers

04 T-Shirts

05 Painting

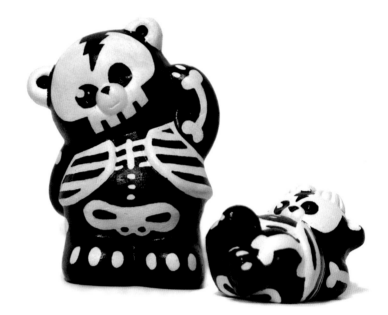

01

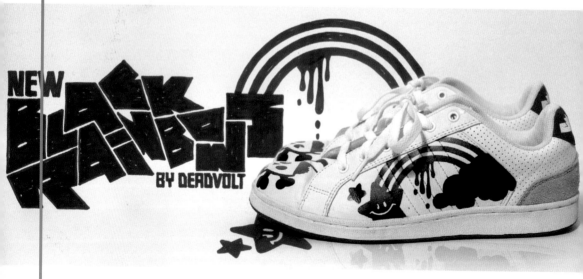

NEW BLACK RAINBOW BY DEADVOLT

02

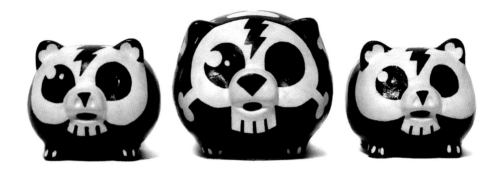

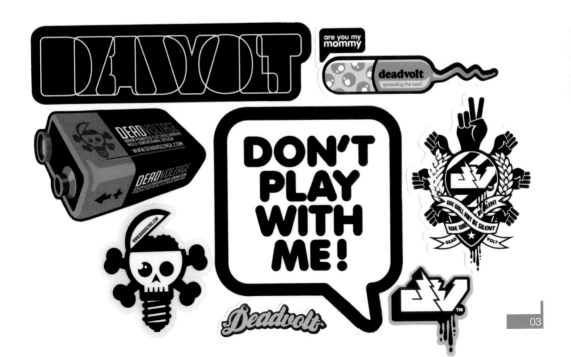

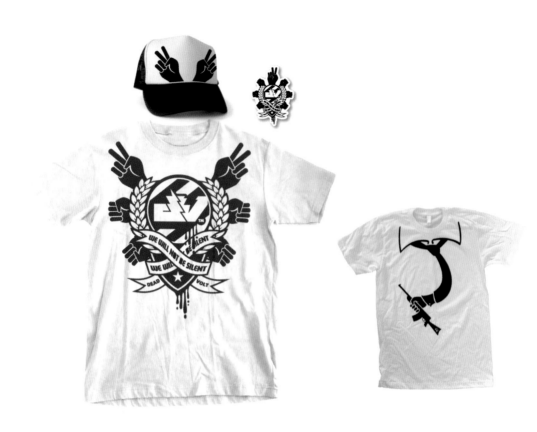

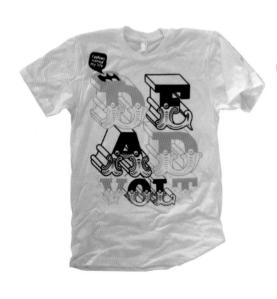

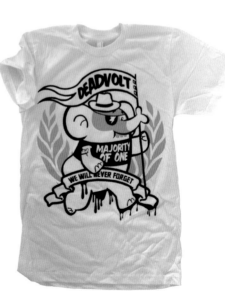

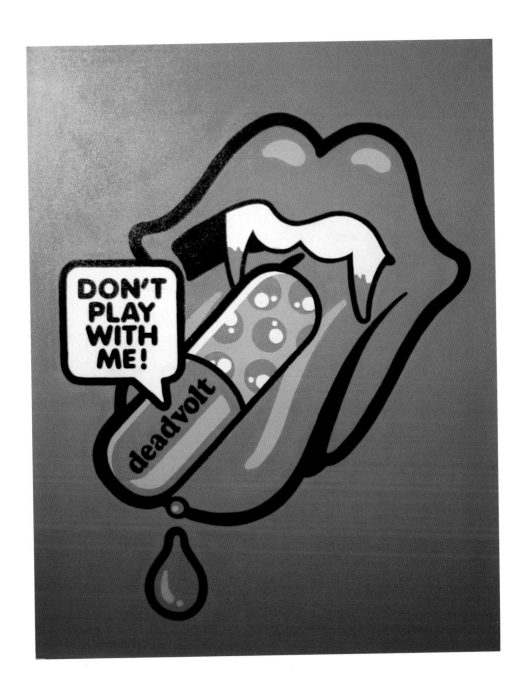

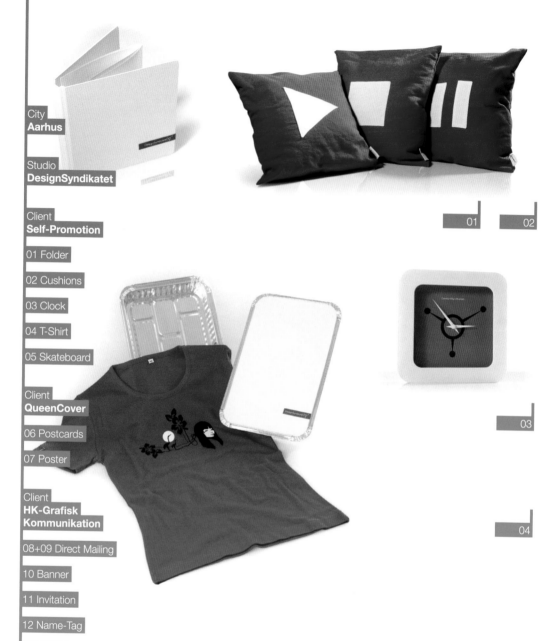

City
Aarhus

Studio
DesignSyndikatet

Client
Self-Promotion

01 Folder

02 Cushions

03 Clock

04 T-Shirt

05 Skateboard

Client
QueenCover

06 Postcards

07 Poster

Client
**HK-Grafisk
Kommunikation**

08+09 Direct Mailing

10 Banner

11 Invitation

12 Name-Tag

13 Leaflet

01

02

03

04

05

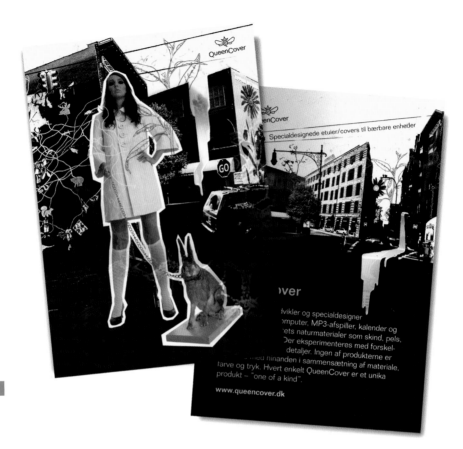

QueenCover

Specialdesignede etuier/covers til bærbare enheder

...ver

...dvikler og specialdesigner
...omputer, MP3-afspiller, kalender og
...ets naturmaterialer som skind, pels,
...Der eksperimenteres med forskel-
...detaljer. Ingen af produkterne er
...med hinanden i sammensætning af materiale,
farve og tryk. Hvert enkelt QueenCover er et unika
produkt – "one of a kind".

www.queencover.dk

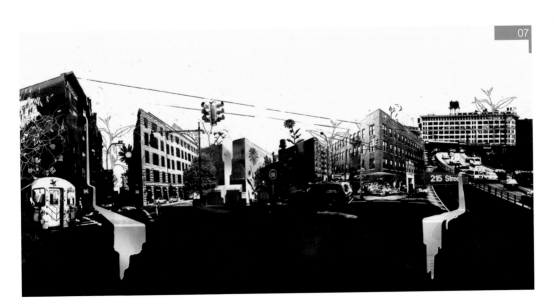

City
Copenhagen

Studio
JDDesign

Client
Nature Know-How

01 T-Shirts, Cap

02 Bags

Client
Shadow

03 Book, Packaging

01

02

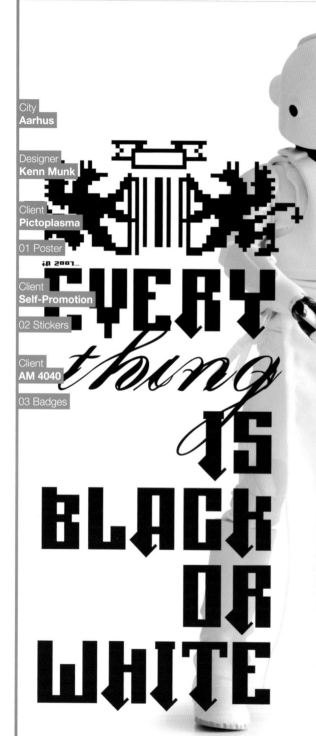

City
Aarhus

Designer
Kenn Munk

Client
Pictoplasma

01 Poster

Client
Self-Promotion

02 Stickers

Client
AM 4040

03 Badges

in 2007...
EVERY *thing* IS BLACK OR WHITE

join the mailing list at www.kennmunk.com
for information as the project unfolds!

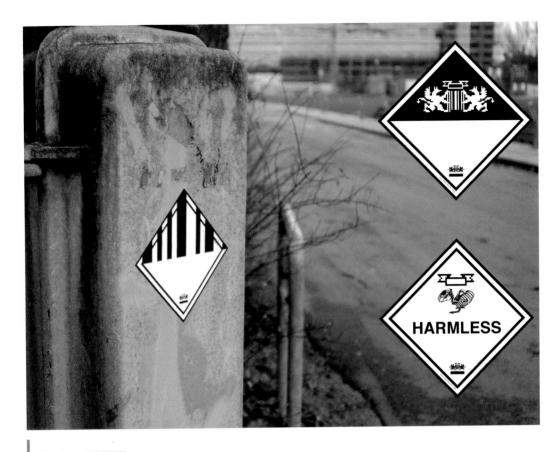

INTRODUCTION

Spoiled Milk is a hands-on media collective from Copenhagen, Denmark.

Their core disciplines are creating websites, print graphics, games, short films, illustrations and ...ons.

City

Copenhagen and thought back into the ...y complementing their technical abilities with a range of handcrafts and a desire to produce something personable.

Studio ...z et københavnsk mediekollektiv.

Spoiled Milk ...efatter design af hjemmesider, ...illustrationer, spil, kortfilm og animationer.

De stræber imod, at sprøjte liv og tanke ind i de projekter, ...de arbeider med, ved at komplimentere deres tekniske
Client en vifte af håndværk og ønsket om at ...not helt særligt.

Self-Promotion

Spoiled Milk is ein Kopenhagener Medienkollektiv.

01 Flyer ...tenzen sind Website Design, Print-Grafik, ...e, Illustration und Animation.

Spoiled Milk hauchen den Formaten, mit denen sie ...arbeiten, durch neue Einfälle Leben ein. Ihre technischen ...Fähigkeiten werden durch vielfältige Handarbeit und den ...Wunsch, faszinierende Inhalte in einer ansprechenden ...Verpackung zu produzieren, ergänzt.

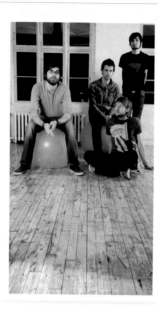

ABOUT US

Spoiled Milk was formed by Russell Quinn and Casper Hübertz Jørgensen back in the autumn of 2004 in Bristol, UK.

After meeting through a small art gallery where Russell volunteered on Sundays, they began working on several film projects together, eventually deciding to move to Copenhagen in the summer of 2005 and start a design partnership.

Following an 18-month period finding their feet, working hard to develop their portfolio and struggling with the Danish tax system, they were joined by Alf Lenni Erlandsen and Frederik Cordes; on art direction and business duties respectively.

SERVICES

* Art direction
* Websites (design, programming, CMS)
* Branding / Identity
* Record covers
* General print design
* Stop-motion animation
* Short films

* C++	* XHMTL
* Java	* CSS
* PHP	* AJAX
* MySQL	* Javascript
* Flash	* UML and software modelling
* Actionscript	

Now a fully fle...
combines a ur...
wizardry with...
handmade cre...

RUSSELL QUINN
russell@spoile...

CASPER HÜBERT...
casper@spoile...

ALF LENNI ERLA...
alflenni@spoil...

FREDERIK CORD...
frederik@spoi...

PORTFOLIO

To view our co...
about us, plea...
www.spoiledm...

For at se vore...
om os, kan du ...
www.spoiledm...

Mehr Informat...
ständiges Por...
www.spoiledm...

spoiled Milk
d creative
simplicity of

d out more

og læse mere
de på

nser voll-
erer Website

SpoiledMilk

A HANDS-ON MEDIA COLLECTIVE

www.spoiledmilk.dk / www.spoiledmilk.co.uk / www.spoiledmilk.de
mail@spoiledmilk.dk / T + 45 32 10 05 33

JULAND
BARCELONA VIENNA,
BERGSTEIGGASSE 14-16/
IN 1170 VIENNA,
AUSTRIA

FLUID

Fluid Studio
Tel: +44 (0)
email: drop

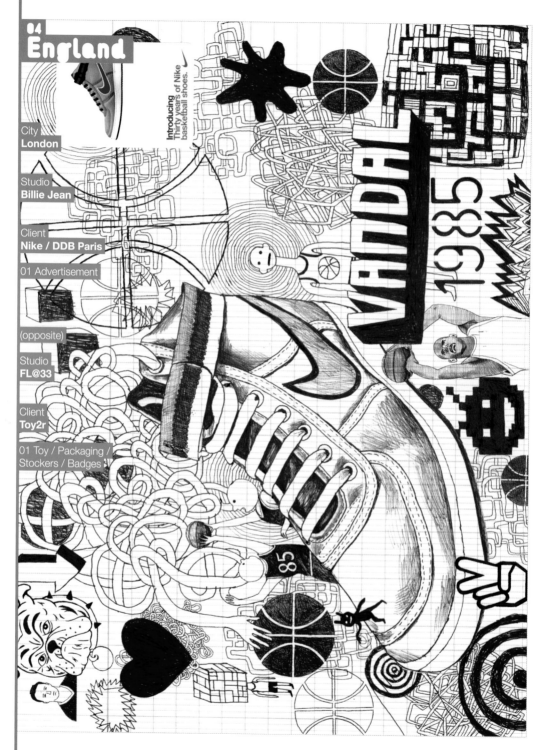

04
England

City
London

Studio
Billie Jean

Client
Nike / DDB Paris

01 Advertisement

(opposite)

Studio
FL@33

Client
Toy2r

01 Toy / Packaging /
Stockers / Badges

Introducing
Thirty years of Nike
basketball shoes.

VANDAL

1985

85

01

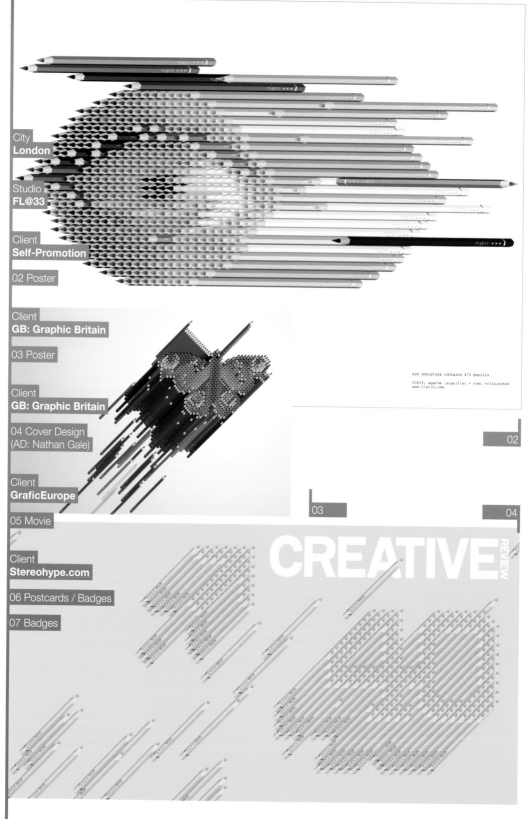

City
London

Studio
FL@33

Client
Self-Promotion

02 Poster

Client
GB: Graphic Britain

03 Poster

Client
GB: Graphic Britain

04 Cover Design
(AD: Nathan Gale)

Client
GraficEurope

05 Movie

Client
Stereohype.com

06 Postcards / Badges

07 Badges

eye sculpture contains 470 pencils
FL@33, agathe jacquillat + tomi vollauschek
www.flat33.com

02

03

04

CREATIVE REVIEW

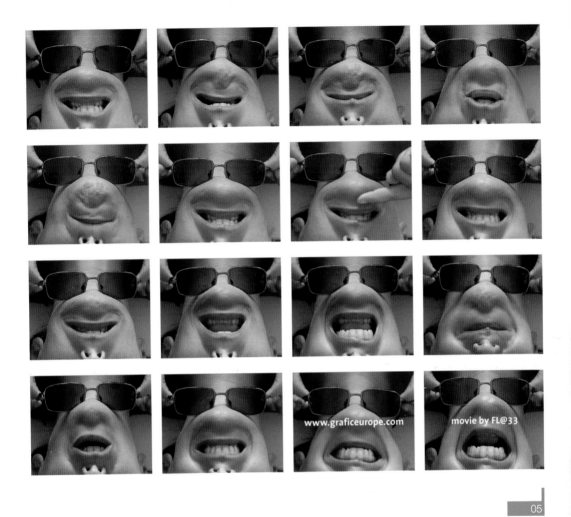

05

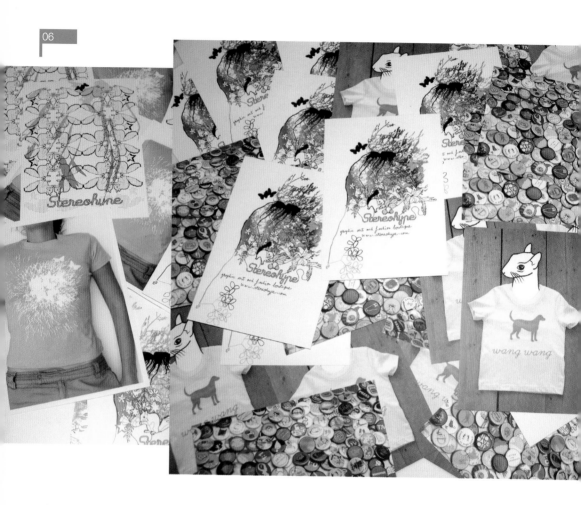

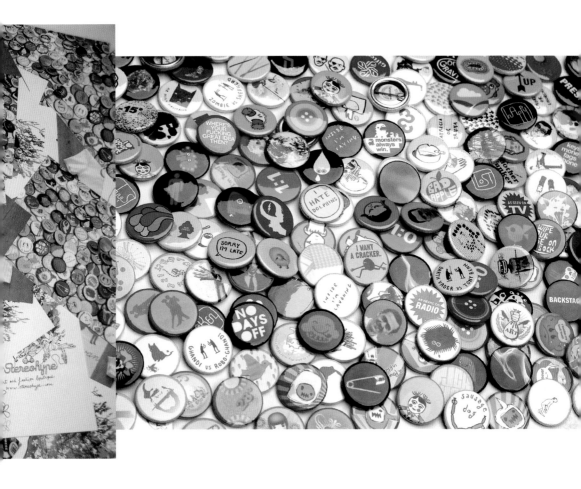

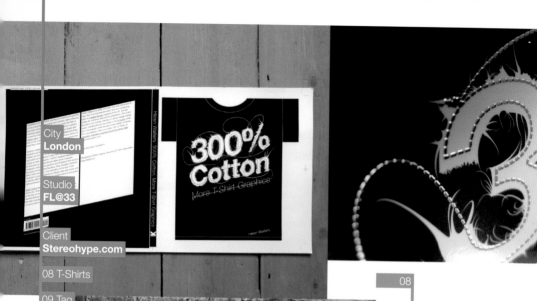

City
London

Studio
FL@33

Client
Stereohype.com

08 T-Shirts

09 Tag

10 Postcard

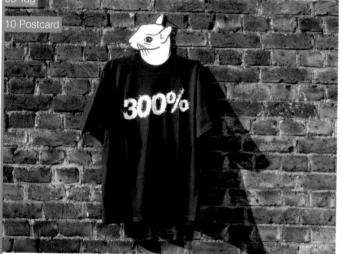

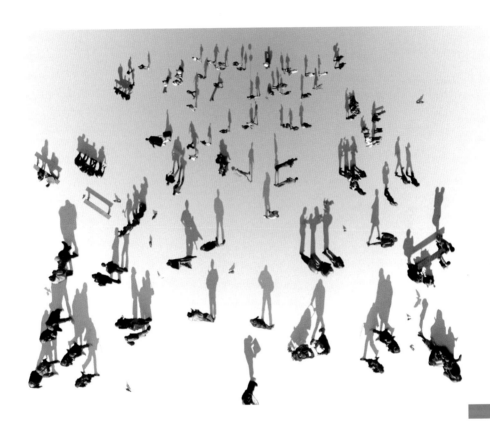

Studio
Fluid Graphic Designs Ltd.

~~Entry deadline September 29th 2006~~
Hackney Design Awards 2006 provides the opportunity for anybody to nominate a
scheme that they feel represents good quality design and sustainable development in
Hackney's built environment.

Client
**London Borough
of Hackney Council**

You can enter your scheme by either:

Hackney Design Awards was first launched in 2004. It received a total of 66 nominations
~~schemes,~~ reflecting the number of good quality developments there
01 Banners ~~borough~~ over the last few years.

**02 Brochure
(Extracts)** short-listed schemes 2004

03 Exhibition-Installation

Photography Competition & Film
A photography competition was launched alongside the main awards and this highly
commended four entries and a short film titled Design Hackney: a dialogue between
young people and architects was made in the spring of 2005.

Contact
For further information about the Hackney Design Awards 2006 and/or related projects
please contact:

designawards@hackney.gov.uk

Hackney Planning Services
Dorothy Hodgkin House
12 Reading Lane
London E8 1HJ
Tel: 020 8356 8164
Fax: 020 8356 8087

For more information on Hackney Planning Services please visit:
www.hackney.gov.uk/planning

⊖Hackney

Hackney Design Awards 2006

Hackney Design Awards 2006
Recognising high quality design and sustainable development in Hackney's built
environment.

Hackney Design Awards 2006 celebrates the best in good design in Hackney's built
environment. Through these awards the Council is able to give recognition to and raise
awareness of high quality contemporary design within the local built environment. The
awards also provide an excellent opportunity to engage with both local and
professional communities, to create an ongoing dialogue regarding the improvement
of Hackney's built environment, and helping towards a better understanding of how
good quality design can make a real difference to where people live, work and relax.

Entry deadline September 29th 2006
You can enter your scheme by either:
:: Completing a Hackney Design Awards 2006 Nomination Form and sending it back
 to the Freepost address. Forms can be pick up from Hackney Town Hall, libraries and
 Planning Reception
:: Online at: www.hackney.gov.uk/planning

What can be nominated?
All entries will have to have made a positive change to the borough and been completed
between July 1st 2004 – August 31st 2006

What needs to be considered?
The Hackney Design Awards 2006 will identify and promote the very best examples of
contemporary design in Hackney. Entries must show that they have considered one or
more of the following:
:: Quality
:: Visibility
:: Innovation
:: Sustainability

Contact
For further information about the Hackney Design Awards 2006 and/or related projects
please contact:

designawards@hackney.gov.uk

Hackney Planning Services
Dorothy Hodgkin House
12 Reading Lane
London E8 1HJ
Tel: 020 8356 8164
Fax: 020 8356 8087

For more information on Hackney Planning Services please visit:
www.hackney.gov.uk/planning

⊖Hackney

Hackney Design Awards 2006

(·) **Hackney**

Shortlisted
Shackelwell Lane Junction

Information
Address Shackelwell Lane Junction, E8
Architects Streetscene, London Borough of Hackney
Client London Borough of Hackney

Shortlisted
Leonard Place

Information
Address Leonard Place, N16 8SR
Architects Brady Mallalieu
Client Community Housing Design

Other Award
Nominations

Project Randal Cremer School
Architect Matthew Lloyd Architects

Project Lift Up House 27 Hoxton Tower
Architect Moss Architects

Project Avril Taylor Centre
Architect Casenove Architects

Project 154 Colford Road
Architect Paul Archer Design

Project Jacqueline Jecel Road
Architect Streetscene, London Borough of Hackney

Project Junction off Retbury and Dawns Fale Road
Architect Streetscene, London Borough of Hackney

Project 263 Mare Street
Architect Fusion Architecture

Project Thomas Fairchild Community School
Architect Haverstock Associates

Brochure
Credits

Design & Art Direction
Fluid / www.fluidesign.co.uk

Architectures Photography
Grant Smith / www.grant-smith.com

Shortlisted
Community Spirit Garden

Information
Address Community Spirit Garden, Fellows Court Estate
 Weymouth Terrace, E2
Architects Erect Architecture
Client London Borough of Hackney

Shortlisted
Dalston Culture House

Information
Address Dalston Culture House, Gillett Square, N16 8JN
Architects Hawkins\Brown
Client Hackney Cooperative Developments

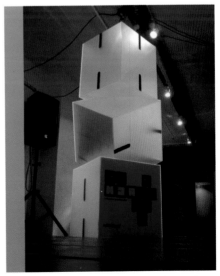

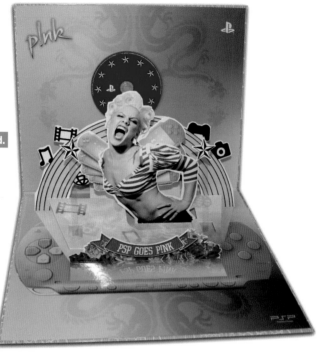

City
Birmingham

Studio
Fluid Graphic Designs Ltd.

Client
**Sony Computer
Entertainment Europe**

04 Press Kit

Client
Capcom

05 DVD Cases

06 Advertisement

07 Packaging / Display /
Set Cards / Sticker

08 T-Shirts

09 DVD Case

10 XBox / Packaging /
Brochure / Advertisement

11 Advertisement

CHOP TILL YOU DROP

DEADRISING

City
Brighton

Studio
red design uk ltd.

Client
Island Records

01 Playing Cards

Client
Raygun

02 Badges / Crayons

Client
Self-Promotion

03 Poster

04 Promotional
Photography

01

02

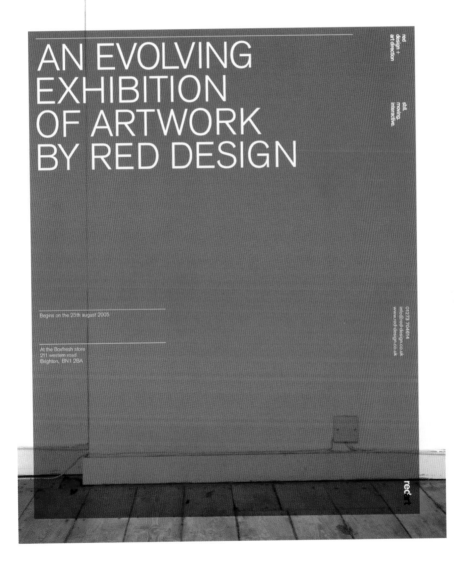

AN EVOLVING
EXHIBITION
OF ARTWORK
BY RED DESIGN

red
design +
art direction

still,
moving,
interactive

01273 704614
info@red-design.co.uk
www.red-design.co.uk

Begins on the 25th august 2005

At the Boxfresh store
211 western road
Brighton, BN1 2BA

red

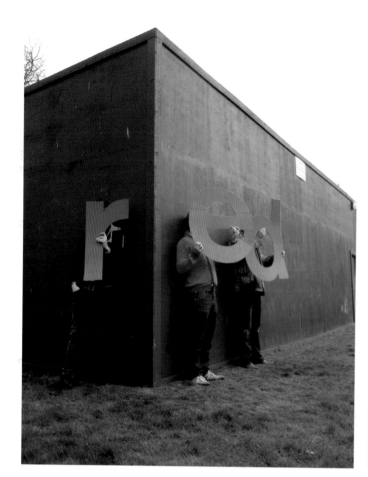

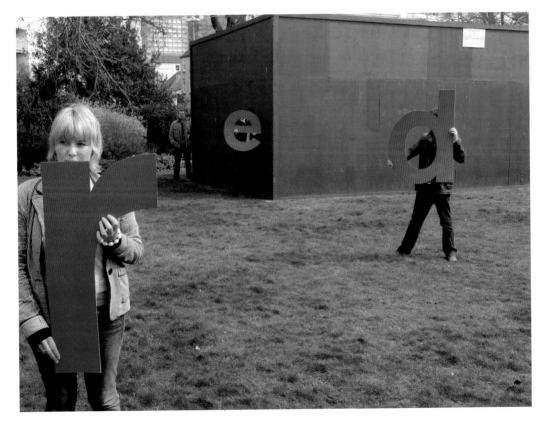

City
Shipley

Studio
Studio MIKMIK

Client
AREA

01 Flyer

02 Booklet

03 Business Card

04 Badges

05 Flyers

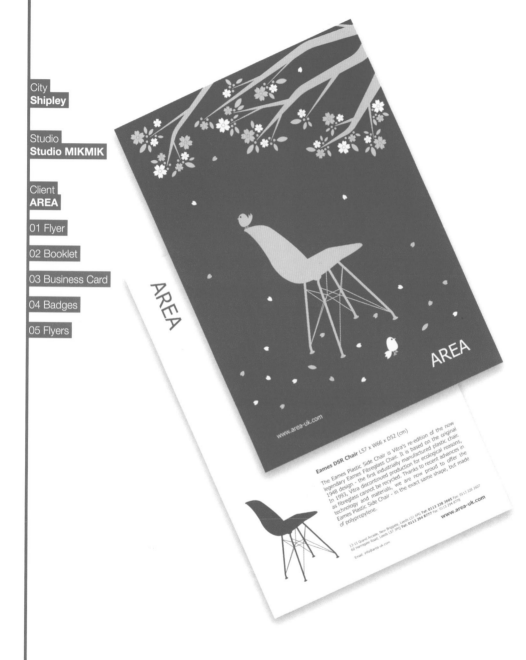

AREA

AREA

www.area-uk.com

Eames DSR Chair L57 x W66 x D52 (cm)
The Eames Plastic Side Chair is Vitra's re-edition of the now legendary Eames Fibreglass Chair. It is based on the original 1948 design - the first industrially manufactured plastic chair. In 1993, Vitra discontinued production for ecological reasons, as fibreglass cannot be recycled. Thanks to recent advances in technology and materials, we are now proud to offer the Eames Plastic Side Chair - in the exact same shape, but made of polypropylene.

13-15 Grand Arcade, New Briggate, Leeds LS1 6PG **Tel: 0113 228 2605** Fax: 0113 228 2607
60 Harrogate Road, Leeds LS7 3PQ **Tel: 0113 294 8777** Fax: 0113 294 8778

Email: info@area-uk.com

www.area-uk.com

A little inspiration

Short of inspiration?

At AREA we have one of the best collections of contemporary design. Stocking designs from Philippe Starck, Charles and Ray Eames to name but a few. Whether you're looking for a gift or inspiration for your home our many products will inspire you.

Most Stylish Home

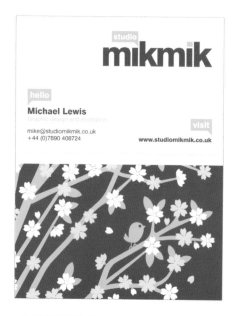

City
Bristol

Studio
Taxi Studio Ltd.

Client
Self-Promotion

01 Floater Pen

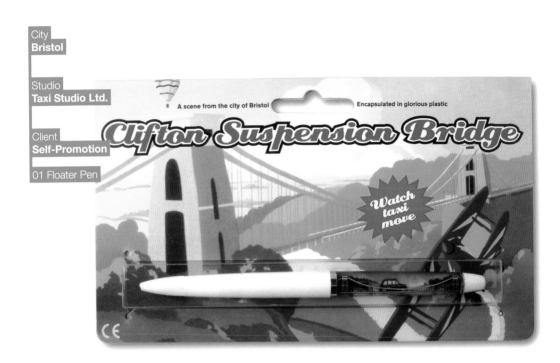

City
Bristol

Studio
Taxi Studio Ltd.

Client
Clarks

02 Brochure (1 of 3)

03 Shoebox
with Brochures

Client
Hamleys

04 Invitation

Client
Design Council

05 Christmas Card

Client
Self-Promotion

06 Valentine's Card

WOMEN's

14 WOMEN'S

TORVILL			CLOUDBURST 2			
	0857	0/D	Desert Suede	0558	14D	Green/Yellow
	0557	18D	Red Tartan Suede	0669	36D	Block/Stripe
				0570	95D	Red/Yellow

33 WOMEN'S

01 CONTENTS

WOMEN'S		MEN'S			
White Section	Blue Section	White Section		Blue Section	
08 Desert Boot	22 Desert Boot	32 Cricketer	45 Desert Mirtee	46 Desert Boot	
09 Thin Mary Jane	23 Desert Mel	33 Crokerd Boot	46 Desert Rain	46 Desert Mid	
09 Tea Time	23 Desert Mel	33 Bowred Over	42 Wallabee Boot	46 Desert Trek	
10 Flower girl	24 Nootie	34 Motto Scenic	Collie	46 Wallabee Boot	
10 Moon Row	24 Wellooce	34 Sheep Nept		46 Wallabee	
12 Petals	24 Jugger	34 Metro Groove		50 Luggor	
12 Tulips	26 Raincott	35 Otterbum		50 Connington	
14 Flowerpower	26 Reapply	35 Riverdrive		50 SilverLone	
14 Fljoma	26 Merchant	36 Hawkhentor			
16 Inoub Hiller	26 Torvill	36 Rostive			
18 Beerly	26 Cloudburst	40 Broad Chevace			

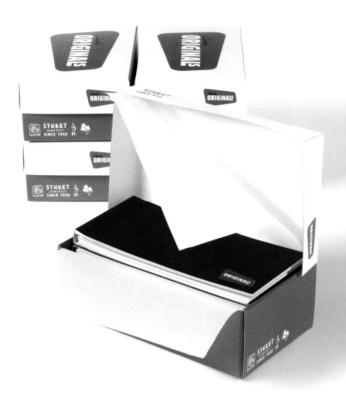

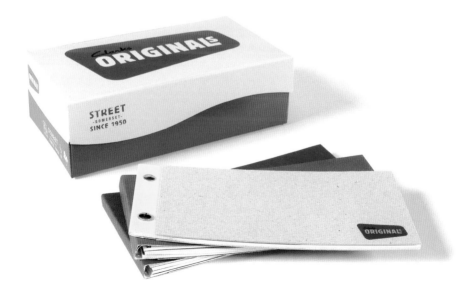

YOU'RE CORDIALLY INVITED TO
THE FAB HAMLEYS RE-LAUNCH PARTY
ON SUNDAY 10TH SEPTEMBER

YOU'RE CORDIALLY INVITED TO
THE FAB HAMLEYS RE-LAUNCH PARTY
ON SUNDAY 10TH SEPTEMBER

I'D LOVE TO **GO**

MARKETING DEPARTMENT
HAMLEYS OF LONDON
FREEPOST 35
LONDON W1E 5PQ

1

NAME _____ COMPANY _____ NO. OF GUESTS: (ADULTS) _____ (CHILDREN) _____ TEL NO. _____

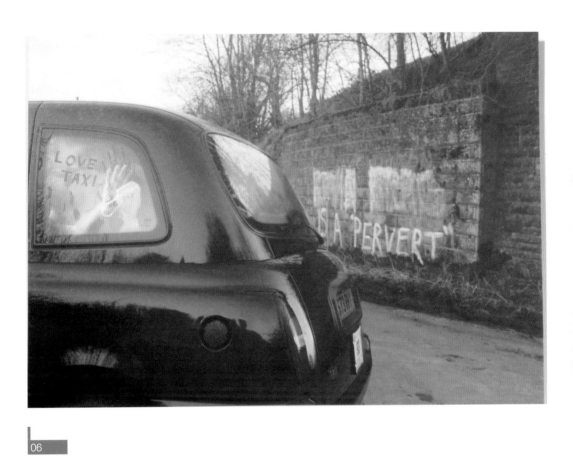

06

EYE
/L

EYE
/R

JULAND Bar

Bergsteigg

A - 1170 V

OSTERREICH

REPUBLIQUE FRANÇAISE

31 TOULOUSE
 ROQUELAINE

21 08 07
 16H 0,60 EUR
G02 PC31922 3,94 FRF

LomaViiemma

se 14–16 / 2 / 14

mma

05

N° 0001 · N° 0002 · N° 0003 · N° 0004 · N° 0005 · N° 0006 · N° 0007

City
Lille

N° 0008 · N° 0009 · N° 0010 · N° 0011 · N° 0012 · N° 0013 · N° 0014

Studio
Atelier Télescopique

Client
Calàcalacity

N° 0015 · N° 0016 · N° 0017 · N° 0018 · N° 0019 · N° 0020 · N° 0021

01 Poster

Client
Wassingue

N° 0023 · N° 0024 · N° 0025 · N° 0026 · N° 0027 · N° 0028

02 Poster

Client
**Compagnie HVDZ –
Guy Alloucherie**

N° 0030 · N° 0031 · N° 0032 · N° 0033 · N° 0034 · N° 0035

03 Poster

Client
**Numerical Type
Foundry**

N° 0036 · N°0037 · N° 0038 · N° 0039 · N° 0040 · N° 0041 · N° 0042

04+05 Posters

N° 0043 · N° 0044 · N° 0045 · N° 0046 · N° 0047 · N° 0048 · N°0049

N° 0050 · N° 0051 · N° 0052 · N° 0053 · N° 0054 · N° 0055 · N° 0056

0056 / 3333
INSTALLATION CALACALACITY
14 10 06 14 01 07 – MAV LILLE FRANCE

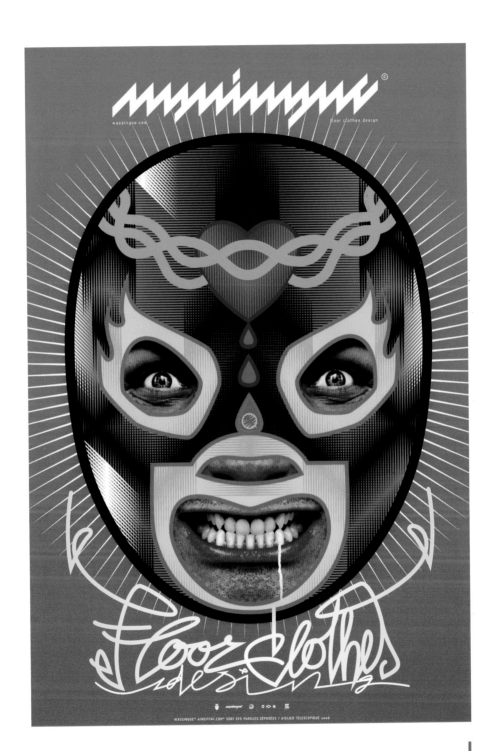

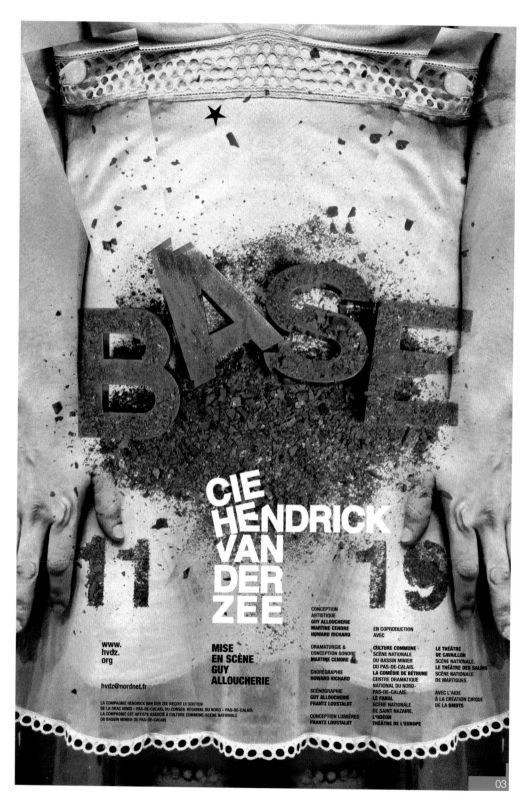

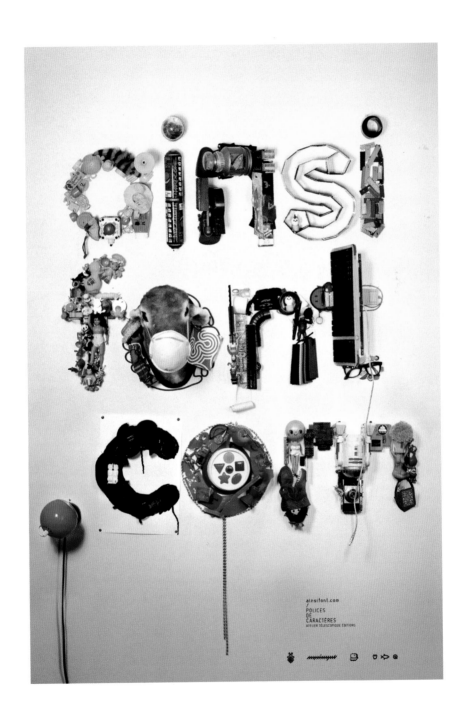

ainsifont.com
/
POLICES
DE
CARACTÈRES
ATELIER TÉLÉSCOPIQUE ÉDITIONS

04

THREE TYPEFACES DESIGNED WITH FRESH TWIST-IDEAL FOR

DIGITAL TYPE FOUNDRY

FOR ORIGINAL TYPEFACES

CREATIVES HUNGRY.

WWW. ainsifont.com

ainsifont pack. MAR 2007

City
Lormont

Designer
Guillaumit

Client
Self-Promotion

01 Postcards
front / back

GANGPOL & MIT
www.gangpol-mit.com
info@gangpol-mit.com

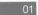

City
Lormont

Designer
Guillaumit

Client
Self-Promotion

02 Dolls,

03 Postcard Motives

04 Jumpers

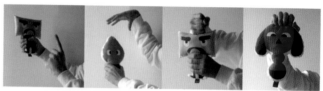

02

03

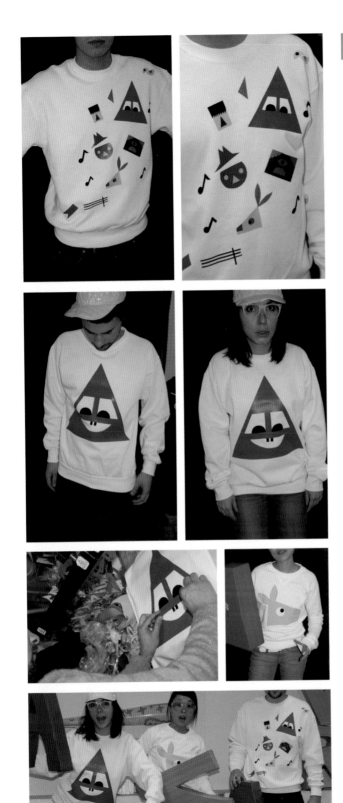

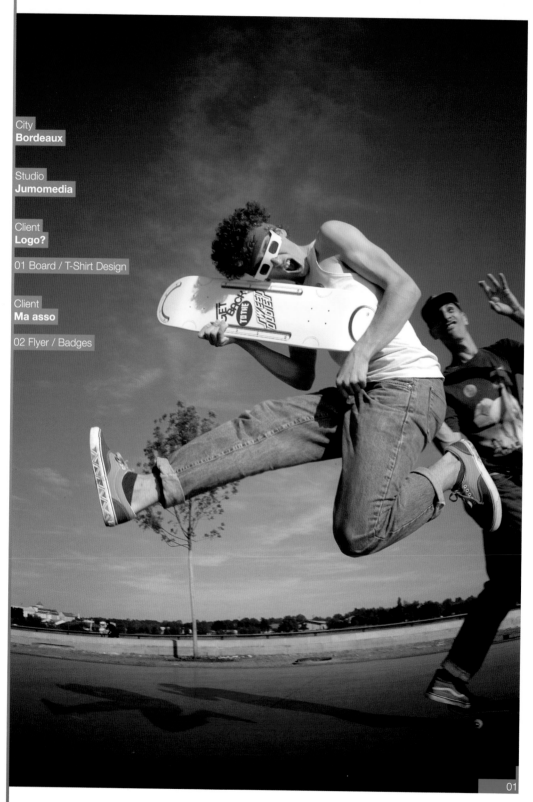

City
Bordeaux

Studio
Jumomedia

Client
Logo?

01 Board / T-Shirt Design

Client
Ma asso

02 Flyer / Badges

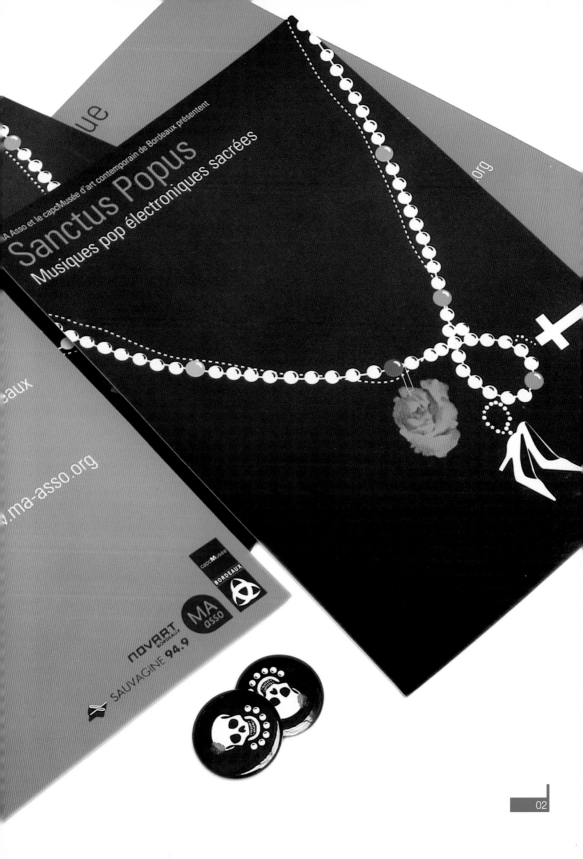

Sanctus Popus

Musiques pop électroniques sacrées

MA Asso et le capcMusée d'art contemporain de Bordeaux présentent

www.ma-asso.org

capcMusée
BORDEAUX

MA asso

novART BORDEAUX

SAUVAGINE 94.9

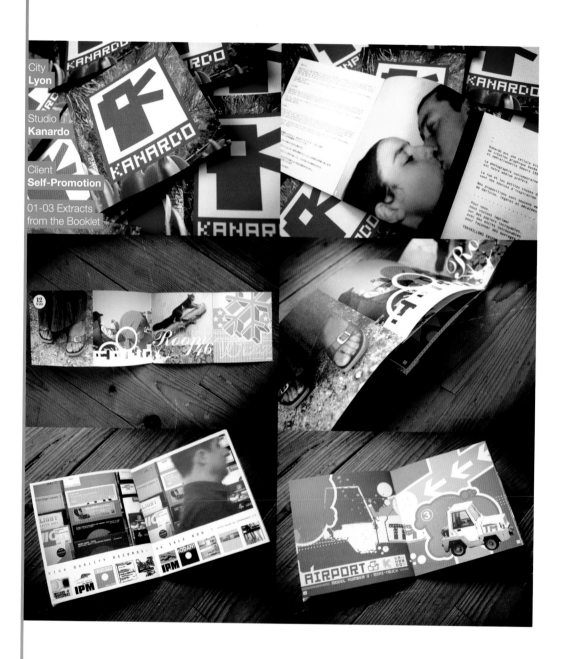

City
Lyon

Studio
Kanardo

Client
Self-Promotion

01-03 Extracts
from the Booklet

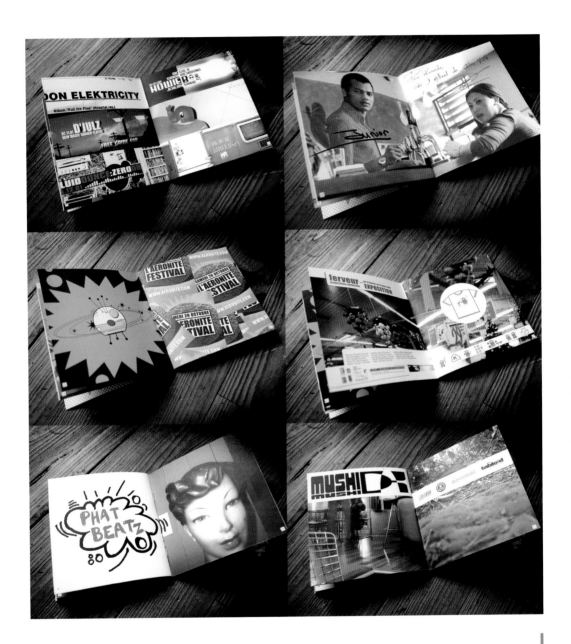

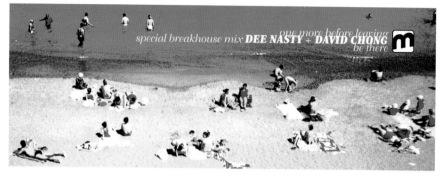

special breakhouse mix **DEE NASTY + DAVID CHONG** *one more before leaving*
be there

WALLPAPER

AVAILABLE SOON / A PARAITRE - BOOK / LIVRE

AVAILABLE NOW / DISPONIBLE - BUTTONS / BADGES

KA::
NAR
DO::

STICKERS / AUTOCOLLANTS

KANARDO

potatoid tabloid

MUSHI
MUSHI

02

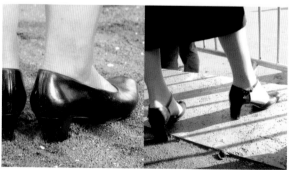

FIVEMCLOPHIN &
2 RUE ROMARIN LYON 1 - METRO HOTEL DE VILLE
FUBU · MECCA · LUGZ · PHAT FARM · CLENCH · DADA DAMANI · DA LINKWENT · SEAN JOHN
ECKO · KARL KANI · PELLE PELLE · ROCA WEAR · BOSS AMERICA · RALPH LAUREN · AND MORE

papangue project
PRINTISDEAD

City
Saint-Denis

Studio
Papangue Project

Client
Self-Promotion

01 Flyer

03 Stickers

04 T-Shirt

Client
DJ Kinjo

02 Sticker

graphic revolution
u s e y o u r m i n d a s a w e a p o n

Print - Stickers - Tee-shirts for suckers !!!

our roots run deep
www.papangueproject.com

PLUG & PLAY
myspace.com/djkinjo

02

03

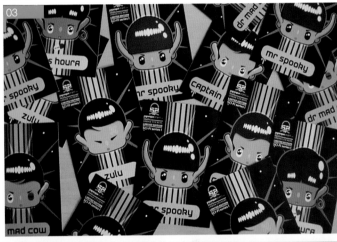

propaganda

papangueproject
PRINTISDEAD

04

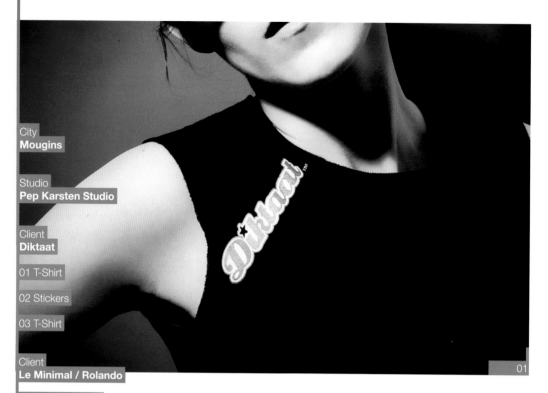

City
Mougins

Studio
Pep Karsten Studio

Client
Diktaat

01 T-Shirt

02 Stickers

03 T-Shirt

Client
Le Minimal / Rolando

04 Advertisements

01

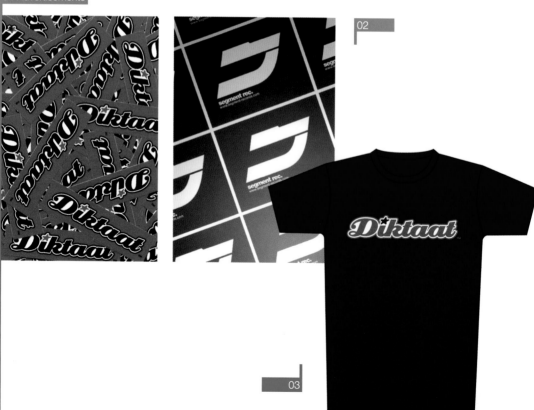

02

03

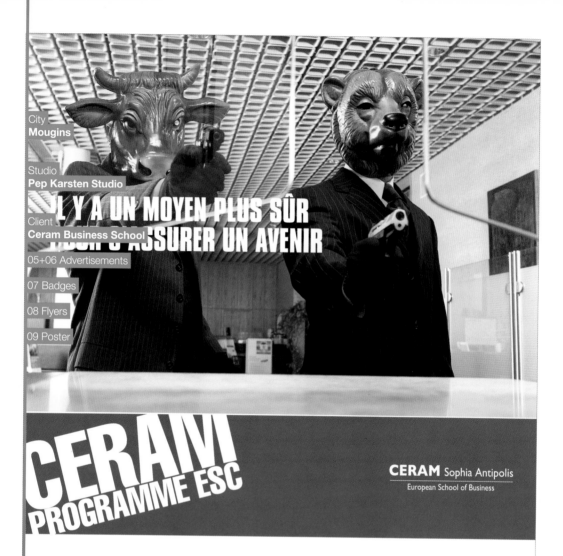

City
Mougins

Studio
Pep Karsten Studio

Client
Ceram Business School

05+06 Advertisements

07 Badges

08 Flyers

09 Poster

CERAM
PROGRAMME ESC

CERAM Sophia Antipolis
European School of Business

⋯⟩ **90 % de nos diplômés embauchés dans un délai de 4 mois**

⋯⟩ **dont 52 % embauchés avant l'obtention du diplôme**

⋯⟩ **21 % de premier emploi à l'étranger**

⋯⟩ **jusqu'à 24 mois d'expérience en entreprise durant le cursus**
(stages, apprentissage, année en entreprise)

Ceram Programme ESC
tél. 04 93 95 44 28 ou 0 820 424 444 (0,12€/min)
info-esc@ceram.fr – www.ceram.fr

Le Ceram c'est aussi : Ceram Mastères Spécialisés, Ceram Masters of Science, Ceram Bachelors,
Programme Doctoral Eudokma, Ceram Executive, Ceram Expert

CCI
NICE CÔTE D'AZUR

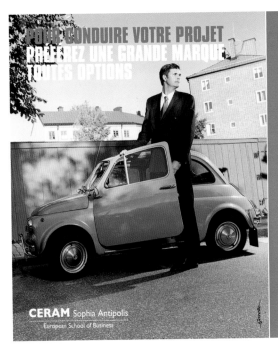

POUR CONDUIRE VOTRE PROJET PRÉFÉREZ UNE GRANDE MARQUE TOUTES OPTIONS

CERAM Sophia Antipolis
European School of Business

CERAM
PROGRAMME ESC

⋯▷ **40 options de parcours à partir de la première année**
(échange académique, expérience en entreprise, programme international...)

⋯▷ **Programme International : *International Master*** en 2ᵉ année
comprenant un semestre délivré intégralement en anglais et un échange dans une
université partenaire ou un stage à l'étranger

⋯▷ **18 spécialisations :**
12 majeures en 3ᵉ année (Finance de Marché, Finance d'Entreprise, Audit &
Expertise, GRH & Conduite du Changement, Entreprendre et Innover, Global Management &
European Business, Conseil en Systèmes d'Informations, Marketing Grande Consommation,
Marketing du Service, Marketing et Management de Projet, Recherche, Banque-Finance)
ou 6 Masters of Science

⋯▷ **Jusqu'à 24 mois d'expérience en entreprise
durant le cursus** (stages, apprentissage, année en entreprise)

⋯▷ **Accompagnement du projet personnel et professionnel**

⋯▷ **Incubateur étudiant pour les projets de
création d'entreprise**

Contactez Marie Bourguet au : 04 93 95 44 28 ou 0 820 424 444 (0,12€/min)
E-mail : info-esc@ceram.fr – **www.ceram.fr**

Le CERAM c'est aussi : CERAM Mastères Spécialisés,
CERAM Masters of Science, CERAM Bachelors,
Programme Doctoral Eudokma, CERAM Executive, CERAM Expert

CCI
NICE CÔTE D'AZUR

CERAM

TROISIEMES CYCLES ET MASTERES SPECIALISES

Finance de Marchés, Innovations et Technologies
Ingénierie et Gestion Internationale de Patrimoine
Intelligence Économique et Knowledge Management
Management Stratégique du Développement Durable
Qualité et Certification dans les Industries de Santé
Ressources Humaines et Changement Social

et votre carrière prend son envol

 CCI NICE CÔTE D'AZUR

CERAM Sophia Antipolis
European School of Business

Tél. : +33 (o) 820 424 444 (0,12€/min)
E-mail : info-ms@ceram.fr
www.ceram.fr

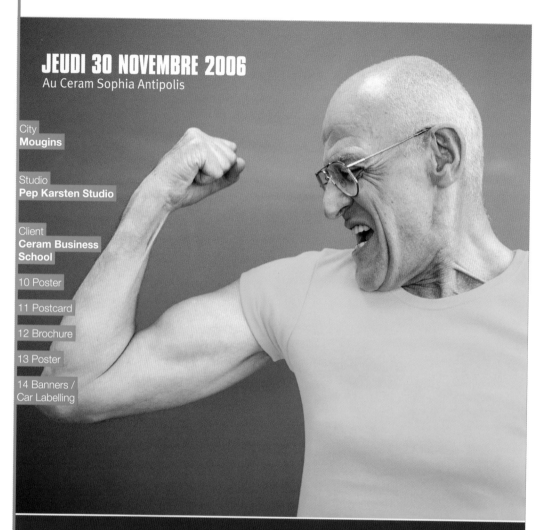

JEUDI 30 NOVEMBRE 2006
Au Ceram Sophia Antipolis

City
Mougins

Studio
Pep Karsten Studio

Client
Ceram Business School

10 Poster

11 Postcard

12 Brochure

13 Poster

14 Banners / Car Labelling

JOURNÉE D'ÉTUDE
VIEILLISSEMENT ACTIF
PÉRENNITÉ DANS L'ACTIVITÉ
SANTÉ ET PERFORMANCE DANS L'ENTREPRISE
Renseignements et inscriptions sur www.ceram.fr/colloque ou tél : +33 (0)4 93 95 44 23

Dans le cadre des Assises Régionales de la Prévention PACA. En partenariat avec la DRTEFP PACA et la DDTEFP 06. Avec le soutien d'ACT Méditerranée, ANDCP, AMETRA 06, ETHICUM, UPE 06.

CCI NICE CÔTE D'AZUR
WWW.CCINICE-COTE-AZUR.COM

CERAM Sophia Antipolis
European School of Business

CENTRE D'ENSEIGNEMENT ET DE RECHERCHE APPLIQUES AU MANAGEMENT

PROGRAMME ESC

CERAM Sophia Antipolis
European School of Business

CHAMBRE DE COMMERCE ET D'INDUSTRIE
NICE CÔTE D'AZUR

Contactez Marie Bourguet au : 04 93 95 44 28
ou : 0 820 424 444 (0,12€ /min)
E-mail : info-esc@ceram.fr
www.ceram.fr

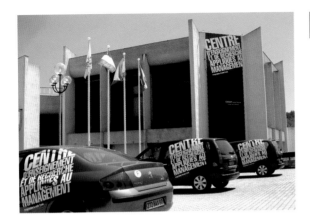

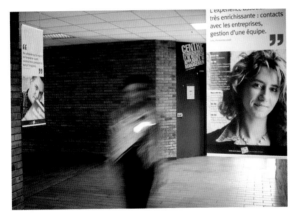

City
Toulouse

Designer
Pierre Vanni

Client
Manystuff

01 Poster

02 Design Model

Client
Ghostape

03 CD Artwork

04 Poster

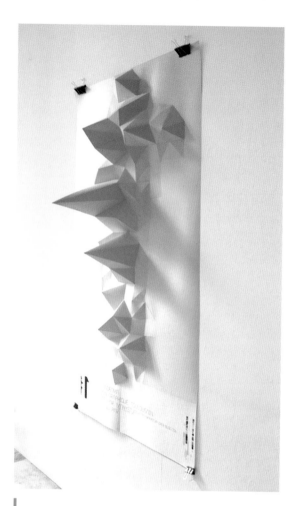

01

02

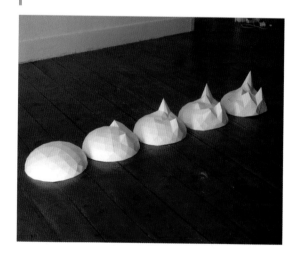

03

04

City
Lille

Studio
POANA ©

Client
Self-Promotion

01 Postcards

02 Promotional
Illustration

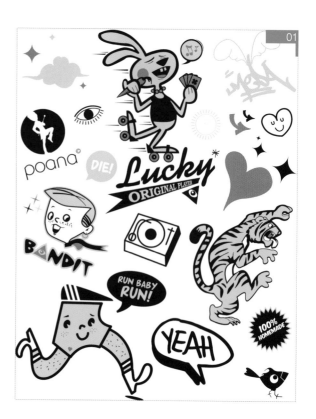

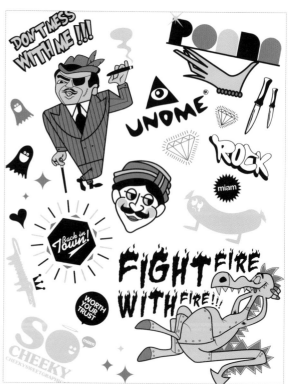

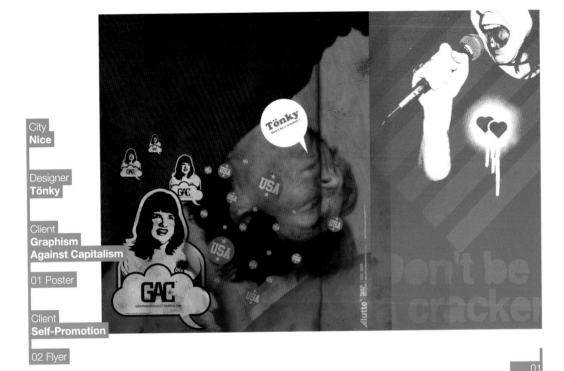

City
Nice

Designer
Tönky

Client
**Graphism
Against Capitalism**

01 Poster

Client
Self-Promotion

02 Flyer

01

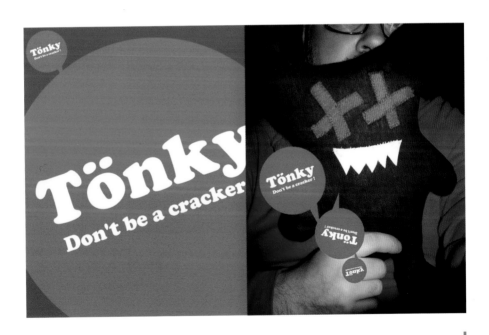

02

City
Nice

Studio
Tönky

Client
Self-Promotion

03 Poster

04 Postcard

Client
Mooky

05 Poster

Client
Vista Nova

06 Stickers

Client
Self-Promotion

07 Calendar

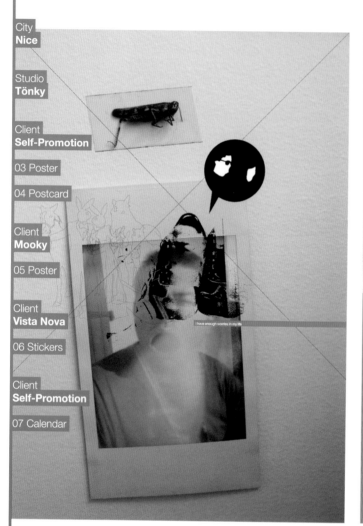

Love me
tender

03

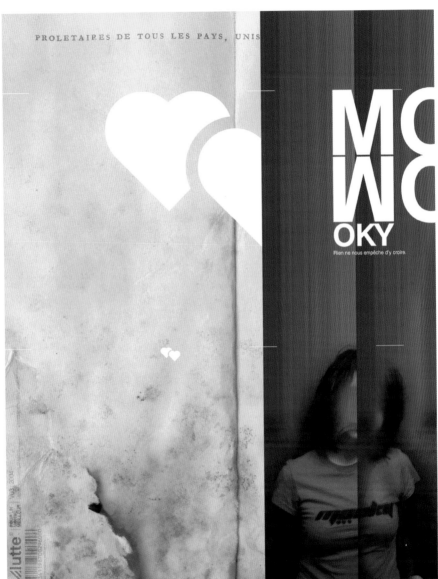

PROLETAIRES DE TOUS LES PAYS, UNIS

MO
WO

OKY

Rien ne nous empêche d'y croire.

//lutte

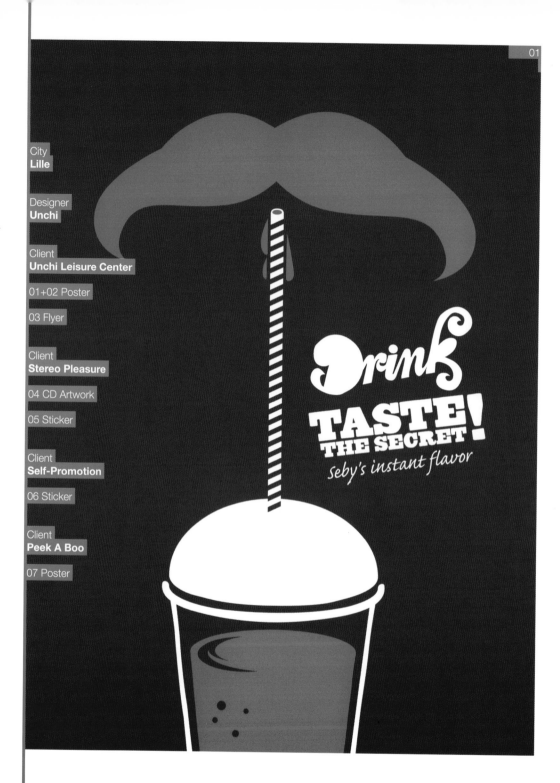

City
Lille

Designer
Unchi

Client
Unchi Leisure Center

01+02 Poster

03 Flyer

Client
Stereo Pleasure

04 CD Artwork

05 Sticker

Client
Self-Promotion

06 Sticker

Client
Peek A Boo

07 Poster

Drink

TASTE!
THE SECRET

seby's instant flavor

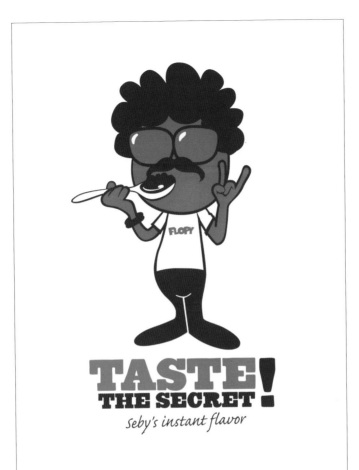

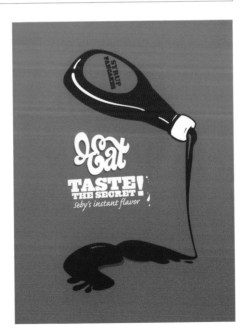

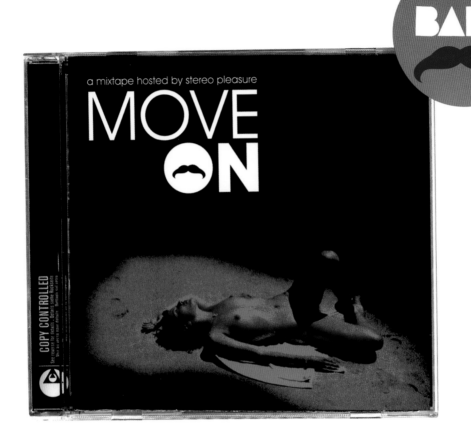

a mixtape hosted by stereo pleasure

MOVE ON

BABY

COPY CONTROLLED

04

05

TOAST IT!

STEREO PLEASURE™

06

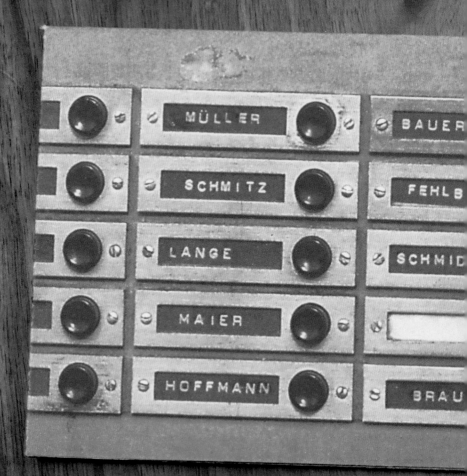

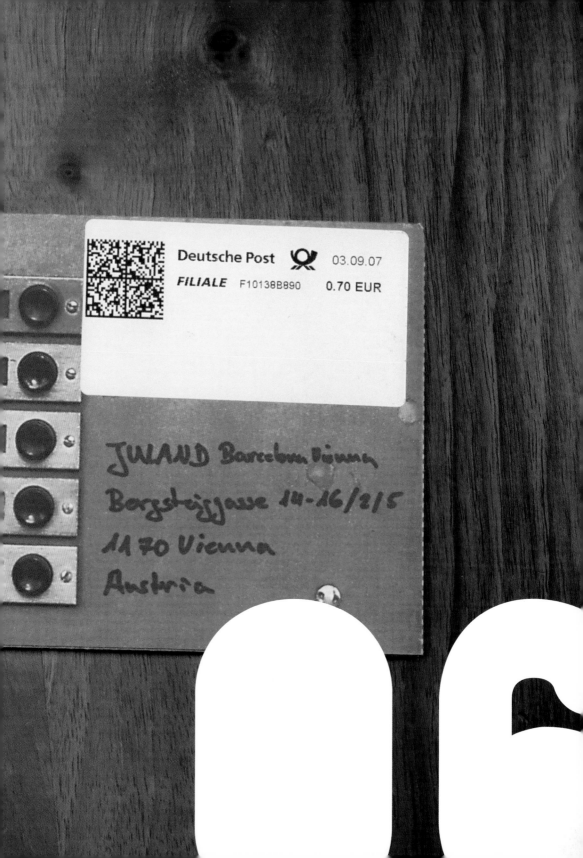

Deutsche Post ✶ 03.09.07
FILIALE F10138B890 **0.70 EUR**

JULAND Barcelona Vienna
Bergsteiggasse 14-16/2/5
1170 Vienna
Austria

City
Pforzheim

Designer
Boris Dworschak

Client
Postweiler/Hauber

01 Poster

(opposite)

Studio
eBoy

Client
Colab Eyewear

01 Poster

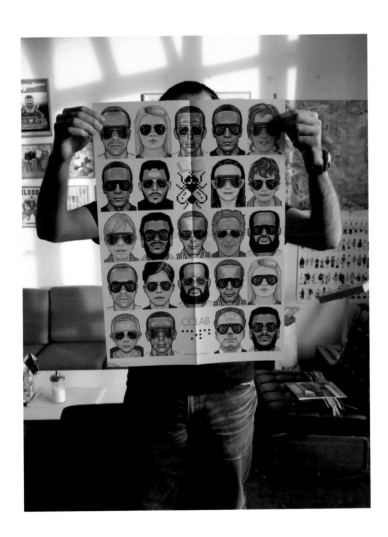

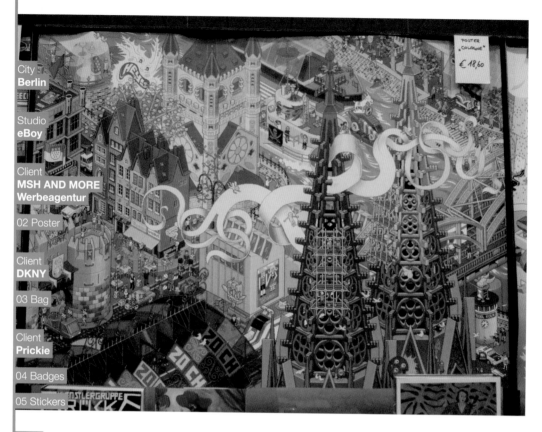

City
Berlin

Studio
eBoy

Client
MSH AND MORE
Werbeagentur

02 Poster

Client
DKNY

03 Bag

Client
Prickie

04 Badges

05 Stickers

Client
Colab Eyewear

06 Sunglasses+
Sticker

02

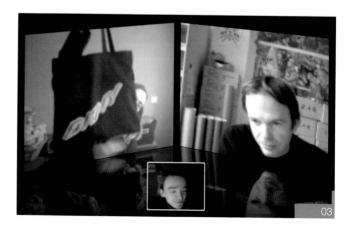

03

04

05

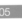

06

City
Berlin

Studio
eBoy

Client
Maxalot

07 Projection
for the
Todaysart Festival 2006

(opposite)

Studio
Eyegix

Client
Merz Akademie

Project
Paul&Luise

01 Catalogue

02 Invitation

Project
Raumstoff

03 Brochure

04 Book

05 Brochure
inside / outside

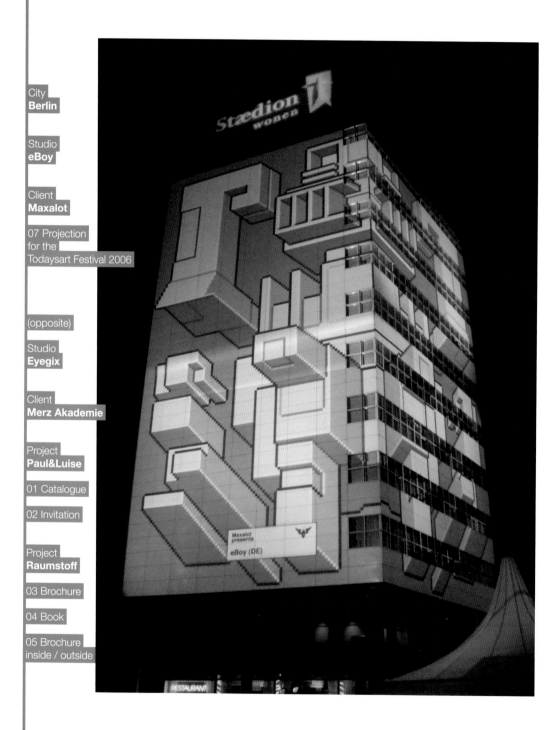

form
pattern
colour

paul & louise™

Hamburg
Madrid
New York
Helsinki
Paris
London

P 04 form
P 12 colour
P 16 pattern
P 22 showroom

paul&louise™
founded 1902 restart 1998

We are working to be one of the most efficient companies in the world, while ensuring that everyone touched by our business process has a positive experience. paul&louise offers the best forms, colours and patterns.

index

01

02

invitation

paul & louise™

museum of modern art
03. july 2005

openchair event
We are looking forward to receiving you as our guest!

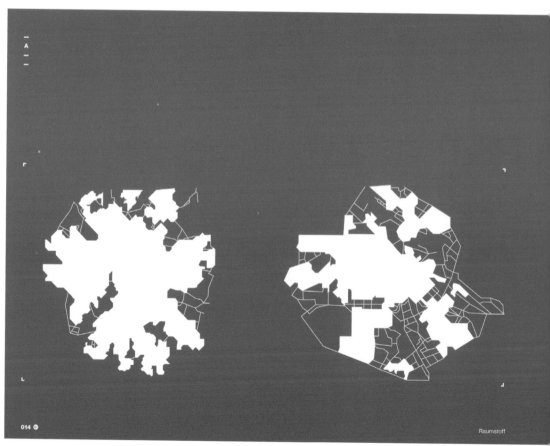

014 ⊕

Raumstoff

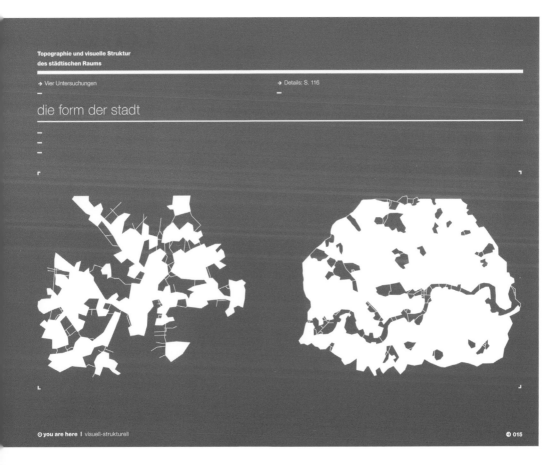

**Topographie und visuelle Struktur
des städtischen Raums**

→ Vier Untersuchungen → Details: S. 116

die form der stadt

umstoff ID Plan

photographischer Index der städtischen Struktur

igraphie IDs: 127 → Raumstoff Etage B/D

dtische Raum konstruiert sich durch die Differenzierung
rmen und Inhalten. Ihre relative Unabhängigkeit zueinander
t und vermischt sich im urbanen Raum, der durch ein
einander und Übereinander von Netzen durchzogen ist.
n, Codes und Strukturen durchziehen das Netz des
chen Raums und werden durch die Photographie lesbar.
Plan ordnet die Photographien in ein flexibles Netz von
ltungen und Strukturen ein und erweitert ihre Lesbarkeit.

Etage B
ID.001 ID.002 ID.003 ID.004 ID.005 ID.006 ID.007 ID.008 ID.009 ID.010 ID.011 ID.012 ID.013 ID.014 ID.015 ID.016 ID.017 ID.018

ID.019 ID.020 ID.021 ID.022 ID.023 ID.024 ID.025 ID.026 ID.027 ID.028 ID.029 ID.030 ID.031 ID.032 ID.033 ID.034 ID.035 ID.036 ID.037

ID.038 ID.039 ID.040 ID.041 ID.042 ID.043 ID.044 ID.045 ID.046 ID.047 ID.048 ID.049 ID.050 ID.051 ID.052 ID.053 ID.054 ID.065 ID.066

ID.057 ID.058 ID.059 ID.060 ID.061 ID.062 ID.063 ID.064 ID.065 ID.066 ID.067 ID.068 ID.069 ID.070 ID.071 ID.072 ID.073 ID.074 ID.075 ID.076 ID.077 ID.078 ID.079

ID.080 ID.061 ID.062 ID.063 ID.064 ID.085 ID.086 ID.067 ID.068 ID.091 ID.092 ID.093 Etage D ID.094 ID.095 ID.096 ID.097 ID.098 ID.099 ID.100 ID.101 ID.102 ID.103

215
214

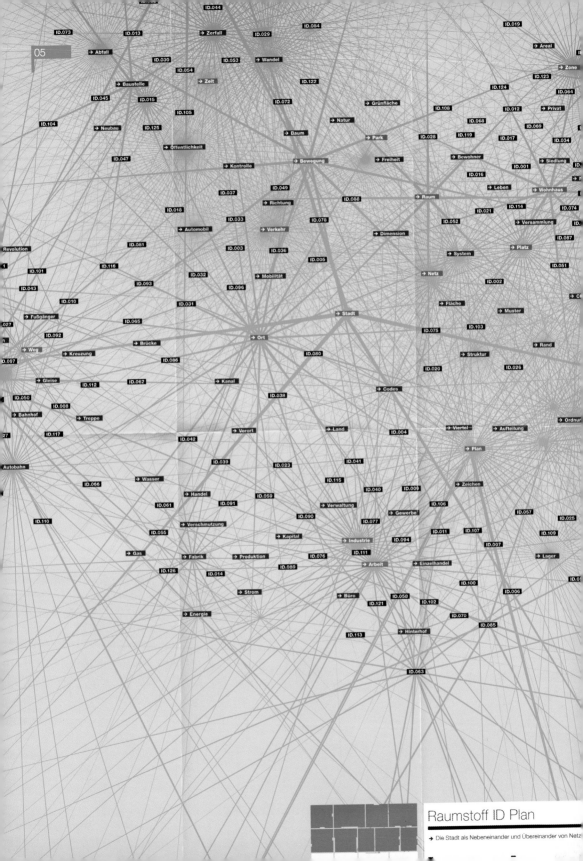

Raumstoff ID Plan

→ Die Stadt als Nebeneinander und Übereinander von Netz

City
Berlin

Studio
Fons Hickmann m23

Client
**Kulturfestivals
Chaumont 2006**

01 Exhibition Design

02 Poster

Client
Bayerische Staatsoper

03 Posters / Flyers

04 Posters / Flyers

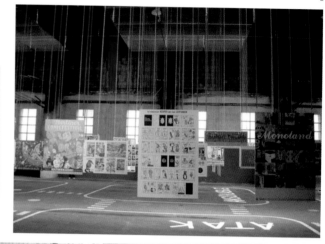

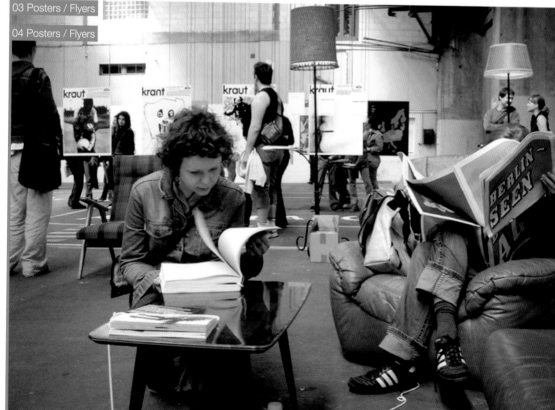

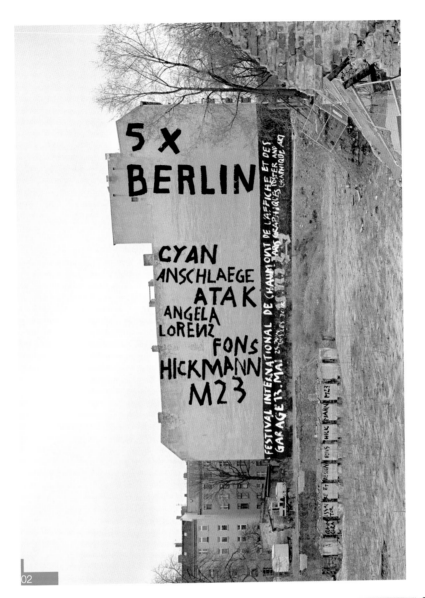

02

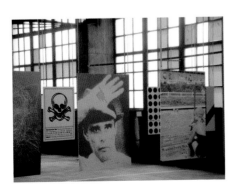

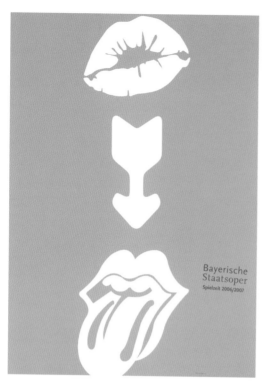

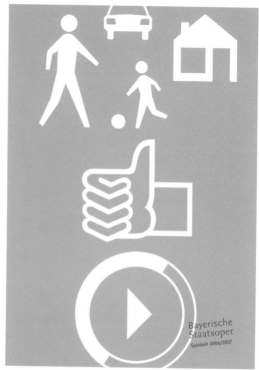

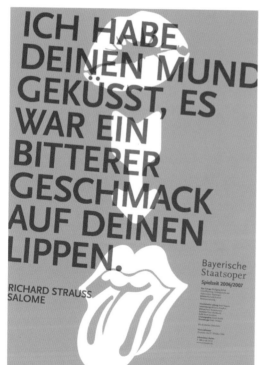

ICH HABE
DEINEN MUND
GEKÜSST, ES
WAR EIN
BITTERER
GESCHMACK
AUF DEINEN
LIPPEN.

RICHARD STRAUSS.
SALOME

Bayerische
Staatsoper
Spielzeit 2006/2007

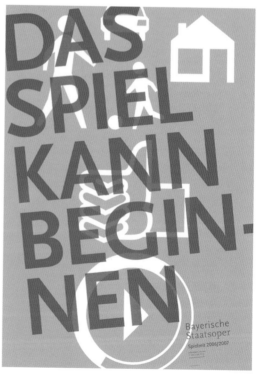

DAS
SPIEL
KANN
BEGIN-
NEN

Bayerische
Staatsoper
Spielzeit 2006/2007

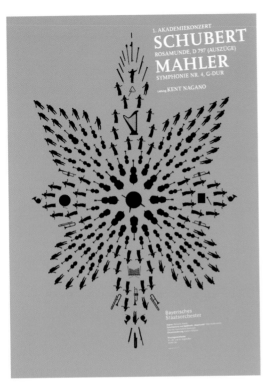

1. AKADEMIEKONZERT
SCHUBERT
ROSAMUNDE, D 797 (AUSZÜGE)
MAHLER
SYMPHONIE NR. 4, G-DUR

Leitung KENT NAGANO

Bayerisches
Staatsorchester

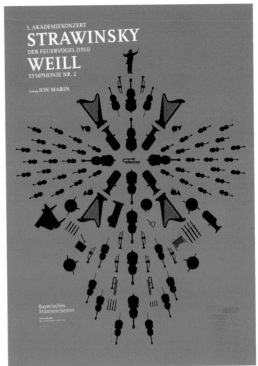

3. AKADEMIEKONZERT
STRAWINSKY
DER FEUERVOGEL (1911)
WEILL
SYMPHONIE NR. 2

Leitung ION MARIN

Bayerisches
Staatsorchester

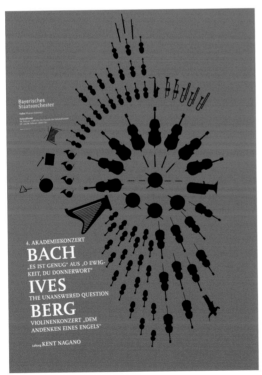

Bayerisches
Staatsorchester

4. AKADEMIEKONZERT
BACH
„ES IST GENUG" AUS „O EWIG-
KEIT, DU DONNERWORT"
IVES
THE UNANSWERED QUESTION
BERG
VIOLINENKONZERT „DEM
ANDENKEN EINES ENGELS"

Leitung KENT NAGANO

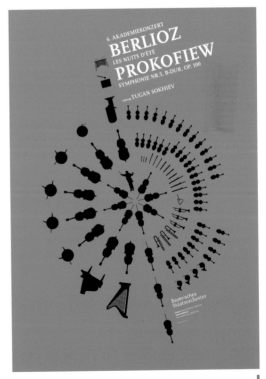

6. AKADEMIEKONZERT
BERLIOZ
LES NUITS D'ETE
PROKOFIEW
SYMPHONIE NR.5, B-DUR, OP. 100

Leitung TUGAN SOKHIEV

Bayerisches
Staatsorchester

City
Frankfurt / Main

Studio
H2D2

Client
Self-Promotion

01 Poster

02 Postcard

(opposite)

City
Karlsruhe

Studio
HGO

Client
Prickie

01 Badges

Client
Threadless

02 T-Shirt Gra

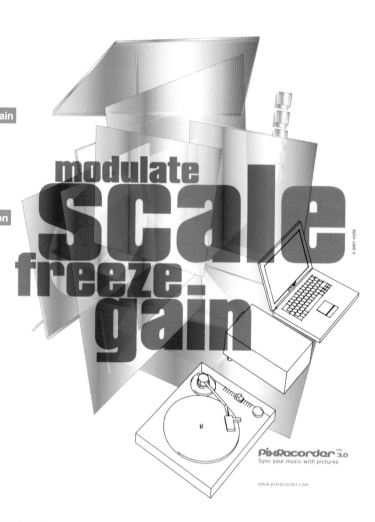

01

02

01

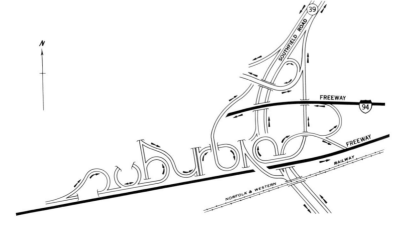

02

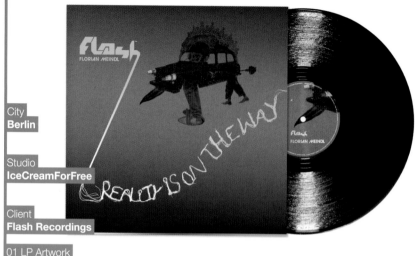

City
Berlin

Studio
IceCreamForFree

Client
Flash Recordings

01 LP Artwork

02 Lighter

Client
Milch

03+04 Flyers

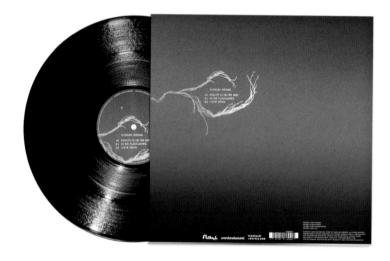

01

02

KOLETZKI & MEINDL
A1 KOLIBRI
B1 GRANDMOTHERS FLASH
B2 PARIS

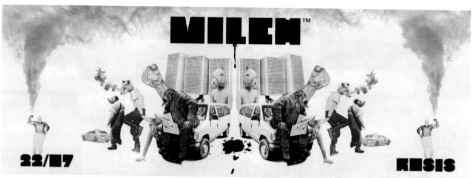

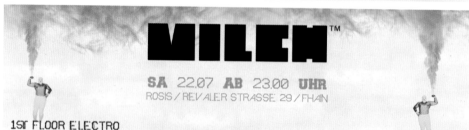

MILCH™

SA 22.07 **AB** 23.00 **UHR**
ROSIS / REVALER STRASSE 29 / FHAIN

1ST FLOOR ELECTRO
3 CHANNELS CROSSTOWNREBELS / TRENTON
ND BAUMECKER FREUNDINNEN SACHWITZ UND WETZEL WMF / CONTENTIS MISSING.NET
MARCEL DETTMANN HARD WAX / O-TON VELTENMEYER ELEKTRO.MOTOR AUF 100,6 / MILCH

2ND FLOOR WAHNSINN

03

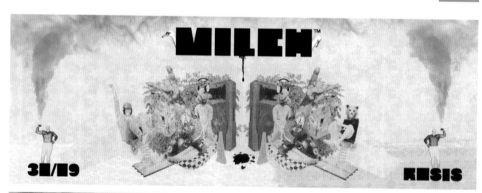

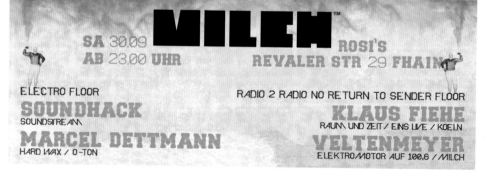

MILCH™

SA 30.09 **ROSI'S**
AB 23.00 **UHR** **REVALER STR 29 FHAIN**

ELECTRO FLOOR RADIO 2 RADIO NO RETURN TO SENDER FLOOR
SOUNDHACK
SOUNDSTREAM

MARCEL DETTMANN
HARD WAX / O-TON

KLAUS FIEHE
RAUM UND ZEIT / EINS LIVE / KOELN
VELTENMEYER
ELEKTRO.MOTOR AUF 100,6 / MILCH

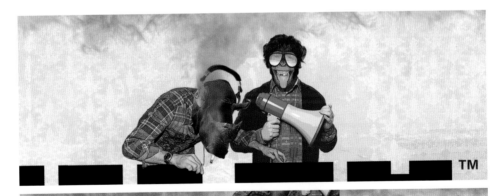

MILCH™

SAMSTAG
25.11 AB 23.00 UHR
ELECTRO FLOOR 01
HIGHFISH
BERLIN
MARCEL DETTMANN
HARD WAX / 0-TON

ROSI'S
REVALER STR 29 FHAIN
ELECTRO FLOOR 02
PHONOMAT
ELECTRIC ICON
VELTENMEYER
ELEKTRO MOTOR AUF MOTOR.FM / MILCH

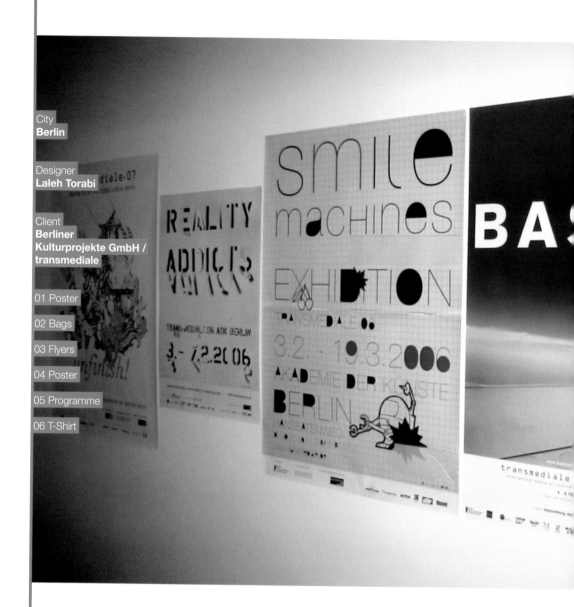

City
Berlin

Designer
Laleh Torabi

Client
**Berliner
Kulturprojekte GmbH /
transmediale**

01 Poster

02 Bags

03 Flyers

04 Poster

05 Programme

06 T-Shirt

transmediale.05

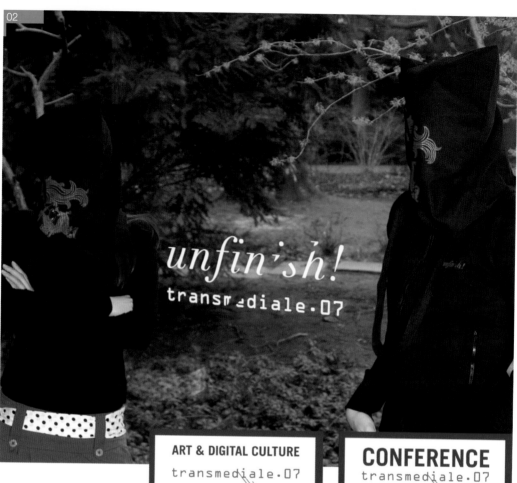

ART & DIGITAL CULTURE
transmediale.07

unfinish!

31. jan - 4. feb 2007 akademie der künste berlin

CONFERENCE
transmediale.07

unfinish!

31. jan - 4. feb 2007 akademie der künste berlin

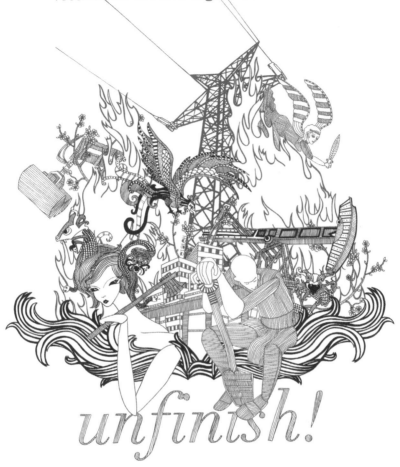

transmediale.07
festival for art and digital culture berlin

unfinish!

31. januar - 4. februar 2007 akademie der künste berlin

www.transmediale.de

ein projekt der
KULTUR PROJEKTE BERLIN

in kooperation mit der
AKADEMIE DER KÜNSTE

gefördert durch die
KULTURSTIFTUNG DES BUNDES

medienboard. BTL -BERLIN **arte.tv** radioeins die tageszeitung TELEPOLIS zitty

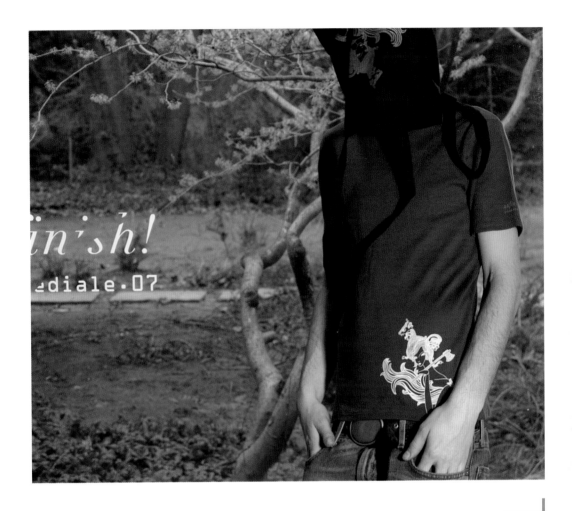

City
Berlin

Studio
potipoti

Client
Self-Promotion

01 Jumper / Puppets

02 Badges

03+04 Puppets

05 Badges

06 Bags

07 Postcards

08 Puppets

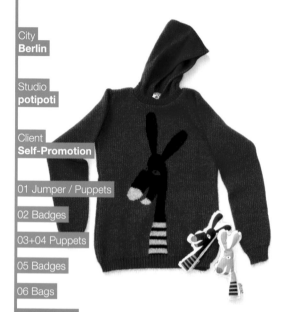

01

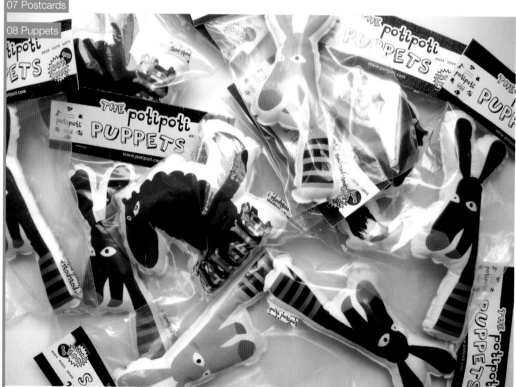

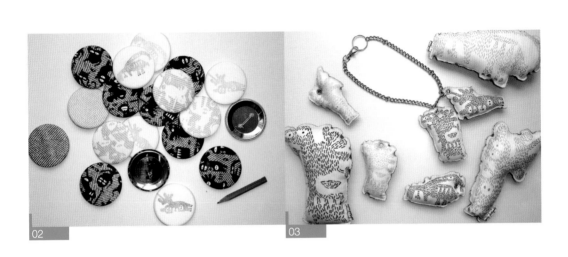

02 03

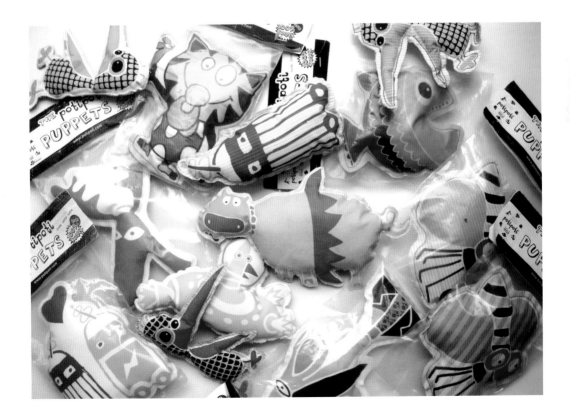

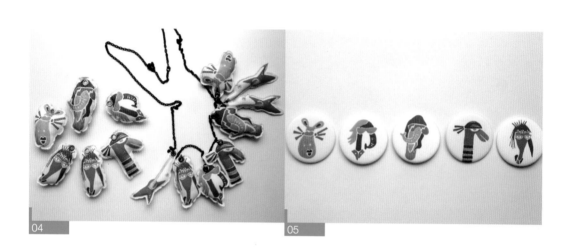

04

05

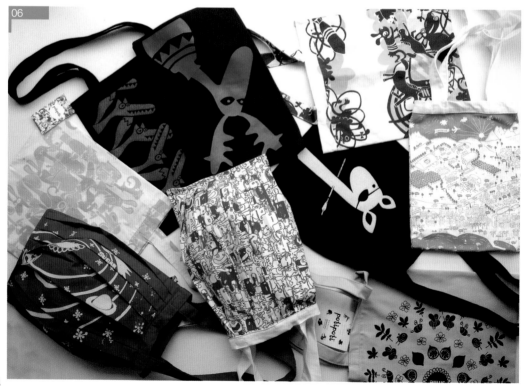

06

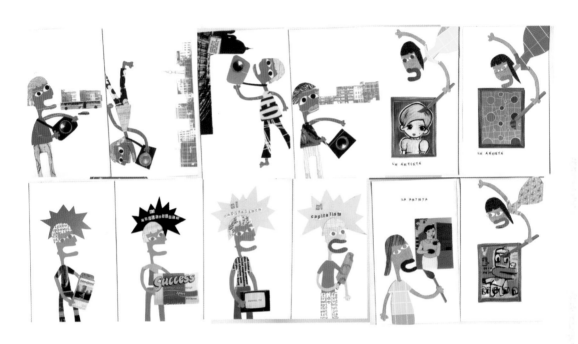

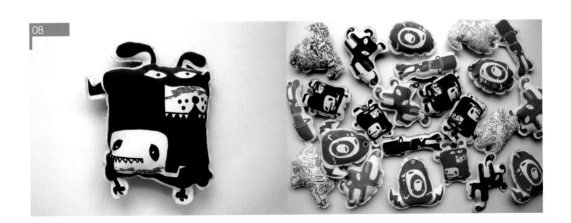

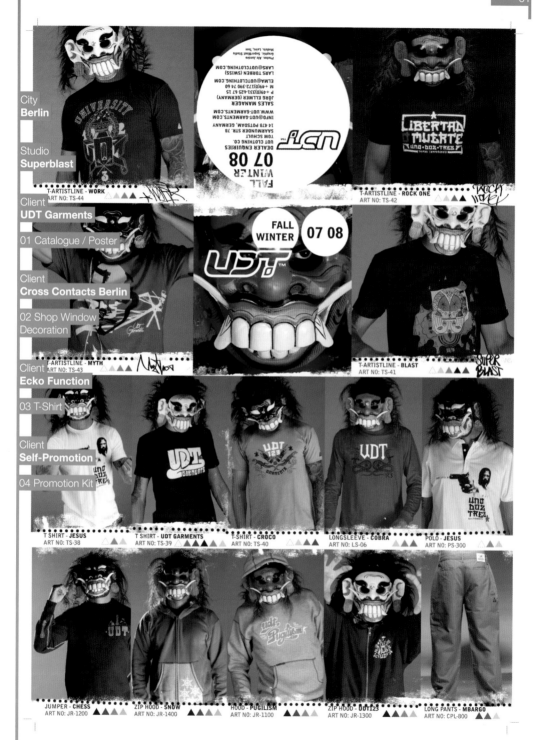

City
Berlin

Studio
Superblast

Client
UDT Garments

01 Catalogue / Poster

Client
Cross Contacts Berlin

02 Shop Window
Decoration

Client
Ecko Function

03 T-Shirt

Client
Self-Promotion

04 Promotion Kit

T-ARTISTLINE - **WORK**
ART NO: TS-44

T-ARTISTLINE - **ROCK ONE**
ART NO: TS-42

T-ARTISTLINE - **MYTH**
ART NO: TS-43

T-ARTISTLINE - **BLAST**
ART NO: TS-41

T SHIRT - **JESUS**
ART NO: TS-38

T SHIRT - **UDT GARMENTS**
ART NO: TS-39

T-SHIRT - **CROCO**
ART NO: TS-40

LONGSLEEVE - **COBRA**
ART NO: LS-06

POLO - **JESUS**
ART NO: PS-300

JUMPER - **CHESS**
ART NO: JR-1200

ZIP HOOD - **SNOW**
ART NO: JR-1400

HOOD - **PUGILISM**
ART NO: JR-1100

ZIP HOOD - **UDT123**
ART NO: JR-1300

LONG PANTS - **MBARGO**
ART NO: CPL-800

DEALER ENQUIRIES
UDT CLOTHING CO.
TOM SCHULZ
SAARWINDER STR. 78
14 478 POTSDAM, GERMANY
INFO@UDT-GARMENTS.COM
WWW.UDT-GARMENTS.COM

SALES MANAGER
JÖRG ELLMER (GERMANY)
P +49(0)331-425 67 15
M +49(0)172-390 74 60
ELMA@UDT-GARMENTS.COM
LARS TORBEN (SWISS)
LARS@UDTCLOTHING.COM

Photo: Ale Jordao
Graphic, Superblast Studio
Modih, Leira, Tom

FALL WINTER 07 08

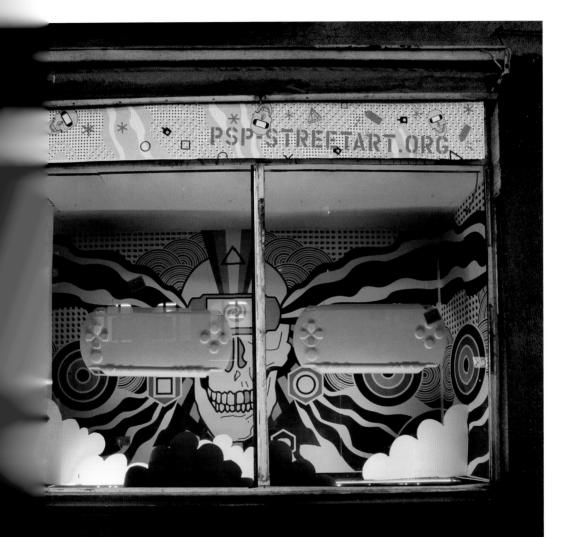

PSP-STREET ART.ORG

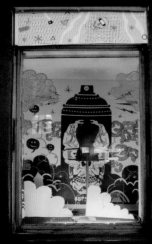

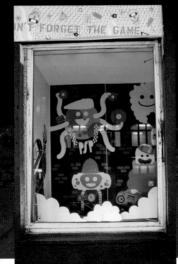

N'T FORGET THE GAME

02

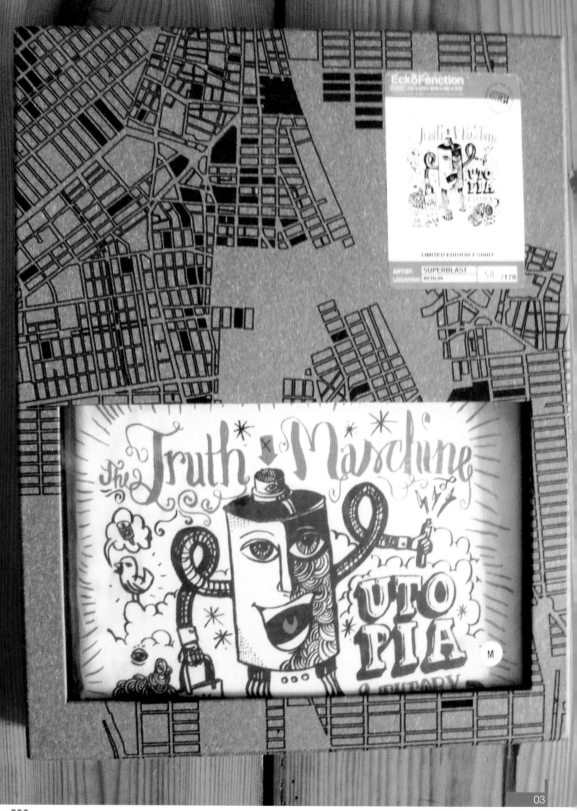

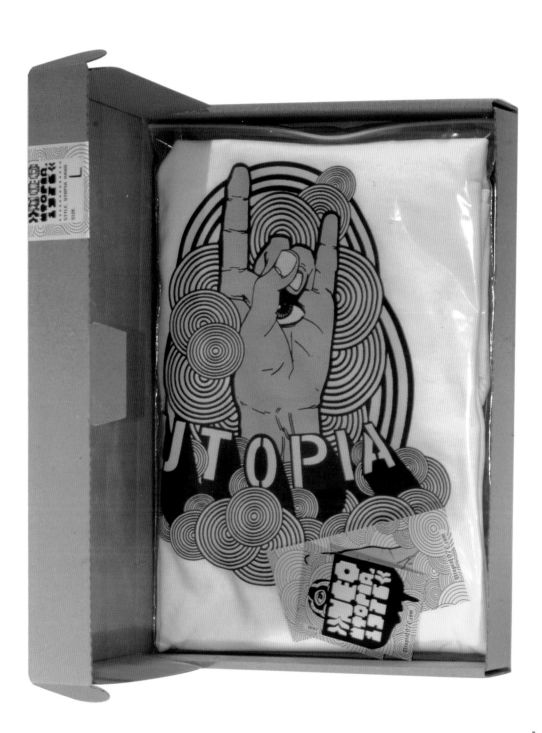

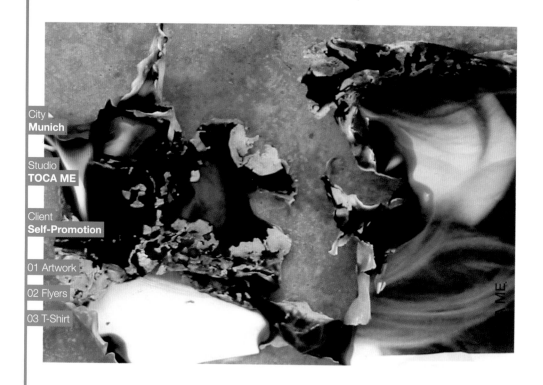

City ►
Munich

Studio
TOCA ME

Client
Self-Promotion

01 Artwork

02 Flyers

03 T-Shirt

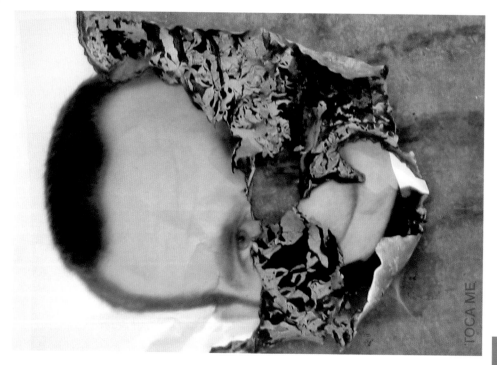

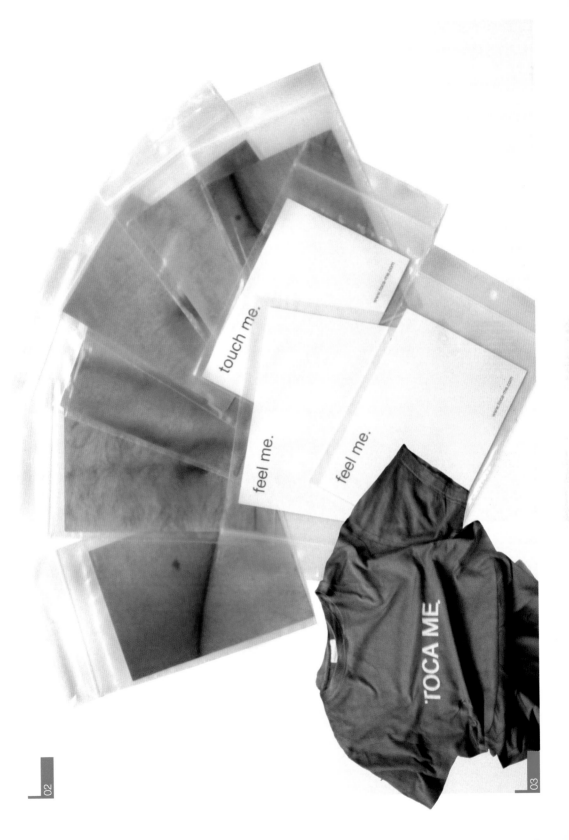

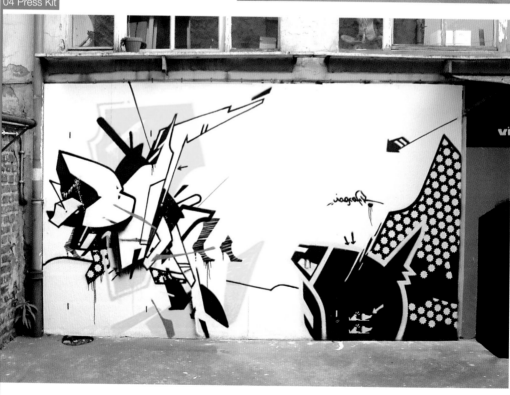

City
Wiesbaden

Studio
Via Grafik

Client
Passage Club

01 Wall Graphics,
Sculpture

02 Poster

Client
Self-Promotion

03 Poster

04 Press Kit

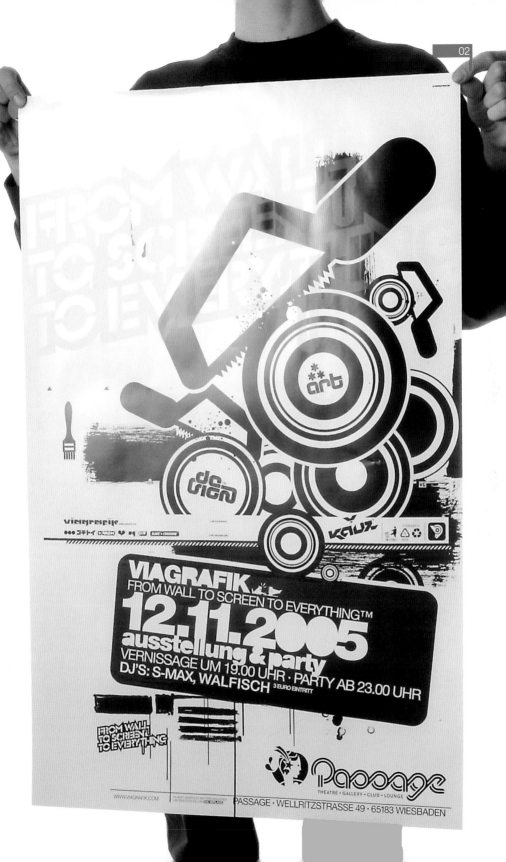

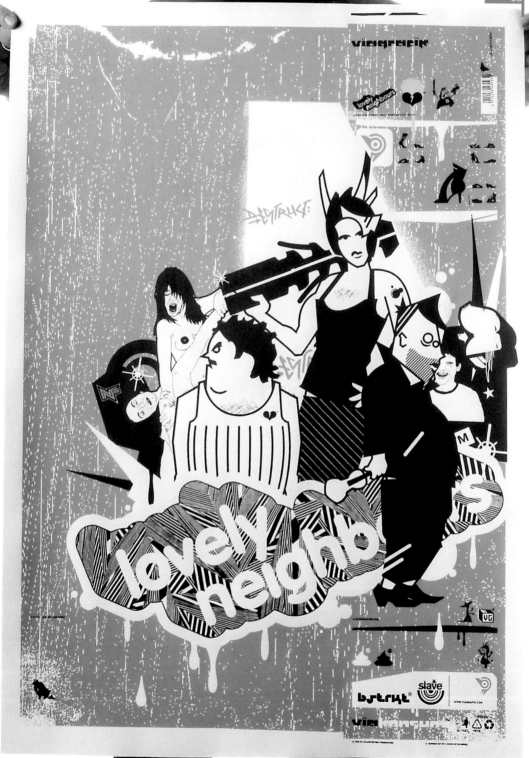

City
Wiesbaden

Studio
Via Grafik

Client
Pyramid Editions

05 Book Design

Client
Self-Promotion

06 Poster

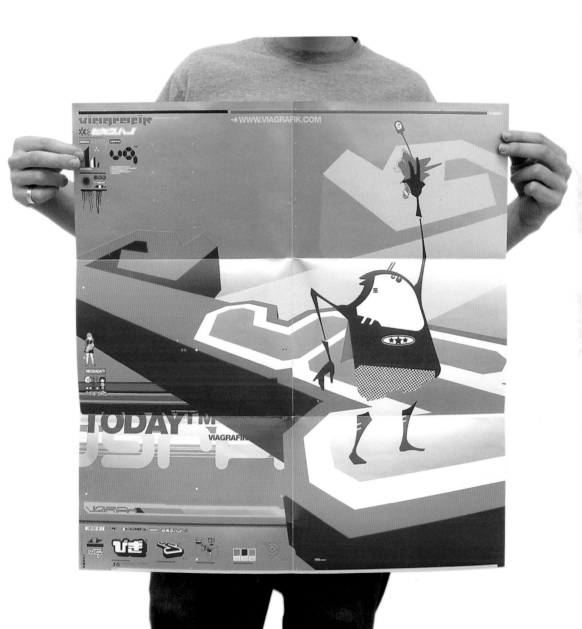

ICELAND
64°08 North 21°56 West

ÍSAFJÖRÐUR

SIGLUF

Flatey

STYKKISHÓLMUR

Kjölur

REYKJAVÍK

VESTMANNAEYJAR

Ís

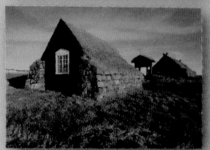

Raufarhöfn

KUREYRI

Myvatn

SEYÐISFJÖRÐUR

VATNAJÖKULL

HÖFN

Skaftafell

nd

City
Reykjavík

Designer
Jónas Valtysson

Client
**Icelandic Academy
of the Arts**

01+02 Posters

Client
Breakbeat.is

03 Poster

Client
I Adapt

04 CD Artwork,
Stickers

Client
Ólafur Arnalds

05 CD Artwork

06 Poster

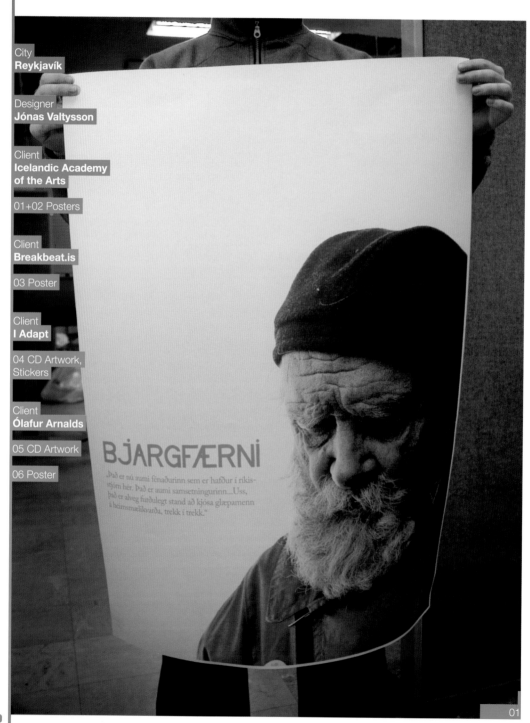

BJARGFÆRNI

„Það er nú aumi fénaðurinn sem er hafður í ríkis-
stjórn hér. Það er aumi samsetningurinn...Uss,
það er alveg furðulegt stand að kjósa glæpamenn
á heimsmælikvarða, trekk í trekk."

01

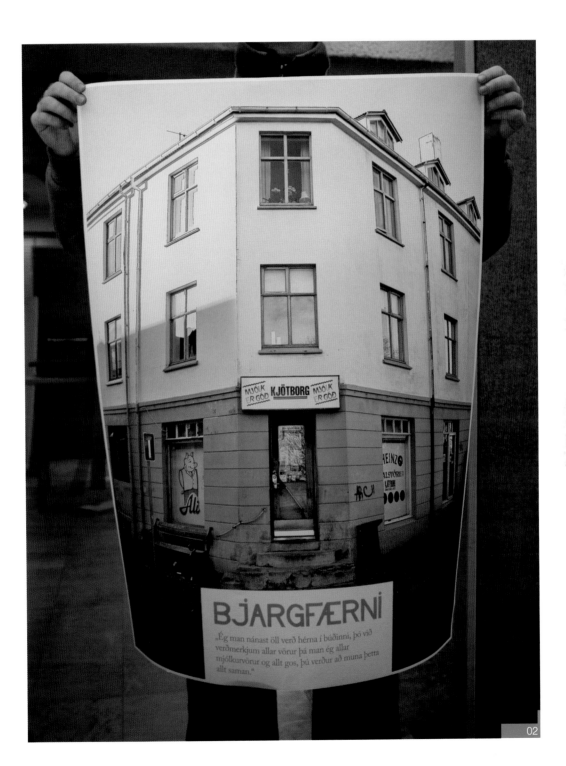

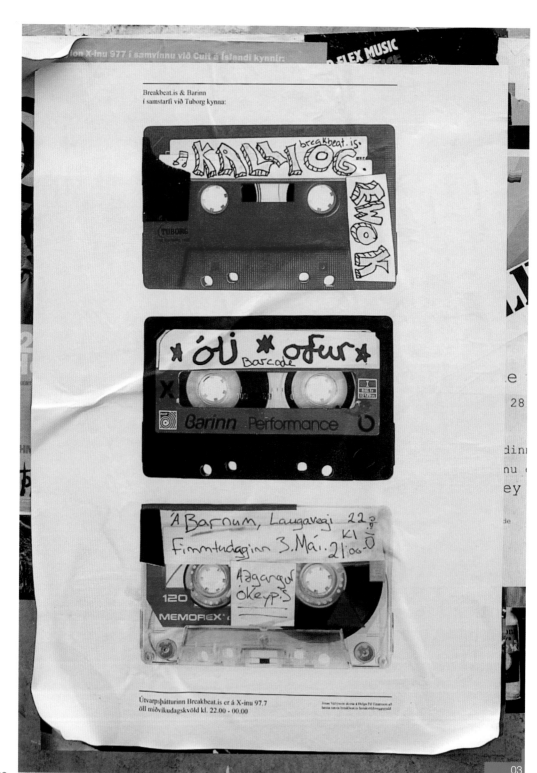

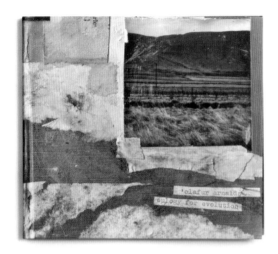

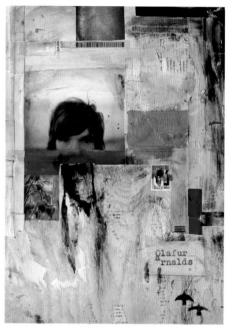

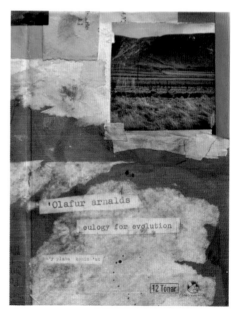

City
Reykjavík

Designer
Ragnar Freyr

Client
Breakbeat.is

01-04 Posters

Client
Ungir Aðgerðasinnar

05 Poster

Breakbeat.is í samstarfi
við Heineken kynnir:

Fyrsta Breakbeat.is klúbb
sumarsins fimmtudaginn
4. maí frá 21.00 til 01.00

Kalli
Lelli
Ewok

Á Pravda í Austurstræti

Útvarpsþátturinn
Breakbeat.is á dagskrá
X-ins 97.7 alla miðviku-
daga frá 22.00 til 00.00

Breakbeat.is & Iceland Airwaves
kynnefarli að Heineken kynna:

Amit

(Live Set)

Breakbeatis DJ's

www.breakbeat.is
www.icelandairwaves.com

1000 krónur eða
Iceland Airwaves armband

Á Pravda kl. 21-01
fimmtudaginn 19. oktober

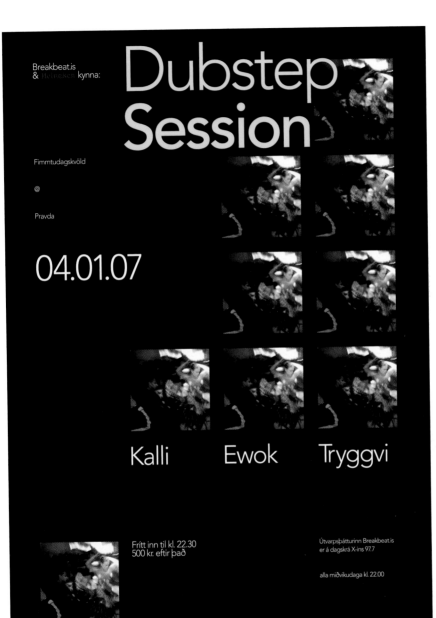

Pendulum

Breakbeat.is kynnir
í samstarfi við X-ið 97.7
og Heineken:

Árslistakvöld Breakbeat.is
á Nasa föstudaginn
20. janúar frá kl. 22.00
Miðaverð er 1000 krónur

Árslistinn 2005 í beinni frá
Nasa á X-inu 97.7
milli kl. 22.00 og 01.00.

PENDULUM
Breakbeat Kaos
Renegade Hardware
31 Records
Perth

KALLI / LELLI / EWOK
Breakbeat.is

breakbeat.is

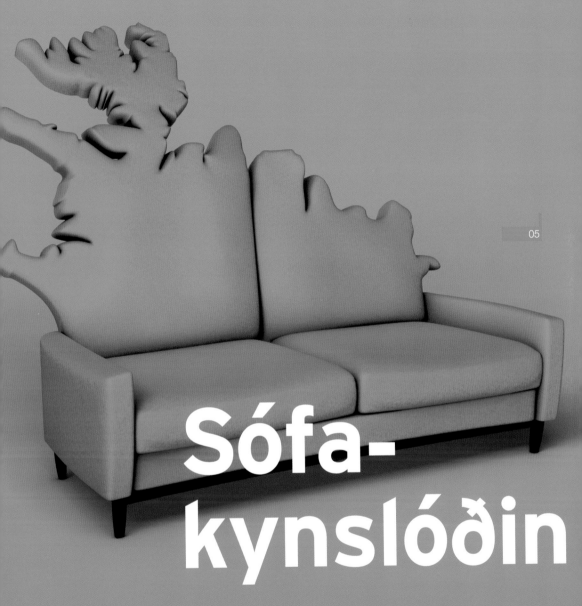

Ungir aðgerðasinnar
kynna mynd eftir

Áslaugu Einarsdóttur
og Garðar Stefánsson

05

Sófa-kynslóðin

Aktivismi á Íslandi

Styrktaraðilar:

Íslandsdeild Amnesty International
Nýsköpunarsjóður Námsmanna
Ungt fólk í Evrópu

City
Reykjavík

Studio
Jónsson&Le'macks

Designer
Sveinbjörn Pálsson

Client
Party Zone

01 Poster

Client
Mr. Destiny

02-04 Poster

ÁRSLISTAKVÖLD
PARTYZONE

Á GAUKNUM 19. JANÚAR FRÁ 21:00

ÁRSLISTINN VERÐUR FLUTTUR
Í RISA ÞÆTTI MILLI 19:30 OG 24:00
LAUGARDAGSKVÖLDIÐ 20. JAN
Á RÁS 2. » WWW.PZ.IS

MEÐ:

LIVE

BOOKA SHADE

Party Zone

„DANCE MUSIC SO PERFECT IT CAN'T HELP BUT MOVE YOU."
- PITCHFORK MEDIA

ÁSAMT:

HAIRDOCTOR LIVE

FM BELFAST LIVE

JACK SCHIDT PINEAPPLE RECORDS, IS

YVONE COCO JA CONFETTI/ FILUR, DK

DARREN C ULTRA PLAY, UK

MISS LORI SPECIAL PEOPLE'S CLUB, DK

DJUNA BARNES SUICIDE OVERKILL, DK

MIÐAVERÐ:
1990 KR Í FORSÖLU (MIÐAGJALD INNIFALIÐ)
TAKMARKAÐ MAGN MIÐA Í FORSÖLU
FORSALA Á MIÐI.IS OG Í VERSLUNUM SKÍFUNNAR

RÁS 2

G-STAR RAW

TUBORG

01

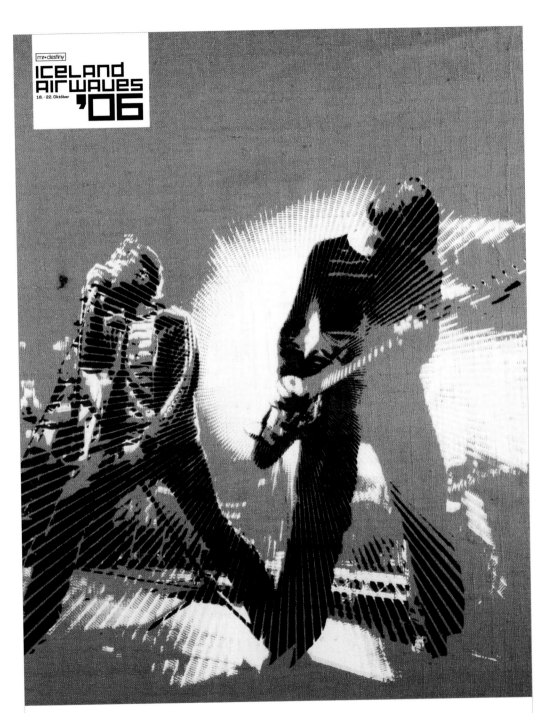

mr.destiny

ICELAND AIRWAVES '06

18. - 22. Október

Reykjavik ★
PURE ENERGY

WWW.ICELANDAIR.IS

Armband á hátíðina kostar 6.900
(+460 kr miðagjald söluaðila)

Fæst í verslunum Skífunnar, BT Akureyri, Eglastöðum og Selfossi og á Midi.is
Frekari upplýsingar : www.icelandairwaves.com

Brazilian Girls (US), The Go!
Team (UK), Islands (CAN),
Kaiser Chiefs (UK), Love is
All (SE), Mínus, Mugison,
We are Scientists (US), Wolf
Parade (CAN)

120 Days (NO), Amanda Blank (US), Amit (UK), Apparat
Organ Quartet, Baggalútur, Benni Hemm Hemm, Brain
Police, Changer, The Cribs (UK), Datarock (NO), Daniel
Ágúst, Dálek (US), Dr. Mister & Mr. Handsome, Eberg, Fields
(UK), Frae, Ghostigital, Gojira (FRA), Hot Club de Paris (UK),
Hermigervill, Jakobínarína, Jenny Wilson (SE), Jeff Who?,
Jóhann Jóhannsson, Kira Kira, Klaxons (UK), Leaves, Mammút,
Mates of State (US), Metric (CAN), My Summer as a Salvation
Soldier, Nico Muhly (US), Pétur Ben, Reykjavík! Seabear, Sign,
Skátabörd (NO), Spektrum (UK), Stillupsteypa, Störsvert Nix,
Noltes, Tilly and the Wall (US), Walter Meego (US), The Whitest
Boy Alive (NO/DE), Whomadewho (DK)

Abhop, Alfons X, Atomstation, Audio Improvement, Bootmotion Troops, Bats, Ben Frost
(US), Bent, Berre Crespo's Gang, Biggi, Blogin, Blindgangur, Bob Burke, Bubbgrod, Buff
Cold no Mind (UK), Dash DJs (UK), Captagol Island, Coral, Cory Andreen (US), Cymi Gyu,
Dikta, Donna, DJ Ammer, DJ Kalli, DJ Ölfur, DJ Jóleth, DJ Flahavin (US), Dr. Spock, Durðlin,
Egill Sæbjörnsson, Electroið, The End, Erol Madness, Eresh, Evoe, Flike (US), Frá Ballað, The
Pugherits, Foreign Monkeys, Forgotten Lores, Fortuna, Frank Murray's Park, Future Future,
Gavin Portland, Handactor, The Handsome Pubis (US), Hafið Valur, Hafrun, Heiðfinli, Hiðrun,
Hjaltalín, Hoffman, Hólmfríður, Helter Swing, Hrúður, Hugriffar (UK), I Adapt, Ídí, Indriði,
Innvertskewe, Jan Mayen, Jara, Jezebel, Jóhny Grocat, Joseph Mandrafti (US), Kenya Nansei
Kalí, Klison (UK), Kiga, Kira (US), Lara, Lara Sport, Langt við og ohuggaren, Lay Low, Lokes
Calnair (US), Lost by a Lion, Lodpeðil, Lost Lumðor, Jonas (US), Loðbra Margold, aka Jets Schult,
Nicola Björnsson (US), Mit, Morbriggaren, Mr, Silla & Mongrama, Mugapðun, Nine Eleven,
Nóló, Noise, Namarro, Nýmonó, Odd One, Orgelsenna, Ósk & Defdal, Our Lives, P. Guy,
Arnalds, Patrick Watson (CAN), Pickrock, Roythein, Rud Bernad, Retro Stefson, Reykjavík Sveng,
Rinuldn, Rúnni, Saktmóðigur (US), Shadow Parade, Siggi Armann, Skakkamanage, Skátin
Sía, Sangerónne, Söbrabi Speasmann, Sørengðarfólkin, Sneed Lord, Shane Sampling, Stamtagger,
Stuart Rogers (US), Surprise Sky, Swords & The TeleportFíelus, Terrorðisco, Tíður, Tingli on Parade,
Thunderclans, Toggi, Tony the Pony, Trost (US), Umfang, Útidúr, Valdimar, Veðurguðirnir (US), Verði
Ydigar! Sigurðsson, Vax, We Made God, Weapons, Where's Green, Wolfgang, 40a, The Zuckalls
Monðoposi Project, Una

ICELANDAIR

Reykjavíkurborg

ICELAND AIRWAVES '05

mr-destiny

19. - 23. Október

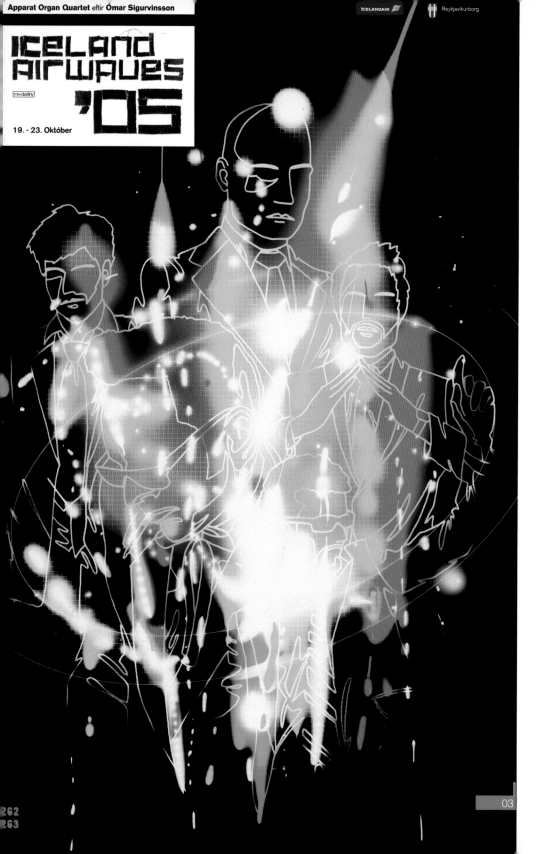

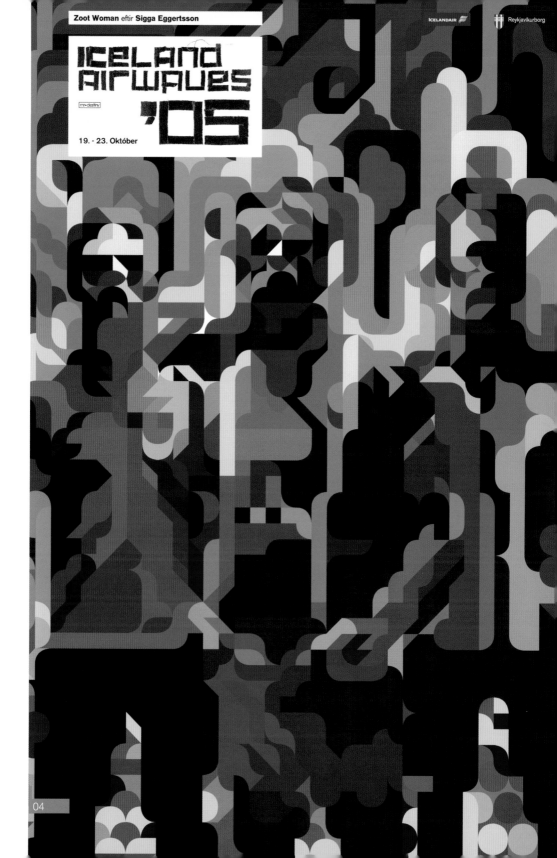

ICELAND AIRWAVES '05

[mr+destiny]

19. - 23. Október

ICELANDAIR

Reykjavíkurborg

City
Reykjavík

Studio
Jónsson&Le'macks

Designer
Sveinbjörn Pálsson

05 Posters

Designer
Sveinbjörn Pálsson

Client
Bad Taste Records

Photography
Börkur Sigþórsson

06 CD Artwork

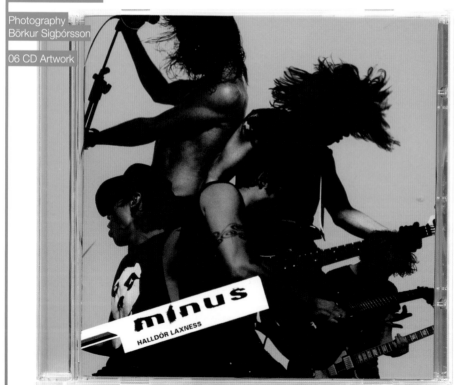

06

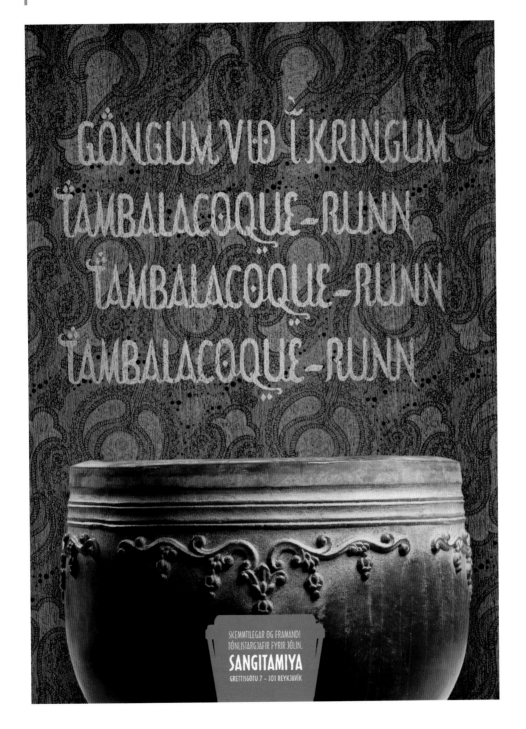

GÖNGUM VIÐ Í KRINGUM
TAMBALACOQUE-RUNN
TAMBALACOQUE-RUNN
TAMBALACOQUE-RUNN

SKEMMTILEGAR OG FRAMANDI
TÓNLISTARGJAFIR FYRIR JÓLIN.
SANGITAMIYA
GRETTISGÖTU 7 – 101 REYKJAVÍK

RR 5310 5438 7 IT

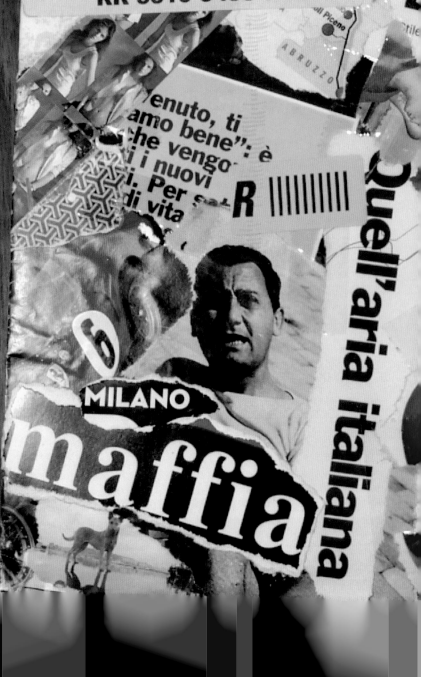

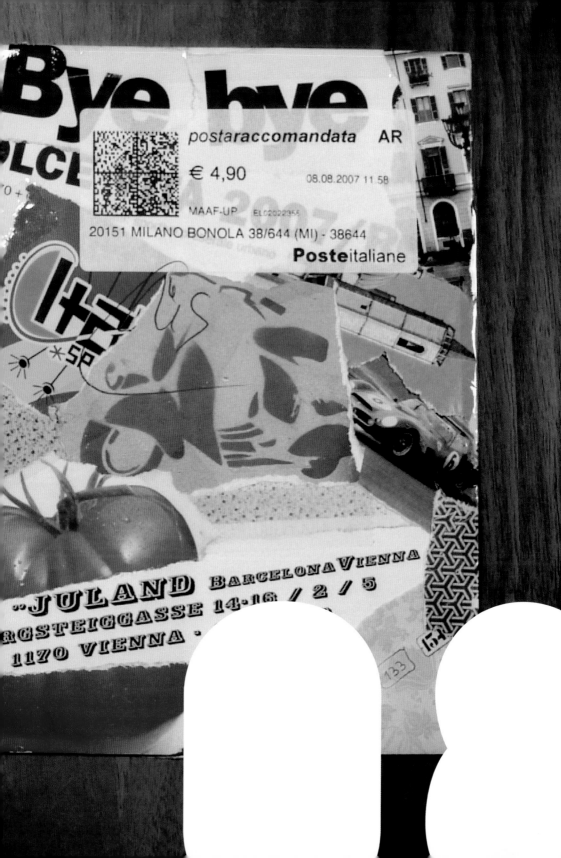

italy

BOX
SHOCK®

City
Milan

Studio
Designaside

Client
**Maxicubo
Self Storage**

01 Poster

Client
www.LayerMatch.com

02+03 Postcards

04 Stickers

Oper forti in spazi protetti
Mostra collettiva

16-18 Dicembre 2004
Maxicubo Self Storage
V a Grumello 32 - Bergamo

01

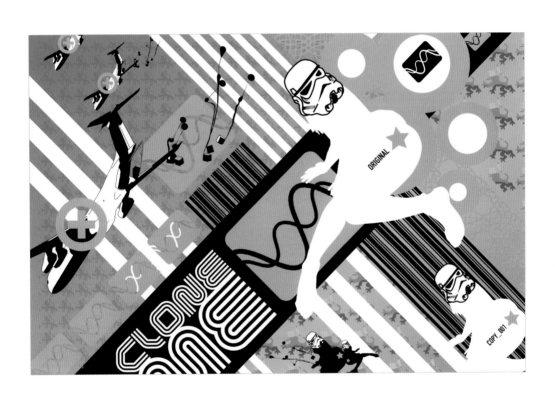

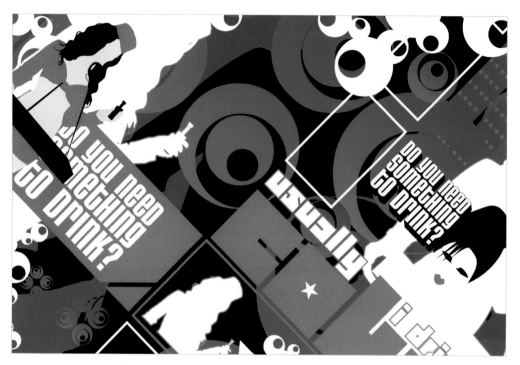

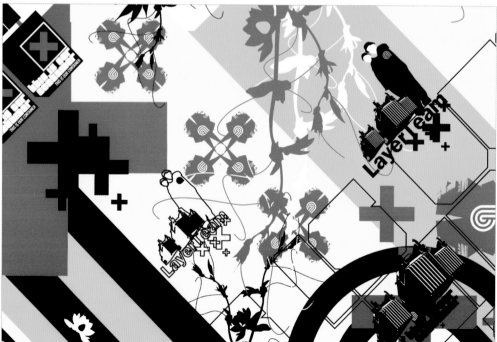

04

City
Milan

Studio
Designaside

Client
Self-Promotion

05 T-Shirts

06 Postcard

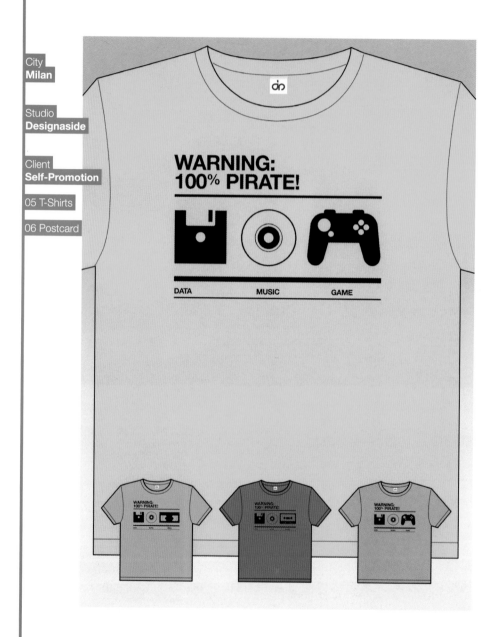

Designaside | PatternQuiz

Memorizza e vinci! Gira la cartolina e scopri come
vincere subito, collegandoti a: www.designaside.com

City
Milan

Studio
Dynamic Foundry

Client
Marconi

01 Invitation,
Business Cards, Booklet,
Press Release

02 Catalogue

03 Box
with Product Cards

04 Booklets

AIDA

THE KITCHEN **COLLECTION**

VASARI
LITTA
ARCONATI
TOSCANA
MANIN
BORGHESE

VASARI

TOSCANA

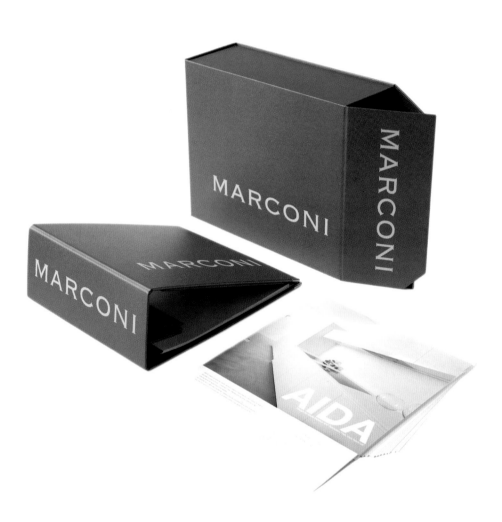

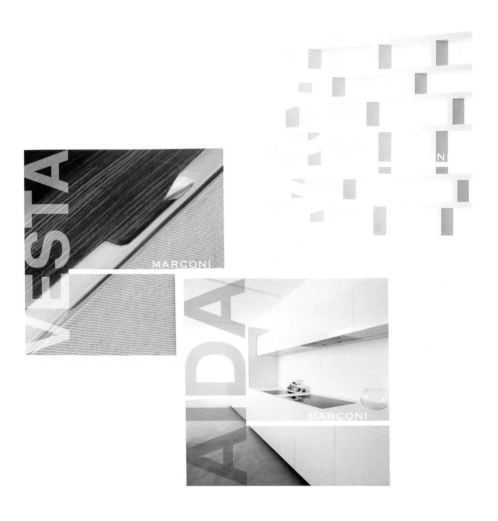

VESTA

MARCONI

AIDA

MARCONI

MOR

Libreria composta da piani orizzontali e montanti di varie altezze, tutte realizzato in legno laccato lucido spazzolato. Misure variabili. Disponibile con o senza impianto di illuminazione a LED

Bookcase made of horizontal shelves and upright pieces of various heights, all made of wood painted with a brushed finish gloss paint. Variable sizes. Available with or without LED lighting system.

Bibliothèque composée d'étagères horizontales et de montants de différentes hauteurs. Réalisée en bois laqué brillant satiné poncé brossé. Mesures variables. Disponible avec ou sans système d'éclairage sur LED.

Bücherregal aus horizontalen Regalboden und Höhenrungen verschiedener Höhe aus lackiertem gebürstetem Holz — verschiedenen Abmessungen. Mit oder ohne Led-Beleuchtungssystem verfügbar.

City
Milan

Studio
Graphic Pack

Client
Self-Promotion

01 Flyers

Client
Magic Room

02 Flyers

Client
Brera

03 Book

Client
So.Close

04+05 Flyers

06 CD Artwork

13 SETTEMBRE 2006

SOUND CHECK
AT MAGIC ROOM

VIA CANDIANI 4 . MILANO
TEL 02 38083948?
WWW.MAGICROOMMILANO.COM

live

26 OTTOBRE 2006

SOUND CHECK 2ND ED.
AT MAGIC ROOM

VIA CANDIANI 4 . MILANO
TEL 02 38083948?
WWW.MAGICROOMMILANO.COM

live

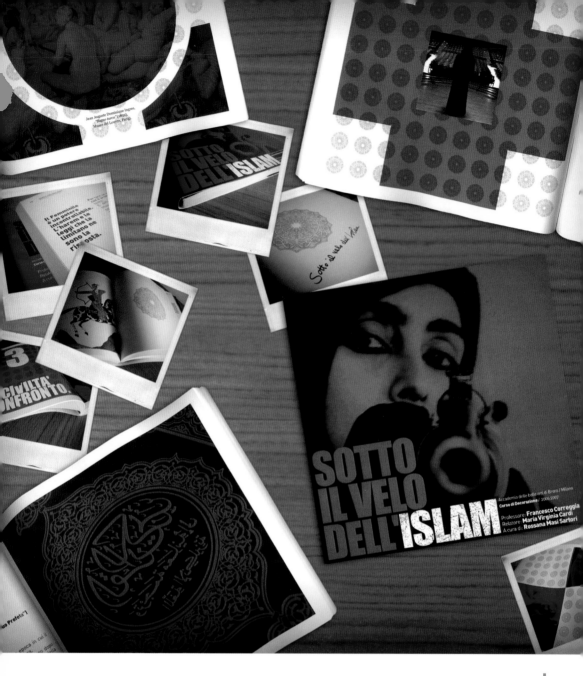

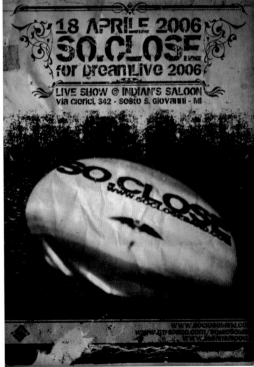

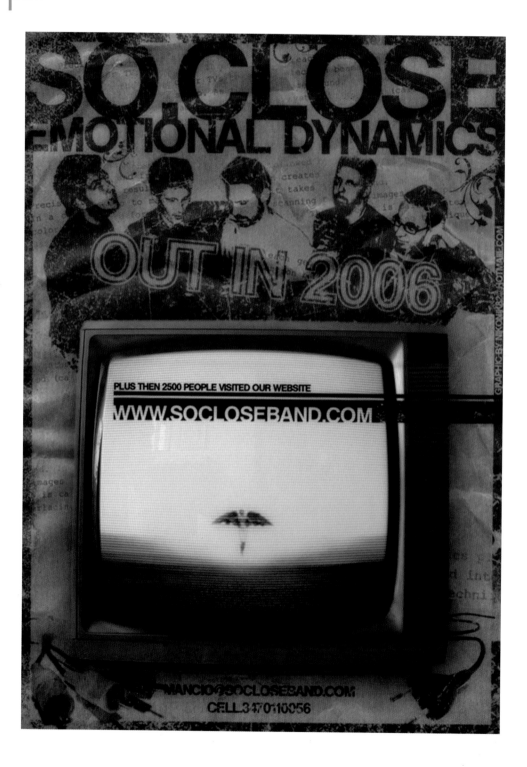

Studio
Graphic Pack

Client
Joint

07 Flyer

Client
You You

08 Flyers

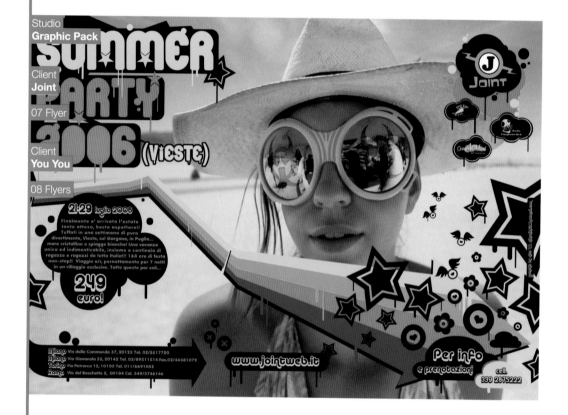

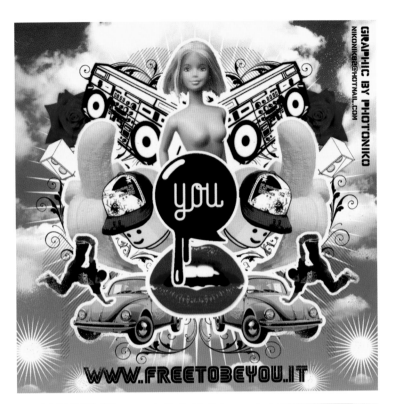

WWW..FREETOBEYOU..IT

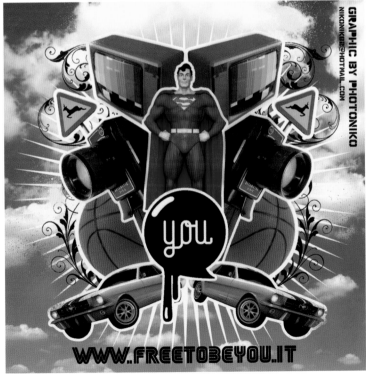

WWW..FREETOBEYOU..IT

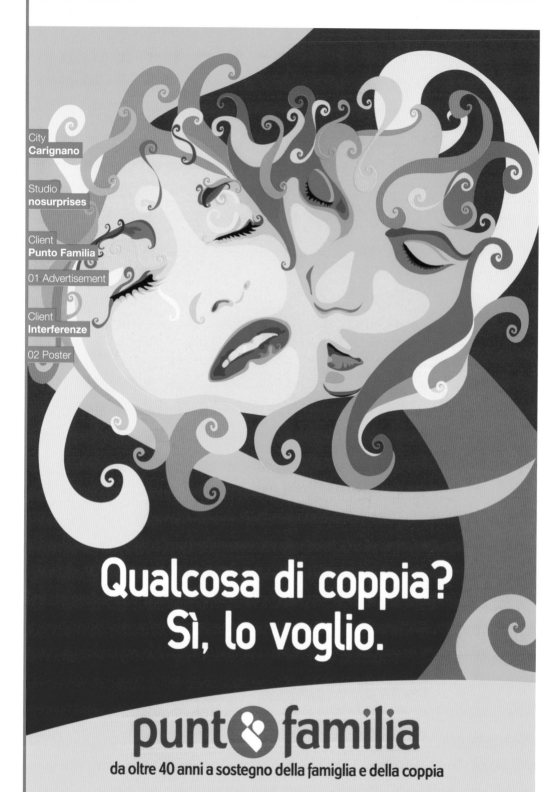

INTERFERENZE 2007

VENERDI 07.09.2007
OFFICINE LUMIERE
IMPROVVISO
MK ULTRA

OSPITI: EL TRES

SABATO 08.09.2007
ROBERTO BISCESE
FABIO BALMAS
MOTORCITYBRAGS

OSPITI: SO:HO.

INGRESSO GRATUITO

INFO:
Comunità Montana Pinerolese Pedemontano
Tel. 0121/794407 – e-mail: info@cmpinerolesepedemontano.it
www.cmpinerolesepedemontano.it – www.musicaround.it

www.kaneda.it

02

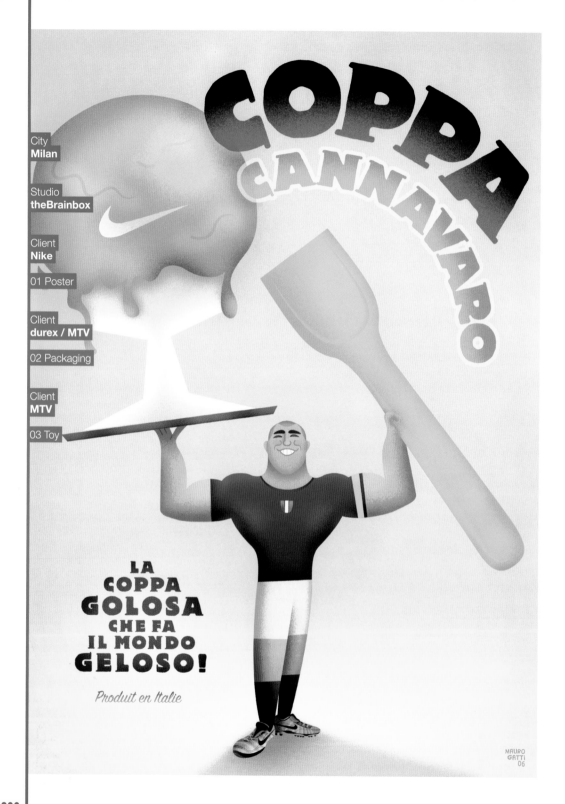

City
Milan

Studio
theBrainbox

Client
Nike

01 Poster

Client
durex / MTV

02 Packaging

Client
MTV

03 Toy

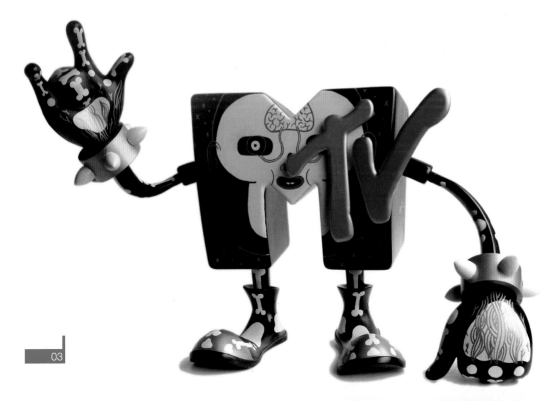

City
Amsterdam

Studio
BENG

Client
**MCS
and Opale Booklets**

01 Booklet

01

(opposite)

City
The Hague

Studio
Dr. Hype

Client
Silly Symphonies

01 Flyers

Client
Safescan

02 Brochure

03 Packaging, Website,
Instruction Leaflet

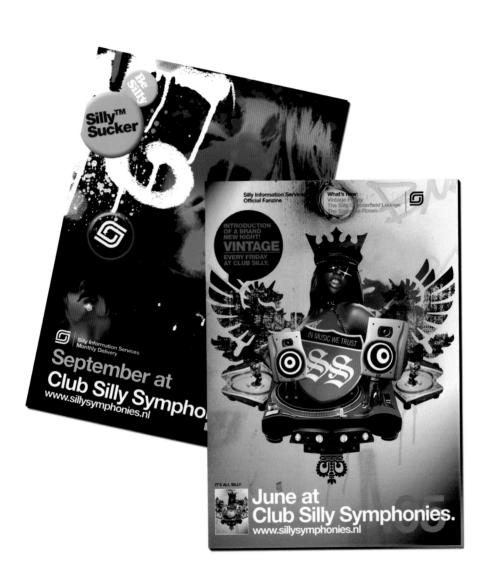

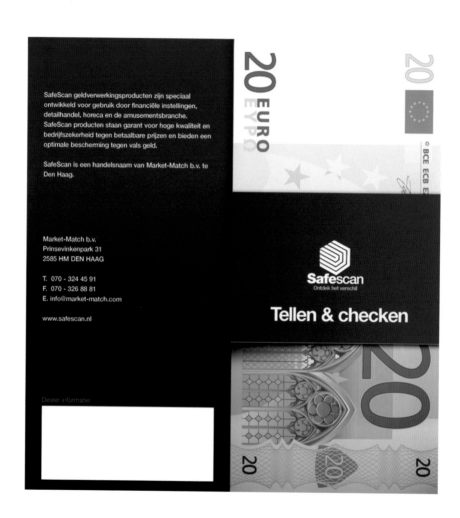

SafeScan geldverwerkingsproducten zijn speciaal
ontwikkeld voor gebruik door financiële instellingen,
detailhandel, horeca en de amusementsbranche.
SafeScan producten staan garant voor hoge kwaliteit en
bedrijfszekerheid tegen betaalbare prijzen en bieden een
optimale bescherming tegen vals geld.

SafeScan is een handelsnaam van Market-Match b.v. te
Den Haag.

Market-Match b.v.
Prinsevinkenpark 31
2585 HM DEN HAAG

T. 070 - 324 45 91
F. 070 - 326 88 81
E. info@market-match.com

www.safescan.nl

Dealer informatie:

Safescan
Ontdek het verschil

Tellen & checken

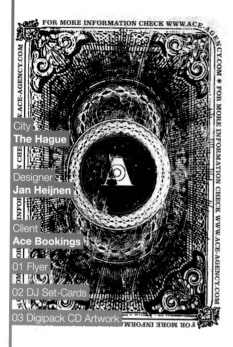

City
The Hague

Designer
Jan Heijnen

Client
Ace Bookings

01 Flyer

02 DJ Set-Cards

03 Digipack CD Artwork

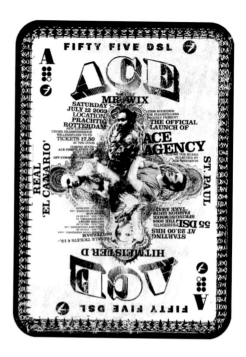

01

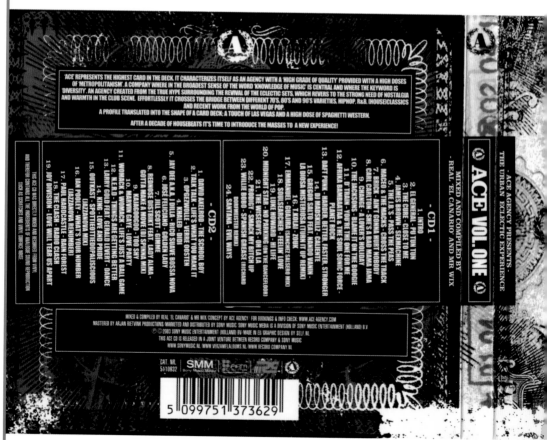

'ACE' REPRESENTS THE HIGHEST CARD IN THE DECK. IT CHARACTERIZES ITSELF AS AN AGENCY WITH A 'HIGH GRADE OF QUALITY PROVIDED WITH A HIGH DOSES OF 'METROPOLITANISM'. A COMPANY WHERE IN THE BROADEST SENSE OF THE WORD 'KNOWLEDGE OF MUSIC' IS CENTRAL AND WHERE THE KEYWORD IS 'DIVERSITY'. AN AGENCY CREATED FROM THE TRUE HYPE SURROUNDING THE REVIVAL OF THE ECLECTIC SETS, WHICH REVERS TO THE STRONG NEED OF NOSTALGIA AND WARMTH IN THE CLUB SCENE. EFFORTLESSLY IT CROSSES THE BRIDGE BETWEEN DIFFERENT 70'S, 80'S AND 90'S VARIETIES, HIPHOP, R&B, (HOUSE)CLASSICS AND RECENT WORK FROM THE WORLD OF POP.
A PROFILE TRANSLATED INTO THE SHAPE OF A CARD DECK; A TOUCH OF LAS VEGAS AND A HIGH DOSE OF SPAGHETTI WESTERN.
AFTER A DECADE OF HOUSEBEATS IT'S TIME TO INTRODUCE THE MASSES TO A NEW EXPERIENCE!

ACE AGENCY PRESENTS
THE URBAN ECLECTIC EXPERIENCE
VOLUME ONE

ACE

MIXED AND COMPILED
BY REAL EL CANARIO AND MR WIX

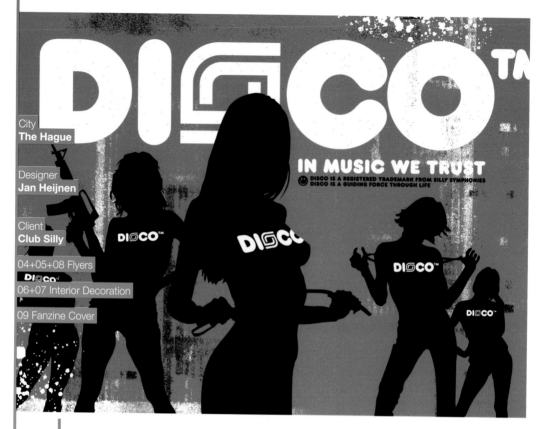

DISCO™

IN MUSIC WE TRUST

DISCO IS A REGISTERED TRADEMARK FROM SILLY SYMPHONIES
DISCO IS A GUIDING FORCE THROUGH LIFE

City
The Hague

Designer
Jan Heijnen

Client
Club Silly

04+05+08 Flyers

DISCO™
06+07 Interior Decoration

09 Fanzine Cover

04 05 06

WE BRING YOU

5 x five.

31.12.04
THOU BELOVED ONES
Thou shall party, Thou shall dance,
Thou shall have
a good time!

As we enter a new year, and reflect on the one passed by. And although it was a bumpy one for most of us. Let us learn from our mistakes, not mourn over the past and MAKE 2005 A YEAR OF CHANGE AND POSITIVITY.

WE GUARANTEE AN EASY ENTRANCE, A PROFESSIONAL WARDROBE, LOADS OF TOILETS. ALL TOGETHER SOMETHING YOU CAN CALL A GREAT PARTY.

The Grand
GroteMarkt

Five Locations
New Years Party

Location Grote Markt
in the center of The Hague
Entrance 37,50 euro
Festivities start at 23.00 hrs
Decoration by Sis Jossip

AT SEPTEMBER
CLUB SILLY
ZETA
ZWARTE RUITER
DE BOTERWAAG
AND A GIGANTIC RELAX TENT
ON THE GROTE MARKT.

REMY
STEF VROLIJK AND
THE 16 BIT LOLITAS
JAQUES DE LA DISQUE
VALDEZ
ARSHAD
MIKEE MARTILLO
SPLENDID! (LIVE)
HIGHNESS
RADAR LOVE
DADDY P
COOKIE RICK

ALL THOU PRETTY ONES AND THE ONES YOU LOVE
WE WISH YOU THE VERY BEST FOR THE COMING
TWO THOUSAND AND FIVE AND AND
HAPPY LOVE

5 x five

07 08 09

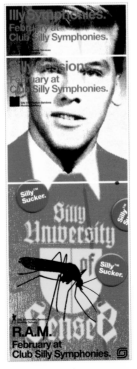

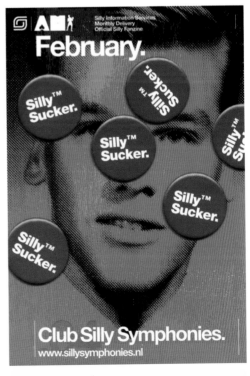

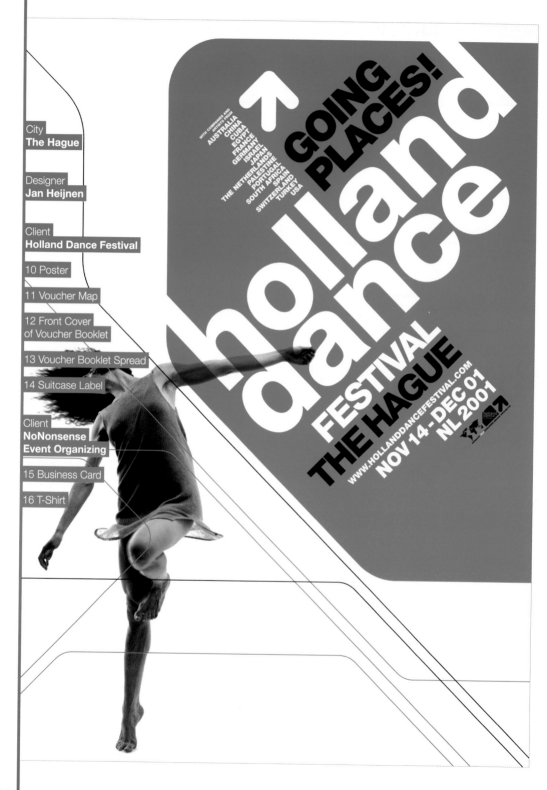

City
The Hague

Designer
Jan Heijnen

Client
Holland Dance Festival

10 Poster

11 Voucher Map

12 Front Cover
of Voucher Booklet

13 Voucher Booklet Spread

14 Suitcase Label

Client
**NoNonsense
Event Organizing**

15 Business Card

16 T-Shirt

INTERNATIONAL

HOLLAND DANCE FESTIVAL
NOBELSTRAAT 21
2513 BC DEN HAAG
THE NETHERLANDS

GOING PLACES!

PTT Post
Port be...
Pays-Ba...

HOLLAND DANCE FESTIVAL / THE HAGUE / NOV 14 - DEC 01 / NL 2001
LUCENT DANSTHEATER / THEATER A/H SPUI / KORZO THEATER
THEATER ZWEMBAD DE REGENTES / IN HET MAGAZIJN / ATRIUM STADHUIS

GOING PLACES!

WITH COMPANIES AND ARTISTS FROM AUSTRALIA / CHINA / CUBA / EGYPT / FRANCE / GERMANY / ISRAEL / JAPAN / THE NETHERLANDS / PALESTINE / PORTUGAL / SOUTH AFRICA / SPAIN / SWITZERLAND / TURKEY / USA

HOLLAND DANCE FESTIVAL

HAPPY LANDING

BON VOYAGE!

TAKE OFF!

WITH COMPANIES AND ARTISTS FROM
AUSTRALIA / CHINA / CUBA / EGYPT / FRANCE / GERMANY / ISRAEL / JAPAN /
THE NETHERLANDS / PALESTINE / PORTUGAL / SOUTH AFRICA / SPAIN /
SWITZERLAND / TURKEY / USA

HDF INFO LINE: 00 31 (0) 70 427 73 69
WWW.HOLLANDDANCEFESTIVAL.COM

GOING PLACES!

HOLLAND DANCE FESTIVAL / THE HAGUE / NOV 14 - DEC 01 / 2001
LUCENT DANSTHEATER / THEATER A/H SPUI / KORZO THEATER
THEATER ZWEMBAD DE REGENTES / IN HET MAGAZIJN / ATRIUM STADHUIS

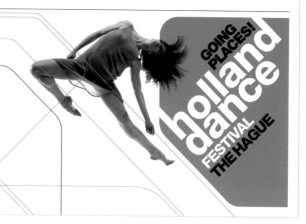

INTERNATIONAL

12

HOLLAND DANCE FESTIVAL

NL	001	NEDERLANDS DANS THEATER I, II, III
ZA	002A	DNA DANCE THEATRE
ZA	002B	VUYANI DANCE THEATRE PROJECT
CH	003	GOPF; METZGER, ZIMMERMANN, DEPERROT
NL	004	CONNY JANSSEN DANST / 010 B'BOYZ
J	005	SHUSAKU TAKEUCHI
USA	006	PILOBOLUS DANCE THEATRE
NL	007	STAMINA C.C.A.
C	008	DANZA CONTEMPORÁNEA DE CUBA
NL	009	CONCERT IN D (A DJAZZEX PRODUCTION)
USA	010	RENNIE HARRIS PUREMOVEMENT
D-NL/USA	011	REGINA VAN BERKEL / BILL SEAMAN
NL/J	012	JIŘÍ KYLIÁN / MEGUMI NAKAMURA
USA	013	MARTHA@HOLLAND DANCE FESTIVAL
TJ	014	GUANGDONG MODERN DANCE COMPANY
ZA	015A	TRACEY HUMAN
IL-NL	015B	URI IVGI
NL	016	INTRODANS
USA	017	TWYLA THARP DANCE
ZA	018	BALLET THEATRE AFRIKAN
NL	019	ELSHOUT / HÄNDELER
NL	020	ARNICA ELSENDOORN PROJECT
NL-USA	021	DYLAN NEWCOMB
AUS/NL	022	MERYL TANKARD / NDT III
P/NL	023	BALLET GULBENKIAN / GALILI DANCE
TR	024	MODERN DANCE TURKEY
ET	025A	MOHAMED SHAFIQ
F	025B	MORGAN BELENGUER
E	025C	EL TINGLAO
NL/USA	025D	JENNIFER HANNA & JEAN EMILE
NL/E	025E	ARTHUR ROSENFELD & ANA TEIXIDÓ
NL	026	TICKET TO HEAVEN
NL	027	DE HAAGSE DANSWEEK!

MAP

INTERNATIONAL

13

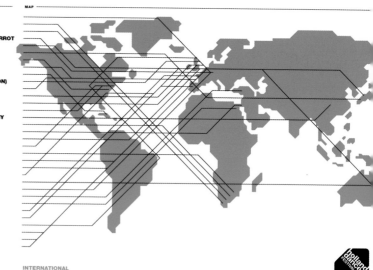

HOLLAND DANCE FESTIVAL INFO
00 31 (0)70 427 73 69
WWW.HOLLANDDANCEFESTIVAL.COM
INFO@HOLLANDDANCEFESTIVAL.COM
UITLIJN 0900 0191 (88CPM)

INTERNATIONAL

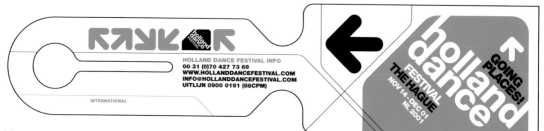

THIS IS OUR
BUSINESSCARD.

BLACK TYPE ON
WHITE BACKGROUND.
UPPERCASE.
FORMAT 85X54 MM.
NO NONSENSE.

15

16

DANCE FESTIVAL

GOING PLACES!
THE HAGUE
HOLLAND DANCE FESTIVAL 2001

GOING
PLACES!

WITH COMPANIES AND ARTISTS FROM

AUSTRALIA / CHINA / CUBA / EGYPT / FRANCE / GERMANY /
ISRAEL / JAPAN / THE NETHERLANDS / PALESTINE / PORTUGAL /
SOUTH AFRICA / SPAIN / SWITZERLAND / TURKEY / USA

INTERNATIONAL//

TAKE OFF!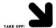

14

City
The Hague

Designer
Jan Heijnen

Client
**Cultural Centre
Paard van Troje**

17 Poster

(opposite)

City
Amsterdam

Studio
Mainstudio

Client
UCK

01 Poster

PK

PRINSEGRACHT 12 DEN HAAG
INFO (070) 3601618 / WWW.PAARD.NL
DECEMBER.98

PaaRD

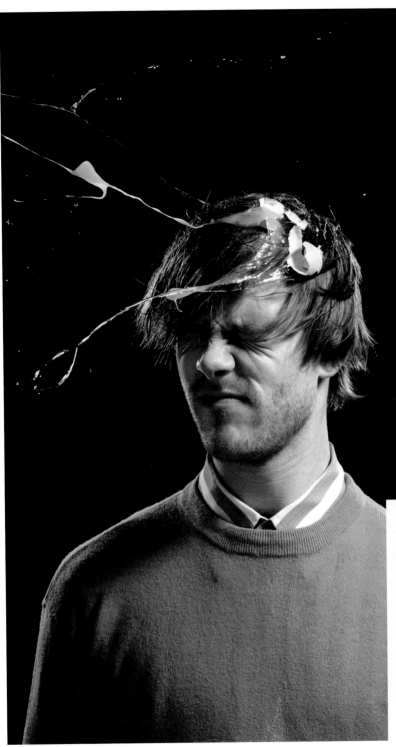

**Amateur
Theater
Festival
Utrecht**

09/10/11 Juni 2006
*Utrechts Centrum
Voor De Kunsten
(UCK) Domplein 4*

www.amateurtheaterfestivalutrecht.nl

01

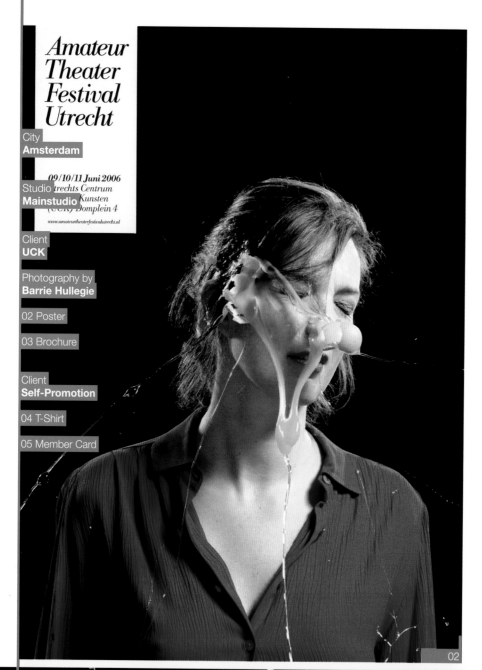

Amateur Theater Festival Utrecht

City
Amsterdam

09/10/11 Juni 2006
Studio *trechts Centrum*
Mainstudio *Kunsten*
(UCK) Domplein 4

www.amateurtheaterfestivalutrecht.nl

Client
UCK

Photography by
Barrie Hullegie

02 Poster

03 Brochure

Client
Self-Promotion

04 T-Shirt

05 Member Card

02

03

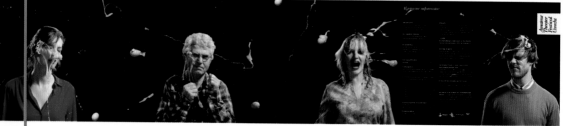

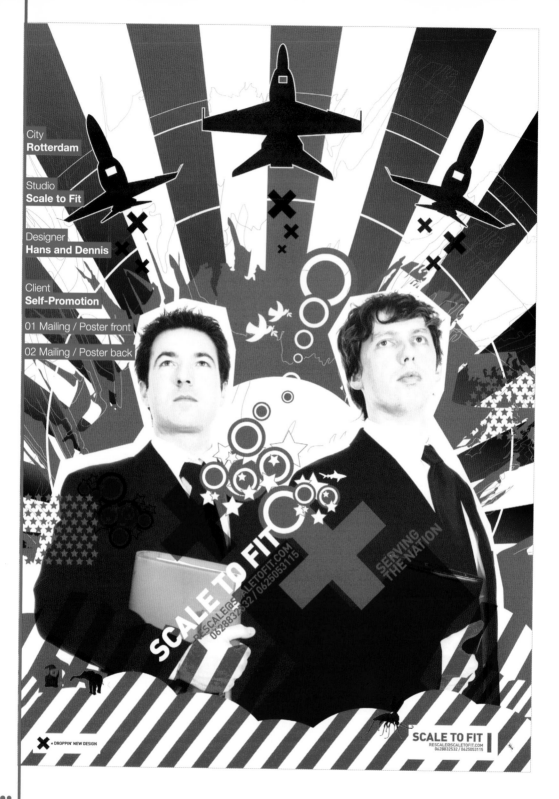

City
Rotterdam

Studio
Scale to Fit

Designer
Hans and Dennis

Client
Self-Promotion

01 Mailing / Poster front

02 Mailing / Poster back

WE COME IN PEACE

WORLD DOMINATION

THE SUN SHINES FOR EVERYONE

FIRE POWER
TOTAL 1/1 327,5GB

iTUNES - SHUFFLE

SERVING THE GLOBE

SIZE MATTERS

TURN ME ON!

THE SECRET OF GREATNESS IS SIMPLE: DO BETTER WORK THAN ANY OTHER MAN IN YOUR FIELD - AND KEEP ON DOING IT.

HANS VS DENNIS IN AMERIKA

SCALE TO FIT vs. THE PEOPLE OF CHINA

CORPS TOP 10

HANS
@SCALETOFIT.COM

DENNIS
@SCALETOFIT.COM

IF YOU WOULD ATTAIN GREATNESS, THINK NO LITTLE THOUGHTS.

IMAGINATION RULES THE WORLD

TAIPEI FINANCIAL CENTER

02

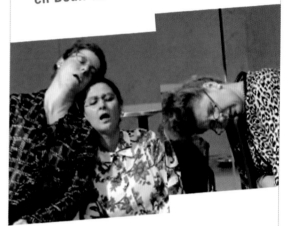

ma 1 tm wo 3 mei, 20.30 uur
SLANGENVEL
Orkater

met Margôt Ros, Wimmie Wilhelm
en Bodil de la Parra

"Hilarische besjes zijn ook
ontroerend." (VK)

Theater Bellevue Leidsekade 90 Amsterdam
kassa 020-5305301 www.theaterbellevue.nl

01

THEATER
BELLE
VUE
2006
2007

THEATER
BELLE
VUE
2006
2007

THEATER
BELLE
VUE
2006
2007

THEATER
BELLE
VUE
2006
2007

THEATER BELLE VUE 06 07

WWW.
HETLEUKSTE
THEATERVAN
AMSTERDAM
.NL
kaarten & informatie (020) 530 5301
Leidsekade 90, Amsterdam

THEATER
BELLE
VUE

↖ GROTE ZAAL
PALONI ZAAL
↓ KLEINE ZAAL
GARDEROBE
TOILETTEN, LIFT

← KLEINE
ZAAL

City
Amsterdam

Studio
Thonik

Client
**Museum Boijmans
Van Beuningen**

06 Flyer
(two of a series of six)

07 Folder

08 Posters

Client
Grachtenfestival 2006

09 Posters

INTERVENTIE #3

Gerda Steiner & Jörg Lenzlinger
Four Vegetative Sleeping Rooms
20 januari 2007 - 28 oktober 2007

Het Zwitserse kunstenaarsduo Gerda Steiner & Jörg Lenzlinger is geïnteresseerd in kunstmatige tuinen, natuurlijke groeiprocessen en alle cross-overs tussen cultuur en natuur. Tijdens de Biënnale van Venetië van 2003 dwarrelden in de roomskatholieke kerk Santa Stae aan het Canal Grande duizenden blaadjes en plantjes aan takken naar beneden. De bezoeker kon liggend op een groot bed naar de hemel staren om dit wonder te aanschouwen.

Op uitnodiging van Museum Boijmans Van Beuningen, daartoe in staat gesteld door het H&F Mecenaat, bouwden Gerda Steiner en Jörg Lenzlinger in de vier grote vitrines van het zgn. klaverblad van het museum een nieuwe vegetatieve installatie. De intieme kamertjes met grote etalages zijn voorzien van resp. een bottenboom, een jungle, een zadenkamer en een uit ureum groeiend roze kristallenbos. Elke kamer is toegankelijk en van elke kamer gaat een weldadige rust uit die je voert langs leven en dood en die je onttrekt aan de drukte van het museum, dat als een film aan je voorbij gaat.

The Swiss artists Gerda Steiner & Jörg Lenzlinger are interested in artificial gardens, natural growth processes and all cross-overs between nature and culture. During the 2003 Venice Biennale in the Roman Catholic church of San Stae on the Grand Canal, thousands of leaves and plants fluttered on branches from the ceiling. Visitors were able to lie on a large bed from which they could behold this miracle above.

Under the auspices of the H&F Patronage, Museum Boijmans Van Beuningen has invited Gerda Steiner and Jörg Lenzlinger to create a new vegetative installation in the museum's four so-called 'four-leaf clover' galleries. The intimate windowfront showcases play host to a bone tree, a jungle, a seed room and a pink crystal forest growing from urea. Visitors may enter and experience each of the rooms, from which emanates a sense of wellbeing and peace that transcends life and death and that removes you from the museum's busy reality, which passes by like a film.

**museum van
boijmans beuningen**
www.boijmans.nl

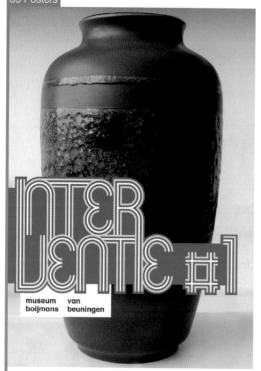

INTERVENTIE #1

Marieke van Diemen - Vazen / Vases
20 januari 2007 - 28 oktober 2007

Vanaf 1930 heeft de Duitse keramische industrie grote aantallen vazen geproduceerd, die in een oneindige hoeveelheid van vormen, kleuren en formaten bestaan. Voor de export werden ze gemerkt met West Germany. Marieke van Diemen boog zich over de vraag hoe dit eens zo populaire, typisch massa industriële product, dat met zulke prachtige tijdsbeelden te associëren is, opnieuw kan worden getoond en geïnterpreteerd.

Op verzoek van Museum Boijmans Van Beuningen ontwierp Van Diemen een installatie waarin een omvangrijke collectie West Germany vazen is te zien die als een groot autonoom kunstwerk wordt gepresenteerd. Hoe wordt een alledaags product een begerenswaardig object? De seriële productie van de vazen en de soms minieme verschillen in kleur en detaillering zijn aspecten die optimaal in Van Diemens installatie tot uitdrukking komen. Impliciet toont Marieke van Diemen aan dat de manier waarop je objecten toont, van doorslaggevende invloed is op de perceptie en waardering ervan.

Since 1930 the German ceramics industry has produced vast quantities of vases in an endless range of sizes, forms and colours. For the export market they were stamped 'West Germany'. Marieke van Diemen began to consider a new framework for displaying and interpreting these popular, typical mass-produced items, which have so many nostalgic associations.

Museum Boijmans Van Beuningen has invited Van Diemen to design an installation in which a vast collection of West Germany vases is presented as a large autonomous work of art. How can an everyday product become a desirable object? Marieke Van Diemen's installation gives optimal expression to the vases' serial production and the minimal differences in their colour and detailing. Implicit within this exhibition is Van Diemen's belief that the manner in which objects are displayed has a decisive influence on our perception and evaluation of them.

**museum van
boijmans beuningen**
www.boijmans.nl

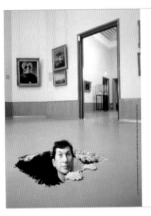

ALGEMEEN

Openingstijden
Dinsdag t/m zondag van 11.00 tot 17.00 uur
Gesloten op maandag, 1 januari, 30 april,
25 december.

Toegangsprijzen
€ 9 per persoon, gratis entree voor personen
van t/m 18 jaar, Vrienden van Museum
Boijmans Van Beuningen en Museumkaart-
houders. Elke woensdag is het museum voor
iedereen gratis toegankelijk. Alle prijzen zijn
exclusief de toeslag bij bijzondere tentoon-
stellingen. Prijswijzigingen voorbehouden.

Bereikbaarheid
Het museum ligt op 15 minuten loopafstand
van het Centraal Station. Het museum
adviseert bezoekers gebruik te maken
van het openbaarvervoer: tram 7 halte
Museumpark, of metro halte
Eendrachtsplein. De parkeermogelijkheden
zijn beperkt en alleen met stippe te
beloten. Het museum is toegankelijk voor
rolstoelgebruikers.

Multimediatour
De multimediatour leidt u langs vele hoogte-
punten van het museum. Deze mobiele
handtour/tre digitale gids is bij de informatie-
balie te huur in het Nederlands en Engels.

Rondleidingen en kinderworkshops
Elke zondag om 12.30 uur is er een gratis
rondleiding over een onderdeel van de

collectie. Reserveren is niet nodig.
Elke eerste en derde zondag van de maand
om 15.30 uur wordt er een workshop voor
kinderen van 6 tot 12 jaar georganiseerd.
Voor meer informatie en reserveringen zie
www.boijmans.nl of educatie@boijmans.nl.

Museumwinkel
De winkel beschikt over een ruime sortering
catalogi, boeken, designobjecten, ansicht-
kaarten en reproducties.

Bibliotheek
Met ruim 100.000 titels is de museum-
bibliotheek één van de grootste museale
kunsthistorische bibliotheken van ons land.
De boeken, catalogi en tijdschriften
beschrijven de breedte van de collectie,
van oude tot hedendaagse kunst en van
kunstnijverheid tot design. De bibliotheek is
gratis toegankelijk en geopend van dinsdag
tot en met zondag van 11.00 tot 16.30 uur.
Voor meer informatie:
bibliotheek@boijmans.nl.

Vrienden
Wordt vriend van onze zeer actieve
vriendenstichting voor € 40. Steun zo het
museum en ontvang gratis toegang,
voorrang bij lezingen, workshops en rond-
leidingen, 10% korting in de museumwinkel
en nog veel meer. Voor meer informatie:
telefoon +31(0)10-4419537.

Zaken en kunst gaan goed samen
Voor zakelijke bijeenkomsten stelt het muse-
um graag zijn zalen c.en u ter beschikking.

Samenwerken
Rotterdam en bezitten werken al meer
dan 160 jaar samen aan de toekomst
van Museum Boijmans Van Beuningen.
Wilt u weten wat u voor het museum kunt
betekenen? Neem dan contact op via
telefoon +31(0)10-4419539.

Ook kent Museum Boijmans Van Beuningen
talloze mogelijkheden voor relatiegeschen-
ken. Voor meer informatie, telefoon
+31(0)10-4419539 of horeca@boijmans.nl.

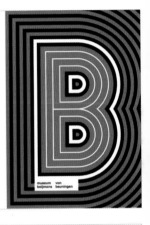

Museum Boijmans Van Beuningen
Museumpark 18-20
NL-3015 CX Rotterdam
telefoon +31(0)10-4419400
www.boijmans.nl

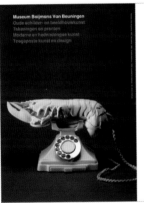

Museum Boijmans Van Beuningen
Oude schilder- en beeldhouwkunst
Tekeningen en prenten
Moderne en hedendaagse kunst
Toegepaste kunst en design

MUSEUM

Museum Boijmans Van Beuningen toont top-
stukken op het gebied van de beeldende
kunst, toegepaste kunst en design. Het biedt
bezoekers een overzicht van Nederlandse
en Europese kunst, van de vroege middel-
eeuwen tot in de 21ste eeuw. De bijzondere
collectie en de toonaangevende exposities
geven het museum internationale allure.

'Must do'
Museum Boijmans Van Beuningen verrast al
meer dan 160 jaar talloze kunstliefhebbers
met zijn collectie en buitenlengevorm tentoon-
stellingen. Een rondgang langs de topstuk-
ken van de verzamelingen, ofwel langs de
Europese kunstgeschiedenis, in dan ook een
'must do'. Met de veelzijnvolende collectie
en de bijzondere tentoonstellingen, het restau-
rant dat uitkijkt op de beeldentuin, en de
prachtige jaren dertig architectuur, staat
Museum Boijmans Van Beuningen garant
voor urenlang kunstgenoot.

De collectie Boijmans
De jurist F.J.O. Boijmans, rocmgever en
een van de vele mecenassen die bijdroeg
aan de vele mecenassen die bijdroeg
aan de nu kunstige museumcollectie, bracht
zijn verzameling op in de eerste helft van de
19de eeuw. Hij bezat schilderijen van de
14de tot de 19de eeuw van Hollandse,
Italiaanse en Franse meesters. Boijmans
legt tevens de basis voor de grote collectie
tekeningen en prenten die nu geroemd
wordt tot de beste van Nederland en een van
de mooiste verzamelingen ter wereld.

De verzameling Van Beuningen
Boijmans' rubbenschap vormt de basis voor
een actief eigen verzamelbeleid met als
kroon op het werk ander meer de verwerving
in 1958 van de collectie van de Rotterdamse
ondernemer Daniël George van Beuningen
(1877-1955). Belangrijke kunstwerken uit zijn
verzameling kwamen nu tot de topstukken
van het museum. De tovan van Babel van
Pieter Bruegel de Oude. De drie Maria's bij
het graf van de gebroeders Van Eyck, en
diverse werken van Peter Paul Rubens.
Tegelijkertijd groeit de collectie tekeningen
en prenten mede door Van Beuningen.
onder en mede door Van Beuningen
inspanningen uit tot een van de grootste en
belangrijkste ter wereld. Redenen te over om
ook zijn naam aan die van het museum toe
te voegen.

De modernen en design
Schilder Dalí, René Magritte en Wassily
Kandinsky zijn slechts enkele van de grote
namen die het museum herbergt. Joseph
Beuys, Walter de Maria, Bruce Nauman en
kunstenaars van de nieuwste generatie die
Matthew Barney, Olafur Eliasson en Andro
Wekua verlenen het museum internationaal
actualiteit.

De verzamelingen toegepaste kunst en
design verdienen bijzondere aandacht, ook
hierin vervult het museum een voortrekkers-
rol. Museum Boijmans Van Beuningen
presenteert permanent een overzicht van
kunstnijverheid dat start bij 14de-eeuwse

gebruiksgoed van de archeologische collec-
tie Van Beuningen-de Vriese en dat via het
17de-eeuwse glas en keramiek eindigt bij
de ontwerpen van Rietveld, Berlage, Frank
Lloyd Wright en de ateliers van Joep van
Lieshout. De tentoonstellingen en nieuwe
aankopen design en kunstnijverheid plaat-
sen het museum in nationaal en internatio-
naal perspectief.

Museumarchitectuur
Met het ontwerp van stadsarchitect Adrianus
van der Steur ontstond een prachtig monu-
mentaal museum dat speciaal rondom de
collectie is gebouwd. Zijn architectuur of

1935 is ingenieus en toegesneden op de
verschillende onderdelen van de collectie
van Museum Boijmans Van Beuningen.
In de loop van de jaren breidt het museum
meerdere malen uit. In 1972 wordt de
aanbouw van Alexander Bodon geopend,
daarna in 1991 het paviljoen van Hubert-Jan
Henket en tenslotte in 2003 de nieuwe
vleugel van Paul Robbrecht en Hilde Daem.
Maar nog steeds springt de kenmerkende
code toikeldak van het torquantachtige jaren
dertig gebouw meteen in het oog.

Kijk voor meer informatie op
www.boijmans.nl

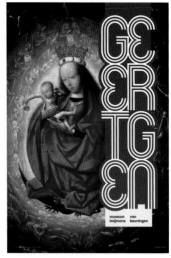

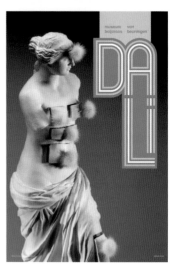

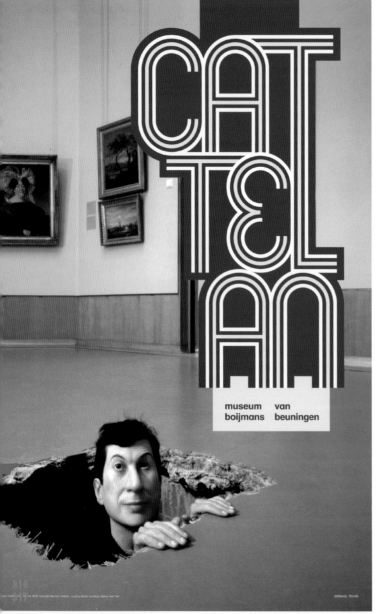

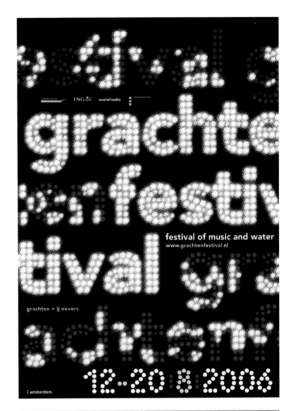

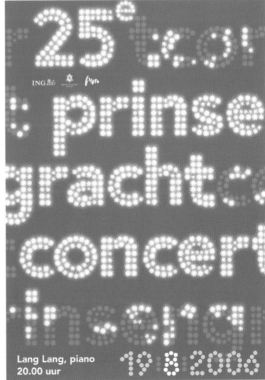

EEN BETER NEDERLAND BEGINT IN HOORN

EEN BETER NEDERLAND BEGINT IN HARDINGSV ELD-GIESEN DAM

City
Amsterdam

Studio
Thonik

Client
Dutch Socialist Party (SP)

10 Posters
(from a series)

11 Signboards

12 Car with balloons

13 Tomato Soup Label

14 Banners

15 Flag

16 Vest, Beer Mats, Bandana, Banana Car

17 Umbrella, Messenger Bag, Cap, Magnet / Sticker

18 Bags

19 Pens

20 Soup Bowl

21 Card Game

22 Sponges

10

11

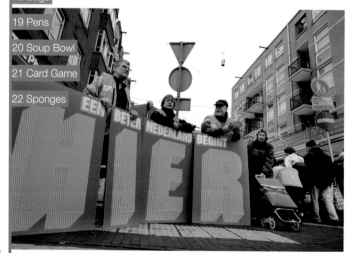

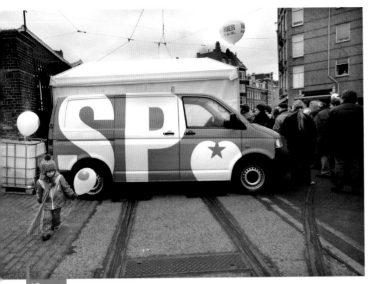

12

13

15

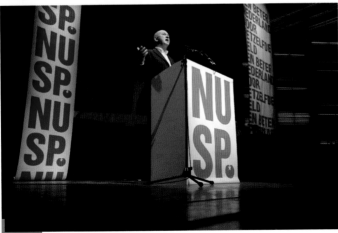

14

HIER BIER

SP. VILTJE

16

ROOD

17

18

19

20

21

22

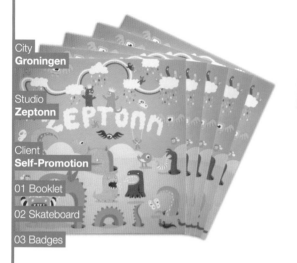

City
Groningen

Studio
Zeptonn

Client
Self-Promotion

01 Booklet

02 Skateboard

03 Badges

01

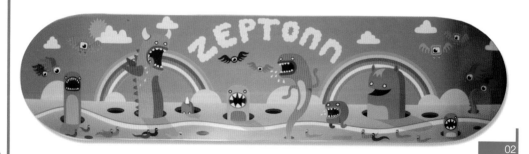

02

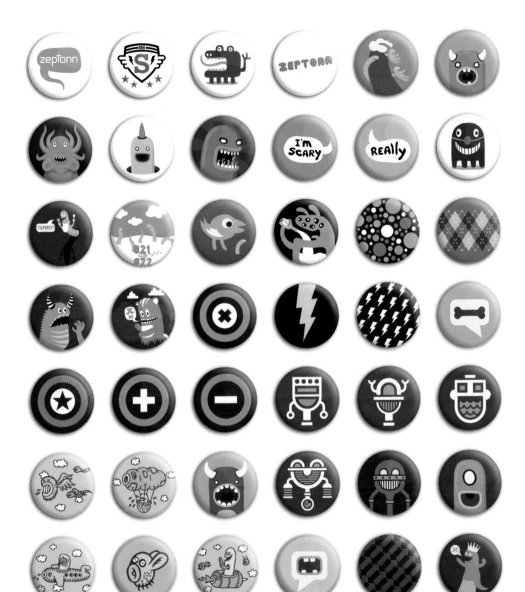

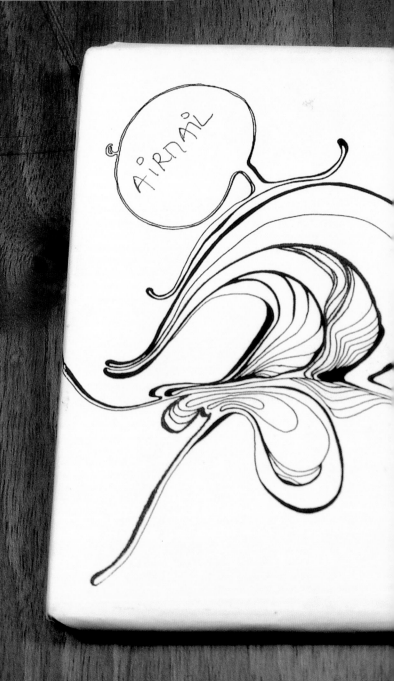

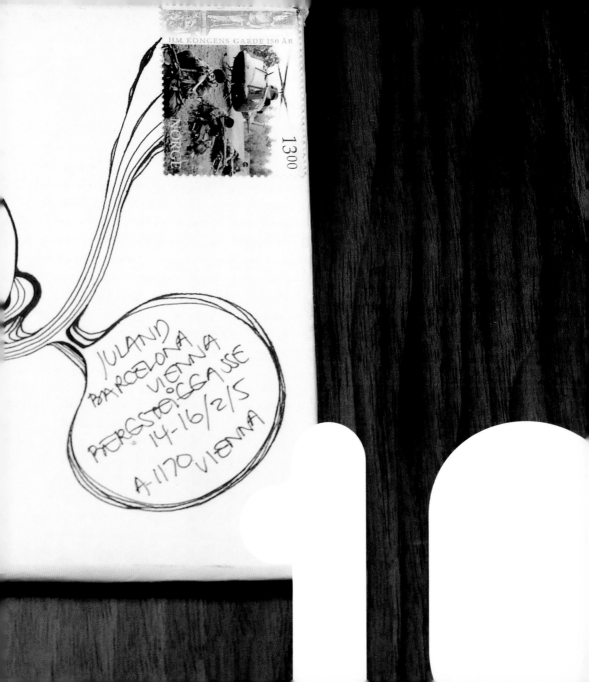

City
Oslo

Studio
Bleed

Client
Alu Spa

01 Artwork,
In-store Design,
Catalogue

02 Exhibition Design

03 Art Direction
for Promotional Images,
Store Design,
Advertisement

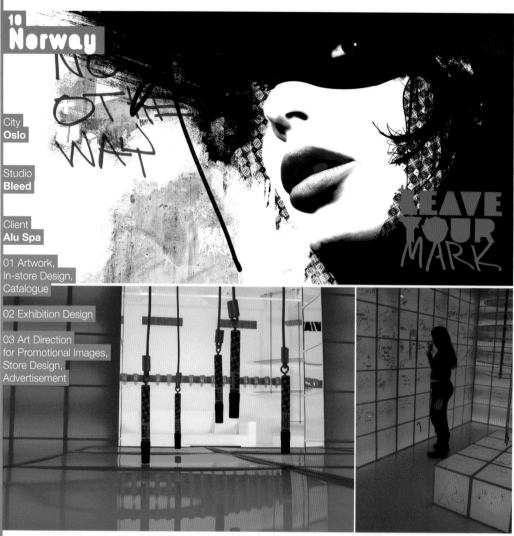

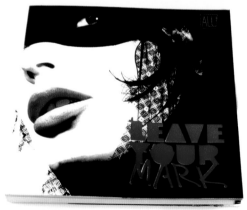

01

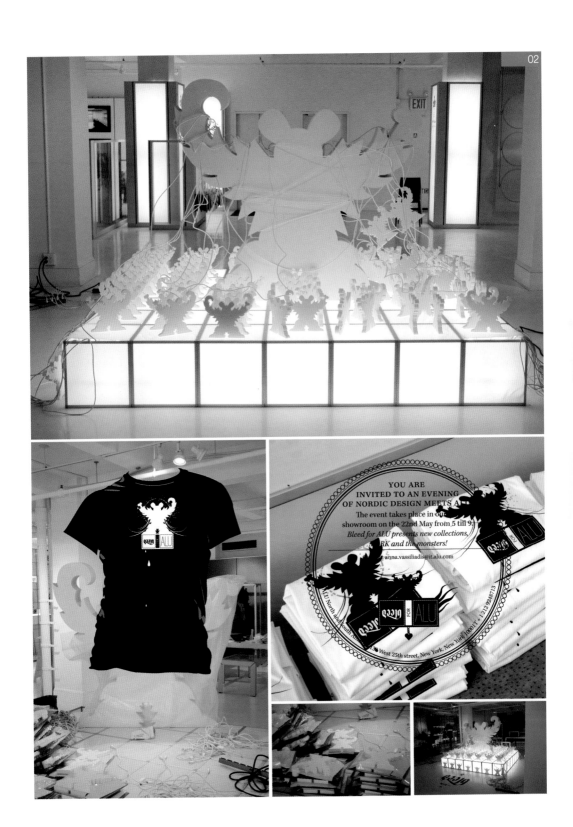

YOU ARE
INVITED TO AN EVENING
OF NORDIC DESIGN MEETS A
The event takes place in our
showroom on the 22nd May from 5 till 9.
Bleed for ALU presents new collections,
RK and the monsters!
anna.vassiliadis@it.alu.com

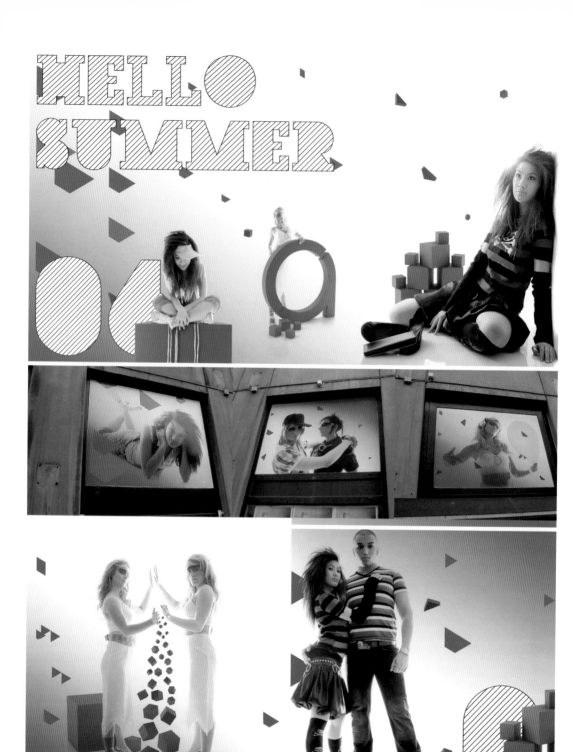

HELLO SUMMER

04

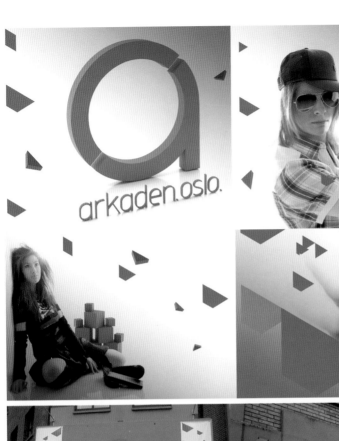
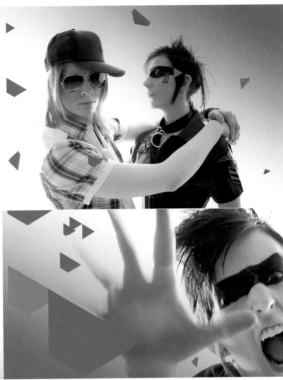

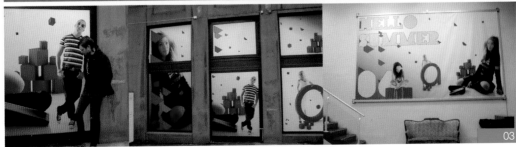

City
Oslo

Studio
Bleed

Client
Diesel

04+05 Posters

06 Invitation
front / back

07 Poster

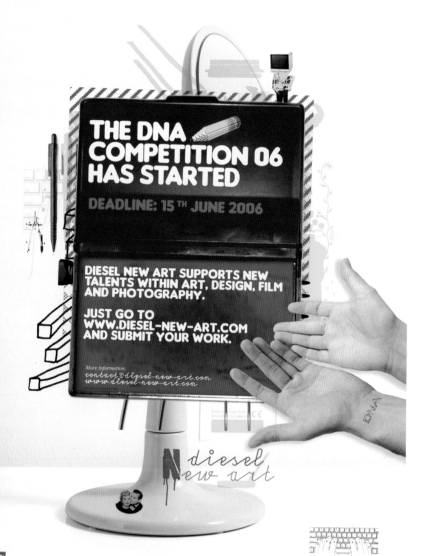

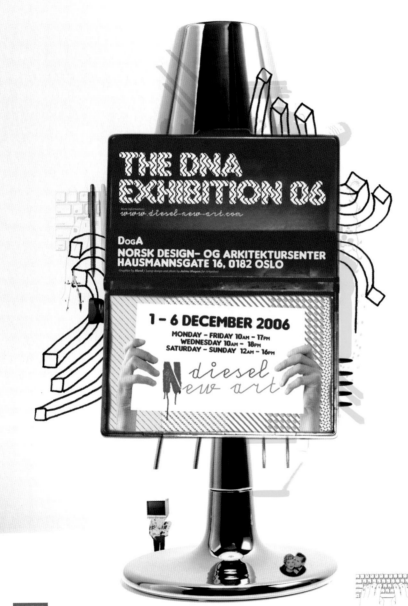

INNBYDELSE TIL
DIESEL NEW ART 2006
DEADLINE: 15 JUNI 2006

DIESEL

Innenfor tradisjonelle og mer ukonvensjonelle kunstarter trengs det flere muligheter for å komme seg frem. Det er vanskelig å få innpass i "utstillingsrommene" og det er heller ikke plass for mange.

Derfor ble Diesel New Arts (DNA) skapt, en plattform for innovativ kunst, design, film og fotografi. DNA er både en konkurranse og en unik mulighet for deg til å få stilt ut dine verk i et seriøst forum med internasjonal utsikt.

DNA startet for tre år siden og finnes nå i Norge, Danmark, Sverige, Slovenia og Østerrike. Nå får du igjen muligheten til å delta i vårt eksperiment. Har du allerede noe liggende klart, halvferdig eller bare en ide – Sett i gang! Vi er åpne for alt.

Kategorier:

- **Action:** Skulptur, installasjon, performance og konseptuelle verk
- **Draw:** Maleri, grafikk og illustrasjon
- **Digital:** Film og interaktive verk
- **Photo:** Kunstfoto, motefoto og styling

Du kan offentliggjøre dine verk og onverdenen følge med på din kreative prosess på DNA ´s web side. Her kan du på en enkel måte laste opp både bilder og tekst, i tillegg redigere materialet ditt, gjennom å logge deg inn på siden.

Alle innleverte verk vil bli tatt imot og bedømt av en uavhengig jury på fem personer.

I hver kategori vil vinneren motta en pris på 20.000 kroner og automatisk få delta på en turnerende utstilling i København, Oslo og Stockholm.

Hvem kan delta?

Alle kan delta i DNA med opptil tre verk, og du har muligheten til å delta i flere kategorier. For å vinne DNA Norway prisen, må du virke i Norge.

Hvordan gjør du det?

Gå inn på www.diesel-new-art.com, velg galleri og trykk på "submit work" og oppgi den informasjonen du blir bedt om. Deretter klikker du på "upload" og laster inn bilder på ditt verk. Har du en film som er for tung for å få lagt inn, kan den sendes i DVD format til følgende adresse:

DNA
Diesel Norge
Nydalsveien 30B
0484 Oslo

Juryen består av:

- **Jan Walaker,** redaktør i Hot Rod og kunstner
- **Marianne Zamecznik,** kurator
- **Tommy Olsson,** kunstkritiker og kunstner
- **Unni Askeland,** kunstner
- **Kalle Runeson,** kunstner og vinner av DNA 05

Vil du vite mer om DNA?

Besøk www.diesel-new-art.com

Mediapartner:

NATT&DAG

DEADLINE:
15 JUNI 2006
www.diesel-new-art.com

DIESEL

DIESEL NEW ART 2006
PRESS RELEASE

www.
diesel-new-art.
com

City
Oslo

Studio
Bleed

Client
Going Underground

08 Posters

Client
Surferosa

09 Posters

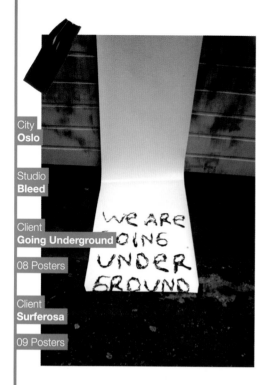

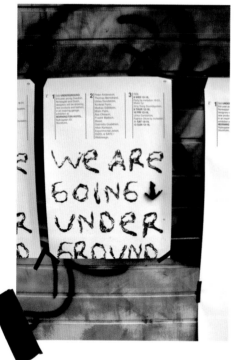

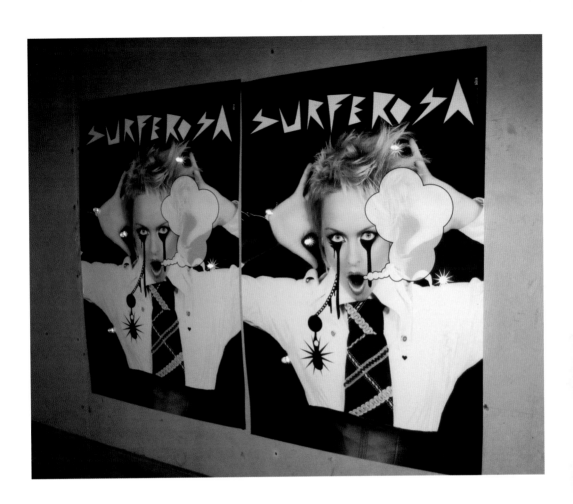

City
Oslo

Designer
Claudia C. Sandor

SiRi
HERMANSEN
BiPOLAR HORiZON

Client
**Bipolar Horizon,
Siri Hermansen**

01 Poster

Client
Crispin Gurholt

02 Invitation / Cards

Designer
**Claudia C. Sandor
& Halvor Bodin**

03 Art Catalogue

Client
Tromsø Kunstforening

04 Christmas Card

STENERSEN
MUSEET
MUNKEDAMSVEIEN 15
OSLO

13.JANUAR-
2b.MARS

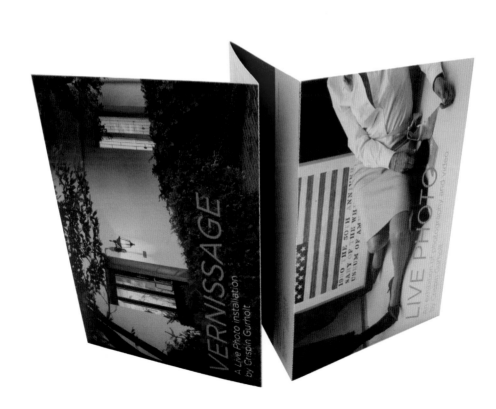

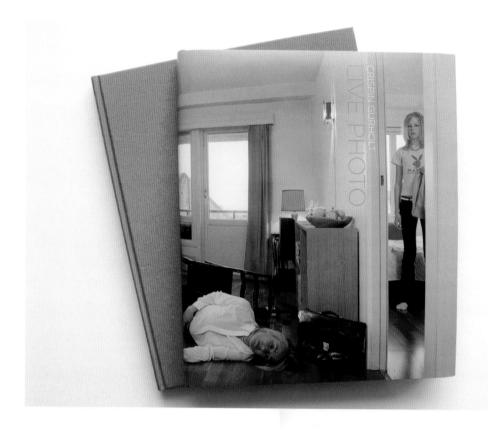

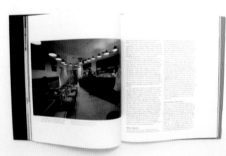

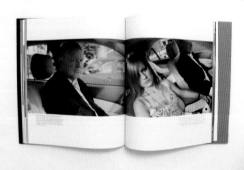

Tromsø
Kunstforening
ønsker dere
en god jul
og et godt
nytt år

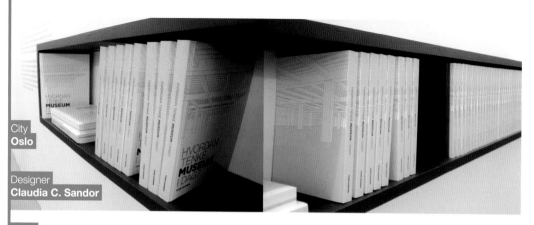

City
Oslo

Designer
Claudia C. Sandor

Client
Tone Hansen

05 Book Cover

06 Flyers

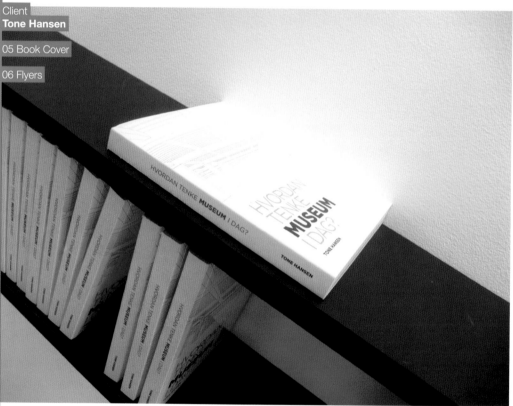

05

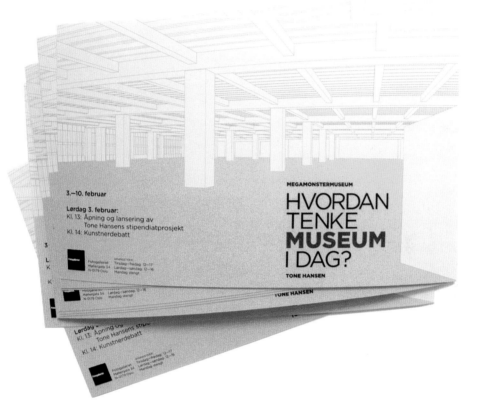

3.–10. februar

Lørdag 3. februar:
Kl. 13: Åpning og lansering av
Tone Hansens stipendiatprosjekt
Kl. 14: Kunstnerdebatt

MEGAMONSTERMUSEUM

HVORDAN
TENKE
MUSEUM
I DAG?

TONE HANSEN

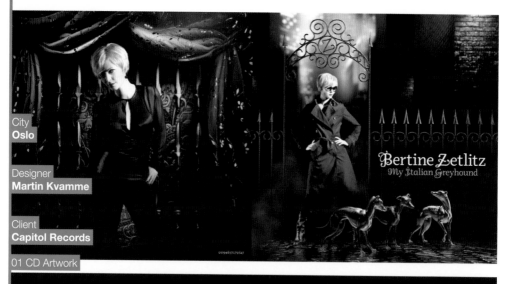

City
Oslo

Designer
Martin Kvamme

Client
Capitol Records

01 CD Artwork

Client
Midnight Monkeys Records

02 CD Artwork

Client
Hecca Records

03 CD Artwork

Client
Ipecac Recordings

04 CD Artwork

Client
Hermerix Records

05 CD Artwork

Client
Metal Blade Records

06 CD Artwork

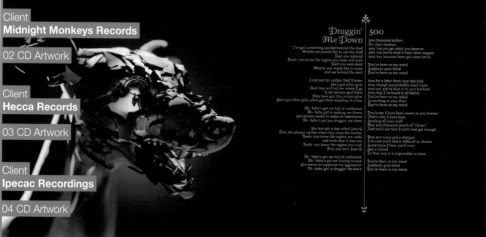

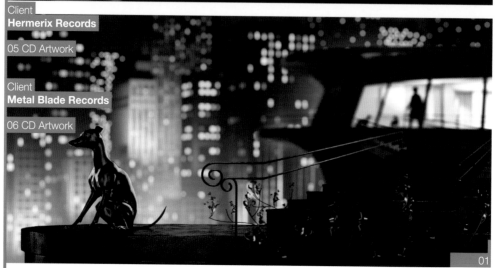

01

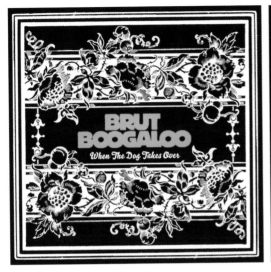

Brut Boogaloo
Henning Solvang: Vocals and guitar
Peter Olofsson: Lead guitar
Børge Sageng Henriksen: Drums and percussion
Peter Boström: Bass and backing vocals

Additional musicians
Cato Thomassen: Organs and piano
Backing vocals on Room of Mirrors by Siri Eriksen

Recorded at Grand Sport Studios by Christian Engfelt
and Parkometer studios by Cato Thomassen
Mixed at Grandsport studios by Christian Engfelt and Cato Thomassen
Mastred by Morten Lund at Masterhuset
Design by Martin Kvamme
Photography by Observatoriet
Make up by Liv Grete Jacobsen and Anette Idsøe

Thank you
Ragnar, Torgeir and Manus at Goldstar, Rolf Yngve at Tuba Records,
Julie and Cathrine at Bpop, Martin Kvamme, Jan Alsaker, Lisbeth and
Happy, Marius and Otto, Patrik and Rocco, Kristin and Bosse, Knut Ole
Mathisen, Johan Forsberg, Geraldo Rojas Flores, Fabian Fabs, Ole Jacob
Erdal, Sorry Dude Teaserman, Arne Skagen, Ole Petter Andreassen,
Øystein Greni, Hugo Alvarstein, L.P. Lorentzen, Alf Gustavsen,
Petter Flaten Eilertsen, Trine and Pastor Svartdahl

www.brutboogaloo.com

THIS IS NOT SWEDEN

BÖSCHAMAZ

01 BOATMAN 7:04
02 WARTHOGS 4:34
03 CLINT IN HAWAII 6:47
04 INSOLE POX 2:25
05 TIERRA DEL FUEGO 7:51
06 KNOW NUN 4:23
07 SIFAKA 5:37
08 WONK NUN 4:53
09 LARCHES 1:55

THIS IS NOT SWEDEN BÖSCHAMAZ

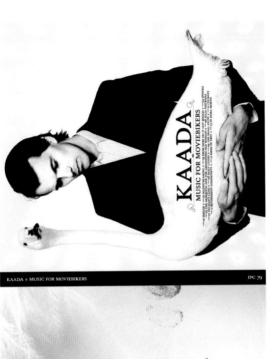

THE OCEAN
Aeolian
www.TheOceanCollective.com

The City In The Sea

Lo! Death has reared himself a throne • In a strange city lying alone • Lo! a strange town, lying alone • Death has reared himself a throne • Far below in the west • Where the good, bad, worst and the best have gone to their eternal rest • There, shrines and towers • Death has reared has self a throne • Time extra towers that tremble not • resemble nothing, nothing that is ours • Down, down in that town, shall settle lower • Hell, rising from its throne, no earthly means, • Shall be it reverence • No care from heaven coming down • On the long night-time of that town • But light from out the lurid sea • Streams up the turrets silently • Gleams up the pinnacles far and free • Up domes up spires up kingly halls • Up fanes up Babylon-like walls — • No swellings tell that winds may be • Upon some far off happier seas • No heavings hint that winds have been • On seas less hideously serene • But lo, a stir is in the air! • The wave there is a movement there! • As if the towers had thrust aside, • In slightly sinking, the dull tide • Resistlessly beneath the sky • The melancholy waters lie • The waves have now a redder glow • The hours are breathing faint and low • And when, amid no earthly moans, • Down, down in that town shall settle lower, • Hell, rising from a thousand thrones, • Shall be it reverence • Down, down in that town, shall settle lower • Hell, rising from the throne, no earthly means, • Shall be it reverence • There open times and gaping graves • Yawn level with the luminous waters • But not the riches there that lie • In each dull's diamonds eye • Not the gaily-jeweled dead • Tempt the waters from their bed • So blend the turrets, shadows there • That all seems pendulous in air • While from a tower in the town • Death looks below • The hours are breathing faint and low • And when, amid no earthly moans, • Down, down in that town shall settle lower • Hell, rising from a thousand thrones, • Shall be it reverence • Far below within the tide West • Where the good and the bad sink • The worst and the best • Home gone to their eternal rest • Waves have now • A red glow • Hours breathe low • No men moan

Dead Serious & Highly Professional

You cannot make me feel guilty • I don't give a shit about respect • I won't ruin your moral master nation • I'm the prodigal son gone off the tracks • You cannot make me feel sorry • I don't give a shit about your pride • I'm the rat gone on your carpet • The last crushing thought before you die • Don't fit in your picture • Don't fit in your worth • Don't match all the lies you feed your kids • Feel no loyalty • This bed was made without me • Sure I never signed it • Your contracts don't apply to me • I'll fuck your bag • Do you still wanna get along with me? • I's rape your daughter • On payment of a small fee • I'll fuck your bag • Do you still wanna get along with me? • I's rape your daughter • How much would you pay?

Austerity

Pouring whiskey in broth-out babies • Cursely brow by brow and bone • Deep inside their mouthless slumb • Thick as roast, green bittersweet • Helpless, their eyes are blind • And all their thoughts are simple • There ears are deaf • And all their songs are trivial • There love gone sour • And all their looks are vacant • Their look is loud • The art they make lurks the challenge • All their minds are empty • All their thoughts are simple • All their songs and books are trivial • All their looks are vacant • Works who once flew with passion • Now they're easily caught with bare hands • Locked in cages, learning their lessons • Bullets for the already-dead • Tasteless, our tongues are brush • And all our speeches are hollow • Our minds are numb • And all our looks are shallow • Our limes are sour • And all our looks are vacant • Once love is loud • The art we make lurks the challenge • All our minds are empty • All our thoughts are simple • All our songs and books are trivial • All our looks are vacant • Works who once flew with passion • Can easily be caught with bare hands • Locked in cages, learning their lessons • Bullets for the already-dead • Can you still see • The stars • Thru layers of grey • They're fading away... • Can you still see the stars? • It's hard to think of the

Killing The Flint

The Origin Of The Cabbe

Fluctuations Tom

Une Saison En Enfer

One With The Ocean

Prhinice

Queen Of The Fools Ships

City
Oslo

Designer
Martin Kvamme

Client
Tik Tak

07 Poster

(opposite)

Studio
Superlow

Client
Bjarne Melgaard / Haugar Art Museum

01 Poster

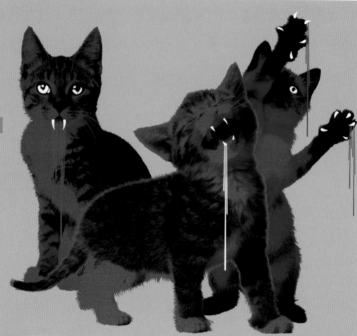

TIKTAK FESTIVAL
BRUKBAR/SUPA · TRONDHEIM · FEBRUARY 8/9/10 · 2007
OPEN 12:00-03:30 · DJS FROM 22:00 · BANDS FROM 01:30
RALPH MYERZ
& THE JACK HERREN BAND
DATAROCK
SKATEBÅRD
MENTAL OVERDRIVE
UNGDOMSKULEN
DJs ALL NIGHT: OLLE ABSTRACT · RALPH MYERZ
EVEN GRANÅS · TARJEI STRØM · URV

150 NOK PR DAY · 300 NOK FESTIVAL PASS THURSDAY-SATURDAY
LIMITED PRESALE AT BRUKBAR OR EMAIL: TRONDHEIM@TIKTAK.NO

SMS CODE <TIKTAK> TO 2010 TO WIN TICKETS (10 NOK)

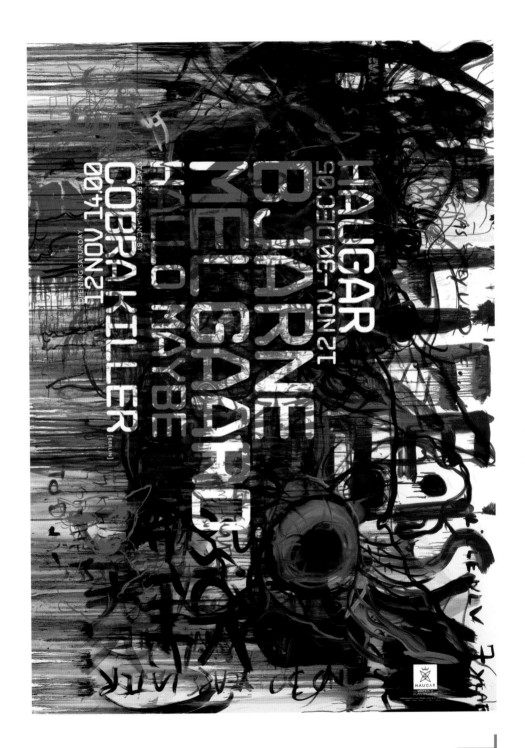

HAUGAR
15 NOV-30 DEC 05

BJARNE
MELGARD
HELLO MAYBE

STAGE PERFORMANCE BY
COBRA KILLER
[BERLIN]

OPENING SATURDAY
12 NOV 14.00

City
Oslo

Studio
Superlow

Client
Les Super

02 Advertisement

03 Poster

Client
**Bjarne Melgaard /
Galerie Krinzinger**

04 Poster

Client
**Oslo International
Film Festival**

05 Poster

Client
**The Norwegian
National Ballet**

06 Posters

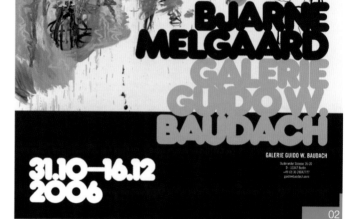

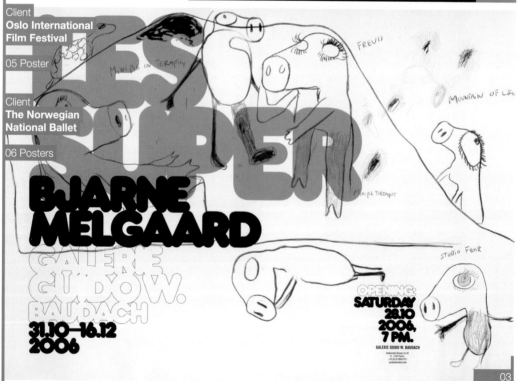

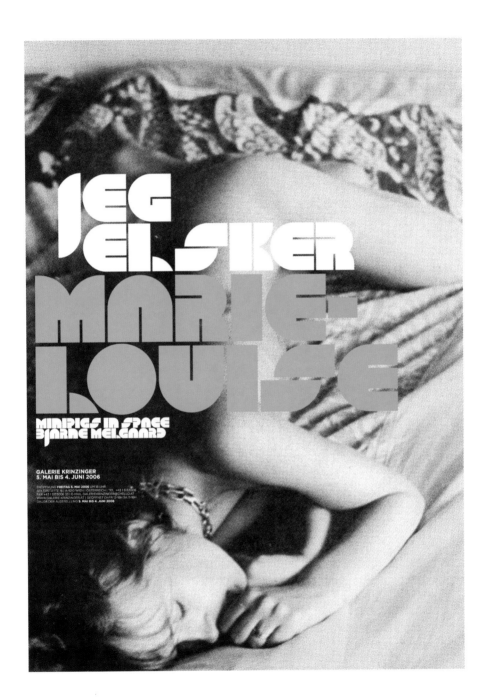

JEG
VEI SKER
MARIE-
LOUISE

MINIPIGS IN SPACE
BJARNE MELGAARD

GALERIE KRINZINGER
5. MAI BIS 4. JUNI 2006
ERÖFFNUNG FREITAG 5. MAI 2006 UM 18 UHR
SEILERSTÄTTE 16 | A-1010 WIEN | ÖSTERREICH | TEL. +43 1 5133006
FAX +43 1 5133006 33 | E-MAIL GALERIEKRINZINGER@CHELLO.AT
WWW.GALERIE-KRINZINGER.AT | GEÖFFNET DI-FR 12-18H SA 11-16H
DAUER DER AUSSTELLUNG 5. MAI BIS 4. JUNI 2006

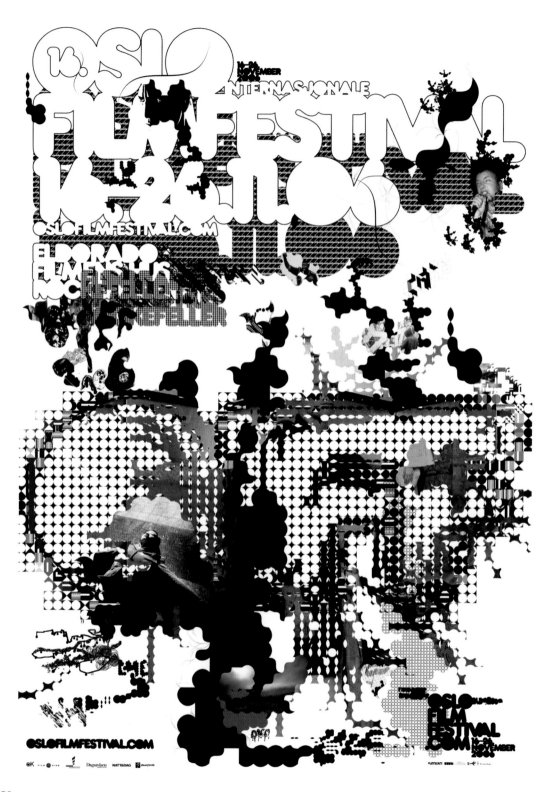

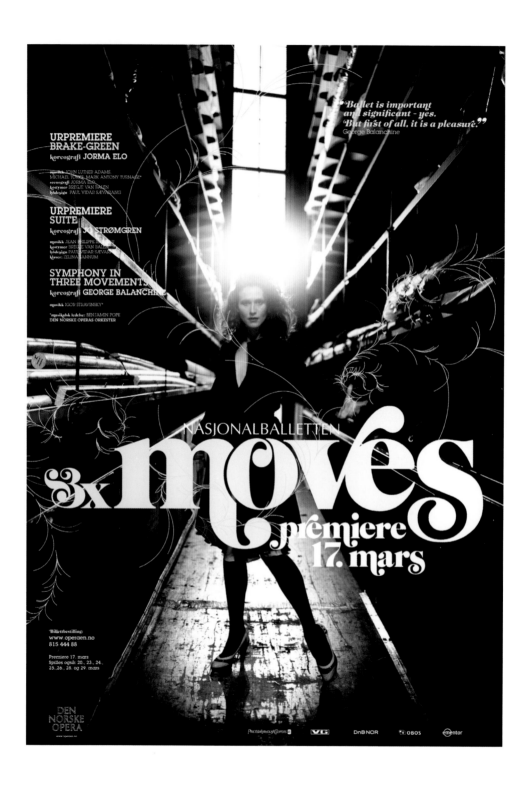

"Ballet is important
and significant - yes.
But first of all, it is a pleasure."
George Balanchine

URPREMIERE
BRAKE-GREEN
koreografi JORMA ELO

musikk JOHN LUTHER ADAMS,
MICHAEL TORKE, MARK ANTONY TURNAGE*
scenografi JORMA ELO
kostymer BREGJE VAN BALEN
lyddesign PAUL VIDAR SÆVARANG

URPREMIERE
SUITE
koreografi JO STRØMGREN

musikk JEAN PHILIPPE RAMEAU
kostymer BREGJE VAN BALEN
lyddesign PAUL VIDAR SÆVARANG
klaver: SELINA MANNUM

SYMPHONY IN
THREE MOVEMENTS
koreografi GEORGE BALANCHINE

musikk IGOR STRAVINSKY

*musikalsk ledelse: BENJAMIN POPE
DEN NORSKE OPERAS ORKESTER

NASJONALBALLETTEN
3x moves
premiere
17. mars

Billettbestilling:
www.operaen.no
815 444 88

Premiere 17. mars
Spilles også: 20., 23., 24.,
25.,26., 28. og 29. mars

DEN
NORSKE
OPERA
www.operaen.no

PricewaterhouseCoopers VG DnB NOR OBOS ementor

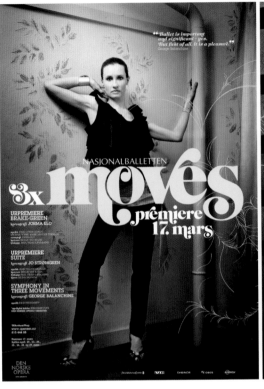
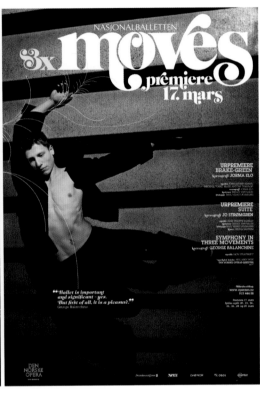

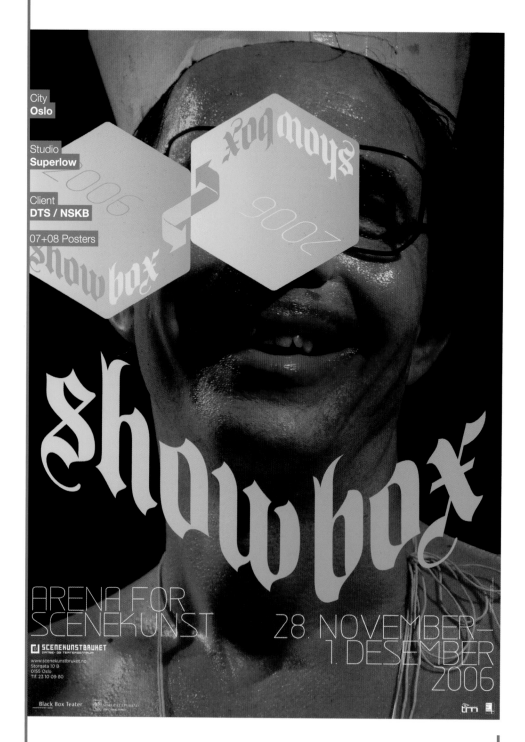

07

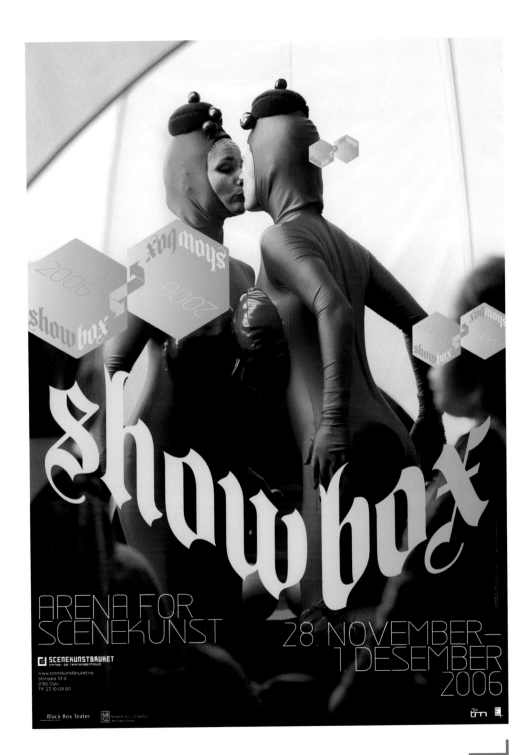

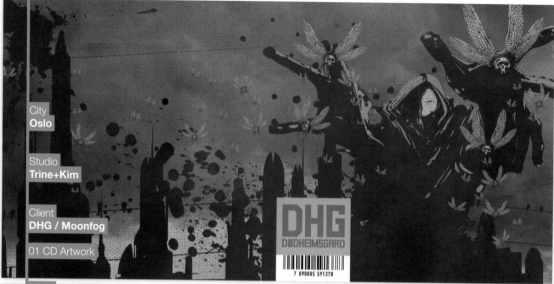

City
Oslo

Studio
Trine+Kim

Client
DHG / Moonfog

01 CD Artwork

Client
Espen Jørgensen

02 Poster

Client
Molitrix

03 Brochure

Client
Gallhammer / Peaceville

04 CD Artwork

01

Performing the soundtrack to your minds eye

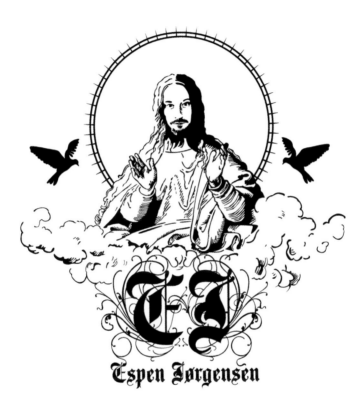

Espen Jørgensen

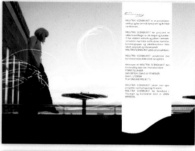

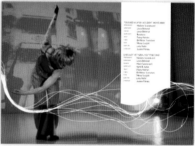

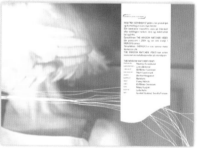

PORTUGAL
38°46' North 09°11' West

MusaWorkLab
R. da Rosa Nº14 E6
1200-381 Lisboa
Portugal

www.musacollective.com

FRANQUIA **€1,25**

PRIORITY

CHIADO (LISBOA)

1200 LISBOA

0506693 05-960284 2007-07-06

Por avião
Air mail

Prioritário
Priority

EXPRES

CORREIO AZUL INTERNACIONAL

JULAND BarcelonaVienna
Bergsteiggasse 14-16/2/5
1170 Vienna
Austria

City
Lisbon

Studio
—nada—

Client
Bombay Sapphire

01 Logo

02 Stationary, Badges

03 Postcards

Client
Angelic

04 Poster

Client
Instituto das Artes

05 Poster

OPEN
DAYS
BOMBAY SAPPHIRE
2006
27+28 DE OUTUBRO

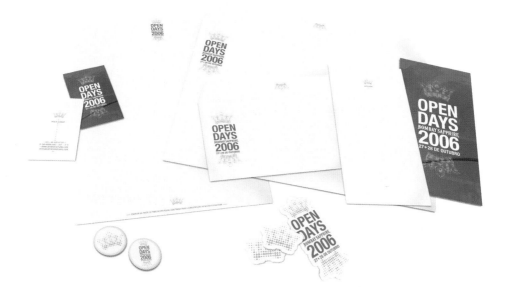

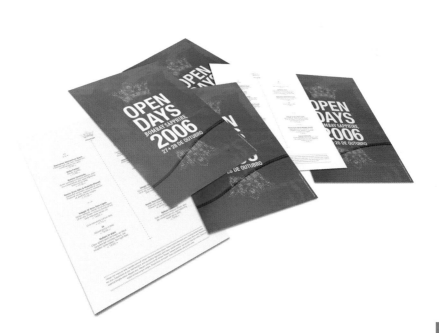

"À MESMA HORA, NO MESMO SÍTIO, PARA VARIAR..."

SPEAKER'S CORNER

Exposição
Dezembro 2006

Galeria do Ministério das Finanças
Terreiro do Paço

Artistas participantes
Ana Judite Cardoso, Fernando Delgado, Nuno Geada, Rui Martins,
Bernardo Mendes, Helena Oliveira, Elsa Pinto, Nuno Quaresma,
Miguel Ribolhos, Hélder Rodrigues, Luis Perpétua Rosa, Ana Catarina Sério

Comissariado
Nuno Sacramento

 Ministério da Cultura

 Instituto das Artes

 INSTITUTO DO EMPREGO E FORMAÇÃO PROFISSIONAL

—www.designedbynada.com—

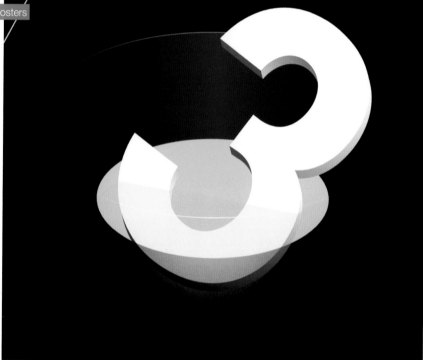

PARTY / TIME
SAN FERNANDO DE HENARES
30 JUL / 11H

City
Lisbon

Studio
—nada—

Client
IKEA

06 Invitation

07 Booklet+Badges

Client
FABRICA

08+09 Posters

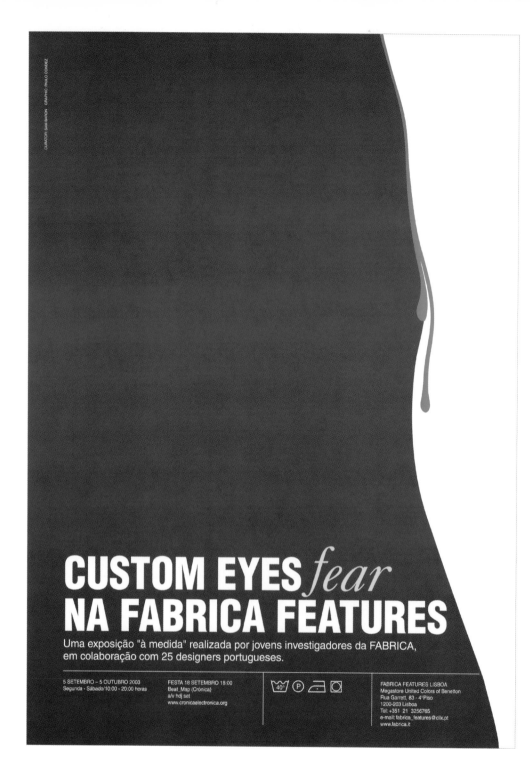

CUSTOM EYES *fear*
NA FABRICA FEATURES

Uma exposição "à medida" realizada por jovens investigadores da FABRICA,
em colaboração com 25 designers portugueses.

5 SETEMBRO – 5 OUTUBRO 2003
Segunda - Sábado/10:00 - 20:00 horas

FESTA 18 SETEMBRO 18:00
Beat_Map (Crónica)
a/v hdj set
www.cronicaelectronica.org

FABRICA FEATURES LISBOA
Megastore United Colors of Benetton
Rua Garrett, 83 - 4°Piso
1200-203 Lisboa
Tel: +351 21 3256765
e-mail: fabrica_features@clix.pt
www.fabrica.it

City
Lisbon

Studio
—nada—

Client
Pratastudio

10 Christmas Card /
Postcards

12 Flyers

Client
TBWA

11 Postcards

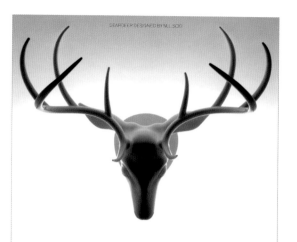

DEARDEER DESIGNED BY M.LL.SCIO

MERRY CHRISTMAS & HAPPY 2007

PRATASTŪDIO™

CLICK HERE TO GET YOUR XMAS VOUCHER FOR 50% DISCOUNT ON YOUR RECSTAND
5 600305 040029

10

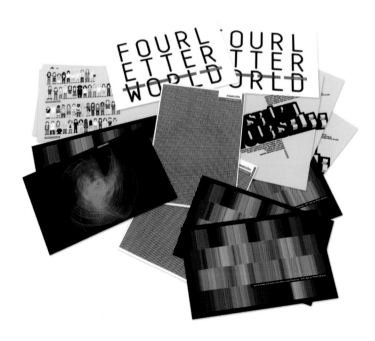

11

switch.

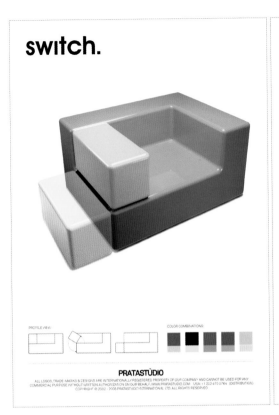

PROFILE VIEW: COLOR COMBINATIONS:

switch.

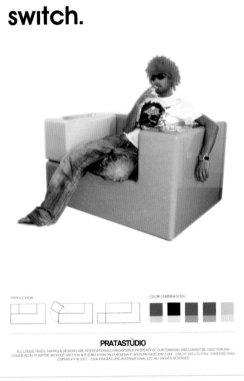

PROFILE VIEW: COLOR COMBINATIONS:

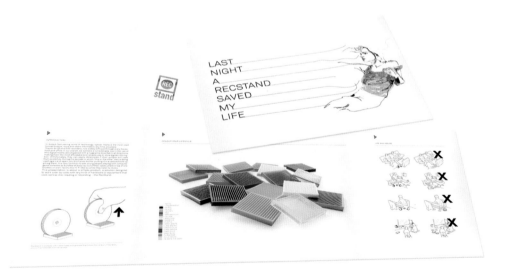

City
Lisbon

Studio
Musa Collective

Client
BA

01 Postcards

02 Flyers, Badges

Client
**Bombay Sapphire
(GBMP)**

03 Promotional Magazine

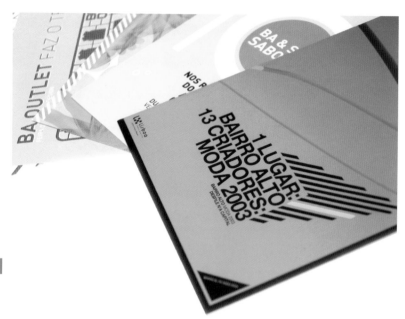

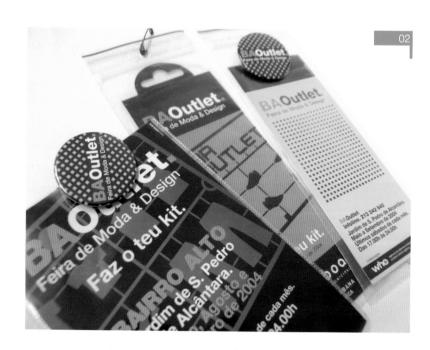

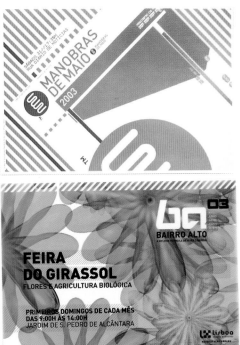

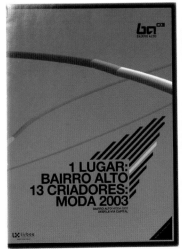

1 LUGAR:
BAIRRO ALTO
13 CRIADORES:
MODA 2003

BAIRRO ALTO MODA 2003
DESFILE N'A CAPITAL

lisboa

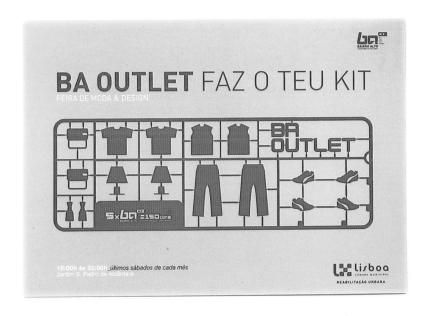

FEIRA
DO GIRASSOL
FLORES E AGRICULTURA BIOLÓGICA

PRIMEIROS DOMINGOS DE CADA MÊS
DAS 9:00H ÀS 14:00H
JARDIM DE S. PEDRO DE ALCÂNTARA

lisboa
REABILITAÇÃO URBANA

BA OUTLET FAZ O TEU KIT
FEIRA DE MODA & DESIGN

15:00h às 22:00h últimos sábados de cada mês
Jardim S. Pedro de Alcântara

lisboa
CÂMARA MUNICIPAL
REABILITAÇÃO URBANA

03

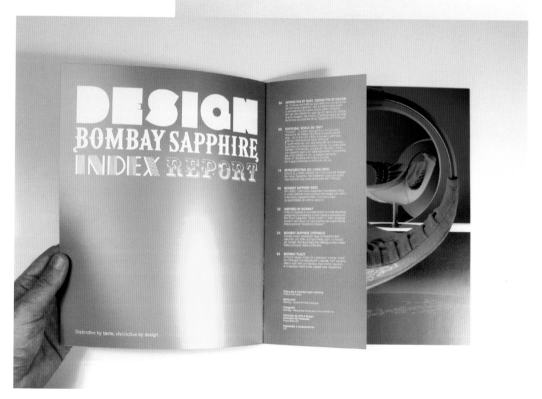

O TIPICAMENTE BRITÂNICO "CHÁ DAS CINCO" E A ILUSÃO
DA BEBIDA QUE PÁRA NO AR FORAM ESTES OS CONCEITOS
QUE INSPIRARAM A CONCEPÇÃO DOS COPOS QUE GANHARAM
RESPECTIVAMENTE O SEGUNDO E O TERCEIRO PRÉMIOS
ATRIBUÍDOS NO CONCURSO NACIONAL DESTE ANO.

2

3

OS OUTROS
PREMIAD OS

CONCURSO
NACIONAL
2007

MUSA
BOMBAY

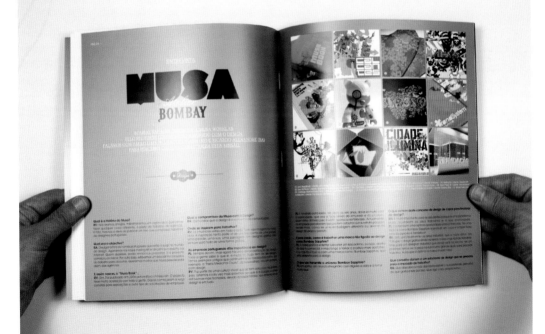

City
Lisbon

Studio
Musa Collective

Client
**Fashion Clinic /
Dreamgate**

04 Catalogue,
CD Artwork

05 Soap

06 Flyer+Catalogue
(Extracts)

Client
Calcantes

07 Bag, Flyer,
Packaging

Client
**GreyGoose Vodka
(GBMP)**

08 Packaging

Client
Self-Promotion

09 Mug, Card

10 Card

Client
Krvkurva / La.ga

11 Bag

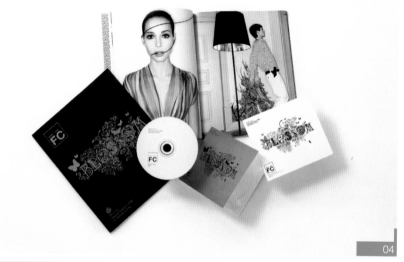

04

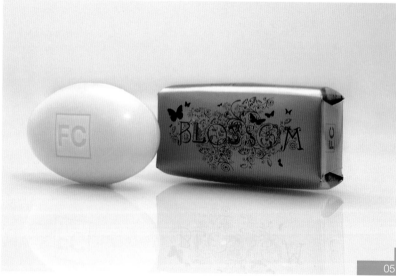

05

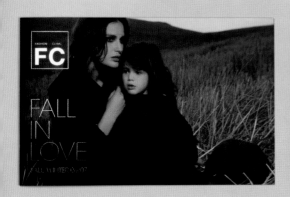

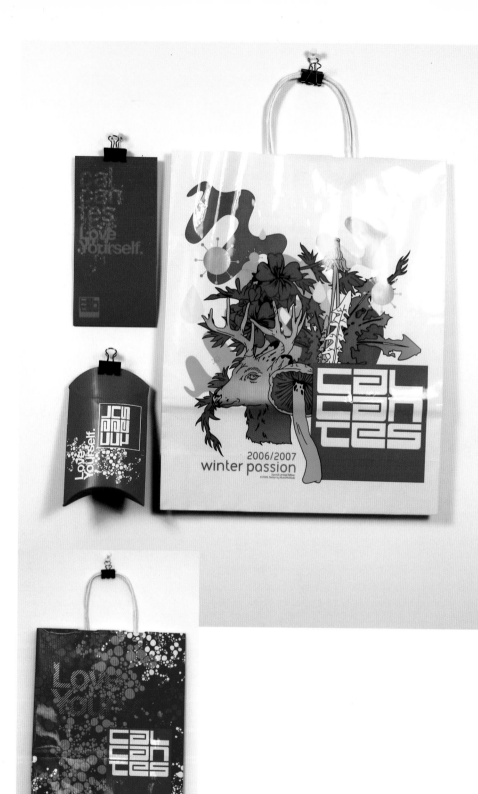

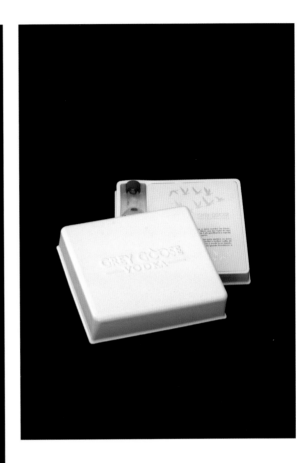

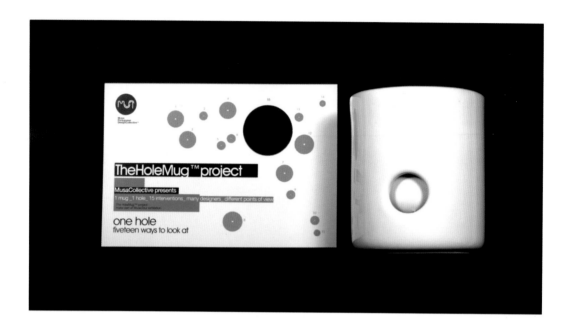

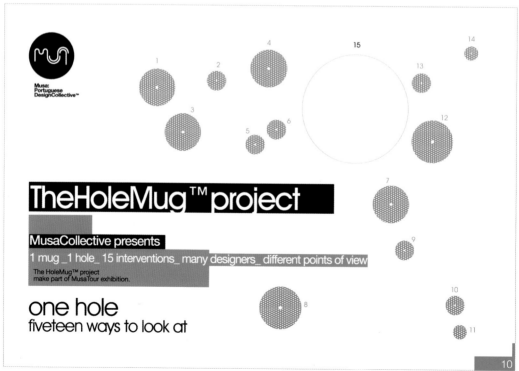

City
Lisbon

Studio
Musa Collective

Client
Self-Promotion

12 Poster

Client
**iDN, Hong Kong /
MusaCollective**

13 Book

Client
Self-Promotion

14 Poster

Client
Laundry

15 T-Shirts

16 Postcards

LANÇAMENTO OFICIAL

MUSABOOK
28 Abril 18h/20h

Edifício Benetton Piso 4
FabricaFeatures
Chiado, Lisboa

Dois anos após o lançamento do
projecto será apresentado
oficialmente o livro MusaBook,
editado pela MusaCollective e
publicado pela idN Hong Kong.

Subordinado à temática Taste,
MusaCollective apresenta o conceito
EAT GRAPHICS convidando os
presentes a algumas surpresas
associadas ao MusaBook.

A cor predominante será o verde.
Verde de esperança.
Esperança, a palavra de ordem
deste livro, que se apresenta assim
como o primeiro livro compilação
de artistas, designers e ilustradores
portugueses.

MUSABOOK
300 PAGES
80 DESIGNERS
1 COUNTRY
FROM PORTUGAL TO EVERYWHERE

Publicado por IDN de Hong-Kong
Edição de MusaCollective
Abril 2006
300 páginas
17.6 x 20.8 cm
Português e Inglês
ISBN-13:978-988-98097-0-6
ISBN-10:988-98097-0-2
Distribuição internacional

IdN

FABRICAFEATURES CIRCUIT EPSON

www.musacollective.com

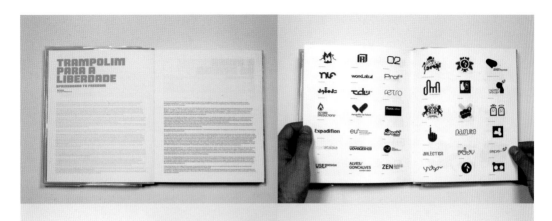

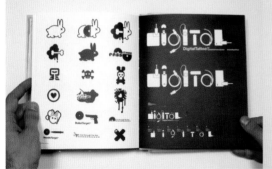

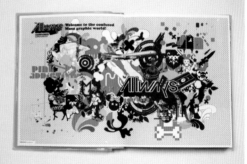

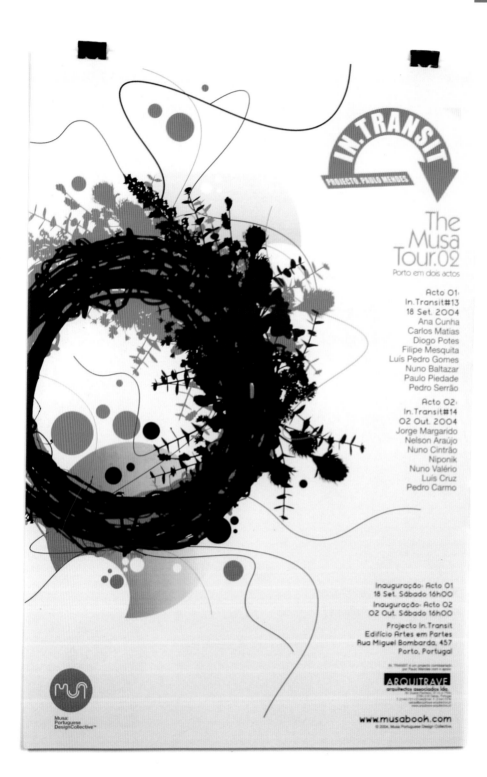

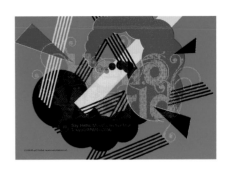

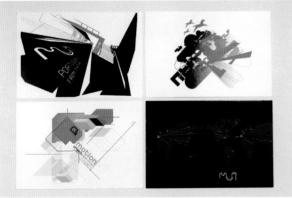

15 16

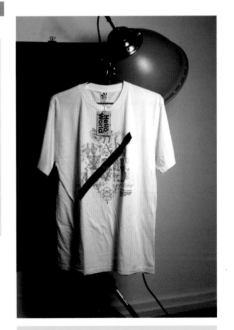

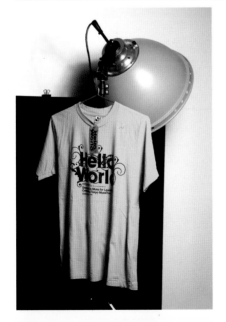

City
Lisbon

Studio
Musa Collective

Client
Self-Promotion

17 Postcards

18 Press Pack

Client
Self-Promotion

19 Promotional Pack:
Happy Qee, T-Shirt,
Lolly,
Badges, one surprise

20 Badges, Lolly

21 T-Shirts

Client
Toy2R

22 Happy Qee Toy

Convite.Exposição MusaLovers

MusaTour 2006 Lisboa

11 Março a 30 Abril

Inauguração: 11 de Março, Sábado 17h00
Fabrica Features / Edifício Benetton / Chiado, Lisboa

Lançamento MusaBook: Abril 2006
Fabrica Features / Edifício Benetton / Chiado, Lisboa
Integrado na programação do Circuit
(data e hora do evento a confirmar no site musacollective e/ou programação do Circuit)

15 Artworks
Projecto HoleMug
Lançamento oficial LaGa Luxury
Apresentação de poufs Musa&Poufmamma
Merchandising MusaCollective
Mostra de vídeo

⊶O CIRCUIT

FABRICAFEATURES

Convite.Invitation www.musabook.com

The Musa Tour 01

Exposição Collective:
03 a 30 Jun 2004

Inauguração: 03 Junho, Quinta-feira 19h00
Fabrica Features / Edifício Benetton / Chiado / Lisboa

Musa StillFrames Video night: 03 Junho, Quinta-feira 22h30
Bar Siluetas / Elevador da Bica

Ana Cunha
Carlos Mafra
Diogo Potes
Mike Mosquito
Jorge Margarido
Luís Pedro Gomes
Nelson Araújo
Nuno Baltazar
Nuno Cândido
Paulo Pacheco
Pedro Carina
Pedro Serrão
Ricardo
Rónin Valério
Zoli Cruz

FABRICAFEATU

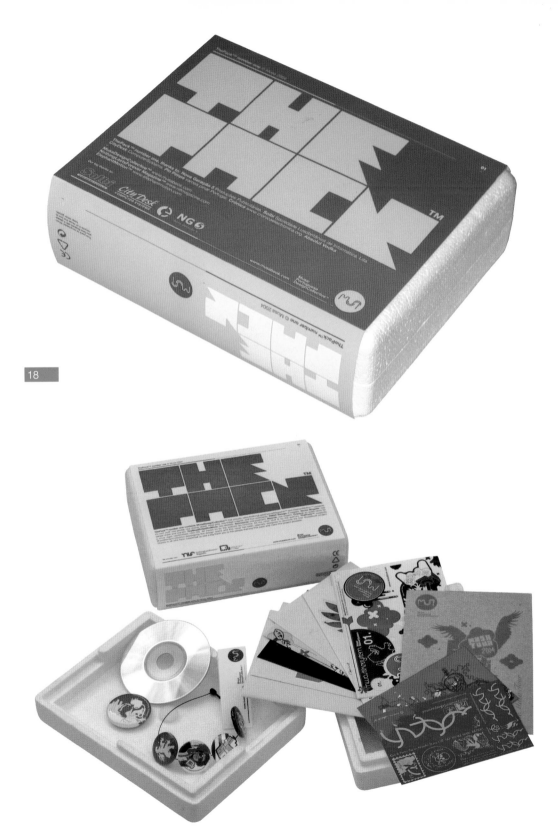

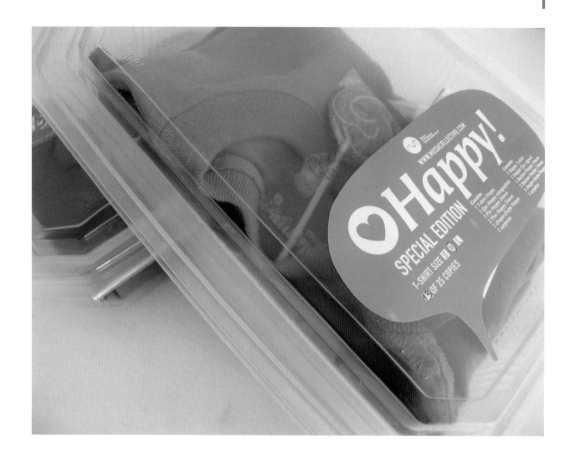

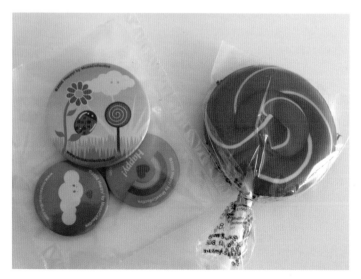

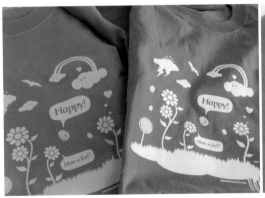

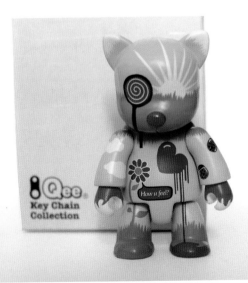

City
Porto

Designer
Nuno Martins

Client
Porto Digital

01 Brochure
front / back / open

Designer
**Nuno Martins
& Pedro Teixeira**

.portodigital.pt

Client
Oceanário de Lisboa

02 Poster, Stickers

Client
Porto Digital

03 Poster

04 Flyer

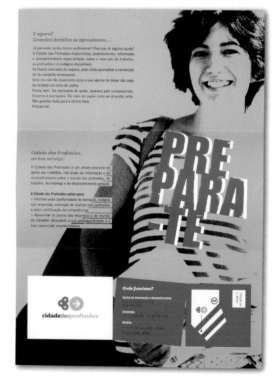

A Mascote do OCEANÁRIO DE LISBOA precisa de um nome

Envia-nos a sugestão da tua turma!

www.oceanario.pt

Oceanário de Lisboa
Sempre diferente.

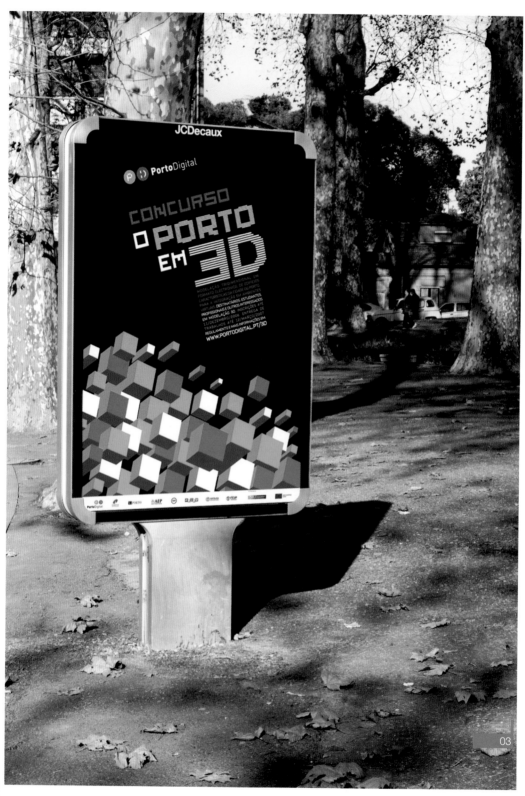

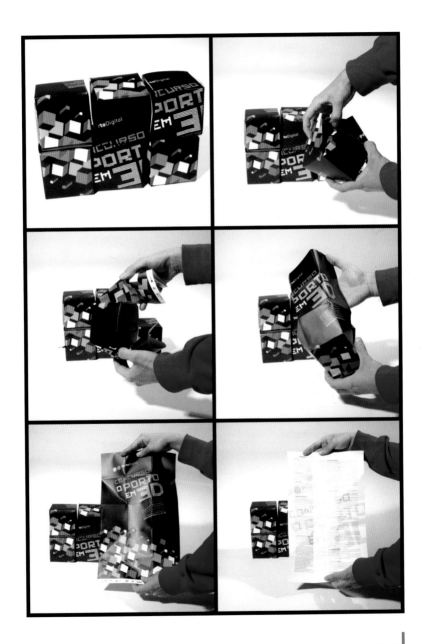

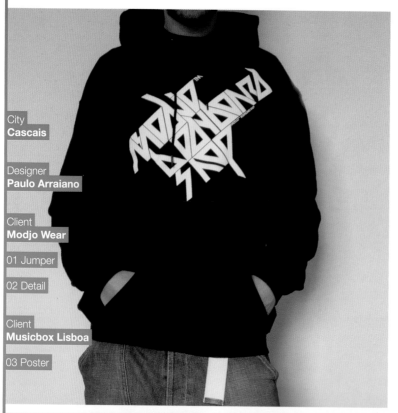

City
Cascais

Designer
Paulo Arraiano

Client
Modjo Wear

01 Jumper

02 Detail

Client
Musicbox Lisboa

03 Poster

01

02

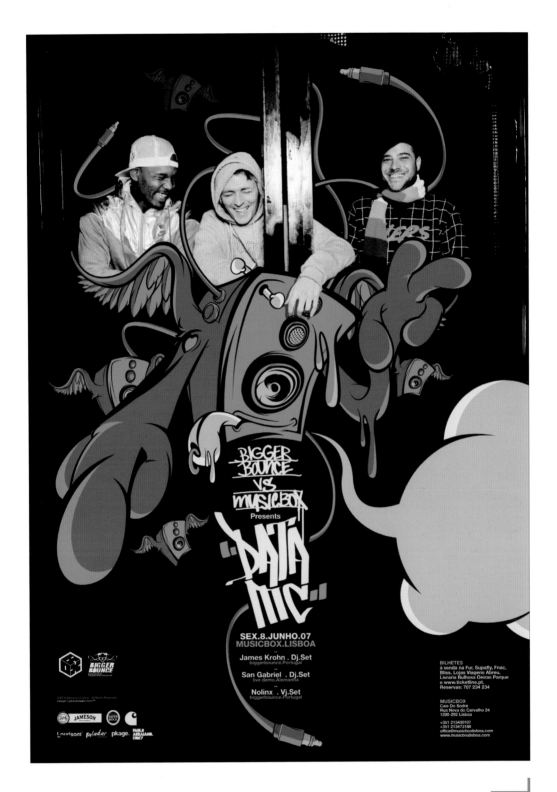

BIGGER BOUNCE VS MUSICBOX Presents

DATA MC

SEX.8.JUNHO.07
MUSICBOX.LISBOA

James Krohn . Dj.Set
biggerbounce.Portugal

San Gabriel . Dj.Set
live demo.Alemanha

Nolinx . Vj.Set
biggerbounce.Portugal

BILHETES
à venda na Fur, Supafly, Fnac,
Bliss, Lojas Viagens Abreu,
Livraria Bulhosa Oeiras Parque
e www.ticketline.pt.
Reservas: 707 234 234

MUSICBOX
Caes Do Sodré
Rua Nova do Carvalho 24
1200-292 Lisboa

+351 213430107
+351 213473188
office@musicboxlisboa.com
www.musicboxlisboa.com

JAMESON SUPER BOCK Lourisom paladar pkage. PAULA ABRAIANA. CM17

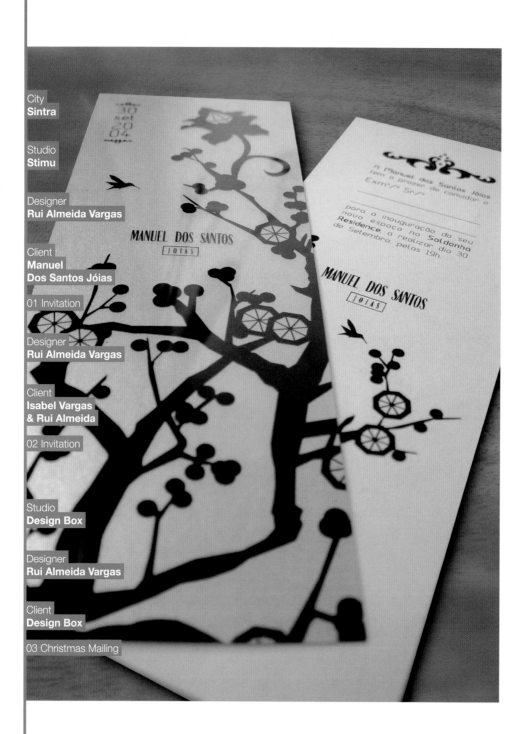

City
Sintra

Studio
Stimu

Designer
Rui Almeida Vargas

Client
**Manuel
Dos Santos Jóias**

01 Invitation

Designer
Rui Almeida Vargas

Client
**Isabel Vargas
& Rui Almeida**

02 Invitation

Studio
Design Box

Designer
Rui Almeida Vargas

Client
Design Box

03 Christmas Mailing

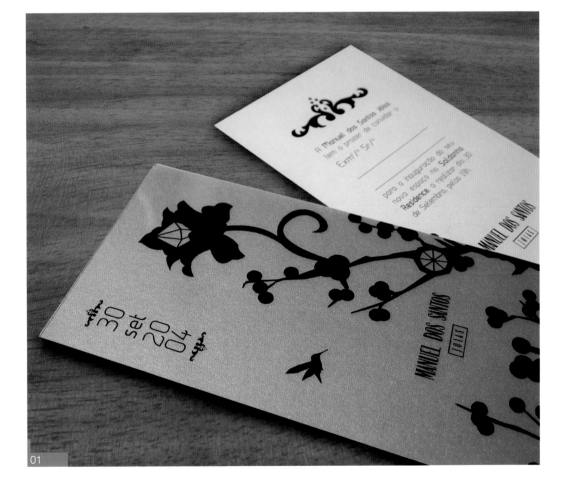

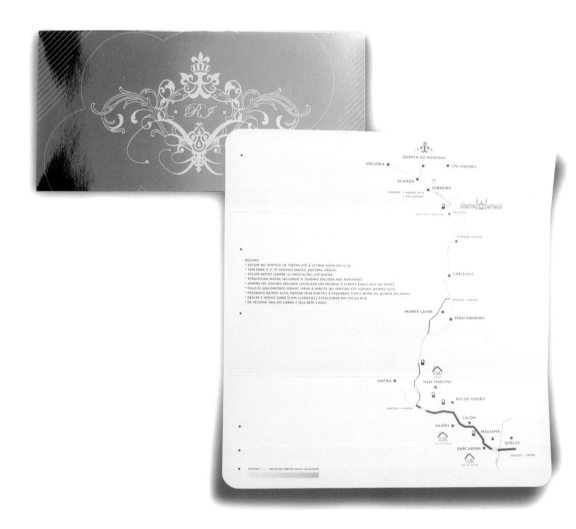

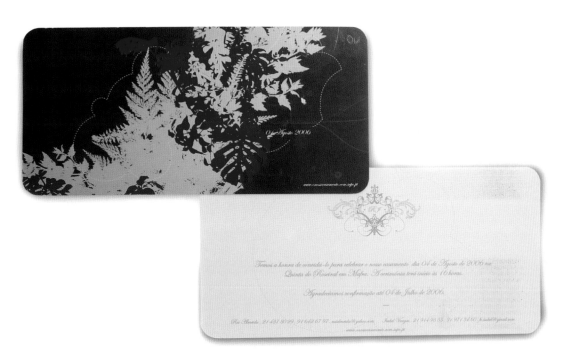

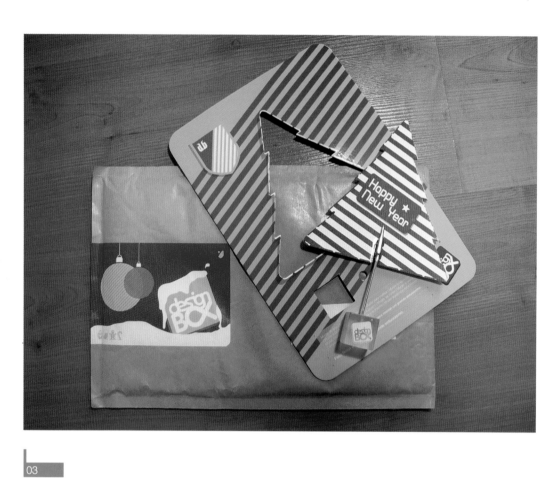

03

City
Lisbon

Studio
Six Letter Word

Client
Gigollo Records

01 LP Cover

Client
Self-Promotion

02+03 Posters

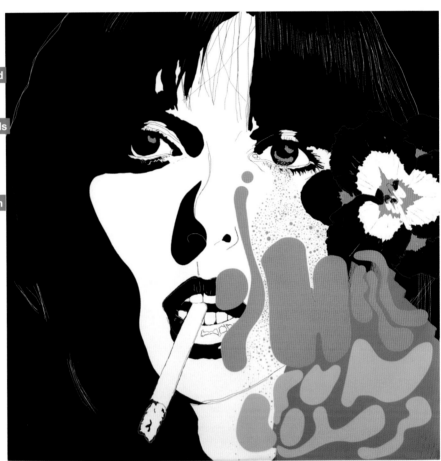

01

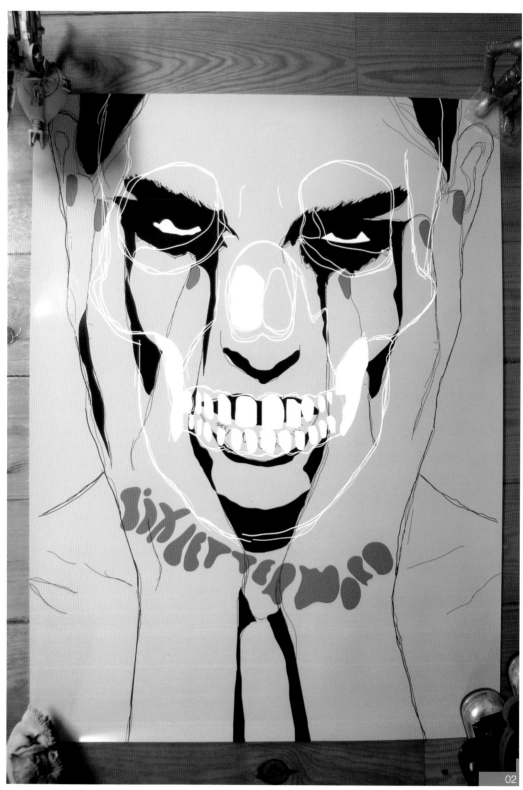

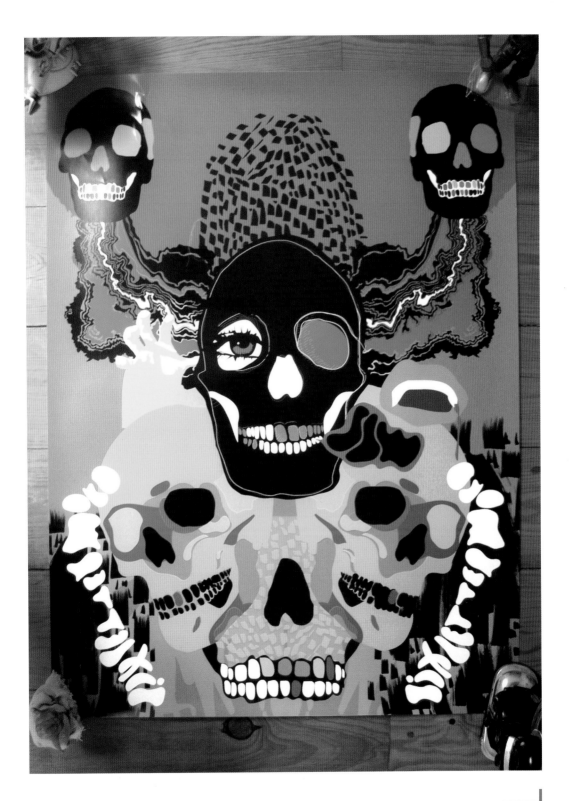

FRAGILE

...LAND
...rcelona Vienna
...rgsteiggasse 14-...
...70 Vienna
...stria

City
Barcelona

Designer
Astrid Stavro

Client
ADG-FAD

01 Advertisements

02 Poster
Inside / Cover

03 Postcards

04 T-Shirts

FORUM LAUS EUROPE 2006

Fronteras
La libertad llama

05 – 08 Julio / Barcelona
www.forumlauseurope.net

Diseñadores que son pensadores. Intelectuales que son directores de arte. Ilustradores que fotografían, tipógrafos que ruedan películas. Prácticos teóricos. Estudios europeos con clientes de Nueva York. Parisinos de Londres, berlineses de Lisboa, madrileños de Barcelona. El Forum Laus Europe 06 reúne a los que cruzan sus propias fronteras. A los que buscan en otros ámbitos. A los que van y a los que vienen.

ADG-FAD y ADC*E presentan este mes de Julio de 2006 un conjunto de participantes variado, heterogéneo, ecléctico y abierto. Voces tan diversas como A2/SW/HK, Oliviero Toscani, â.b.ä.k.e., Spin, David

Casacuberta, Francesc Ruiz, Red Spider, Tony Herzt, Francesc Muñoz, Wieden & Kennedy y Alexandre Bettler entre muchos otros.

A través de conferencias, workshops y presentaciones conoceremos sus experiencias, compartiremos sus ideas y debatiremos sus aportaciones. ¿Qué buscan fuera? ¿Cómo redibujan los límites de sus respectivos ámbitos? ¿Cómo viven la multidisciplinariedad? ¿Qué significa para ellas y ellos la identidad? ¿Y la globalización?

Queremos conocer sus opciones creativas y sus tentativas para alcanzar una cuota mayor de libertad.

Organizan: Instituciones: Ajuntament de Barcelona Generalitat de Catalunya Institut de Cultura. Colaboran: Lynx Fundació BancSabadell hp

FORUM
LAUS
EUROPE
2006

Frontiers
Freedom calls

01 - 09 July / Barcelona
www.forumlauseurope.net

FORUM
LAUS
EUROPE
2006

Fronteras
La libertad llama

01 - 09 Julio / Barcelona
www.forumlauseurope.net

FORUM
LAUS
EUROPE
2006

Fronteras
La libertad llama

01 - 09 Julio / Barcelona
www.forumlauseurope.net

01

FORUM
LAUS
EUROPE
2006

Fronteras / Fronteres / Frontiers

La libertad llama / La libertat crida / Freedom calls

05-08 Julio / Juliol / July > Barcelona

A2/SW/HK (HENRYK KUBEL & SCOTT WILLIAMS) *Ales Conspicationtis Bisquidus* / A.B.Ä.K.E. / *Phasponotis IV Ductisatus* /
ALEXANDRE BETTLER *Panis Panis jacksbum* / DAVID CASACUBERTA *E Philosophus* / FRANCESC RUIZ *Expandes artistos* /
TONY HERTZ *Megalonesstus Rodesfessconus* / ANA HIDALGO *Creatibus docentis directoris* / FRANCESC MUÑOZ *Geographicus
urbem spiritus* / RED SPIDER (GEORGE SHEPERD) *Annus Riskwattus* / SPIN *Cullabum amnestudias* / OLIVIERO TOSCANI
Provocati sibi R ilk su Gaudo Colum / WIEDEN & KENNEDY (ÁLVARO SOTOMAYOR) *Jantilabur analinctoris* / FLE 2006

FORUM LAUS EUROPE 2006

Fronteras / Frontiers
La libertad llama / Freedom calls

05 - 08 Julio / July
www.forumlauseurope.net

Diseñadores que son pensadores. Intelectuales que son directores de arte. Ilustradores que fotografían, tipógrafos que ruedan películas. Estudios europeo con clientes de Nueva York. Parisinos en Londres, berlineses en Barcelona.

ADG-FAD y ADC'E reúnen en el Forum Laus Europe 06 a los que cruzan sus propias fronteras para buscar en otros ámbitos. Vamos tan diversos como Spin, A2/SW/HK, Uwe Loesch, Oliviero Toscani, i.b.a.t.e., David Casacuberta, Wieden & Kennedy, Red Spider, Francesc Ruduí, Ruiz entre muchos otros.

Conoceremos sus experiencias, compartiremos sus ideas y debatiremos sus agitaciones. Queremos saber cómo codifican los límites de sus propios territorios. Con qué opciones creativas cuentan. Cuáles son sus tentativas para alcanzar una cuota mayor de libertad.

Designers that are thinkers. Intellectuals than are art directors. Illustrators that shoot photographs, typographers that make films. European studios with New York City clients. Parisians in London, Berliners in Barcelona.

At Forum Laus Europe 06, ADG-FAD and ADC'E unite those who cross their own boundaries to explore other fields. Voices as eclectic as Spin, A2/SW/HK, Uwe Loesch, Oliviero Toscani, i.b.a.t.e., David Casacuberta, Wieden & Kennedy, Red Spider, Alexandre Bettler and Francesc Ruduí amongst many others.

They'll recount tales of travels across disciplines, and share their experiences and ideas. We want to know how they codify the limits of their own territories, what their creative options are, and how far they've had to go to achieve creative freedom.

Organitza / Organizers:
adg-fad ADC'E

Contribueixen / Contributors:

Col·laboren / Sponsors:
Lynx *S hp

03

04

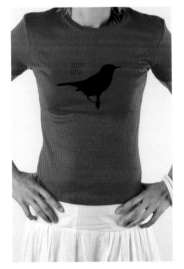

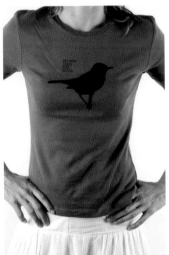

City
Barcelona

Designer
Astrid Stavro

Client
Royal College of Art

01 Notepads

Client
**Museo Nacional
Centro
de Arte Reina Sofia**

02 Sets of Postcards

03 Notepads

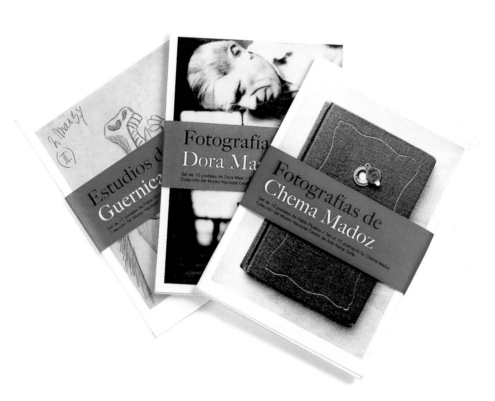

Estudios de
Guernica

Set de 10 postales de Pablo Picasso
Colección del Museo Nacional

Fotografías
Dora Ma...

Set de 10 postales de Dora Maar /
Colección del Museo Nacional Cent

Fotografías de
Chema Madoz

Set de 10 postales de Pablo Picasso / Set of 10 postcards by Chema Madoz
Colección del Museo Nacional Centro de Arte Reina Sofía

Guernica, Pablo Picasso, 1937 Óleo sobre lienzo / 68 x 66 cm

Naturaleza Muerta, Pablo Picasso, 1918 Óleo sobre lienzo / 68 x 66 cm

Celestial Navigation, colegia Guernica, 1918 Óleo sobre lienzo / 100 x 66 cm

AllWeAreTheCorporateImageAuthority
AllWeDreamOn.AllWeLoveThisPopster.AllWeHateIt.AllWeDesign.AllWeFloat.AllWeLoose.AllWeChan
ge.AllWeSuffer.AllWeLaugh.AllWeCry.

City
Madrid

Studio
Design People Studio

Client
Self-Promotion

01 Poster

02 T-Shirts

03 Label, Patch

04 Postcards

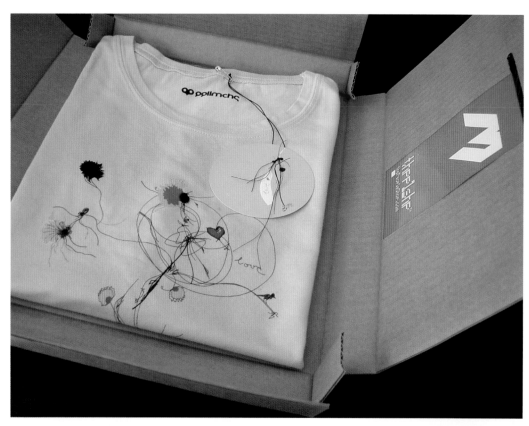

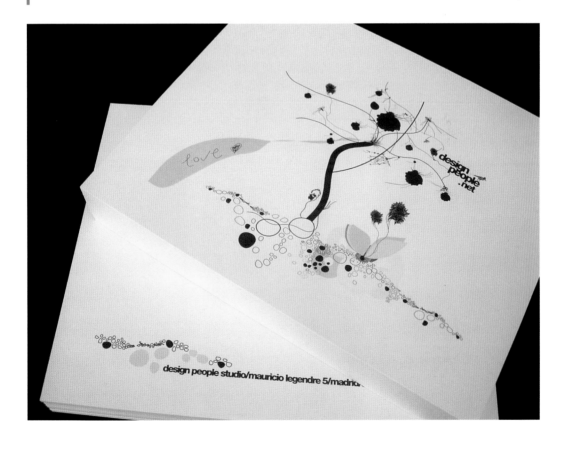

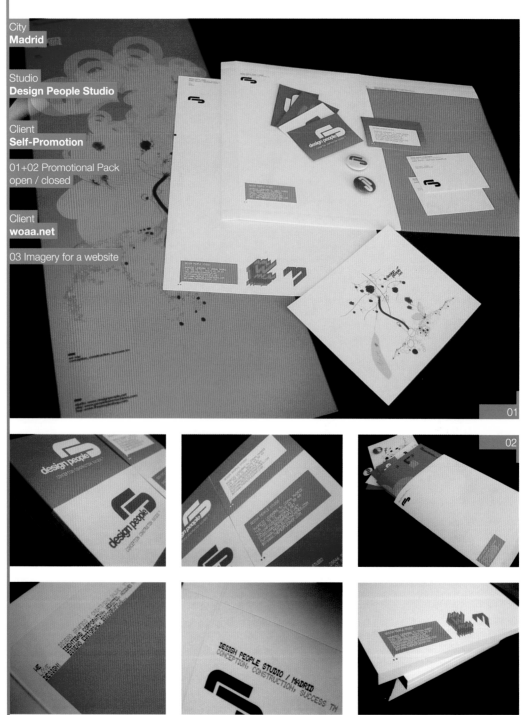

City
Madrid

Studio
Design People Studio

Client
Self-Promotion

01+02 Promotional Pack
open / closed

Client
woaa.net

03 Imagery for a website

01

02

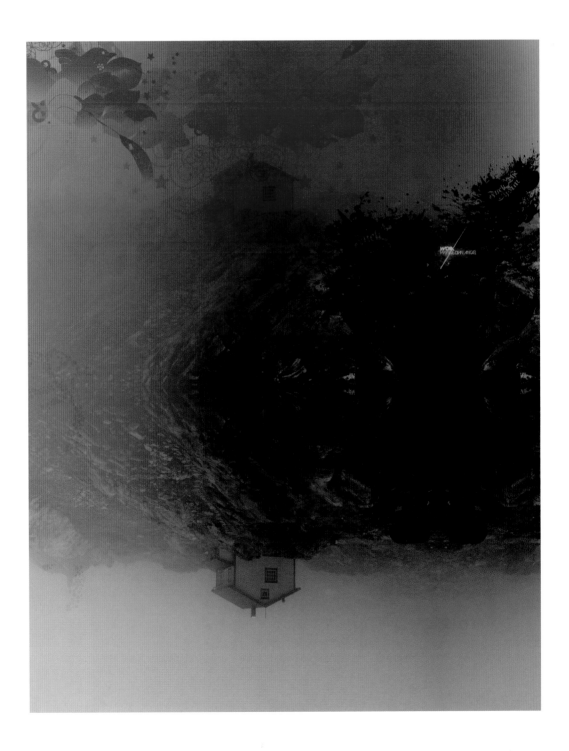

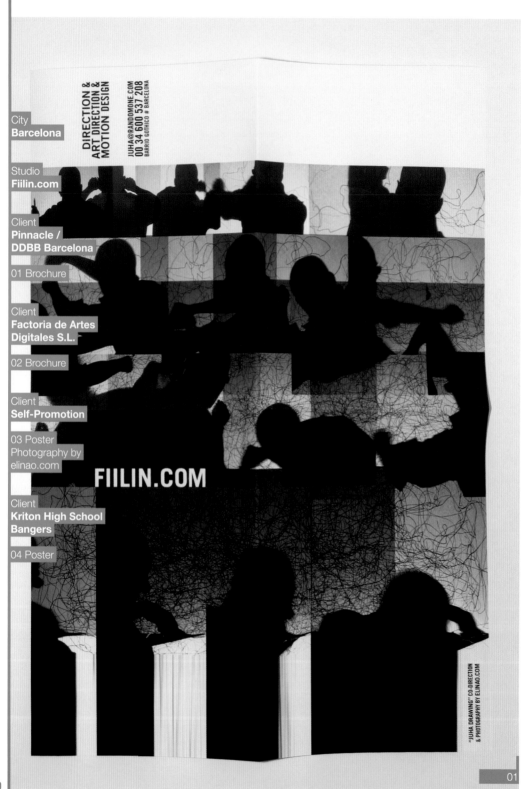

City
Barcelona

Studio
Fiilin.com

Client
**Pinnacle /
DDBB Barcelona**

01 Brochure

Client
**Factoria de Artes
Digitales S.L.**

02 Brochure

Client
Self-Promotion

03 Poster
Photography by
elinao.com

Client
**Kriton High School
Bangers**

04 Poster

DIRECTION &
ART DIRECTION &
MOTION DESIGN

JUHA@RANDOMONE.COM
00 34 600 537 208
BARRIO GOTHICO # BARCELONA

FIILIN.COM

"JUHA DRAWING" CO-DIRECTION
& PHOTOGRAPHY BY ELINAO.COM

01

WHAT IT DO!
KRITON HIGH SCHOOL BANGERS
presents DA HORROR CRUNK ANTHEM
"SCARED MONEY"

THE VIDEO BY FIILIN.COM
POPPIN OUT OF DA TRUNK SUMMER 2007
KEEP CHECKIN THAT SHIT AT
KRITON.BIZ & FIILIN.COM

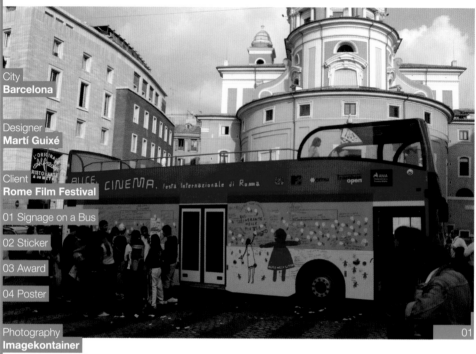

City
Barcelona

Designer
Martí Guixé

Client
Rome Film Festival

01 Signage on a Bus

02 Sticker

03 Award

04 Poster

Photography
Imagekontainer

01

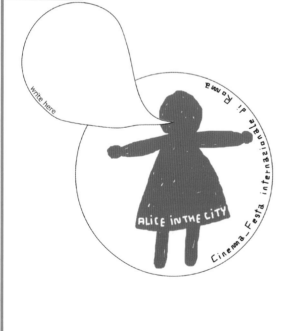

02

03

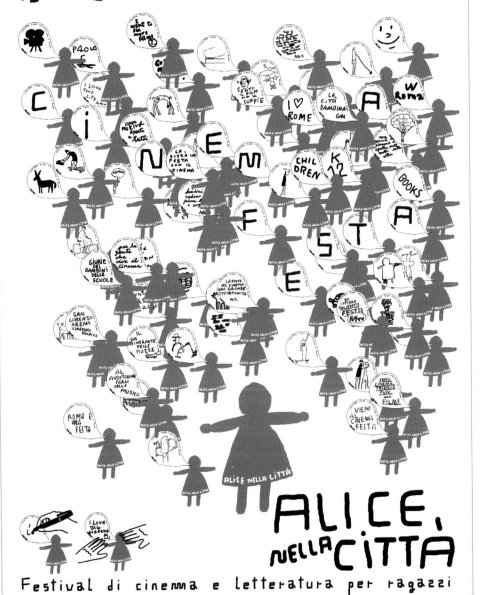

City
Barcelona

Studio
Meat Collective

Client
Self-Promotion

01 Postcards

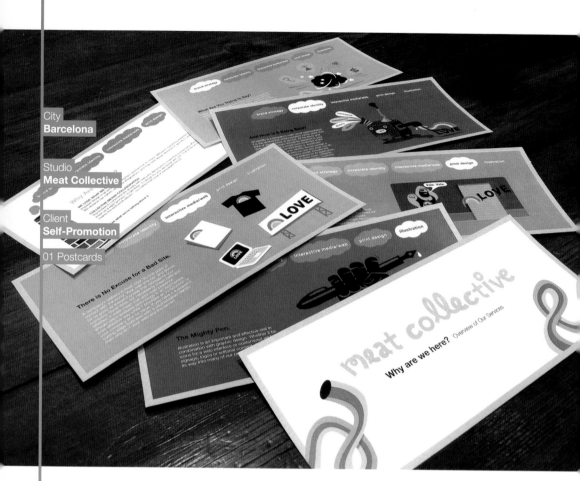

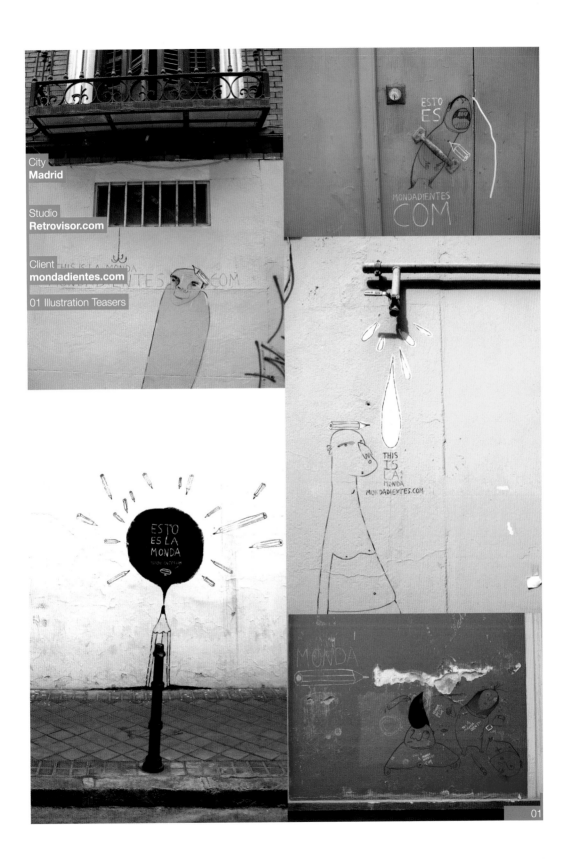

City
Madrid

Studio
Retrovisor.com

Client
mondadientes.com

01 Illustration Teasers

01

City
Madrid

Studio
Serialcut

Client
**Istituto Europeo di design /
IED ModaLab**

01 Booklet

Client
Lladró

02 Art Direction
for Promotional Images

Photography
IPSUM PLANET

Client
Neo2

03 Art Direction
for Promotional Image

Client
Boite®

04 Art Direction
for a Promotional Image

05 Entrance Tickets

06 VIP-Card

07 Cloakroom Ticket

08 Flyers

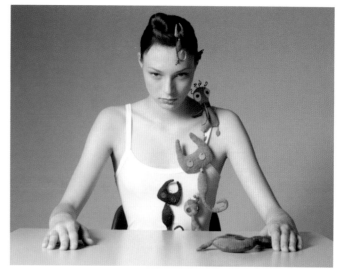

01

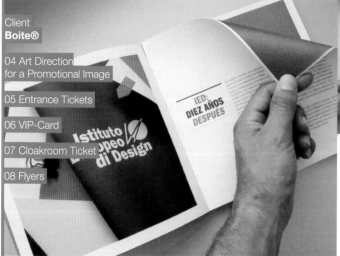

04

05

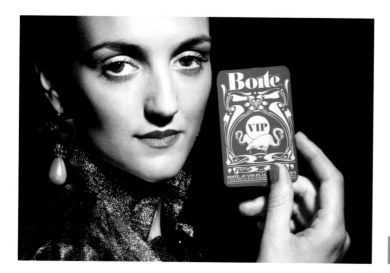

06

07

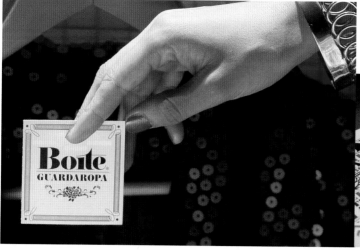

08

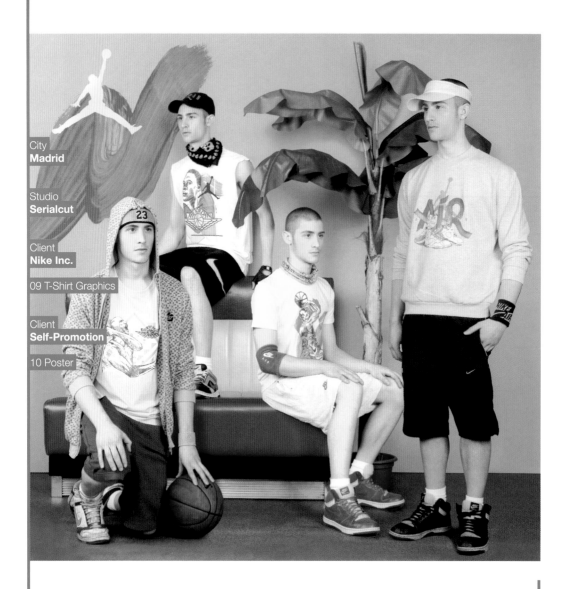

City
Madrid

Studio
Serialcut

Client
Nike Inc.

09 T-Shirt Graphics

Client
Self-Promotion

10 Poster

09

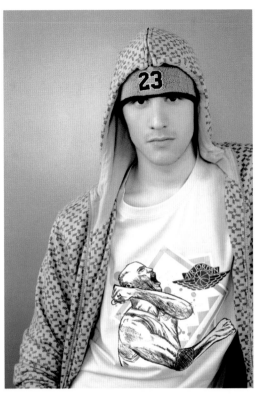

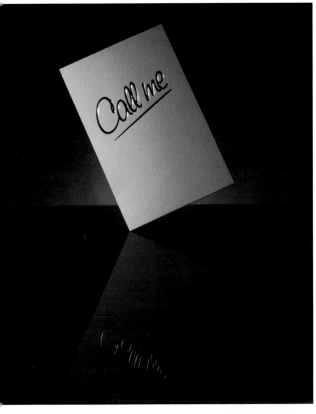

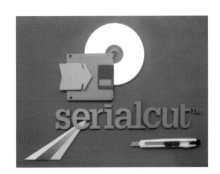

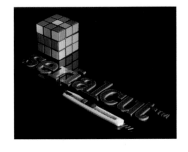

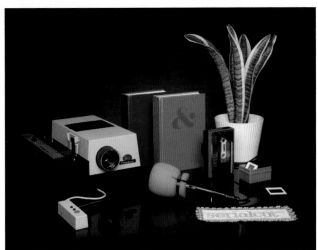

City
Barcelona

Studio
Toormix

Client
Galería Alea

01 Postcards

Client
**Ajuntament
de Barcelona – ICUB**

02 Posters

03 Flyer
front / back

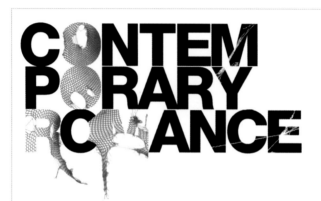

JOIES TEXTILS A ALEA

GALERIA DE JOIES
alea

MERCAT
DE LES FLORS

C/ LLEIDA 59, BARCELONA
TEL. 93 426 18 75 | www.mercatflors.org

TEMPORADA
2006-2007

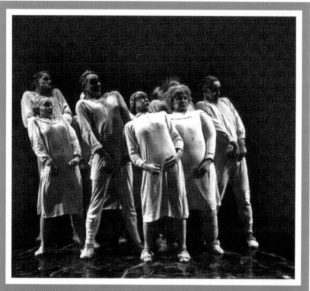

CIA. MAGUY MARIN
MAY B

"Una obra basada en els escrits de Samuel Beckett"

Dates: Del 28 al 30 de setembre Horari: **21h** Preu: **18€ (Anticip.) 20€ (Taquilla)**
Dia 1 d'octubre: UMWELT espectacle de nova creació
Abonaments: consulteu www.mercatflors.org

02

MERCAT
DE LES FLORS

SOCIETAT DOCTOR ALONSO /
TOMÀS ARAGAY-SOFIA ASENCIO
EL TRASPIÉS DE LUISA

SOCIETAT DOCTOR ALONSO /
TOMAS ARAGAY -SOFIA ASENCIO
EL TRASPIÉS DE LUISA
DEL 8 A L'11 DE FEBRER

Quatre ballarines que intenten fer una altra cosa

Horaris: **Dj a Ds:** 21h / **Dg:** 19h
Preu: **10€ (Anticip.) 12€ (Taquilla)**
Sala: **MAC**

Societat Doctor Alonso planteja un espectacle sobre l'error. Sofia Asencio proposa a Idurre Azkue, Iva Horvat i Mia Esteve, les tres ballarines i l'actriu de l'obra, la formació d'una banda de música pop. No saben tocar i només disposen de dos mesos. Però decideixen experimentar l'error des d'aquesta aventura. Sembla un encert. Però, potser, és un error. Però si és un error seria un encert. L'única sortida és mostrar el procès tal com és.

Direcció **Sofía Asencio**
Dramatúrgia **Tomas Aragay** i **Sofía Asencio**
Assistent a la dramatúrgia **Òscar Abril Ascaso**
Interpretació **Mía Esteve, Iva Horvat, Idurre Azkue** i **Sofía Asencio**

2A PART DE "EL TRASPIÉS DE LUISA":
CONCERT LUISA (+ TU MADRE)
AL SIDECAR
13 DE FEBRER

Horari: **22h**
Preu: **6€**
Sidecar: **Plaça Reial**

3€
Presentant l'entrada de
ELTRASPIÉS DE LUISA
del Mercat de les Flors
al Sidecar

ticketix.com

City
Madrid

Toormix

Client
Various

01+02 Wedding
Invitations

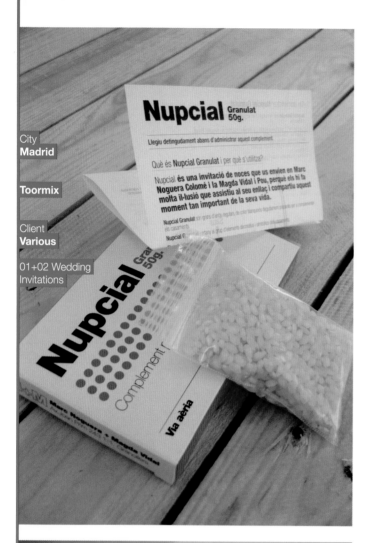

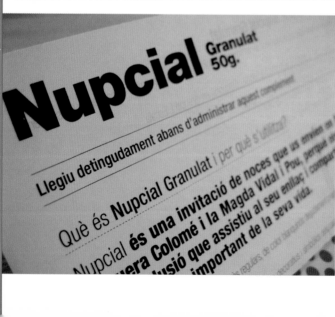

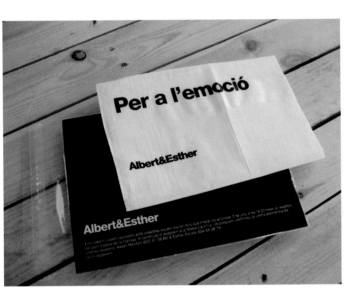

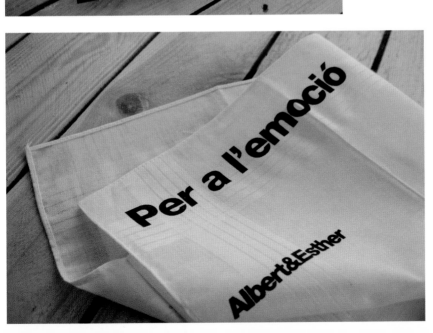

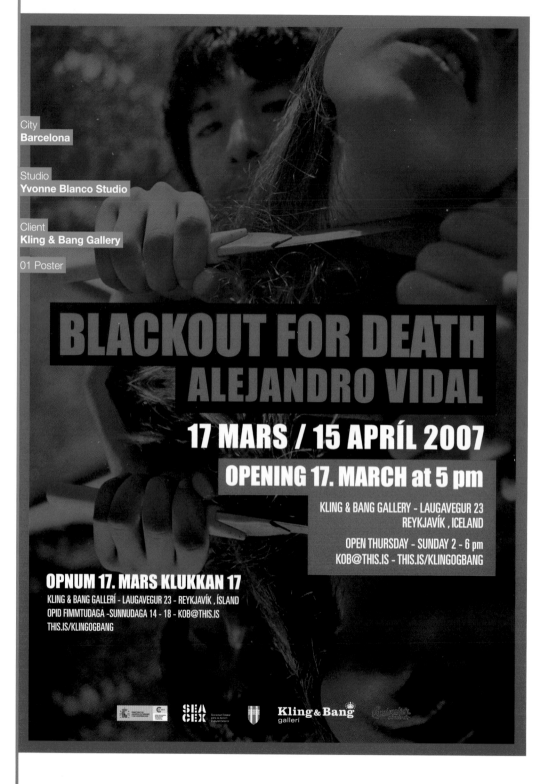

City
Barcelona

Studio
Yvonne Blanco Studio

Client
Kling & Bang Gallery

01 Poster

BLACKOUT FOR DEATH
ALEJANDRO VIDAL

17 MARS / 15 APRÍL 2007
OPENING 17. MARCH at 5 pm

KLING & BANG GALLERY - LAUGAVEGUR 23
REYKJAVÍK , ICELAND

OPEN THURSDAY - SUNDAY 2 - 6 pm
KOB@THIS.IS - THIS.IS/KLINGOGBANG

OPNUM 17. MARS KLUKKAN 17
KLING & BANG GALLERÍ - LAUGAVEGUR 23 - REYKJAVÍK , ÍSLAND
OPID FIMMTUDAGA -SUNNUDAGA 14 - 18 - KOB@THIS.IS
THIS.IS/KLINGOGBANG

Kling & Bang
gallerí

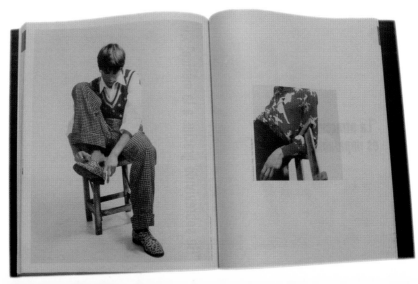

SWEDEN
59°21' North 18°04' East

JULAND BAR
BERGSTEIGG
1170 VIENNA
AUSTRIA

SVERIGE 11 KR

2007-07-05

ONAVIENNA
E 14-16 / 2 / 5

City
Stockholm

Studio
Artwerk

Client
Stockholm Film Festival

01 Living Statues

Client
AP Fastigheter

02 Light Show
(changing its light
according to
the street sounds)

Client
adidas International

03 "Paper Mates"

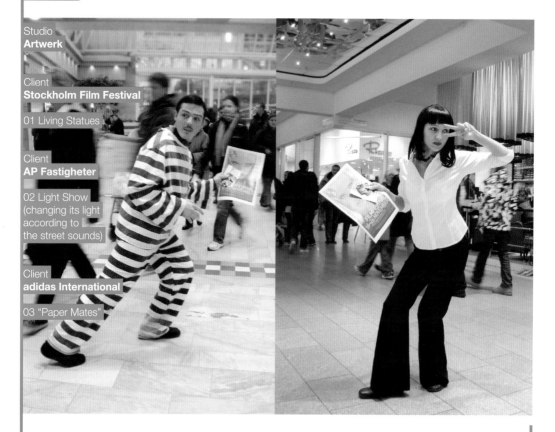

01

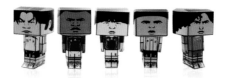

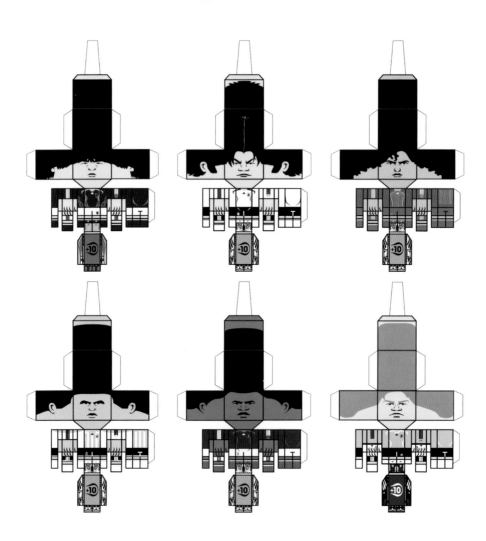

DPR BONUS

Diskussioner och debatter på respektive ort i samband med föreställningarna

DPR 1
LOG MED
SPÖKE

"Svartfötter får räkna med sämre säkerhet. Nåt ska det väl kosta att gå bakom ryggen på sina kamrater"

DPR 4
EN SVENSK PITBULL

City
Stockholm

"Dåligt samvete är den bästa öronproppen."

Studio
Chevychase Design Studio

med ett spöke
lse, en reflekt n över dubbel-
motsatser och språkförbistring i
land och en n värld. Maciej Za-
monolog är o så ett möte med
kor, förutfattat meningar och ett
e efter att för

I rollerna Odile Nunes

Jacob Nordenson

Jarinja Thelestam Mark

Regi Ulla Gi

Client
Riksteatern

remba

01+02 Posters

Regi Lennart Hjulström

03 Advertisement

I rollen Per Burell

En svensk pitbull är en berättelse om kärlek – kärleken
till en annan människa, till sig själv, sitt land, sina dröm-
mar och ideal... men vad händer när kärleken visar sig
vara föräkt, hat och rädsla? I ett hårt skruvat triangel-
drama möter vi en svensk fackombudsman, en baltisk
tolk och en PR-kvinna som alla försöker styra genom
verklighetens och känslornas fallgropar.

Av Lena Andersson

America Vera Zavala

"Alla latinos älskar Palme!"

Av Alexander Ahndoril

DPR 2
SOCIALISTISK TÄVLAN

Regi Gustav Deinoff

I rollerna Jonatan Rodrigues

Martin Aliaga

Benjamin Moliner

Regi Richard Turpin

I Socialistisk tävlan ställs
höga ideal, stenhårda princi-
per och mänskliga behov
mot varandra. En arbetslös
byggjobbare söker desperat
arbete samtidigt som facket
rustar för strid mot utländsk
konkurrens och för att be-
hålla lönerna, sina villkor och
kollektivavtal. Vem drabbas
och vem vinner i det nya
gränslösa Europa?

Concha tu madre handlar om två latinamerikanska killar. De
jobbar på ett bygge och tillsammans snackar de om livet, pengar,
kärlek och vardagen... och om Sverige. Sverige som ett fantas-
tiskt land - Olof Palmes land, drömmarna, friheten, solidariteten.
Eller ett land som sviker, krånglar och stänger dörrar. Den ene
killen är här illegalt medan den andre har svenskt medborgarskap
och komplikationer uppstår när en förman vill kontrollera deras
legitimationer. En pjäs om drömmar, illusioner och lojalitet.

PR 3
NCHA
MADRE

I rollerna Jonatan Rodrigues

Martin Aliaga

Benjamin Moliner

"Blockad, det är
tufft för dem so
drabbas, men...
är det nu en gån
med alla princip

FYRA PJÄSER OM SVERIGE OCH
DET NYA EUROPA - OM MAKT,
FEGHET OCH SOLIDARITETENS
GRÄNSER. EN HELDAG MED
TEATER, DISKUSSIONER OCH DE-
BATTER. VAD TYCKER DU? KOM
OCH TA STÄLLNING!

01

RIKSTEATERN

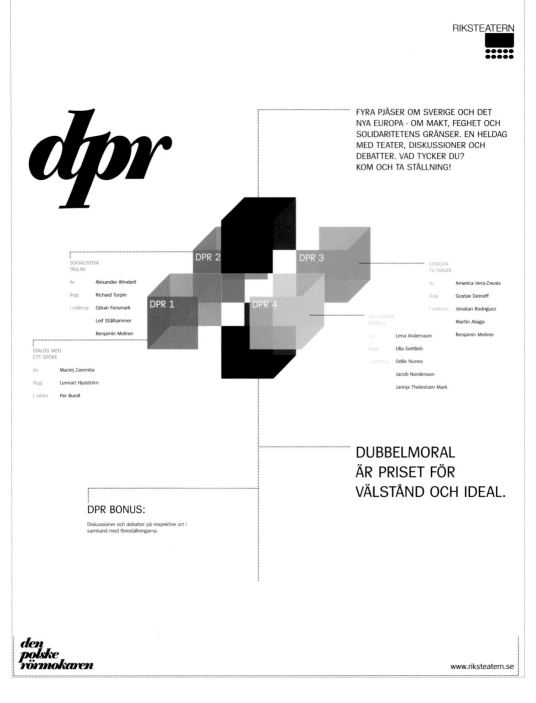

FYRA PJÄSER OM SVERIGE OCH DET
NYA EUROPA - OM MAKT, FEGHET OCH
SOLIDARITETENS GRÄNSER. EN HELDAG
MED TEATER, DISKUSSIONER OCH
DEBATTER. VAD TYCKER DU?
KOM OCH TA STÄLLNING!

SOCIALISTISK TÄVLAN

Av	Alexander Ahndoril
Regi	Richard Turpin
I rollerna	Göran Forsmark
	Leif Stålhammer
	Benjamin Moliner

DIALOG MED ETT SPÖKE

Av	Maciej Zaremba
Regi	Lennart Hjulström
I rollen	Per Burell

DPR 1 DPR 2 DPR 3 DPR 4

CONCHA TU MADRE

Av	America Vera-Zavala
Regi	Gustav Deinoff
I rollerna	Jonatan Rodriguez
	Martin Aliaga
	Benjamin Moliner

EN SVENSK PITBULL

Av	Lena Andersson
Regi	Ulla Gottlieb
I rollerna	Odile Nunes
	Jacob Nordenson
	Jarinja Thelestam Mark

DUBBELMORAL ÄR PRISET FÖR VÄLSTÅND OCH IDEAL.

DPR BONUS:

Diskussioner och debatter på respektive ort i
samband med föreställningarna.

den polske rörmokaren

www.riksteatern.se

RIKSTEATERN

Fyra pjäser om
Sverige och det
nya Europa

DPR 2

DPR 3

DPR 1

DPR 4

*den
polske
rörmokaren*

City
Stockholm

Designer
Emma Megitt

Client
Kiss&Bajs i Sverige

01 Tattoo Set

02 Packaging

03 Folder

04 Christmas Card

05 Interactive
Memory Game

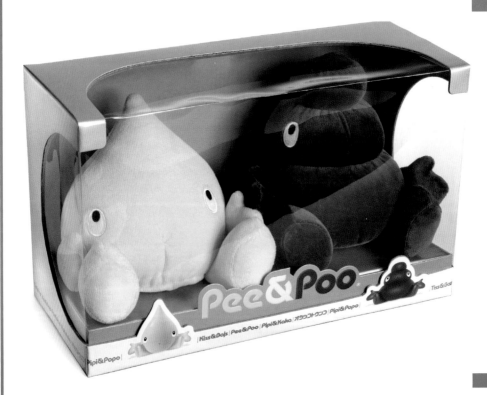

01

02

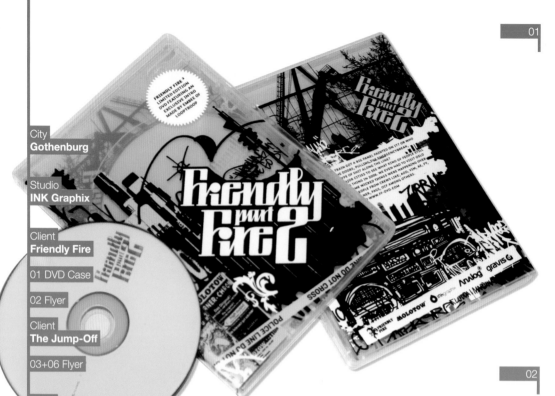

City
Gothenburg

Studio
INK Graphix

Client
Friendly Fire

01 DVD Case

02 Flyer

Client
The Jump-Off

03+06 Flyer

Client
Club Quality

04 Candy

05 Tickets

Client
Timbuktu

07 CD Artwork

08 CD Artwork, Poster

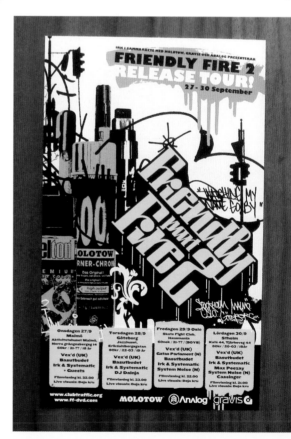

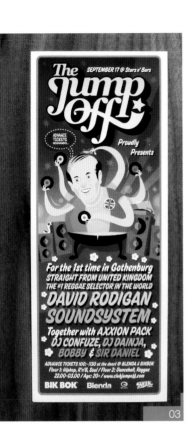

03

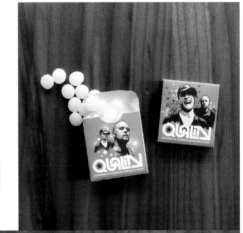

04

05

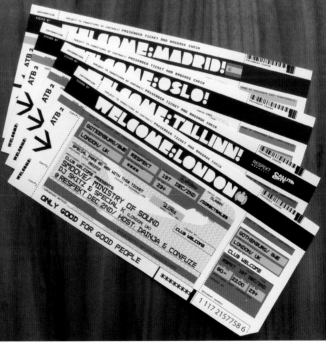

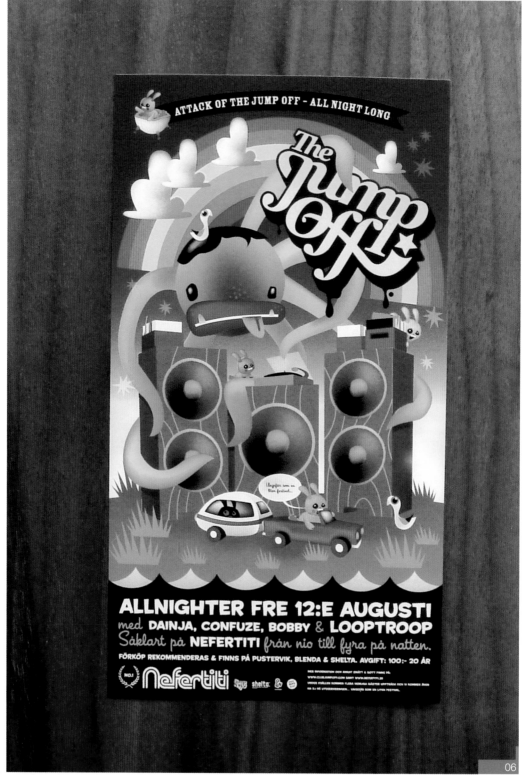

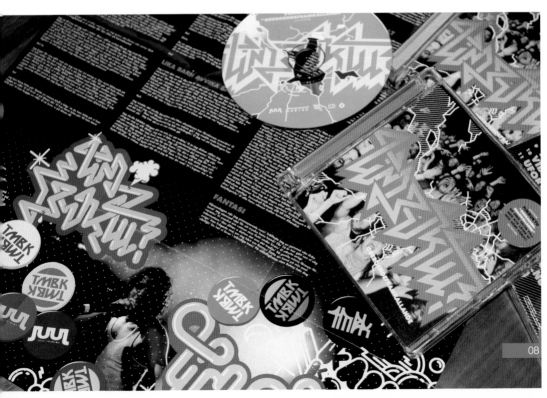

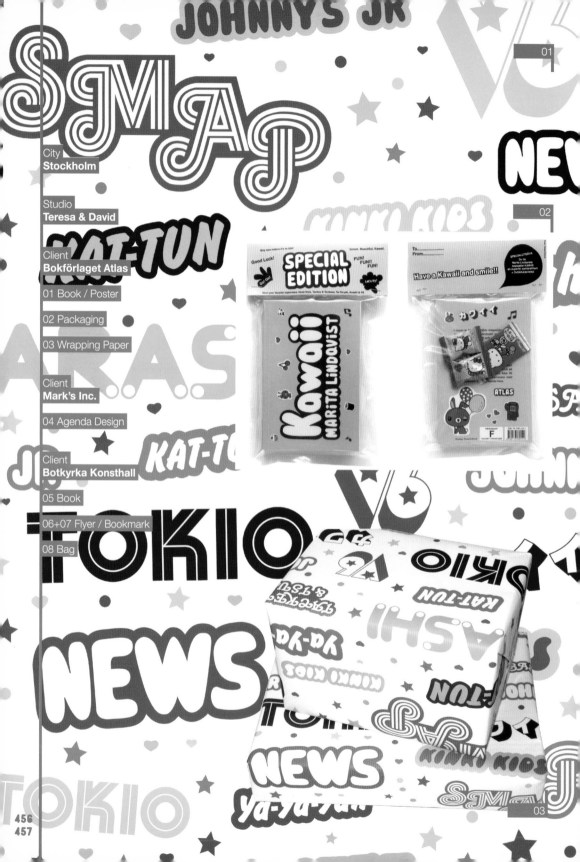

City
Stockholm

Studio
Teresa & David

Client
Bokförlaget Atlas

01 Book / Poster

02 Packaging

03 Wrapping Paper

Client
Mark's Inc.

04 Agenda Design

Client
Botkyrka Konsthall

05 Book

06+07 Flyer / Bookmark

08 Bag

AGENDA 2006

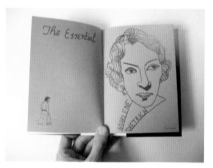

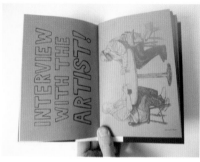

City
Stockholm

Studio
Zion Graphics

Client
Bisse Bengtsson

01 Invitation Card

City
Stockholm

Studio
Zion Graphics

Client
EMI Music

02 CD Artwork

Client
Hobby Film

03 CD Artwork,
Business Cards

Client
EMI Music

04 CD Artwork

Client
J. Lindeberg

05 Invitation Card

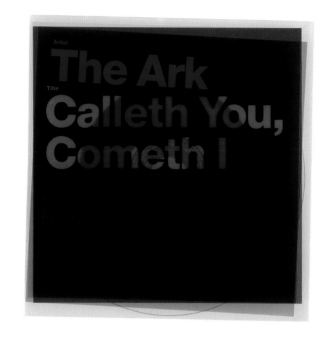

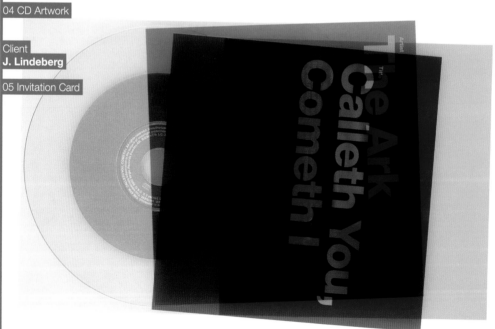

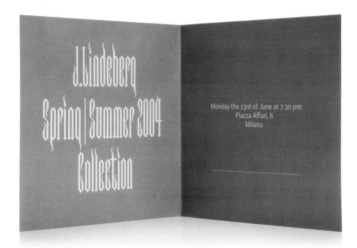

Monday the 23rd of June at 7.30 pm
Piazza Affari, 6
Milano

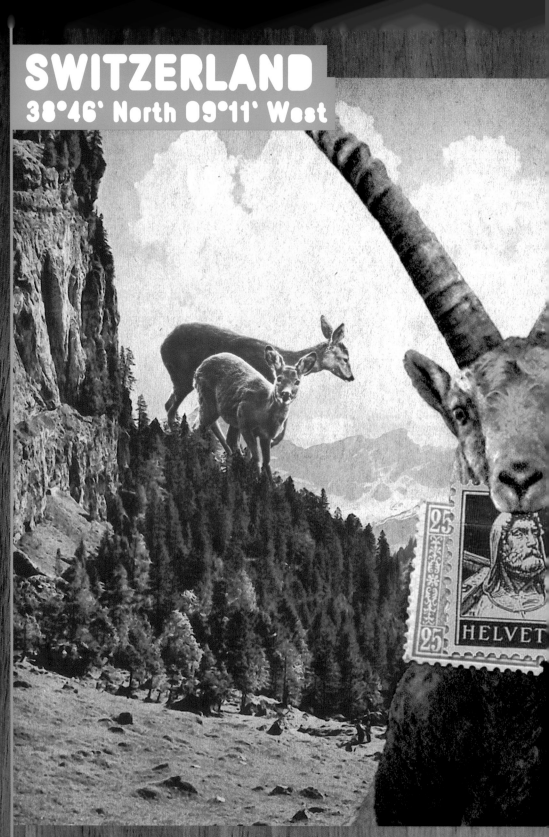

AN/TO:

JuLAND BarcelonaVienna

Bergsteiggasse 14-1

A-1170 Vienna

City
Geneva

Studio
at-elier

Client
Lausanne Underground Film & Music Festival

01 Poster

Client
Reverse Engineering

02 CD Artwork

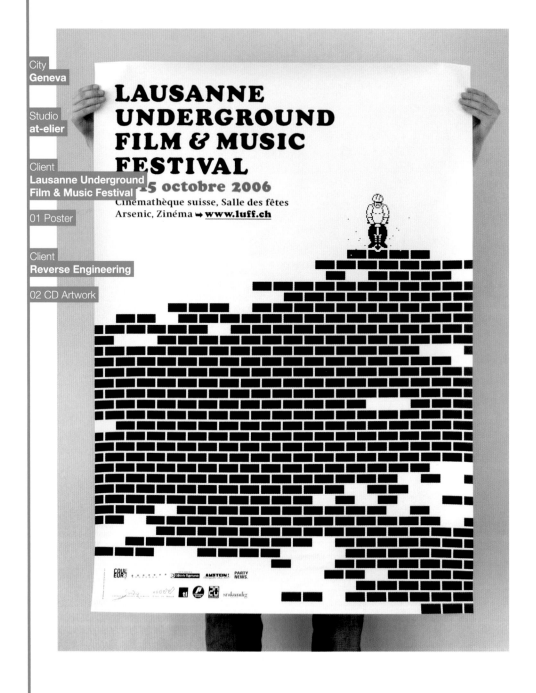

01. WORLDWIDE PANIC
02. TUG O WAR
03. BRAIN IN A BOX
04. A TOASTER IN THE DARK
05. PORCINET
06. THIS IS NOT A TEST
07. SOUNDSYSTEM (DUMBFOUNDED)
08. EARTH VS THE FLYING CAQUELONS
09. CONCRETE EVIDENCE
10. CLARITY
11. DOCTOR WAGNER
12. ATTACK OF THE 50KO CREATURES
13. TRANSISTOR GIRL

JARRING EFFECTS - 13 RUE RENÉ LEYNAUD, 69001 LYON - T +33 (0) 4 78 30 50 29 - CONTACT@JARRINGEFFECTS.ORG
®+© JARRING EFFECTS 2005 - FX051 CD - WWW.JARRINGEFFECTS.ORG - WWW.REVENG.CH
graphic design: ah-stet.net

241 9351820
2I0F

5 413356 057225

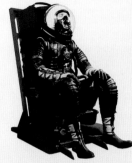

ЯEVEЯSE
EИ϶IИEEЯIИϽ
DUCK
& COVEЯ

ЯEVEЯSE
EИ϶IИEEЯIИϽ
DUCK
& COVEЯ

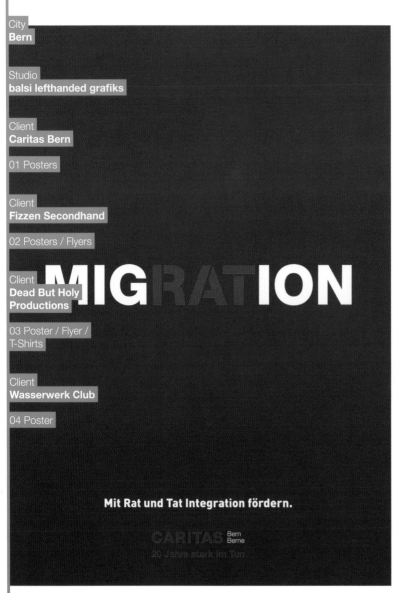

City
Bern

Studio
balsi lefthanded grafiks

Client
Caritas Bern

01 Posters

Client
Fizzen Secondhand

02 Posters / Flyers

Client
**Dead But Holy
Productions**

03 Poster / Flyer /
T-Shirts

Client
Wasserwerk Club

04 Poster

MIGRAT**ION**

Mit Rat und Tat Integration fördern.

CARITAS Bern
Berne
20 Jahre stark im Tun

SCI

Wachsa

WACH

zial Schwachen.

Bern
Berne

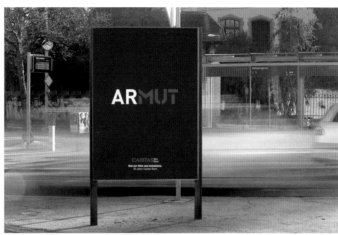

01

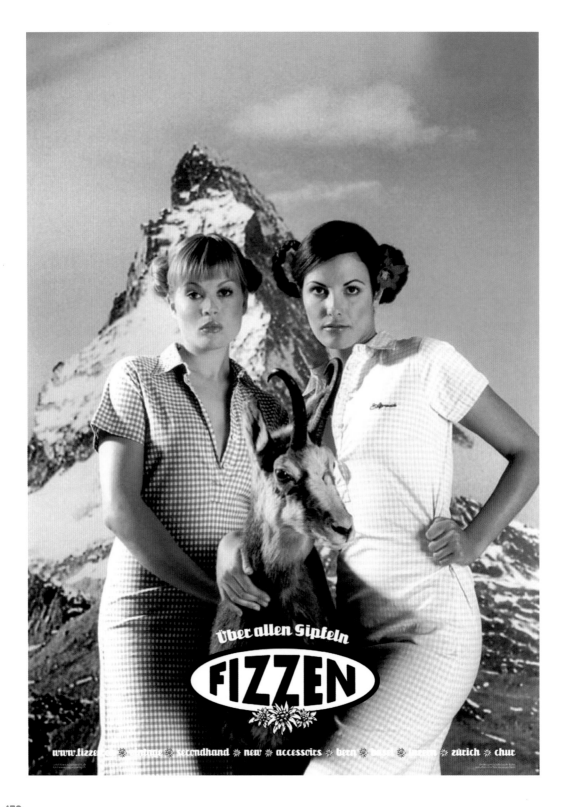

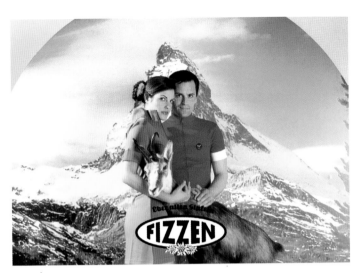

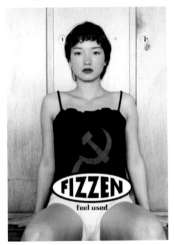

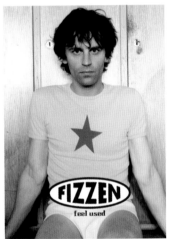

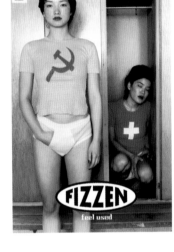

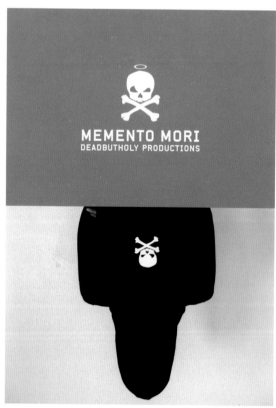

MEMENTO MORI
DEADBUTHOLY PRODUCTIONS

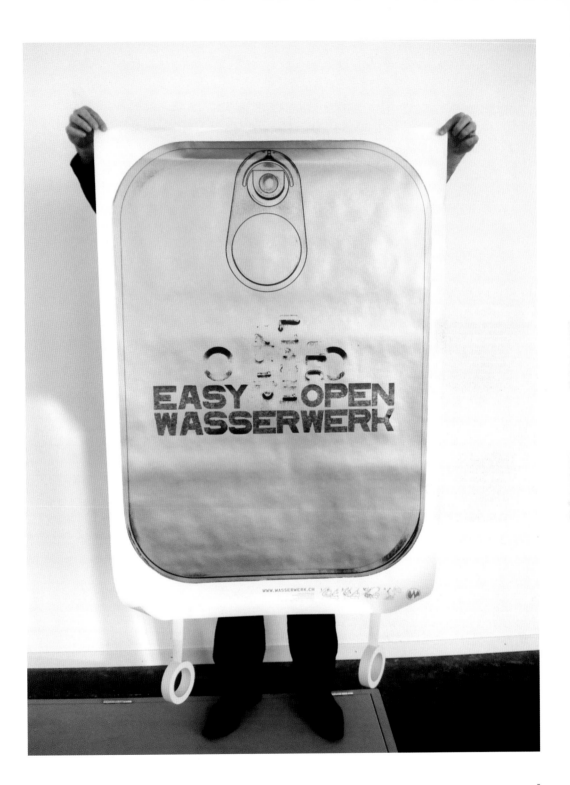

City
Bern

Studio
balsi lefthanded grafiks

Client
fiji

01 Sticker

02 Poster

03 CD Artwork

04 Pants

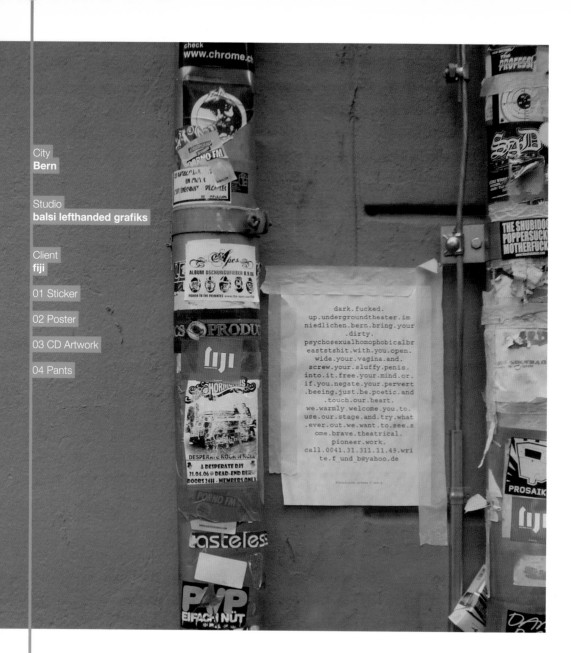

dark.fucked.
up.undergroundtheater.im
niedlichen.bern.bring.your
.dirty.
psychosexualhomophobicalbr
eaststshit.with.you.open.
wide.your.vagina.and.
screw.your.sluffy.penis.
into.it.free.your.mind.or.
if.you.negate.your.pervert
.beeing.just.be.poetic.and
.touch.our.heart.
we.warmly.welcome.you.to.
use.our.stage.and.try.what
.ever.out.we.want.to.see.s
ome.brave.theatrical.
pioneer.work.
call.0041.31.311.11.49.wri
te.f_und_b@yahoo.de

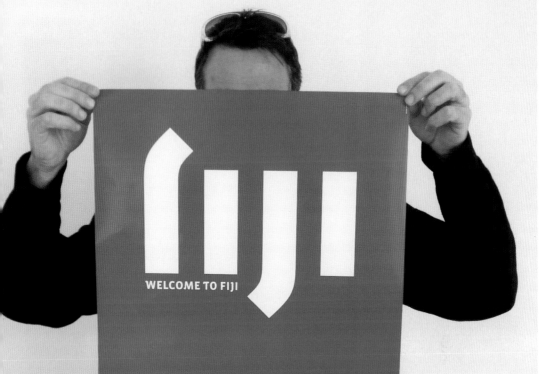

WELCOME TO FIJI

★ AND HAVE A NICE GIG ★

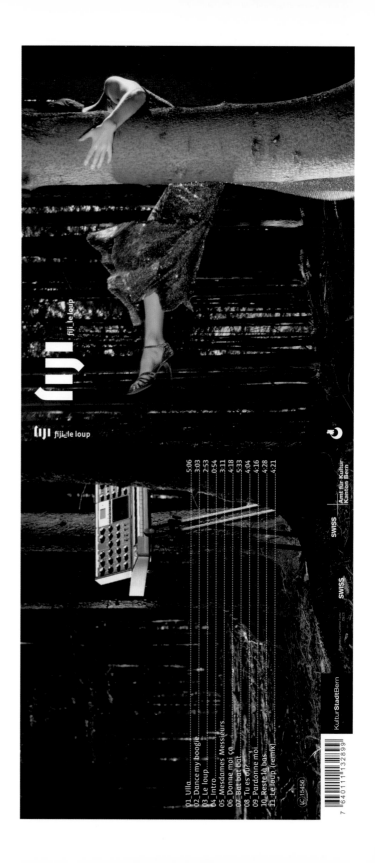

fiji_le loup

fiji_le loup

01. Ulla. ... 5:06
02. Dance my boogie 3:03
03. Le loup. 2:53
04. Intro. ... 0:54
05. Mesdames Messieurs. 3:11
06. Donne moi ça. 4:18
07. Bat bat bat. 5:33
08. Tu es où. 4:04
09. Pardonne moi. 4:16
10. Reste là bas. 4:28
11. Le loup (remix) 4:21

(C)15456

SWISS

SWISS

Amt für Kultur
Kanton Bern

Kultur**Stadt**Bern

7 640111 132899

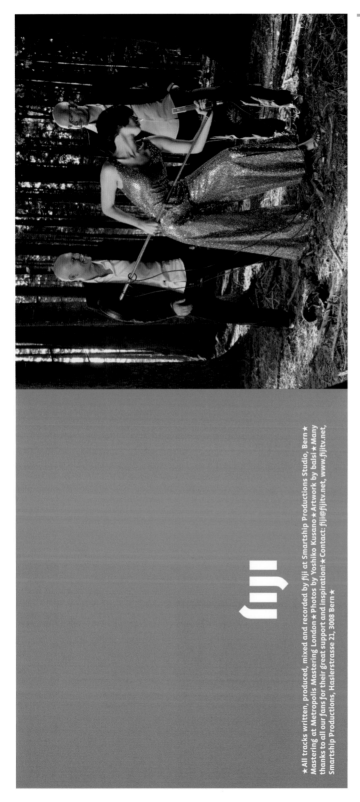

★ All tracks written, produced, mixed and recorded by fiji at Smartship Productions Studio, Bern ★ Mastering at Metropolis Mastering London ★ Photos by Yoshiko Kusano ★ Artwork by balsi ★ Many thanks to all our fans for their great support and inspiration! ★ Contact: fiji@fijitv.net, www.fijitv.net, Smartship Productions, Haslerstrasse 21, 3008 Bern ★

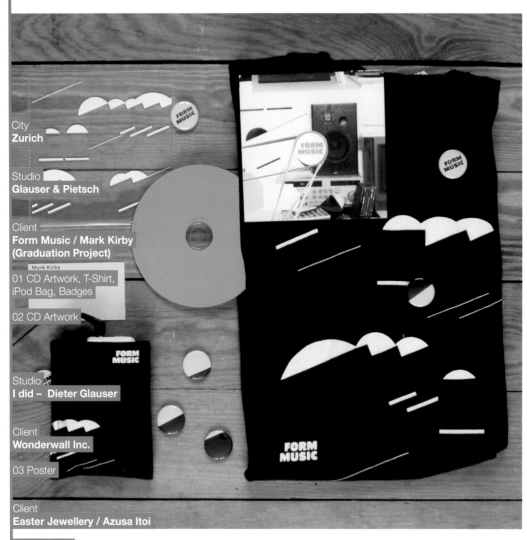

City
Zurich

Studio
Glauser & Pietsch

Client
**Form Music / Mark Kirby
(Graduation Project)**

Mark Kirby

01 CD Artwork, T-Shirt,
iPod Bag, Badges

02 CD Artwork

Studio
I did – Dieter Glauser

Client
Wonderwall Inc.

03 Poster

Client
Easter Jewellery / Azusa Itoi

04 Postcards

05 Folder

01

02

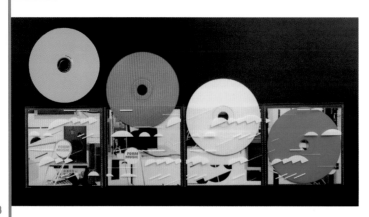

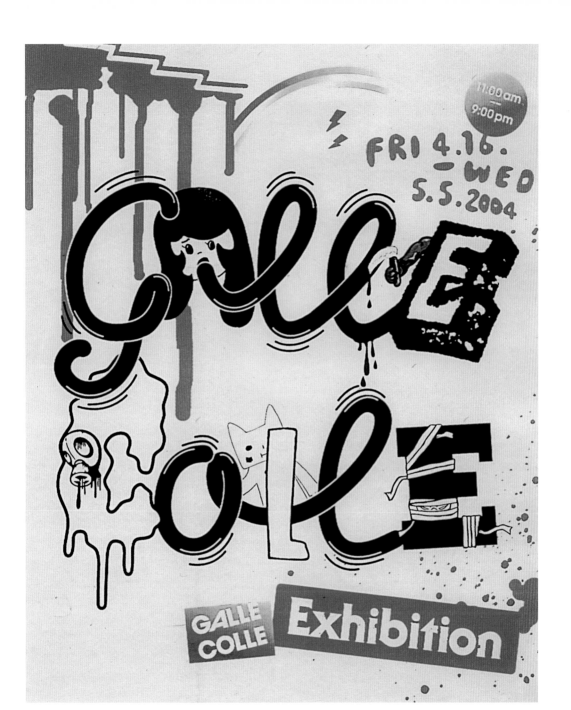

GALLE COLLE Exhibition

FRI 4.16. – WED 5.5.2004

11:00am – 9:00pm

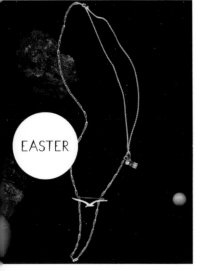

EASTER

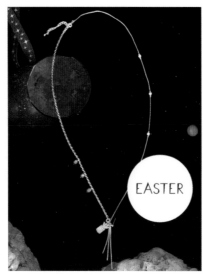

EASTER

EASTER

'MY VERY EDUCATED
MOTHER JUST SERVED
US NINE PIZZA'
COLLECTION

EASTER

A PROJECT BY AZUSA 1101 EASTERJEWELLERY.COM

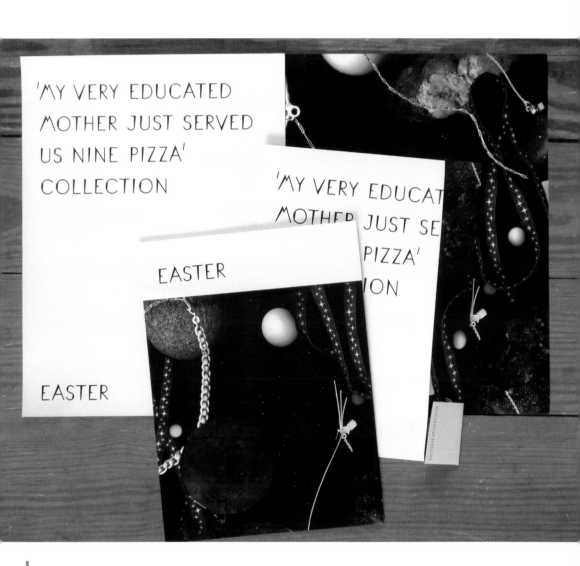

City
Zurich

Designer
**Dieter Glauser
& Michael Häne**

Client
HGKZ

06 Invitation Card
front / back

Hochschule für Gestaltung und Kunst Zürich

P. P.
CH-8031 ZÜRICH
D. Glasser & M. Häne

**EINLADUNG ZUR AUSSTELLUNG DER
DIPLOMARBEITEN 2003**
Sa 28.6. bis Do 10.7.
HGKZ, Hauptgebäude, Ausstellungsstrasse 60, 8005 Zürich, Eintritt frei
Mo-Fr 10 bis 20 Uhr, Sa-So 11 bis 18 Uhr

VERNISSAGE Fr 27.6., 17 bis 22 Uhr
Begrüssung im Foyer des Hauptgebäudes durch Prof. Dr. Hans-Peter Schwarz,
Rektor HGKZ, anschliessend Barbetrieb im ganzen Haus

FINISSAGE, DIPLOMÜBERGABE, VERLEIHUNG DER FÖRDERPREISE 2003
Do 10.7., 17 Uhr an der HGKZ, Hauptgebäude, Vortragssaal
Sommerfest ab 19 Uhr

Folgende Studienbereiche stellen im Hauptgebäude aus:
**INDUSTRIAL DESIGN, INNENARCHITEKTUR, HÖHERES LEHRAMT FÜR BILDNERISCHE
GESTALTUNG, MODE, TEXTIL, THEORIE DER GESTALTUNG UND KUNST, VISUELLE
GESTALTUNG, WERKEN, WISSENSCHAFTLICHE ILLUSTRATION, NDS GENDER STUDIES,
NDS MOBILE APPLICATION DESIGN, NDS SZENISCHES GESTALTEN**

Folgende Studienbereiche stellen im Sihlquai aus:
BILDENDE KUNST, FOTOGRAFIE Sihlquai 125
NEUE MEDIEN Galerie Binz 39, Sihlquai 133
Mo-Fr 12 bis 20 Uhr, Sa-So 11 bis 18 Uhr

MODESCHAU Fr 20.6., Show im Kaufleuten,
Pelikanstrasse 18, Zürich, Türöffnung 20.30 Uhr
Vorverkauf: Ticket Corner oder Abendkasse

FILM/VIDEO Mi 2.7., 12 Uhr
Filmvorführung, HGKZ, Hauptgebäude, Vortragssaal

Info: 01 446 21 11/www.hgkz.ch

ZEICHENMACHVORM HGKZ ...seit 125 jahren
Zürcher Fachhochschule

06

City
Bernex / Geneva

Designer
Thejudge

Client
Butter Bullets

01+02 Album Cover

Promotional Pictures

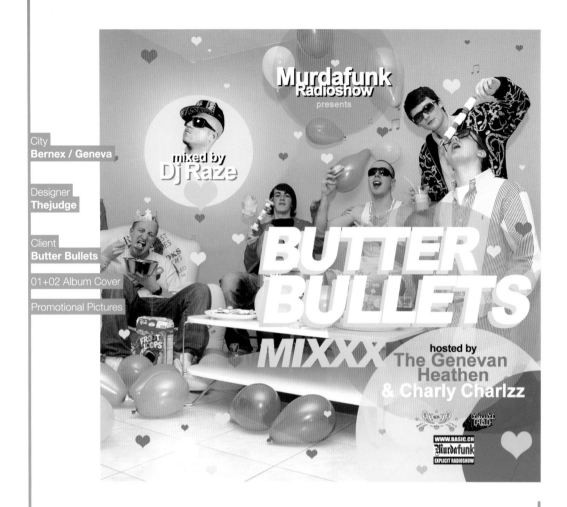

01

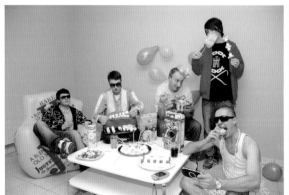

BUTTER BULLETS
MIXXX

1. Intro
2. Introduction
3. Yung Sid freestyle
4. Funky Break
5. Butter feat. Teki Latex & Raze : Week end
6. Jingle
7. Shaggy : Church Heathen
8. Lil Mama intro
9. Lil Mama: My lip gloss
10. Butter Bullets : Je fais ce que je veux
11. Come to me break
12. Butter Bullets feat. Omnikrom : Passez donc nous voir
13. USDA: White gurl intro
14. USDA : White gurl
15. Break em off
16. Paul Wall & Lil Kéké : Break em off
17. Yung Sid's ot shit
18. Butter Bullets : Sois débile
19. Jingle
20. 2pac & Nate Dog : Scandalous
21. Butter Bullets : Joyeuse Saint-Valentin Pétasse
22. Yung Sid freestyle
23. Butter Bullets : Où est mon fric?
24. Yung Sid: Get Buck
25. Jingle
26. 33HZ feat. Devin the Dude & Teki Latex (Dj Raze remix)
27. Yung Sid & Seen Mak : Love on the radio
28. Freaks of the Industry outro

www.murdafunk.com
www.liqwidcrack.com
www.myspace.com/murdafunk
www.myspace.com/butterbullets
www.myspace.com/genevanheathen

mai 06 2007 Artwork and pictures: ©thejudge (www.myspace.com/thejudge)

WWW.BASIC.CH
Murdafunk
EXPLICIT RADIOSHOW

02

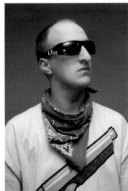
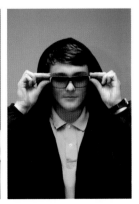

03

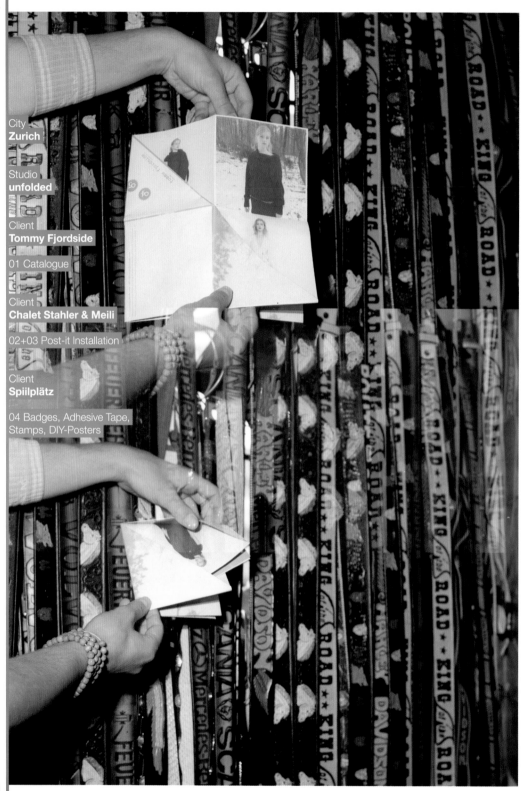

City
Zurich

Studio
unfolded

Client
Tommy Fjordside

01 Catalogue

Client
Chalet Stahler & Meili

02+03 Post-it Installation

Client
Spiilplätz

04 Badges, Adhesive Tape,
Stamps, DIY-Posters

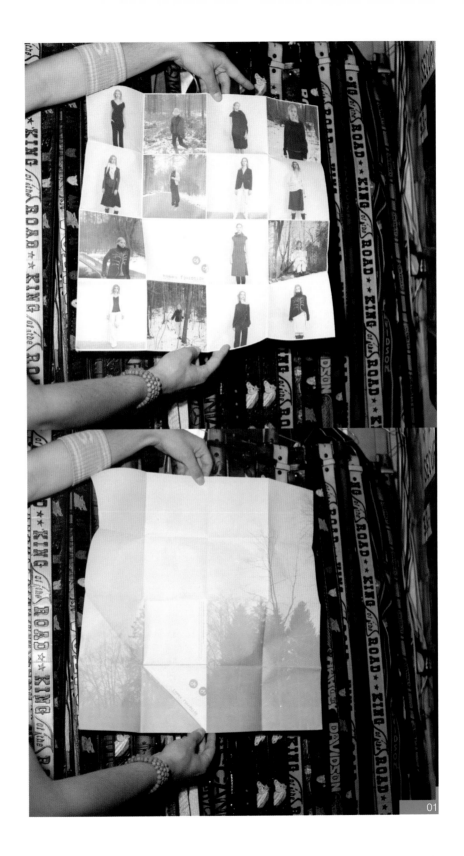

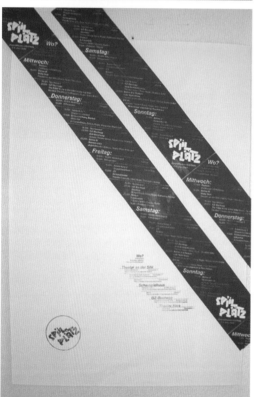

04

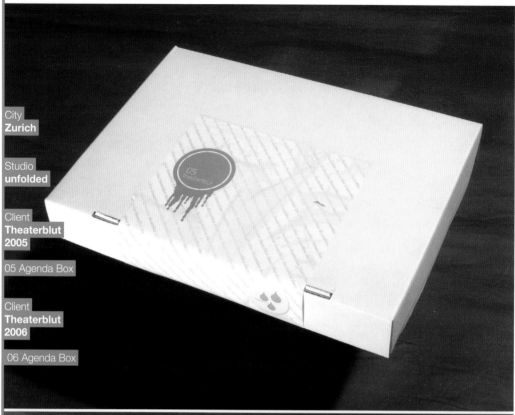

City
Zurich

Studio
unfolded

Client
**Theaterblut
2005**

05 Agenda Box

Client
**Theaterblut
2006**

06 Agenda Box

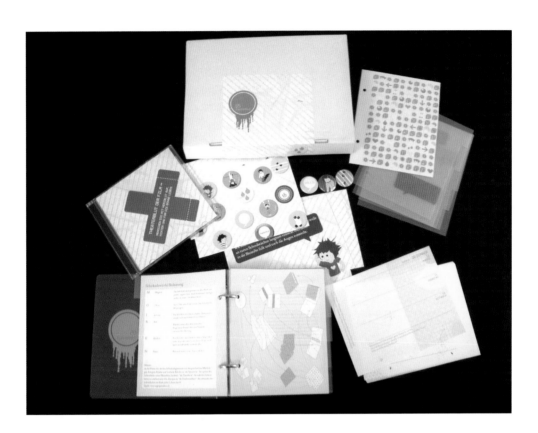

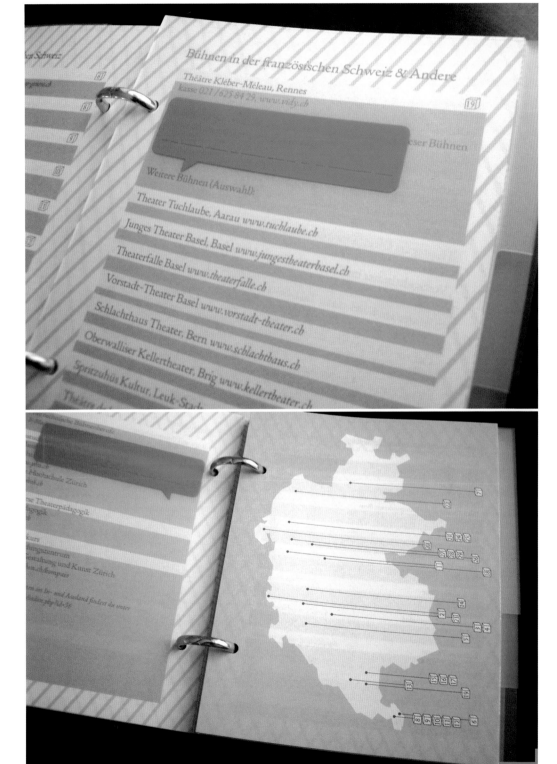

Théâtre Kléber-Méleau, Rennes
Kasse 021 / 625 84 29, www.vidy.ch

...eser Bühnen

Weitere Bühnen (Auswahl):

Theater Tuchlaube, Aarau www.tuchlaube.ch

Junges Theater Basel, Basel www.jungestheaterbasel.ch

Theaterfalle Basel www.theaterfalle.ch

Vorstadt-Theater Basel www.vorstadt-theater.ch

Schlachthaus Theater, Bern www.schlachthaus.ch

Oberwalliser Kellertheater, Brig www.kellertheater.ch

Spitzuhun Kultur, Leuk-Stadt...

...Hochschule Zürich

...e Theaterpädagogik

...gungszentrum
...ildung und Kunst Zürich

...en im In- und Ausland findest du unter

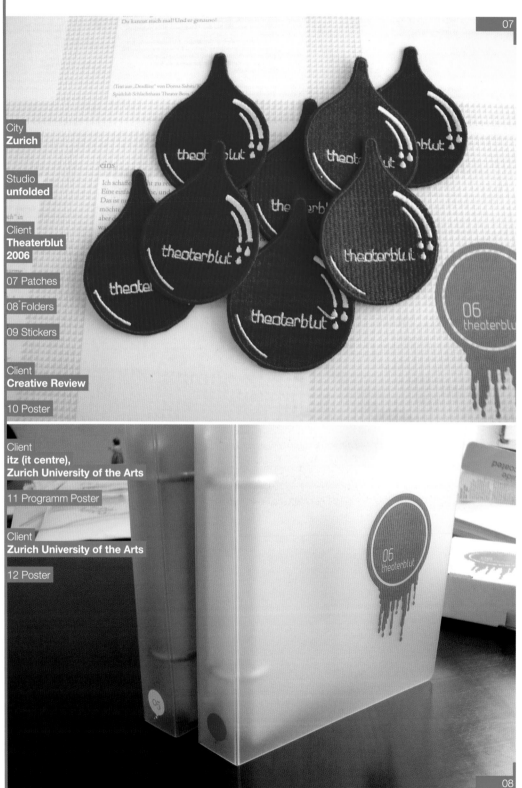

City
Zurich

Studio
unfolded

Client
**Theaterblut
2006**

07 Patches

08 Folders

09 Stickers

Client
Creative Review

10 Poster

Client
**itz (it centre),
Zurich University of the Arts**

11 Programm Poster

Client
Zurich University of the Arts

12 Poster

Date: Thursday 5 July | DJs: G the P & Grandmaster Nolan
Time: 7pm-1am
Entry: FREE
Venue: The Social,
5 Little Portland St,
W1

The Get Involved DJs return home to
The Social after a fun-filled Glastonbury trip,
tired but with big smiles on their faces.
No guest DJ this month as G the P and Grandmaster
Nolan answer Mastermind questions (via the medium
of old records) on their specialist subject:
Tracks that make you get up and dance,
clap your hands and say Yeah!

If you like dancing, smiling, whooping for joy
and monkeying around with a pair of maracas to a
soundtrack of the most uplifting records ever
committed to wax, what the heck are you waiting for?
Get involved)

www.myspace.com/getinvolvedclub

IF YOU COULD...
DRAW/WRITE YOUR MESSAGE
BELOW, WHAT WOULD YOU DO?
GET
INVOLVED!

Graphic design by Build

10

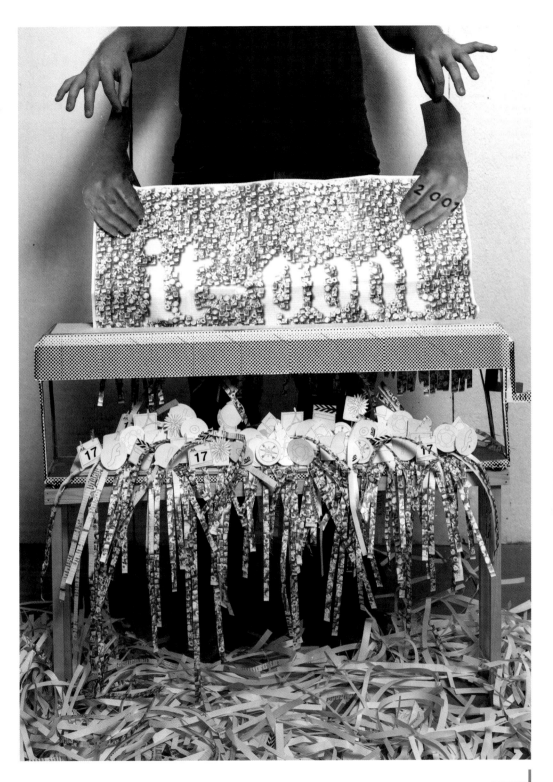

SZENOGRAFIE

Die neue Vertiefungsrichtung

SZENOGRAFIE

im zukünftigen Departement Darstellende Künste und Film

Die Verortung einer Vertiefungsrichtung Szenografie im zukünftigen Departement Darstellende Künste und Film (an der geplanten Zürcher Hochschule der Künste) hat zum Ziel, die Szenografie in Bezug zu den Künsten zu setzen, die ihren Ursprungsort und ihr Bezugsfeld beschreiben.

Es geht um die Schaffung einer Vertiefung für die Gestaltung von Raum im Theater, im Film und für Ausstellungen, Felder für die Präsenz und Präsentation von Mensch und Objekt. Es geht dabei am wenigsten um die Gestaltung von Umgebungen.

Szenografie beschreibt sowohl die Bühne des Theaters, den Zeit/Raum des Films, als auch den inszenierten Raum der Ausstellung.

Szenografen arbeiten selten allein. Das Studium ist von Anfang an auch als Einübung in die Teamorientiertheit und Teamabhängigkeit der Darstellenden Künste zu verstehen. Szenografinnen und Szenografen sind befähigt, ihre Ideen den künstlerisch beteiligten Partnern zu vermitteln. In Übungen und Arbeitsmodulen werden Aufgabenstellungen formuliert, die von ihrer Anlage her zu einem Arbeiten miteinander verpflichten. In der Auseinandersetzung mit Mitstudierenden soll der Student lernen, seinen künstlerischen Standpunkt zu beschreiben, ihn zur Diskussion zu stellen und Entscheidungen im Sinne des Anschlusses der beteiligten Kunstpartner zu fällen.

Die Besonderheit der Ausbildung im Departement Darstellende Künste und Film liegt neben dem Angebot der drei Richtungen Theater, Film und Ausstellung darin, dass die Studierenden schon während des Studiums innerhalb eines Systems von Theater- und Filmschaffenden und von Ausstellungsmachern arbeiten können, das dem der späteren Berufswelt entspricht. Das theoretisch Vermittelte kann praktisch erprobt werden.

Den Aufbau des 3-jährigen Studiums könnte man mit einem Container vergleichen, der die Grundausstattung enthält. Die wird den Studierenden befähigen, mit dem Abschluss als Assistent in den genannten Bereichen der Szenografie zu arbeiten.

Die Studienfächer sind:
- *Objekt/Mensch im Verhältnis zu Raum und Umraum*
- *Wahrnehmung und Umsetzung des Dreidimensionalen*
- *Zeichnen als Mittel der Komposition und der Kommunikation*
- *Entwerfen, technisches Zeichnen und CAD*
- *Fotografie und elektronische Bildbearbeitung*
- *Modellbau als übersetzte Wirklichkeit und Mittel der Raumerfahrung*
- *der Umgang mit Licht/Farbe/Sound in Raum und Natur*
- *Material und Wirkung*
- *Transformation und Verwandlungstechnik*

Das Erwerben von «basic tools» steht im Mittelpunkt.

Im Hinblick auf die sehr komplexen Berufsfelder geht es um ein praxisorientiertes Studium, es wird bei der Neuverortung um die Konkretheit der zu vermittelnden Studieninhalte gehen; den Studierenden wird durch den Erwerb konkreter Fähigkeiten ein hohes Maß an Kompetenz für die professionelle Praxis vermittelt, handwerkliche Fähigkeiten in den verschiedenen Aufgabenbereichen stehen dabei im Zentrum. Die künstlerische Persönlichkeit wird gestärkt durch das Ausprobieren in kleinen, genau definierten, früh in Bezug zu den Projekten in der Theater-, Film- und Tanzausbildung stehenden Projektformen. Diese Stehgreifübungen sind die Basis für die Anwendung des Erlernten. Das Prozessuale der Arbeit steht im Mittelpunkt.

Weitere Informationen:
Hochschule Musik und Theater Zürich
Departement Theater
Gessneralle 11, 8001 Zürich, Schweiz
Telefon: +41 43 305 43 31
E-Mail: departement-theater@hmt.edu
Internet: www.hmt.edu

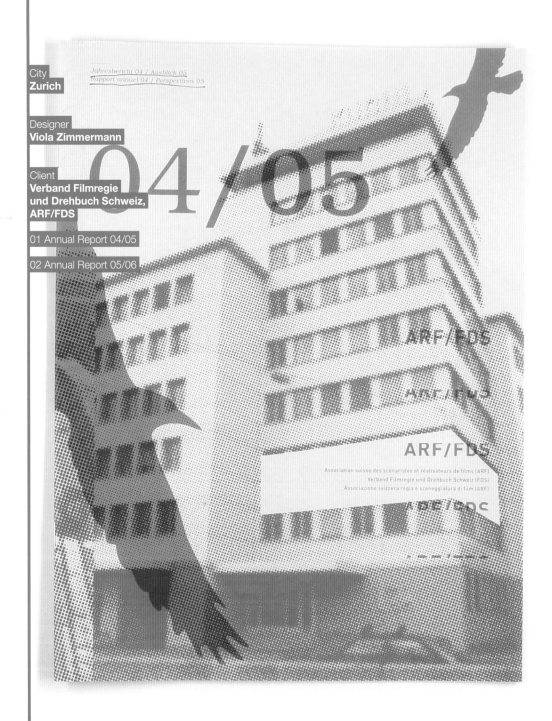

City
Zurich

Designer
Viola Zimmermann

Client
**Verband Filmregie
und Drehbuch Schweiz,
ARF/FDS**

01 Annual Report 04/05

02 Annual Report 05/06

Jahresbericht 04 / Ausblick 05
Rapport annuel 04 / Perspectives 05

ARF/FDS

Association suisse des scenaristes et realisateurs de films (ARF)
Verband Filmregie und Drehbuch Schweiz (FDS)
Associazione svizzera regia e sceneggiatura di film (ARF)

Unterstützung regionaler Aktivitäten

Situation in der Branche und kulturpolitische Irrungen und Wirrungen

Inhaltliche Auseinandersetzung mit unseren Filmwerken und kulturpolitische Veranstaltungen

Romed Wyder

»Timing«
von Romed Wyder

32 Ausblick 2005
Der ARF/FDS setzt sich im Verbandsjahr 2005 folgende Schwerpunkte:

Ralf Lang

Hans-Ulrich Schlumpf

Jahresbericht 2005 und Ausblick 2006
Rapport annuel 2005 et perspectives 2006

City
Zürich

Designer
Viola Zimmermann

Client
Gaucho Delux GmbH

03 Beer Mats

04 Packaging,
Matches, Flyer

Client
Self-Promotion

05 Card Game

Client
**Pro Helvetia –
Schweizer Kulturstiftung**

06 Poster

Client
Rote Fabrik

07 Flyer

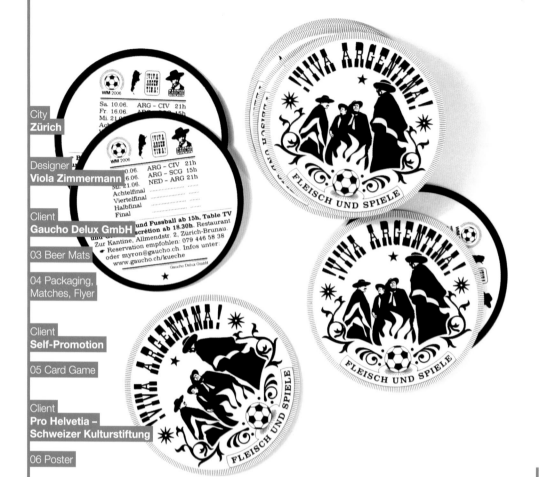

03

04

City
Zürich

Designer
Viola Zimmermann

Client
Rote Fabrik

08 Posters
(in Co-Operation
with Francois Châlet)

Client
Atame

09 Bag

Client
Rote Fabrik

10 Poster

Client
Timetunnel

11 Postcards

Client
Co-Lab, Claudia Güdel

12 Poster / Flyer

08

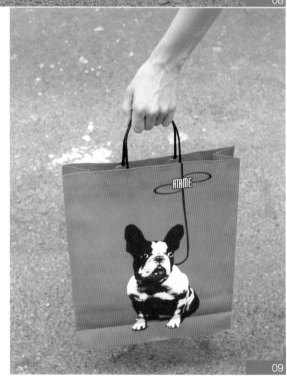

09

ROTE FABRIK
SEESTR. 395, ZÜRICH
WWW.LETHARGY.CH

LETHARGY
'07

FR. 10.8.
23:00

AKTIONSHALLE
JOAKIM & THE ECTOPLASMICS LIVE (VERSATILE PARIS F)
GUI BORATTO LIVE (KOMPAKT SAO PAULO BR)
ALEX SMOKE LIVE (SOMA / VAKANT REC. GLASGOW UK)
MR FLAZH (VIKING MUSIC GE)
SKY JANSSEN & EZIKIEL(ANYMANY ZH / TI)
BEDA (P45 ZH) U/S: PROJEKTIL / TIEFGLANZ / LENARMY
BLUBBBLUBB / FLEXXI / TRIGGER

CLUBRAUM
BLACK DEVIL DISCO CLUB LIVE (LO-REC. PARIS F)
PADDED CELL LIVE + DJ (DC RECORDINGS LONDON UK)
ANNAKIN LIVE (AKIN REC. ZH)
SHAHIRA (MINIMALDESIGNER BERLIN / ZH)
JACQUI (ARCHIPEL / LAUSANNE VD)

FABRIKTHEATER
VARIOUS PRODUCTION (XL REC. LONDON UK)
HEY-O-HANSEN LIVE (HEY REC. BERLIN D)
MALA (DIGITAL MYSTIKZ / DMZ LONDON UK)
PEAK (FINE ART ZH)
NEW.COM (P45 / COMFORTNOISE.COM ZH)
BLADE (GET REC. ZH)

SHEDHALLE CHILL OUT
MARCO REPETTO LIVE (INZEC REC. BE)
ANDY GOBELI LIVE (MINIMALDESIGNER ZH)
PACO (NEUES NICHTS ZH)
ELI VERVEINE (SCANDAL! ZH)

SA. 11.8.
23:00

AKTIONSHALLE
WIGHNOMY BROTHERS (FREUDE AM TANZEN JENA D)
REDSHAPE LIVE (PRESENT / STYRAX BERLIN D)
KISSOGRAM LIVE (LOUISVILLE BERLIN D)
GALOPPIERENDE ZUVERSICHT LIVE (BRUCHSTÜCKE ZH)
CROWDPLEASER LIVE (MENTALGROOVE GE)
SAMPAYO (CHROMOLUX /GRUBENSTRASSE ZH)
PERLE DER SÜDSEE (GLÜCKSSCHERBEN ZH / BS)
U/S: PASCAL GRECO / LABORATOIRE / TOMAS KUDRNA
BILDSTÖRUNG / IVAN E / TRIGGER / PIXELPUNX

CLUBRAUM
UTAH SAINTS DECKS'N'FX (SUGARBEATCLUB LEEDS UK)
DMX KREW LIVE (REPHLEX / BREAKIN' LONDON UK)
REMUTE LIVE (NUM / AREAL HAMBURG DE)
RIZZOKNOR LIVE (ZH)
PA-TEE (ABBRUCHHAUS SG)
RUMORY (BEATPIRATES ZH)

FABRIKTHEATER
SICK GIRLS (REVOLUTION N° 5 BERLIN DE)
K CHICO LIVE (FESTPLATTEN BERLIN D)
AST (EFFEKTHASCHEREI ZH)
CEO MÜLLER (TRES AMIGOS / RAPHISTORY ZH)
MT DANCEFLOOR (SAALSCHUTZ / ZICK ZACK ZH)

SHEDHALLE CHILL OUT
COSILT LIVE (P45 / MOTOGUZZI ZH)
DES WAHNSINNS FETTE BEUTE (D)
FANGO PACKUNG (D)
PANAUSE (SYNTOSIL ZH)

SO. 12.8.
AFTERHOUR
OPENAIR / CLUBRAUM
THE KOOKY SCIENTIST LIVE (PLUS 8, SUBSTATIC USA)
STYRO2000 (BRUCHSTÜCKE ZH)
P.BELL (BEATPIRATES ZH)
IDA (BEATPIRATES ZH)
CO:MINI (GLÜCKSTÜCK / GRUBENSTRASSE ZH)

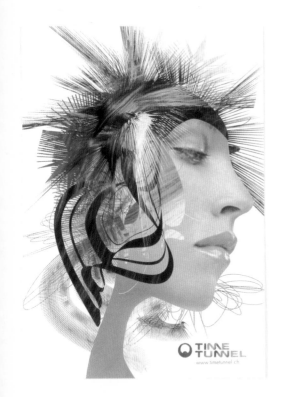

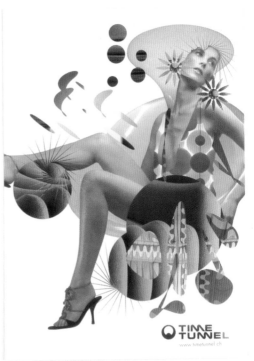

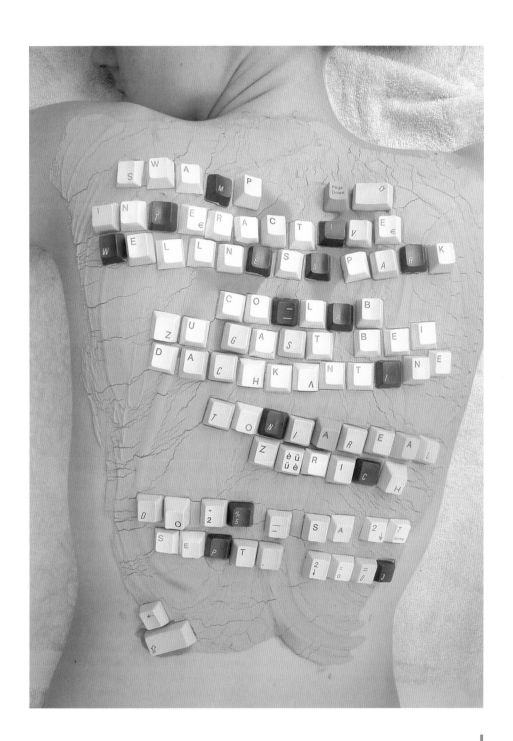

City
Zürich

Designer
Viola Zimmermann

Client
**Y – Institut für
Transdisziplinarität,
Hochschule der Künste Bern**

13 Poster

14 Flyer

15 Booklet

31.3.–1.4.2006: Ein Symposium zu Kunst und Wissenschaft
des Instituts für Transdisziplinarität (Y) der HKB

leicht

Information: www.hkb.bfh.ch/y

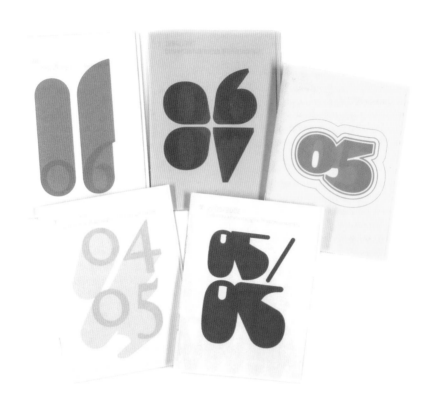

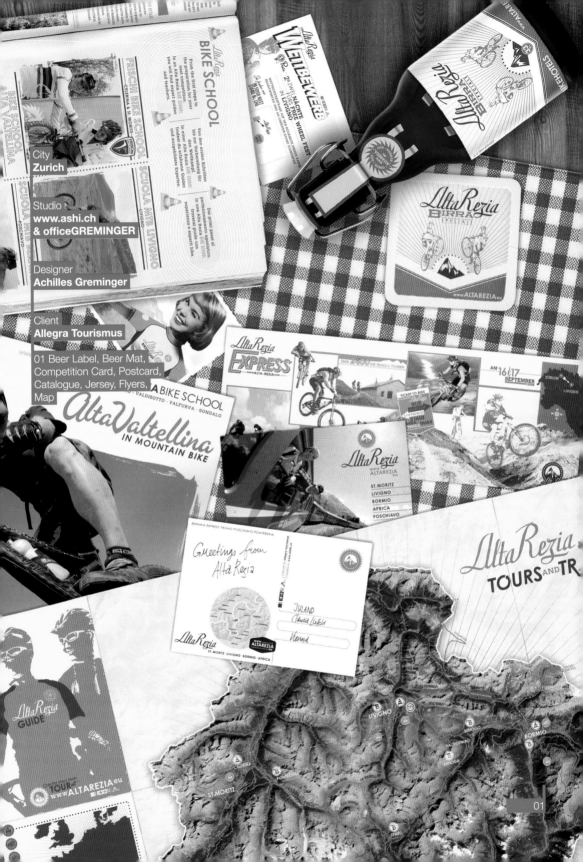

City
Zurich

Studio
www.ashi.ch
& officeGREMINGER

Designer
Achilles Greminger

Client
Allegra Tourismus

01 Beer Label, Beer Mat,
Competition Card, Postcard,
Catalogue, Jersey, Flyers,
Map

Now we will see how designers and studios promote themself

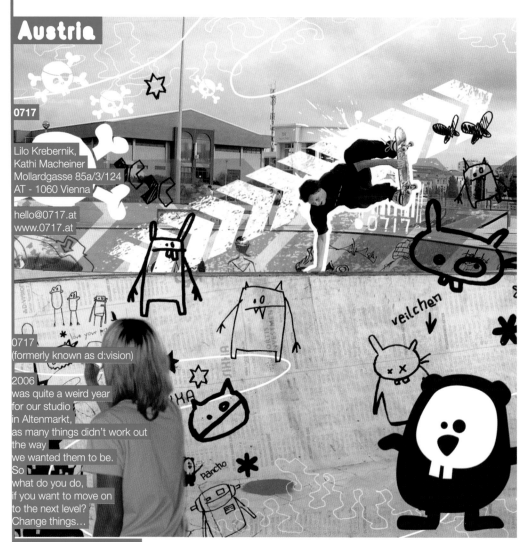

Austria

0717

Lilo Krebernik,
Kathi Macheiner
Mollardgasse 85a/3/124
AT - 1060 Vienna

hello@0717.at
www.0717.at

0717
(formerly known as d:vision)

2006
was quite a weird year
for our studio
in Altenmarkt,
as many things didn't work out
the way
we wanted them to be.
So
what do you do,
if you want to move on
to the next level?
Change things…

Moving the studio early 2007
to Vienna
was just one decision.
Dropping the name d:vision
was another.

But teaming up
with people like Via Grafik,
C100 or Raw Studio
on
different projects
opens up a lot more
opportunities for the
future.

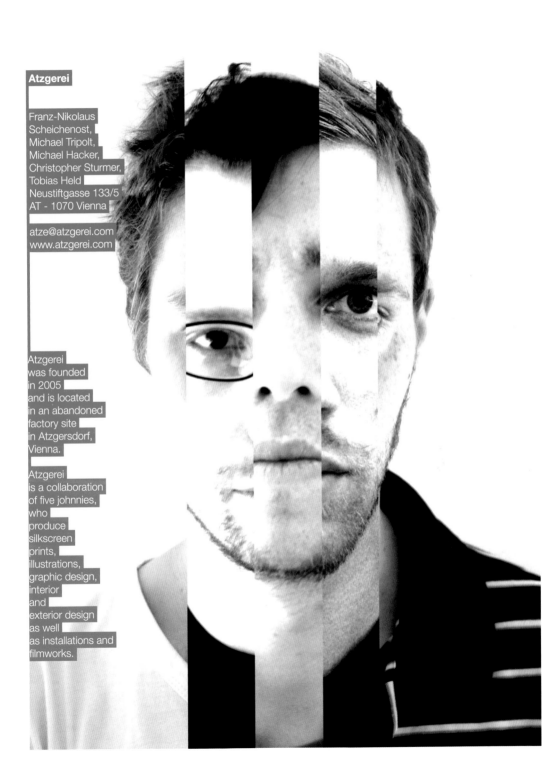

Atzgerei

Franz-Nikolaus
Scheichenost,
Michael Tripolt,
Michael Hacker,
Christopher Sturmer,
Tobias Held
Neustiftgasse 133/5
AT - 1070 Vienna

atze@atzgerei.com
www.atzgerei.com

Atzgerei
was founded
in 2005
and is located
in an abandoned
factory site
in Atzgersdorf,
Vienna.

Atzgerei
is a collaboration
of five johnnies,
who
produce
silkscreen
prints,
illustrations,
graphic design,
interior
and
exterior design
as well
as installations and
filmworks.

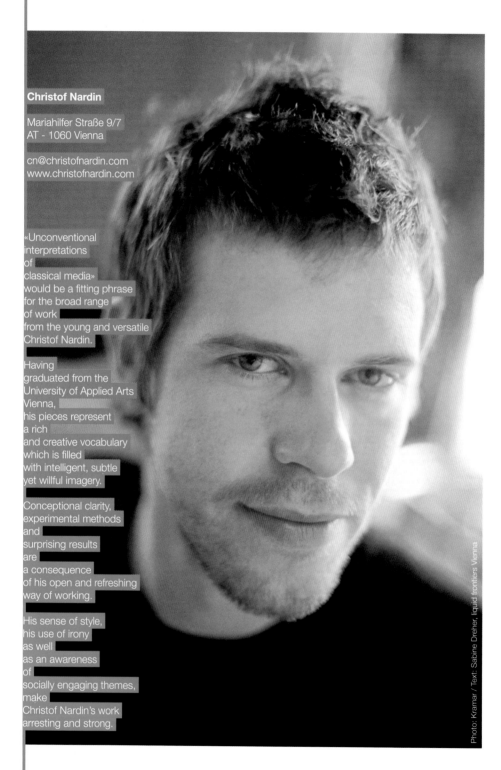

Christof Nardin

Mariahilfer Straße 9/7
AT - 1060 Vienna

cn@christofnardin.com
www.christofnardin.com

«Unconventional
interpretations
of
classical media»
would be a fitting phrase
for the broad range
of work
from the young and versatile
Christof Nardin.

Having
graduated from the
University of Applied Arts
Vienna,
his pieces represent
a rich
and creative vocabulary
which is filled
with intelligent, subtle
yet willful imagery.

Conceptional clarity,
experimental methods
and
surprising results
are
a consequence
of his open and refreshing
way of working.

His sense of style,
his use of irony
as well
as an awareness
of
socially engaging themes,
make
Christof Nardin's work
arresting and strong.

Photo: Kramar / Text: Sabine Dreher, liquid frontiers Vienna

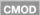

CMOD

Paul Busk
Museumsplatz 1/e1/4/1
AT - 1070 Vienna

cmod@gmx.at
www.cmod.at

BUSK says hello

CMOD is an office
for font
and graphic design
in Vienna, Austria.

Motivation: City

Message: MODification

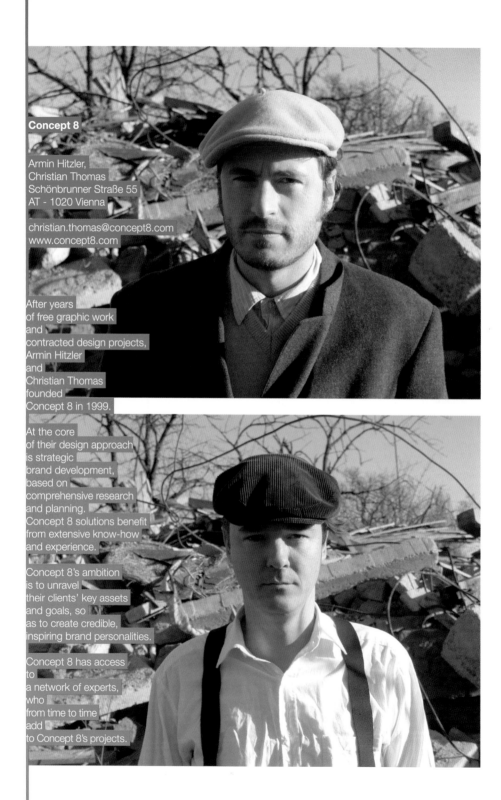

Concept 8

Armin Hitzler,
Christian Thomas
Schönbrunner Straße 55
AT - 1020 Vienna

christian.thomas@concept8.com
www.concept8.com

After years
of free graphic work
and
contracted design projects,
Armin Hitzler
and
Christian Thomas
founded
Concept 8 in 1999.

At the core
of their design approach
is strategic
brand development,
based on
comprehensive research
and planning.
Concept 8 solutions benefit
from extensive know-how
and experience.

Concept 8's ambition
is to unravel
their clients' key assets
and goals, so
as to create credible,
inspiring brand personalities.

Concept 8 has access
to
a network of experts,
who
from time to time
add
to Concept 8's projects.

Daniel Hammer

Erdberger Lände 10/19
AT - 1030 Vienna

od777@hotmail.com
www.hammertype.com

Daniel Hammer
graduated in 2006
at the
Meisterklasse
für Grafik- und
Kommunikationsdesign
in Linz.

While working
on
several freelance
projects,
mainly in the field
of
print design,
he is also
working
for the Viennese
design
agency Rosebud Inc.

Drahtzieher

Margit Ehrnstorfer,
Robert Six,
Marcus Sterz,
Barbara Wais
Otto Bauer Gasse 24
AT - 1060 Vienna

welcome@drahtzieher.at
www.drahtzieher.at

Drahtzieher
creative studio
represents a team of
four
graphic designers
specialised
in corporate design,
editorial design,
exhibition design
as well as
typography,
illustration
and screen design.

Being «design-aficionados»,
we always
keep an eye on current
design
developments
and
love to participate
in the
exchange of fresh ideas!

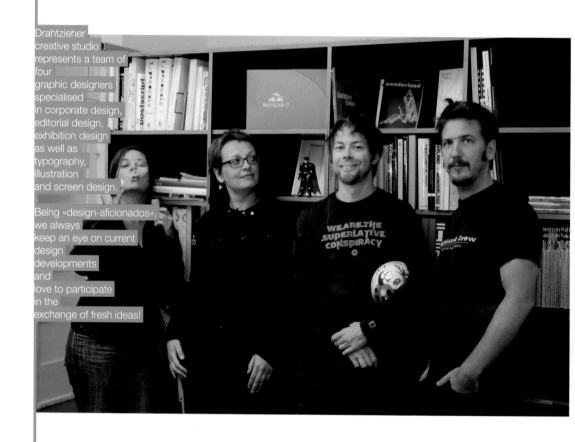

ICHIBAN

Brunhildengasse 1/1/1
AT - 1150 Vienna

office@ichiban.at
www.ichiban.at

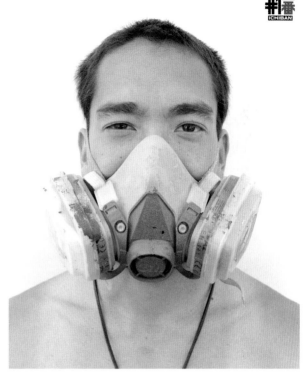

The roots of ichiban,
the Japanese word
for number one,
are based in the family.
Founded
from the brothers Akira
and
Ken Sakurai-Karner,
ichiban started as a family project,
to serve as an innovative platform
for
visual communication,
within a community of artists.

Later also Ray,
the oldest brother,
and
Maiko Sakurai-Karner,
the youngest sister,
Sito Schwarzenberger
and Bastian Kissler decided
to join ichiban.

The results of all these efforts
is the creation
of
an innovative possibilities
for figurative communication
in countless variations.

The motivation
and underlying goal is to
create
something with permanence,
something inspiring and
moving.

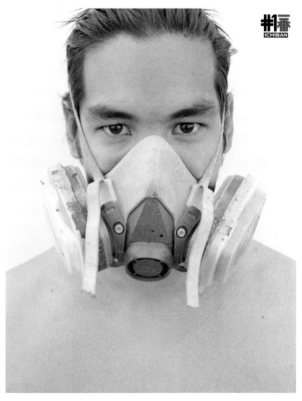

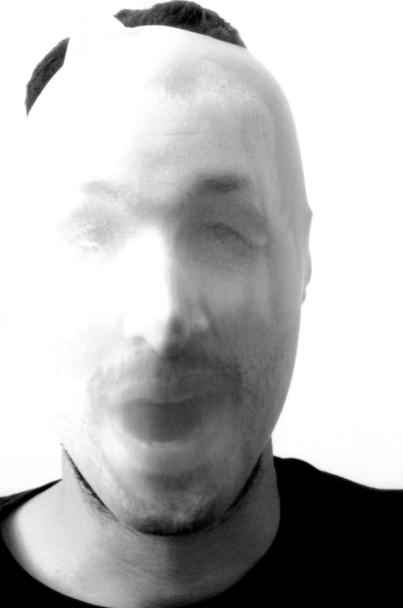

isebuki

Mag. Bernhard Faiss
Hufeland 1/10
AT - 1120 Vienna

b@isebuki.com
www.isebuki.com

Bernhard Faiss
is a digital artist
and
communications designer.
Born in Vienna
and educated at the
University
of Applied Arts Vienna,
and
UdK Berlin,
he is the founder of «isebuki»,
an
independent,
interdisciplinary network
for
people working
in the creative fields.
His clients include
musicians,
social associations
and industrial designers.

Bernhard Faiss
seeks to bring
new approaches
to the design process.
His
concept of reduced
design refers to
a graphic technique
that adheres
to
the tenets of minimalism.

JULAND BarcelonVienna

Julia Taubinger
Andrés Fredes
Bergsteiggasse 14-16/2/5
AT - 1170 Vienna

vienna@julandscape.com
www.julandscape.com

JULAND develops projects
and visions
in line
with creative communication.
JULAND designs concepts
and strategies
on the basis of research
and an architecture of solutions.
Architecture, Design, Design Consulting,
Event management, Music, Publishing,
Design Curation
AroundEurope collection books
PadFinderMagazine.com
and
The project
PureAustrianDesign
has been created in 2004
by Julia Taubinger
and Andrés Fredes
aiming
to promote Austrian design,
in the
international design-scene.
Ever since
its beginning, a sustainable
clear statement
of the AustrianDesign
has been created
and carried out
worldwide by publications,
exhibitions
and the internet platform
www.pureaustriandesign.com

Peach

Birgit Vollmeier
Yudi Warsosumarto
Gumpendorferstraße 43
AT - 1060 Vienna

office@peach.at
www.peach.at

Peach is a small and powerful team/ founded in 1999/ offers their services to clients and agencies as a professional project team in the areas of Advertising, Brand-Creation, Direct Marketing, Promotion and Design/ works according to the individual demands with competent partners.

Photo: Markus Vollmeier

NAPOLEON WASN'T BIG EITHER.

See that small can do big stuff.

Sabine Lorenz

Stolzenthalergasse 17/7A
AT - 1080 Vienna

sabine.lorenz@flim.at
www.flim.at

Sabine Lorenz
studied
Intermedia
at the
Fachhochschule Vorarlberg
in Dornbirn.

With the zero-edition of
FLIM
as her final project,
she finished
her studies successfully.

Her theoretical
as well as
practical interest
is
directed at
films and graphic design.

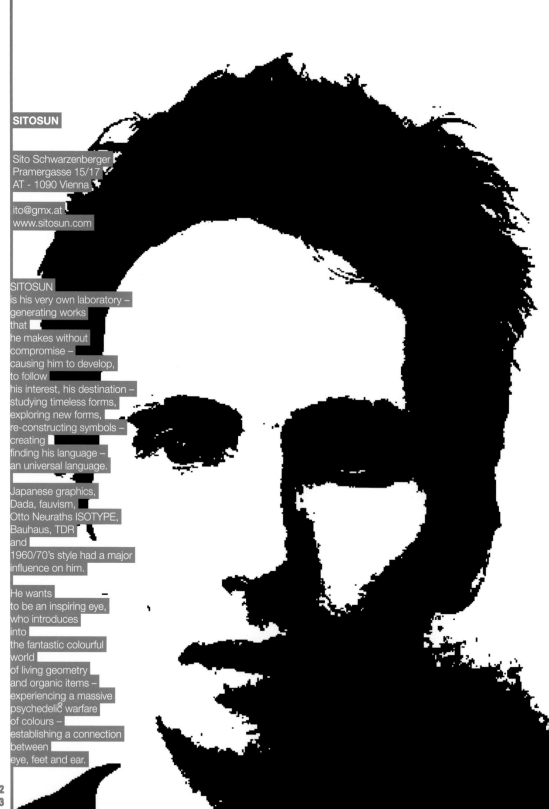

SITOSUN

Sito Schwarzenberger
Pramergasse 15/17
AT - 1090 Vienna

ito@gmx.at
www.sitosun.com

SITOSUN
is his very own laboratory –
generating works
that
he makes without
compromise –
causing him to develop,
to follow
his interest, his destination –
studying timeless forms,
exploring new forms,
re-constructing symbols –
creating
finding his language –
an universal language.

Japanese graphics,
Dada, fauvism,
Otto Neuraths ISOTYPE,
Bauhaus, TDR
and
1960/70's style had a major
influence on him.

He wants
to be an inspiring eye,
who introduces
into
the fantastic colourful
world
of living geometry
and organic items –
experiencing a massive
psychedelic warfare
of colours –
establishing a connection
between
eye, feet and ear.

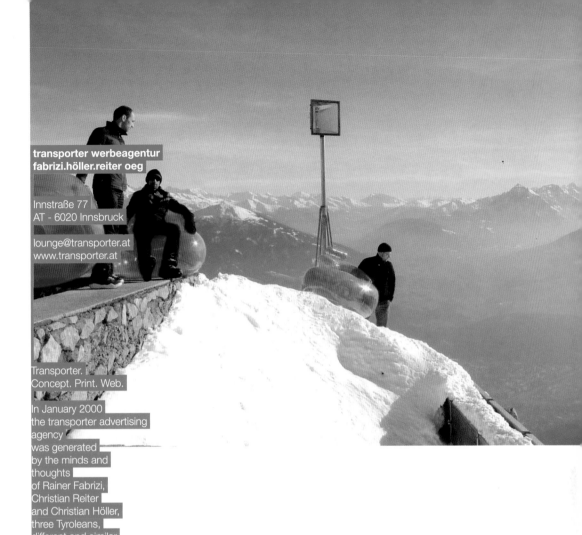

transporter werbeagentur
fabrizi.höller.reiter oeg

Innstraße 77
AT - 6020 Innsbruck

lounge@transporter.at
www.transporter.at

Transporter.
Concept. Print. Web.

In January 2000
the transporter advertising
agency
was generated
by the minds and
thoughts
of Rainer Fabrizi,
Christian Reiter
and Christian Höller,
three Tyroleans,
different and similar
enough
to provide
a high-productive
environment
with
the force to create.

transporter develops
design solutions
for the
individual design challenge
assuring
to be unique
and eye-catching
while «transporting»
the message
straight to the audience.

Treibhaus Wien

Ulrike Dorner,
Georg Leditzky
Siebensterngasse 19/1/3
AT - 1070 Vienna

info@treibhaus-wien.at
www.treibhaus-wien.at

Treibhaus Wien
are
Ulrike Dorner
and
Georg Leditzky.

We both
have graduated
at the
Fachausbildung
für Grafik Design
at the
Wiener Werbe Akademie.

After collecting
some
useful experiences
from
work experience
and freelancing,
we
have thrown ourselves
in at the deep end
and
have founded
Treibhaus Wien.

We work in
the fields of
Corporate Design,
Editorial Design,
Packaging, Illustration
and
Advertising.

Belgium

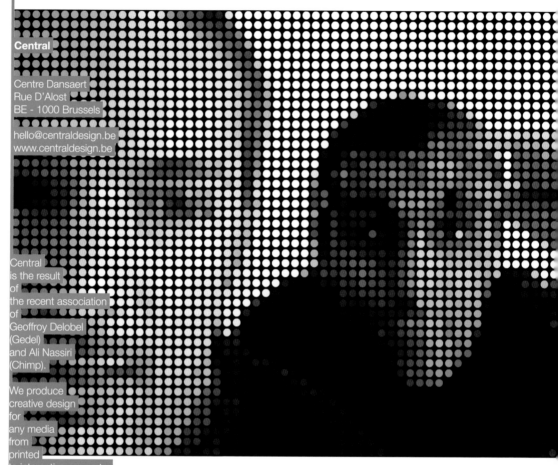

Central

Centre Dansaert
Rue D'Alost
BE - 1000 Brussels

hello@centraldesign.be
www.centraldesign.be

Central
is the result
of
the recent association
of
Geoffroy Delobel
(Gedel)
and Ali Nassiri
(Chimp).

We produce
creative design
for
any media
from
printed
to interactive supports.

Central
is based in Brussels,
Belgium.

Dikke Neus Verbond

Bert Beckers
Gischotelle 391
BE - 2140 Borgerhout

bert.beckers@dikkeneusverbond.be
www.dikkeneusverbond.be

In 1999
I graduated as a graphic
designer/
illustrator at St. Lucas
in Antwerp.

Immediately I started working
as production design slave
in several dot bombs.
I felt
I had to make more of
my illustration/design
qualities
and started exploring
possibilities
of
becoming a freelance illustrator.

My new found activities
were all bundled under the name
«Het Dikke Neus Verbond»
a one man
illustration/
graphic design alliance,
working
for a couple of small
companies
and
some non-profit organisations.

Since then
I started working
for
«These Days» in Antwerp
as an Multimedia designer
during the day,
at night
I transform into
a mean lean
illustration design machine!

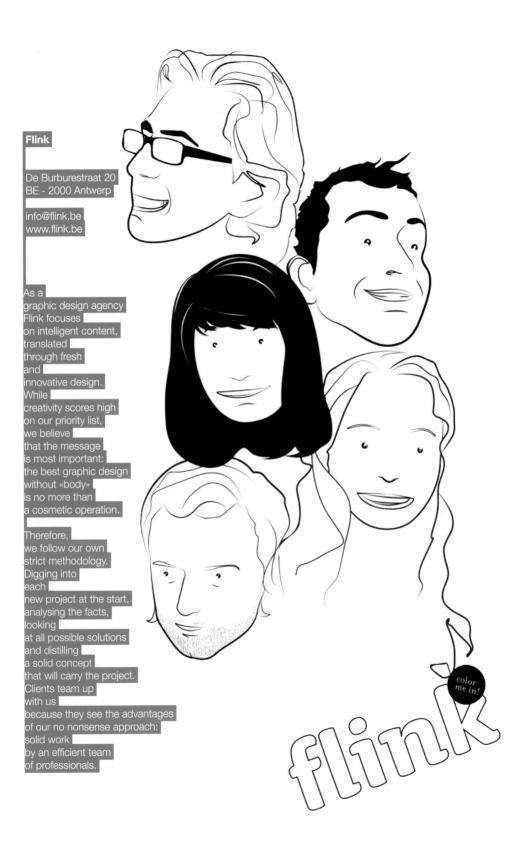

Flink

De Burburestraat 20
BE - 2000 Antwerp

info@flink.be
www.flink.be

As a
graphic design agency
Flink focuses
on intelligent content,
translated
through fresh
and
innovative design.
While
creativity scores high
on our priority list,
we believe
that the message
is most important:
the best graphic design
without «body»
is no more than
a cosmetic operation.

Therefore,
we follow our own
strict methodology.
Digging into
each
new project at the start,
analysing the facts,
looking
at all possible solutions
and distilling
a solid concept
that will carry the project.
Clients team up
with us
because they see the advantages
of our no nonsense approach:
solid work
by an efficient team
of professionals.

color
me in!

flink

Ingeborg Schindler

22, Rue Antoine Labarre
BE - 1050 Brussels

inge.binge@gmx.de
www.ingraphisme.com

German-French
influenced
designer and illustrator
Ingeborg Schindler always
loved drawing.

Obsessed
since her childhood –
expressing
with colours,
combinated by forms
and images,
shadowed
by the use of literature –
she graduated
at the
University of Applied Sciences
in Mainz, Germany.

Dedicated her degree
in illustration,
she finalised
her Bachelor at the
Académie des Beaux-Arts
de Bruxelles.

«French-illustration-style-inspired»
she stayed
and collaborated
in several design agencies.

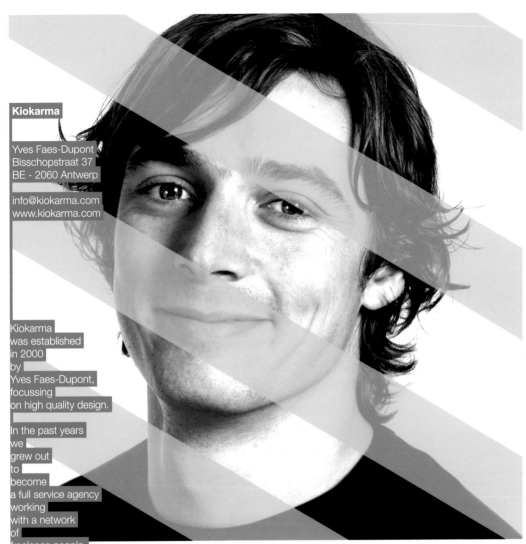

Kiokarma

Yves Faes-Dupont
Bisschopstraat 37
BE - 2060 Antwerp

info@kiokarma.com
www.kiokarma.com

Kiokarma
was established
in 2000
by
Yves Faes-Dupont,
focussing
on high quality design.

In the past years
we
grew out
to
become
a full service agency
working
with a network
of
freelance people.

We specialise
in
corporate identity,
print
and webdesign,
illustration
and
product graphics.

**Not Another
Graphic Designer**

Pieter De Kegel
Henri Pirennelaan 67
BE - 9050 Gent

info@notanothergraphicdesigner.com
www.notanothergraphicdesigner.com

NAGD
is
Not Another
Graphic Designer.

Graduated
in 2003 at Sint-Lucas
College
of Science and Art
in Gent, Belgium.

Started
doing freelance
graphic design
in the
summer of 2005.

Currently Art Director
and
graphic designer
for Cult of Cool
and
Move-X magazine.

NAGD
is
doing graphic design
in
all colours, shapes
and sounds.

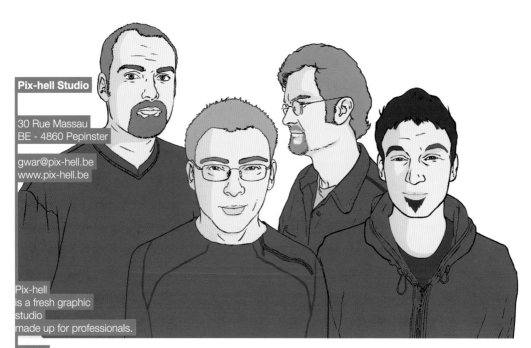

Pix-hell Studio

30 Rue Massau
BE - 4860 Pepinster

gwar@pix-hell.be
www.pix-hell.be

Pix-hell
is a fresh graphic
studio
made up for professionals.

Pix-hell
offers a wide variety
of services
in many domains
like
illustration, 3D, graphic
and web design.

We try to give
to
our customers
a dynamic
and original way
to
valorise their products,
projects or events.

What
we like in life:
fur dices,
bobble head dogs,
swinging
tunes of Samantha Fox
and
Céline Dion's slow songs,
singing trout,
the little house on the prairie…

We are just like you:
happy consumers…

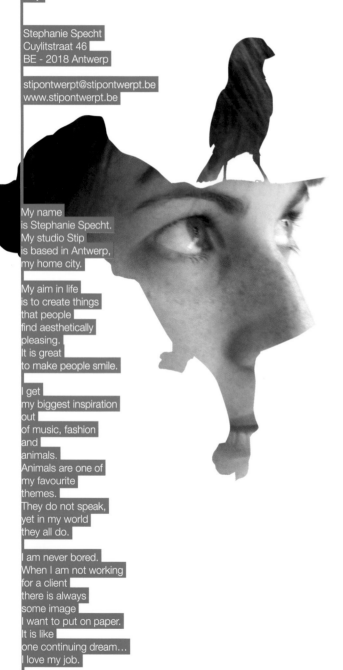

Stip

Stephanie Specht
Cuylitstraat 46
BE - 2018 Antwerp

stipontwerpt@stipontwerpt.be
www.stipontwerpt.be

My name
is Stephanie Specht.
My studio Stip
is based in Antwerp,
my home city.

My aim in life
is to create things
that people
find aesthetically
pleasing.
It is great
to make people smile.

I get
my biggest inspiration
out
of music, fashion
and
animals.
Animals are one of
my favourite
themes.
They do not speak,
yet in my world
they all do.

I am never bored.
When I am not working
for a client
there is always
some image
I want to put on paper.
It is like
one continuing dream...
I love my job.

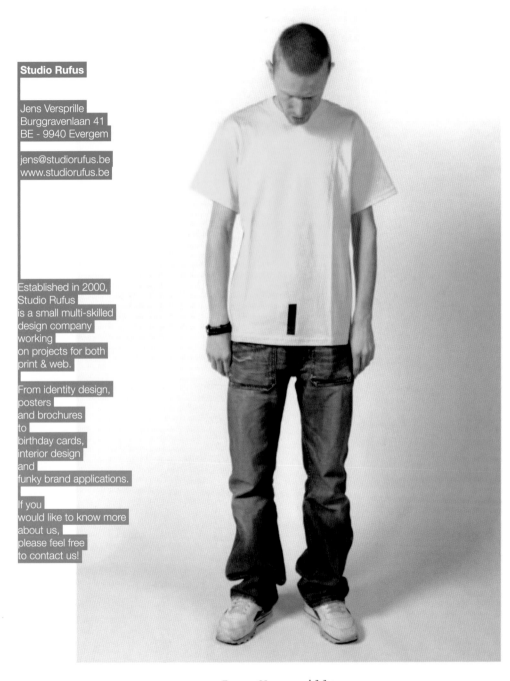

Studio Rufus

Jens Versprille
Burggravenlaan 41
BE - 9940 Evergem

jens@studiorufus.be
www.studiorufus.be

Established in 2000,
Studio Rufus
is a small multi-skilled
design company
working
on projects for both
print & web.

From identity design,
posters
and brochures
to
birthday cards,
interior design
and
funky brand applications.

If you
would like to know more
about us,
please feel free
to contact us!

Jens Versprille,
Founder of Studio Rufus

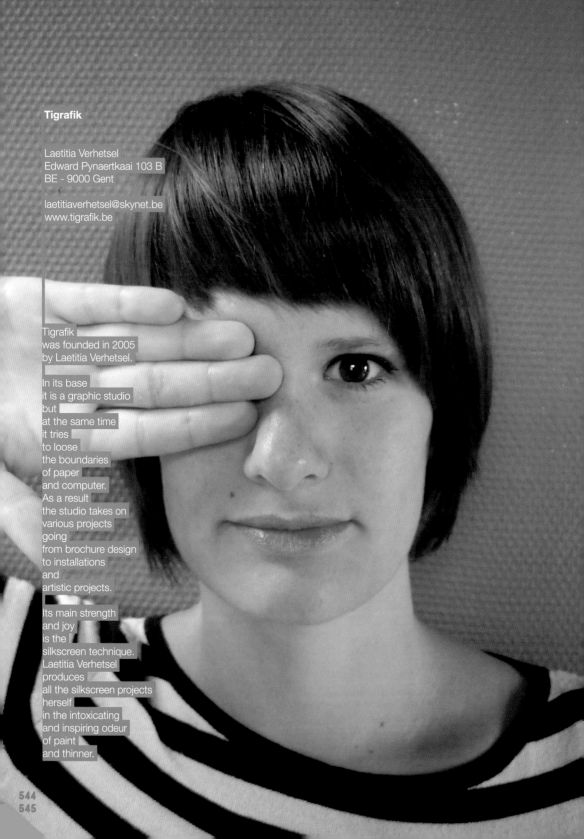

Tigrafik

Laetitia Verhetsel
Edward Pynaertkaai 103 B
BE - 9000 Gent

laetitiaverhetsel@skynet.be
www.tigrafik.be

Tigrafik
was founded in 2005
by Laetitia Verhetsel.

In its base
it is a graphic studio
but
at the same time
it tries
to loose
the boundaries
of paper
and computer.
As a result
the studio takes on
various projects
going
from brochure design
to installations
and
artistic projects.

Its main strength
and joy
is the
silkscreen technique.
Laetitia Verhetsel
produces
all the silkscreen projects
herself
in the intoxicating
and inspiring odeur
of paint
and thinner.

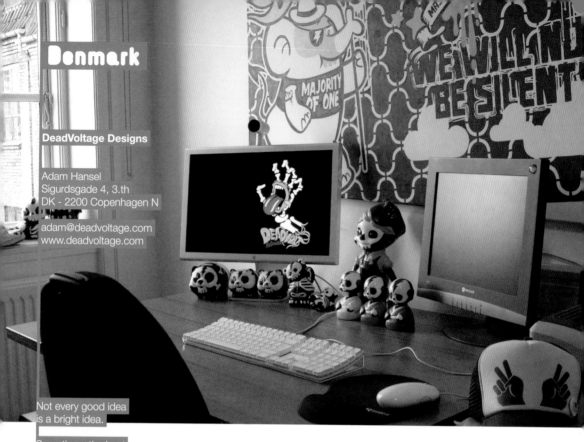

Denmark

DeadVoltage Designs

Adam Hansel
Sigurdsgade 4, 3.th
DK - 2200 Copenhagen N

adam@deadvoltage.com
www.deadvoltage.com

Not every good idea
is a bright idea.

Sometimes the best
graphic approaches
come from
the worst possible concepts.

I try to look
at most things backwards,
and often that leads me
to a positive solution.

Who knows… two negatives
really
do equal a positive.

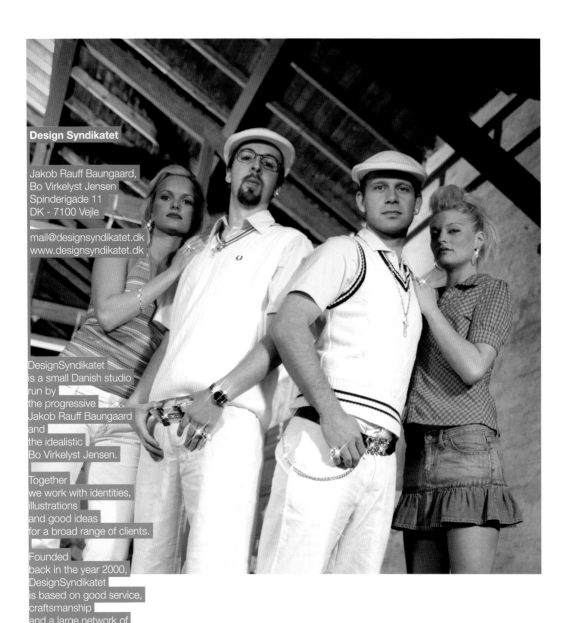

Design Syndikatet

Jakob Rauff Baungaard,
Bo Virkelyst Jensen
Spinderigade 11
DK - 7100 Vejle

mail@designsyndikatet.dk
www.designsyndikatet.dk

DesignSyndikatet
is a small Danish studio
run by
the progressive
Jakob Rauff Baungaard
and
the idealistic
Bo Virkelyst Jensen.

Together
we work with identities,
illustrations
and good ideas
for a broad range of clients.

Founded
back in the year 2000,
DesignSyndikatet
is based on good service,
craftsmanship
and a large network of
skilled freelancers.

An important part
of our work is «play» –
by
giving ourselves
the time
to explore and play,
we constantly evolve as
graphic designers,
have fun doing so
and provide
better
solutions for our clients.

JDDesign

Jens Dreier
Mågevej 89 st. 2
DK - 2400 Copenhagen NV

info@jensdreier.dk
www.jensdreier.dk

Intuition and crossing borders
are keywords for me.

I'm a graphic designer
with some years experience
from different design studios.
I have now started
my own design studio,
which offers solutions within
different genres
such as graphic design,
illustrations
and packaging design.

My visions
are to use the international
arena
and to get corporation partners
beyond
the national borders.
To communicate with people
from a different culture
and
with a different view on things
gives me inspiration
to think in new
and untraditional ways,
and
to begin work with a
design project from another angle.

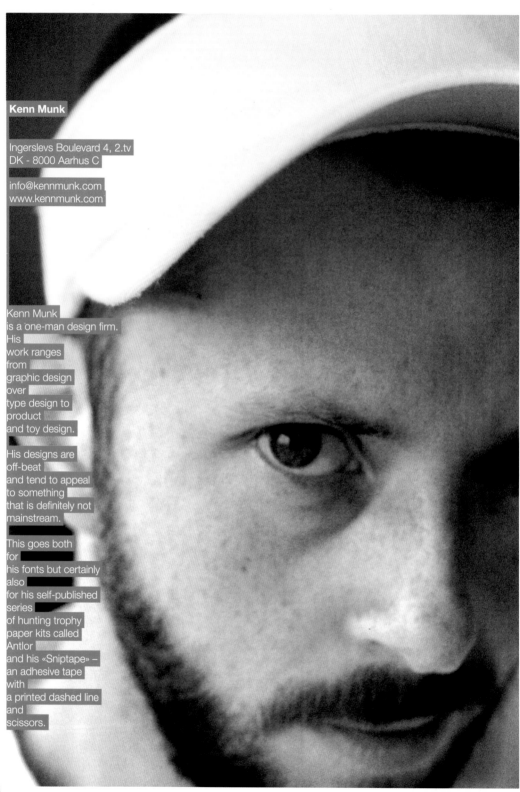

Kenn Munk

Ingerslevs Boulevard 4, 2.tv
DK - 8000 Aarhus C

info@kennmunk.com
www.kennmunk.com

Kenn Munk
is a one-man design firm.
His
work ranges
from
graphic design
over
type design to
product
and toy design.

His designs are
off-beat
and tend to appeal
to something
that is definitely not
mainstream.

This goes both
for
his fonts but certainly
also
for his self-published
series
of hunting trophy
paper kits called
Antlor
and his «Sniptape» –
an adhesive tape
with
a printed dashed line
and
scissors.

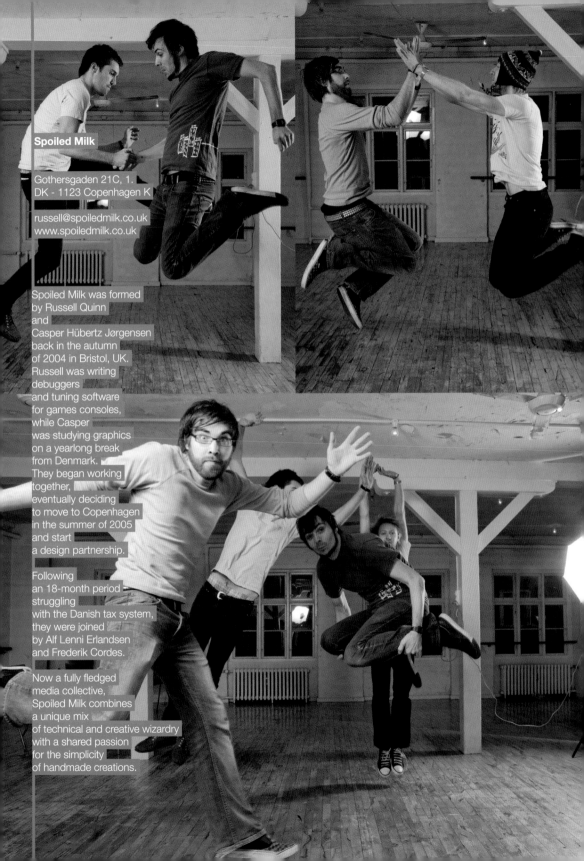

Spoiled Milk

Gothersgaden 21C, 1.
DK - 1123 Copenhagen K

russell@spoiledmilk.co.uk
www.spoiledmilk.co.uk

Spoiled Milk was formed by Russell Quinn and Casper Hübertz Jørgensen back in the autumn of 2004 in Bristol, UK. Russell was writing debuggers and tuning software for games consoles, while Casper was studying graphics on a yearlong break from Denmark. They began working together, eventually deciding to move to Copenhagen in the summer of 2005 and start a design partnership.

Following an 18-month period struggling with the Danish tax system, they were joined by Alf Lenni Erlandsen and Frederik Cordes.

Now a fully fledged media collective, Spoiled Milk combines a unique mix of technical and creative wizardry with a shared passion for the simplicity of handmade creations.

England

Billie Jean

10 Davies Lane
Leytonstone
UK - London E11 3DR

sam@billiejean.co.uk
www.billiejean.co.uk

Billie Jean lives
and
works in Leytonstone,
East London.

He makes
most of his work
off
the computer
using
pencils, biros, paints
and crayons.

His client list includes
Sony Music, Nike,
The Samaritans,
Hanes,
MTV, Howies,
Blueprint magazine
and
Creative Review.

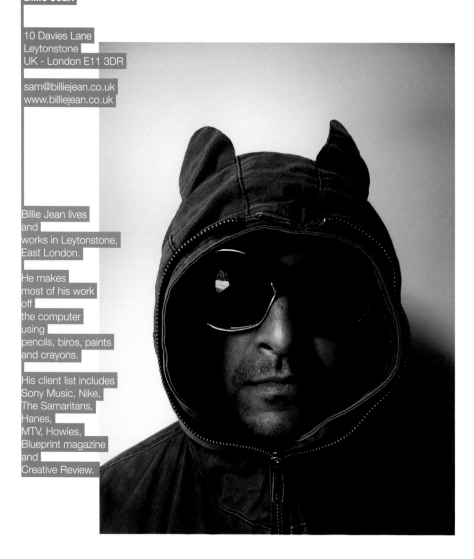

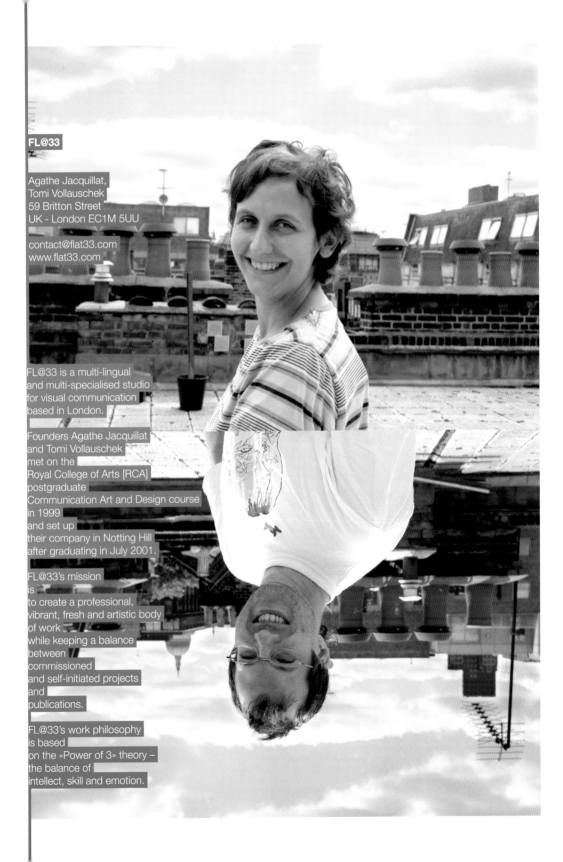

FL@33

Agathe Jacquillat,
Tomi Vollauschek
59 Britton Street
UK - London EC1M 5UU

contact@flat33.com
www.flat33.com

FL@33 is a multi-lingual
and multi-specialised studio
for visual communication
based in London.

Founders Agathe Jacquillat
and Tomi Vollauschek
met on the
Royal College of Arts [RCA]
postgraduate
Communication Art and Design course
in 1999
and set up
their company in Notting Hill
after graduating in July 2001.

FL@33's mission
is
to create a professional,
vibrant, fresh and artistic body
of work
while keeping a balance
between
commissioned
and self-initiated projects
and
publications.

FL@33's work philosophy
is based
on the «Power of 3» theory –
the balance of
intellect, skill and emotion.

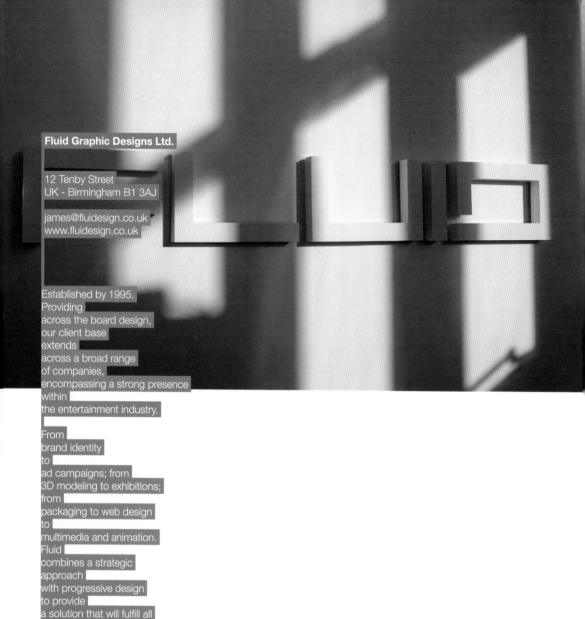

Fluid Graphic Designs Ltd.

12 Tenby Street
UK - Birmingham B1 3AJ

james@fluidesign.co.uk
www.fluidesign.co.uk

Established by 1995.
Providing
across the board design,
our client base
extends
across a broad range
of companies,
encompassing a strong presence
within
the entertainment industry.

From
brand identity
to
ad campaigns; from
3D modeling to exhibitions;
from
packaging to web design
to
multimedia and animation.
Fluid
combines a strategic
approach
with progressive design
to provide
a solution that will fulfill all
your
requirements. Whether
you need
a universal vision
or
unique attitude
to an individual project,
Fluid's
comprehensive knowledge
and
experience
ensure successful solutions
on every level.

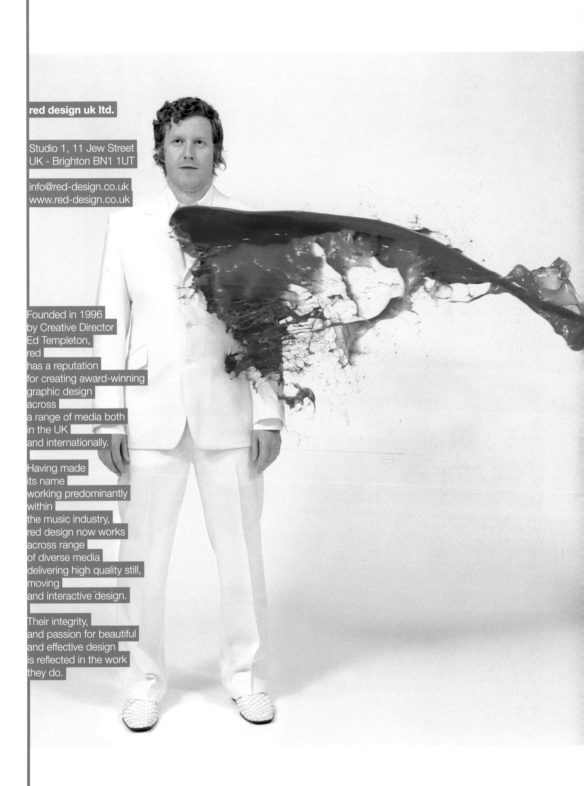

red design uk ltd.

Studio 1, 11 Jew Street
UK - Brighton BN1 1UT

info@red-design.co.uk
www.red-design.co.uk

Founded in 1996
by Creative Director
Ed Templeton,
red
has a reputation
for creating award-winning
graphic design
across
a range of media both
in the UK
and internationally.

Having made
its name
working predominantly
within
the music industry,
red design now works
across range
of diverse media
delivering high quality still,
moving
and interactive design.

Their integrity,
and passion for beautiful
and effective design
is reflected in the work
they do.

Studio MIKMIK

Michael Lewis
65 George Street
Saltaire Shipley
UK - West Yorkshire BD18 4PL

mike@studiomikmik.co.uk
www.studiomikmik.co.uk

Studio MIKMIK
is the work
of graphic designer
and
illustrator Michael Lewis.

He was born in
Lancashire, England
in 1979
and studied at
Leeds College of Art
and Design.

After several years
working
in busy UK design studios
Michael decided
to set up Studio MIKMIK
in early 2006.

His time is now
happily divided between
print design and
illustration,
with a little web work
thrown in
from time to time.

Taxi Studio Ltd.

93 Princess Victoria Street
Clifton
UK - Bristol BS8 4DD

alex@taxistudio.co.uk
www.taxistudio.co.uk

We established Taxi Studio
in 2002.
Our two founding
principles
were based on creativity.

They still are.

1: We believe
in creating ideas that
stand out from the norm
and
get noticed.

2: We also believe
in creating
results that stand out
from the norm
and
get noticed.

These two principles
underpin
our purpose.
Whether we are busy
designing
packaging, logos
or brochures, our aim
is
to achieve tangible,
measurable gains for our
clients.

Lift & stairs

France

Atelier Télescopique

Stéphane Meurice,
Sébastien Delobel,
Xavier Meurice,
Guillaume Berry,
Baptiste Servais
54 Rue Gustave Delory
FR - 59000 Lille

telescopique@wanadoo.fr
www.ateliertelescopique.com

Atelier Télescopique
is a
close-knit group
of designers
that opened
its studio in 1998.

They do
groundbreaking
work
in multiple media –
print, video, web
and
art exhibitions.

They also create
unique
typefaces.

This same
eclecticism
can be found in their
clientele,
which
is composed
of big
industry and institutions
as well as
members of the
culture scene.

Guillaumit

Guillaume Castagné
25 bis Quai Numa sensine
FR - 33310 Lormont

guillaumit@free.fr
www.gangpol-mit.com

I'm a
freelance illustrator
and
graphic designer
from Bordeaux.

I use
differents techniques
in
severals projects:
drawings, print, clothes,
video,
and live performance.
Each
time I try to combine fun,
complexity, colours
and
concept.

I work
in Gangpol & Mit project,
Gangpol
does the sound,
I do the visual artwork.
We work
together
to produce a mix
of
advanced electronica
and
crazy visuals
recycling pop culture
in a funny
and thoughtful way.

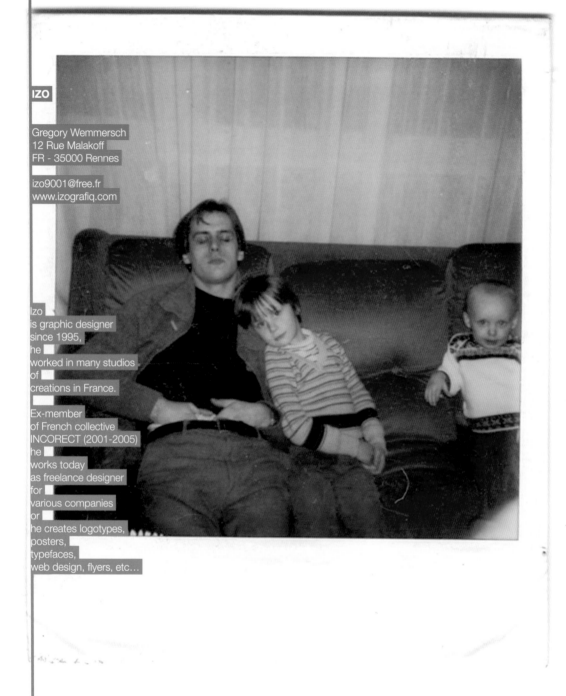

IZO

Gregory Wemmersch
12 Rue Malakoff
FR - 35000 Rennes

izo9001@free.fr
www.izografiq.com

Izo
is graphic designer
since 1995,
he
worked in many studios
of
creations in France.

Ex-member
of French collective
INCORECT (2001-2005)
he
works today
as freelance designer
for
various companies
or
he creates logotypes,
posters,
typefaces,
web design, flyers, etc…

Jumo Media

Grégoire Grange
aka Jumo
05 Rue Maydieu
FR - 33000 Bordeaux

info@jumomedia.com
www.jumomedia.com

Intimate,
ironic,
and disenchanted
are
three adjectives
that
can be used
in order to
describe
Jumo's work.

Graphic designer
and
photographer,
Grégoire Grange aka Jumo,
lives
and works
in Bordeaux, France.

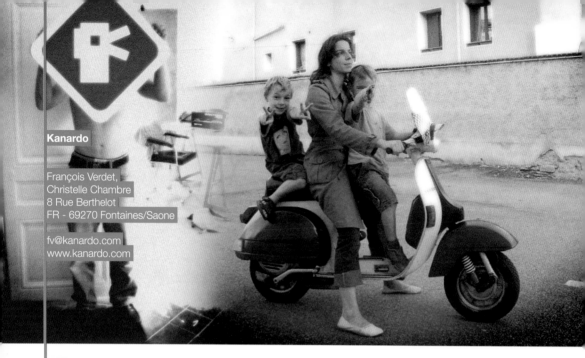

Kanardo

François Verdet,
Christelle Chambre
8 Rue Berthelot
FR - 69270 Fontaines/Saone

fv@kanardo.com
www.kanardo.com

Kanardo is
a two-headed unit
(former
journalist
François Verdet
and
his card-carrying
press-photographer
partner
Christelle Chambre)
based in Lyon, France.

Dealing
in graphic design,
contemporary
photography, magazine
layout
and «unexpected projects»,
Kanardo
has been called
«one
of France's
most exciting
design teams».

(Computer Arts,
UK, December 05)

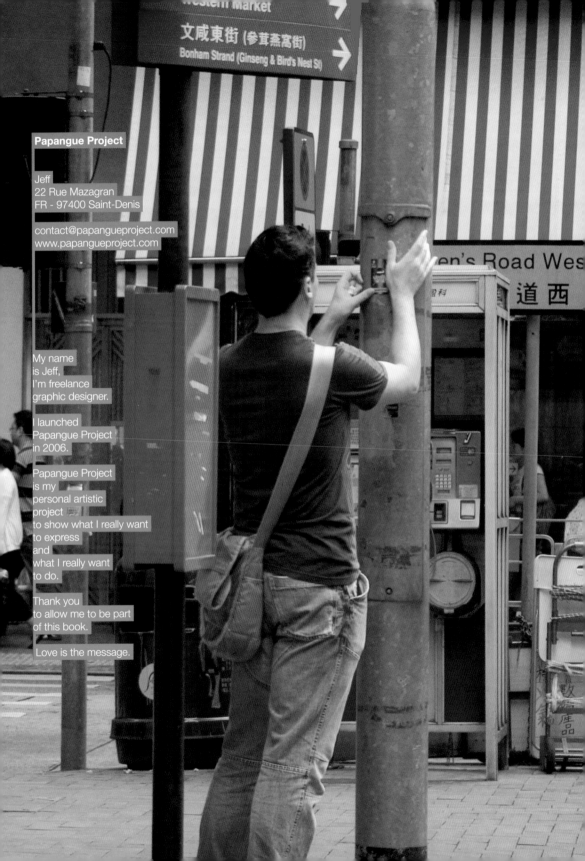

Papangue Project

Jeff
22 Rue Mazagran
FR - 97400 Saint-Denis

contact@papangueproject.com
www.papangueproject.com

My name
is Jeff,
I'm freelance
graphic designer.

I launched
Papangue Project
in 2006.

Papangue Project
is my
personal artistic
project
to show what I really want
to express
and
what I really want
to do.

Thank you
to allow me to be part
of this book.

Love is the message.

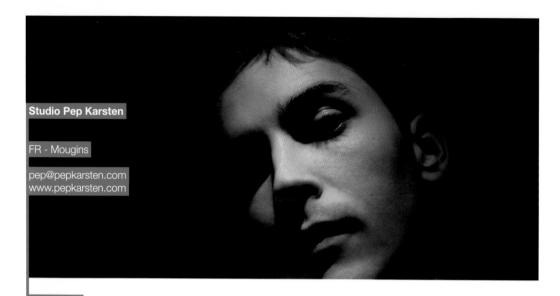

Studio Pep Karsten

FR - Mougins

pep@pepkarsten.com
www.pepkarsten.com

Pep Karsten
is a 29
years old
French Art Director,
designer
and
photographer.
After graduating
in industrial design
engineering,
he took
a new direction
and
started working
as a fashion designer
and
project manager.

Since 2001,
he has worked
as
a freelancer.
At the same time,
Pep
has developed
an
online personal art project
called Nineaem
(www.nineaem.com)
which
spreads now
to numerous publications,
exhibitions, shows
and wins an award
at the
Esquire
Digital Photo Awards
2004-2005.

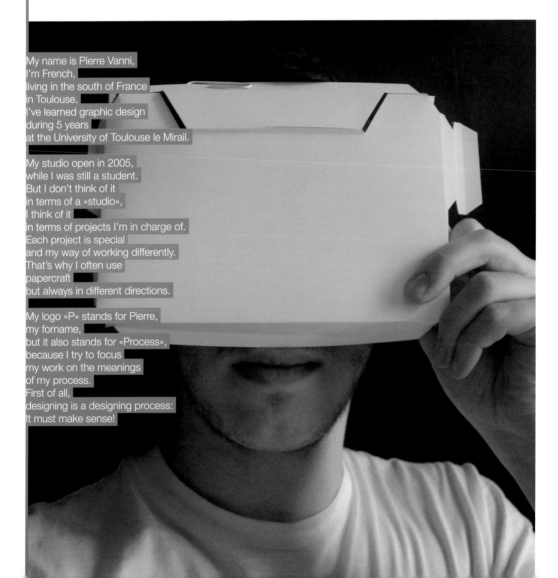

Pierre Vanni

29 Rue du Commissaire Philippe
FR - 31000 Toulouse

pvanni@hotmail.fr
www.pierrevanni.com

My name is Pierre Vanni,
I'm French,
living in the south of France
in Toulouse.
I've learned graphic design
during 5 years
at the University of Toulouse le Mirail.

My studio open in 2005,
while I was still a student.
But I don't think of it
in terms of a «studio»,
I think of it
in terms of projects I'm in charge of.
Each project is special
and my way of working differently.
That's why I often use
papercraft
but always in different directions.

My logo «P» stands for Pierre,
my forname,
but it also stands for «Process»,
because I try to focus
my work on the meanings
of my process.
First of all,
designing is a designing process:
It must make sense!

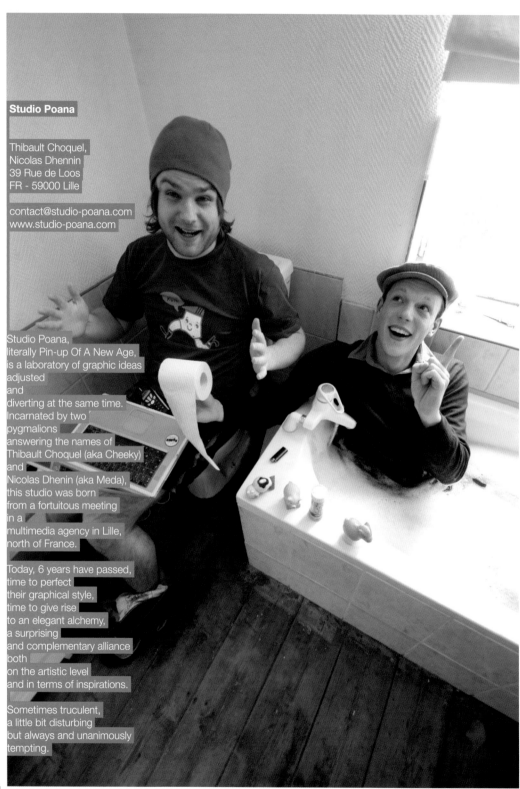

Studio Poana

Thibault Choquel,
Nicolas Dhennin
39 Rue de Loos
FR - 59000 Lille

contact@studio-poana.com
www.studio-poana.com

Studio Poana,
literally Pin-up Of A New Age,
is a laboratory of graphic ideas
adjusted
and
diverting at the same time.
Incarnated by two
pygmalions
answering the names of
Thibault Choquel (aka Cheeky)
and
Nicolas Dhenin (aka Meda),
this studio was born
from a fortuitous meeting
in a
multimedia agency in Lille,
north of France.

Today, 6 years have passed,
time to perfect
their graphical style,
time to give rise
to an elegant alchemy,
a surprising
and complementary alliance
both
on the artistic level
and in terms of inspirations.

Sometimes truculent,
a little bit disturbing
but always and unanimously
tempting.

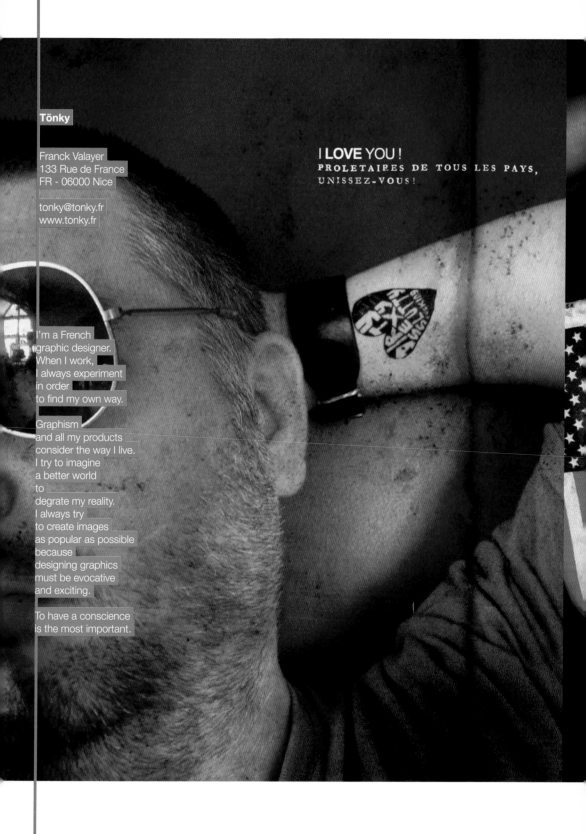

Tönky

Franck Valayer
133 Rue de France
FR - 06000 Nice

tonky@tonky.fr
www.tonky.fr

I LOVE YOU !
PROLETAIRES DE TOUS LES PAYS,
UNISSEZ-VOUS !

I'm a French
graphic designer.
When I work,
I always experiment
in order
to find my own way.

Graphism
and all my products
consider the way I live.
I try to imagine
a better world
to
degrate my reality.
I always try
to create images
as popular as possible
because
designing graphics
must be evocative
and exciting.

To have a conscience
is the most important.

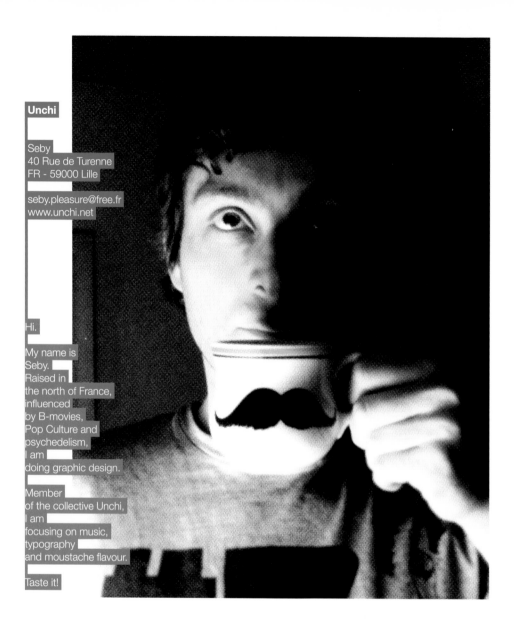

Unchi

Seby
40 Rue de Turenne
FR - 59000 Lille

seby.pleasure@free.fr
www.unchi.net

Hi.

My name is
Seby.
Raised in
the north of France,
influenced
by B-movies,
Pop Culture and
psychedelism,
I am
doing graphic design.

Member
of the collective Unchi,
I am
focusing on music,
typography
and moustache flavour.

Taste it!

Germany

Boris Dworschak

Theaterstraße 9 A
DE - 75175 Pforzheim

info@borisdworschak.de
www.borisdworschak.de

I'm a graphic designer
and typographer.

My field of work
reaches from
corporate design,
poster design,
book and magazine design
to illustration,
exhibition graphics,
and typedesign.

The starting point
of my design is always
content;
everything else
is a result of the content.

For any inquiry,
please feel free to contact me.

Thank you/Vielen Dank!

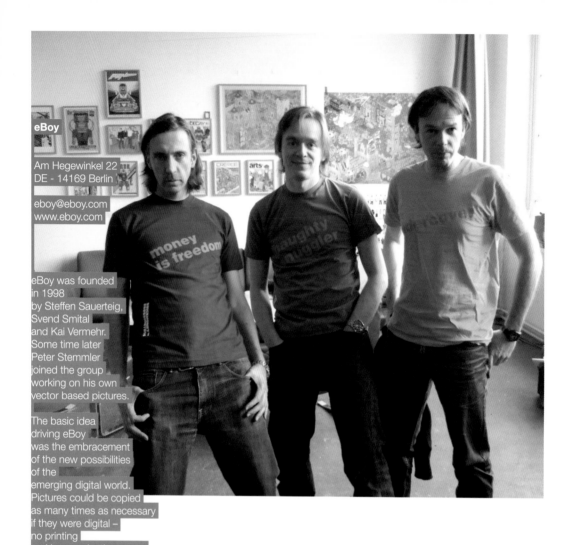

eBoy

Am Hegewinkel 22
DE - 14169 Berlin

eboy@eboy.com
www.eboy.com

eBoy was founded
in 1998
by Steffen Sauerteig,
Svend Smital
and Kai Vermehr.
Some time later
Peter Stemmler
joined the group
working on his own
vector based pictures.

The basic idea
driving eBoy
was the embracement
of the new possibilities
of the
emerging digital world.
Pictures could be copied
as many times as necessary
if they were digital –
no printing
and low production costs.

The work
had to be designed
specifically for the screen
and so eBoy
went the pixel way.
Pixels felt quite good
and were good fun handling.
Also eBoy decided
to only feature freestyle stuff
on its website.

Soon the word spread,
and magazines began writing
about the eBoy universe.
The so called «pixel style»
begun to spread
all over the world.

eyegix

Daniel Bretzmann
Senefelderstraße 39
DE - 70176 Stuttgart

input@eyegix.com
www.eyegix.com

Daniel Bretzmann
studied
communication design
and completed
the master programme
EMMA
at the Merz-Akadamie
in Stuttgart,
Germany.

During his studies
he gained
work experience
at agencies in Stuttgart
and Vienna.

After
receiving a scholarship
from the
MFG
Foundation
Baden-Württemberg,
he created
various projects
as a freelance designer
for
online and offline media.

Currently
he works
for the advertising agency
Jung von Matt/Neckar.

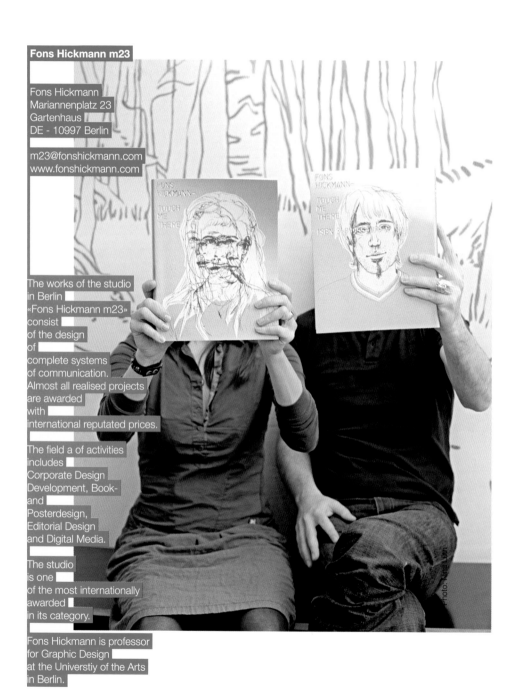

Fons Hickmann m23

Fons Hickmann
Mariannenplatz 23
Gartenhaus
DE - 10997 Berlin

m23@fonshickmann.com
www.fonshickmann.com

The works of the studio
in Berlin
«Fons Hickmann m23»
consist
of the design
of
complete systems
of communication.
Almost all realised projects
are awarded
with
international reputated prices.

The field a of activities
includes
Corporate Design
Development, Book-
and
Posterdesign,
Editorial Design
and Digital Media.

The studio
is one
of the most internationally
awarded
in its category.

Fons Hickmann is professor
for Graphic Design
at the Universtiy of the Arts
in Berlin.

Photo: Nina Lüth

H2D2

Markus Remscheid
Kaiserstraße 79
DE - 60329 Frankfurt am Main

markus@h2d2.de
www.h2d2.de

H2D2: a strategic-creative
design firm with heart.
Developing visual identities
for companies,
brands
and
products,
the starting point of our work
is
always a strong conceptual idea
that determines
the medium
and style.
Because
in the long run,
it isn't
mere visual effects
that drive success,
but rather
a
coherent concept.

HGO

Heiko Hoos
Werderstraße 34 A
DE - 76137 Karlsruhe

h_hoos@gmx.de
http://-hgo-.blogspot.com

HGO was founded 2004
by Heiko Hoos
for
his personal projects.
Heiko studied
Visual Communication
at the
University of Applied
Sciences
in Pforzheim, Germany,
where
he graduated in 2003.

He has published
several
typefaces for
Union Fonts and T26.

He also collaborates
with
Canadian
Artist Philip Pocock
on
various art projects for
ZKM/Center for Art
and Media in Karlsruhe.

He is currently
working
as a freelance designer
in Karlsruhe.

ICE CREAM FOR FREE ™

Oliver Wiegner
Anklammer Straße 13
DE - 10115 Berlin

oli@icecreamforfree.com
www.icecreamforfree.com

ICE CREAM FOR FREE ™
is a
Berlin based design
studio
founded in 2005
by Oliver Wiegner.

Having developed
from a collective,
ICFF TM
has access to a
multidisciplinary team of
designers.

The main
focus is on print.
Their style results from
impressions
of the current street
and
fine art scene in Berlin
and
from all over the world.

Bubbling with ideas,
ICFF ™ is ready to go.

Laleh Torabi

Glogauer Straße 6
DE - 10999 Berlin

laleh@spookymountains.com
www.spookymountains.com

Since I came to Berlin
three years ago
I'm
part of the transmediale team,
where I'm responsible
for the festival design.

Each year
the festival for art and digital culture
runs under a different motto
and I'm creating its visual identity.

Besides
I started my own project
spookymountains.com

Potipoti

Silvia Salvador,
Nando Cornejo
Choriner Straße 50
DE - 10435 Berlin

info@potipoti.com
www.potipoti.com

Potipoti
is a young fashion company
founded in Berlin
at the end of 2004.

Potipoti
makes graphic fashion,
taking
its references
from sources such as
the mythical music duo
Vainica Doble
to classic cartoons
and street art.

Potipoti also
does illustration
and
graphic design
and
team up with pop bands
developing visual art
for
their shows and
with
music festivals.

They also do exhibitions
of their illustrations,
feeding
their fashion designs
back with the results
of such experiments.

All these makes their style

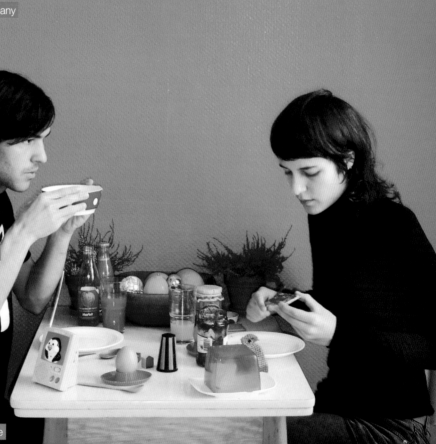

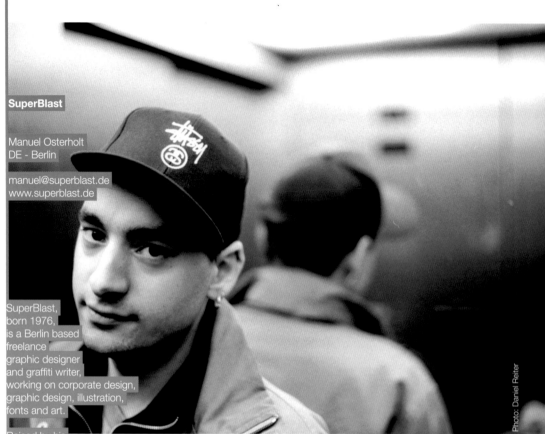

SuperBlast

Manuel Osterholt
DE - Berlin

manuel@superblast.de
www.superblast.de

SuperBlast,
born 1976,
is a Berlin based
freelance
graphic designer
and graffiti writer,
working on corporate design,
graphic design, illustration,
fonts and art.

Raised by his
German/Greek parents
in Heidelberg,
he learned by their
different cultural background
to understand that
there isn't
just one view
on things.
Which remained
his view on the world
until today.

Among his freelance work,
he is always creating
graphical art
for himself
or solo/collective
art shows
and still is writing his name:
SuperBlast aka Komet.

Photo: Daniel Reiter

TOCA ME

Nina Schmid,
Thorsten Iberl,
Ronald Iberl
Arcisstraße 68
DE - 80801 Munich

info@toca-me.com
www.toca-me.com

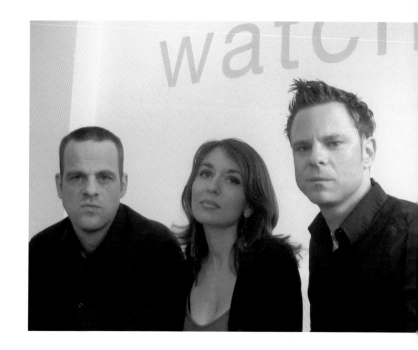

TOCA ME
is a Germany-based design studio.
Aside of working
for multinational clients
in the
fields of print design, web design
and
event management,
TOCA ME
has consistently established
an international
design community
since the beginning of 2003
covering
all disciplines of design:
from
multimedia and interactive design,
photography, illustration,
architecture and music
to
fashion design and movie direction.
On the one hand
internationally renown designers
and multimedia artists
are featured
at a virtual communication platform;
on the other hand star-designers
are annually invited
to the TOCA ME design conference
in Munich, Germany
to hold speeches
on state-of-the-art design
and their innovative works
and creations.

Via Grafik

Leo Volland,
Lars Herzig,
André Nossek,
Robert Schwartz,
Tim Bollinger,
Till Heim
Rheinstraße 38
DE - 65185 Wiesbaden
mnwrks@viagrafik.com
www.vgrfk.com

We are
a professional design
studio
located in Wiesbaden.
We offer a wide range
of services.
On the one hand
we are specialised
in
everything related to print:
logo design,
corporate identities,
illustration, font design,
book
and catalog design,
but
also interior/exterior design
and web design.
On the other hand we offer
motion and
animation
design and live visuals.

We are also an art studio.
Everyone
of us
has a background
in graffiti or street art
and we are always trying
to
combine our artistic
with
our design skills.
We participate in exhibitions,
thus
we share a great diversity.

Iceland

Jónas Valtýsson

Miðtún 52
IS - 105 Reykjavík

jonasval@gmail.com
www.jonasval.com

My name
is Jónas Valtýsson.
I was born
and
raised in Iceland
and
I'm currently living
in
Iceland's capital
Reykjavík, where I live
with
my beautiful girlfriend
and son.

I'm currently studying
graphic design
at the
Icelandic
Academy of Arts.
And I will be
graduating
in spring 2008.

I have a great intrest
in photography
and I'm always
looking for ways
to mix it
with design.

I believe in ghosts
and
I love peanut butter.

Ragnar Freyr

342 N. Crooks Road
USA - 48017 Clawson, MI

r@ragnarfreyr.com
www.ragnarfreyr.com

Ragnar Freyr
is
a 26 years old
freelance
graphic designer
from Reykjavík,
Iceland
who
currently lives
with his wife
and
pug puppy
in Michigan, USA.

Sveinbjörn Pálsson

Njálsgata 55
IS - Reykjavik

sveinbjorn@sveinbjorn.com
www.sveinbjorn.com

I'm
a 28 year old
designer
and
type enthusiast.

I've been doing
all kinds
of work,
but more often
than not
it's somehow
music related.

When
I'm not designing
I like
practicing
my cowbell
playing
skills
or playing music
for
drunk people
at
bars and clubs.

My motto
is
«You haven't lived
until
you've seen
FM Belfast in concert».

Truly
words to live by.

Designaside

Mauro Caramella
Corso Lodi 47
IT - 20139 Milan

mauro@designaside.com
www.designaside.com

I'm 30
years old.
I studied
in an art school
in Milan.

I'm
currently living
in Milan
and
working as
Art Director
in a
digital marketing
company.

Founder
of Designaside,
nowadays
an
important site
become
a benchmark
on
Italian digital
and
non-digital art,
graphics,
design and
photography,
who
counts on
a
strong community.

Dynamic Foundry

Caroline Hue
Piazza Oberdan, 2
IT - 20129 Milan

caroline.hue@dynamicfoundry.com
www.dynamicfoundry.com

Founded in 2004
and
headed by the French
art director Caroline Hue,
Dynamic Foundry
is
a network of professionals
who create
wide-ranging publicity
and advertising products
for all types of media.

Dynamic Foundry
involves
the finest
international professionals
from the field
of media strategy,
creativity and technology,
to look beyond
national borders,
and to study the social,
commercial
and cultural behaviours
which affect public
sensitivity
and perceptions.
This philosophy lies
at the heart of Dynamic Foundry's
solid
strategies and effective services,
which combine brilliant,
refined creativity
and
innovative technology.

Graphic Pack

Marco Nicotra
Via Donadoni 10
IT - 20151 Milan

nikonik82@hotmail.com
www.thetrip.it

My name is Marco Nicotra,
and
I like graphic design concepts
more than art ones
because I find them more useful.

I consider art and design
as two very different things,
moved
by two different purposes.
Both in art and in design
you convey a message,
but in design
you need to be sure that people
can catch it easier and faster;
if you design
a poster for a concert,
the user needs to be captured
first by the graphic design,
but in the end it's important
that he remembers the day
of the concert, or the price.

The only way
to create a good poster,
is to consider it less
as an art expression
and more as a work process,
where the target
is the very
final objective to reach
and seduce.
Once you have considered this,
you can start opening your mind
and make the fantasy
fly free!

MWGRAPHICS

Cristiano Ripanucci
Via E. de Santis, 3
IT - 00045 Genzano
di Roma (RM)

wario@mwgraphics.it
www.mwgraphics.it

I'm a freelance
visual designer
born
in a small country,
Genzano di Roma
near Rome.
I'm studying fashion sciences
at «La Sapienza»
university,
trying to make my dreams
come true.

I'm addicted to art,
sneakers
and video games.
I want to do many things,
and
for some reason they are
all so expensive!

I want
to be someone.
Maybe
someone else.

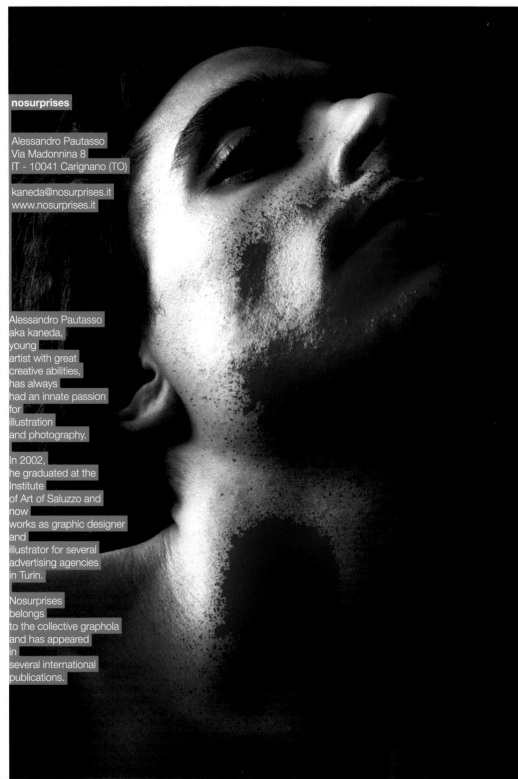

nosurprises

Alessandro Pautasso
Via Madonnina 8
IT - 10041 Carignano (TO)

kaneda@nosurprises.it
www.nosurprises.it

Alessandro Pautasso
aka kaneda,
young
artist with great
creative abilities,
has always
had an innate passion
for
illustration
and photography.

In 2002,
he graduated at the
Institute
of Art of Saluzzo and
now
works as graphic designer
and
illustrator for several
advertising agencies
in Turin.

Nosurprises
belongs
to the collective graphola
and has appeared
in
several international
publications.

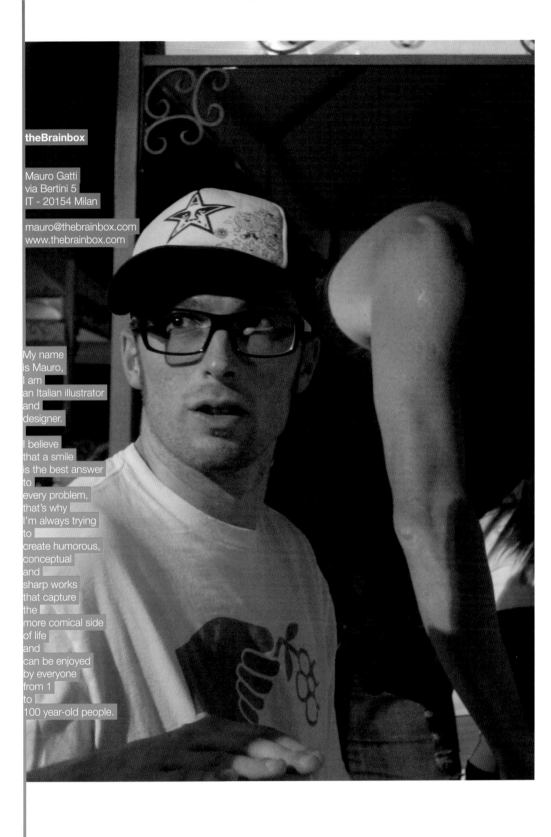

theBrainbox

Mauro Gatti
via Bertini 5
IT - 20154 Milan

mauro@thebrainbox.com
www.thebrainbox.com

My name
is Mauro,
I am
an Italian illustrator
and
designer.

I believe
that a smile
is the best answer
to
every problem,
that's why
I'm always trying
to
create humorous,
conceptual
and
sharp works
that capture
the
more comical side
of life
and
can be enjoyed
by everyone
from 1
to
100 year-old people.

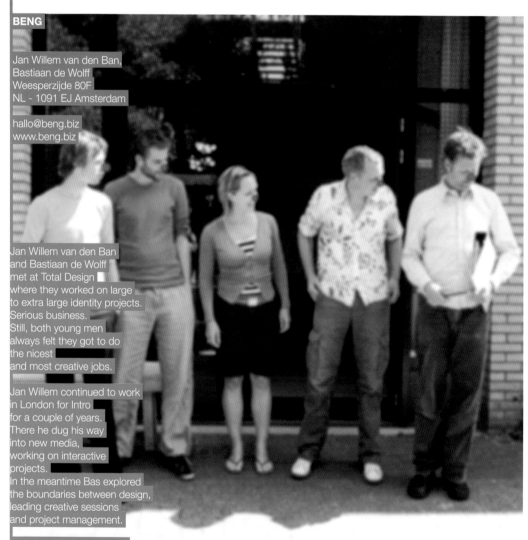

BENG

Jan Willem van den Ban,
Bastiaan de Wolff
Weesperzijde 80F
NL - 1091 EJ Amsterdam

hallo@beng.biz
www.beng.biz

Jan Willem van den Ban
and Bastiaan de Wolff
met at Total Design
where they worked on large
to extra large identity projects.
Serious business.
Still, both young men
always felt they got to do
the nicest
and most creative jobs.

Jan Willem continued to work
in London for Intro
for a couple of years.
There he dug his way
into new media,
working on interactive
projects.
In the meantime Bas explored
the boundaries between design,
leading creative sessions
and project management.

BETTER AND MORE FUN!

With that idea in mind
Jan Willem and Bas reunited.
Since 1998 they are BENG
and serve clients with outspoken
communication concepts
combined with fresh
and powerfull design.
BENG focusses on identities
and effect.

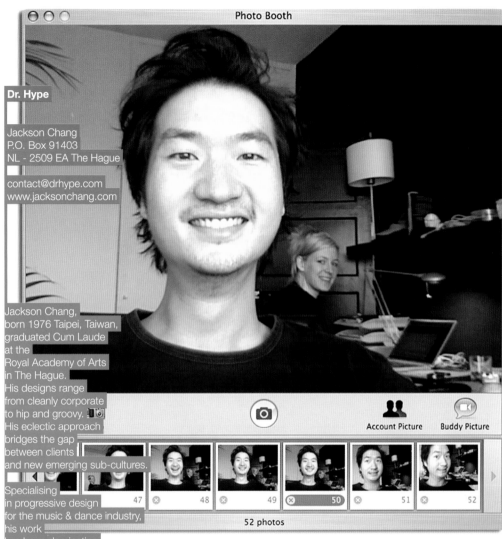

Photo Booth

Dr. Hype

Jackson Chang
P.O. Box 91403
NL - 2509 EA The Hague

contact@drhype.com
www.jacksonchang.com

Jackson Chang,
born 1976 Taipei, Taiwan,
graduated Cum Laude
at the
Royal Academy of Arts
in The Hague.
His designs range
from cleanly corporate
to hip and groovy.
His eclectic approach
bridges the gap
between clients
and new emerging sub-cultures.

Specialising
in progressive design
for the music & dance industry,
his work
has been dominating
the scene ever since.
Keen on developing
innovative visual codes,
with his unique
eclectic approach,
Jackson Chang
has strongly influenced
and contributed
to the Dutch design scene.

He recently started DrHype.com.
A design studio
specialising in design
for event promotion.
Dr. Hype can deliver!

Account Picture Buddy Picture

47 48 49 50 51 52

52 photos

Jan Heijnen

Papestraat 27
NL - 2513 AV The Hague

mail@janheijnen.com
www.janheijnen.com

Services:
Branding
and identity,
consulting,
print design,
web design,
typographical design
and
illustration.

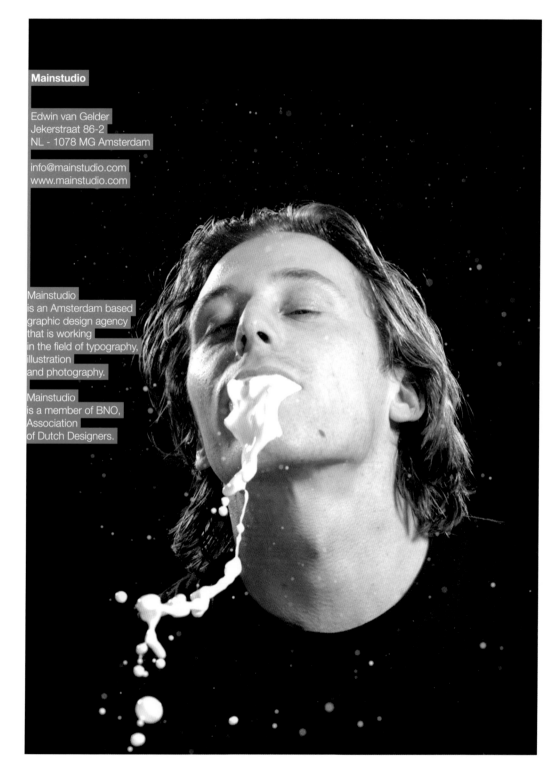

Mainstudio

Edwin van Gelder
Jekerstraat 86-2
NL - 1078 MG Amsterdam

info@mainstudio.com
www.mainstudio.com

Mainstudio
is an Amsterdam based
graphic design agency
that is working
in the field of typography,
illustration
and photography.

Mainstudio
is a member of BNO,
Association
of Dutch Designers.

Scale to Fit

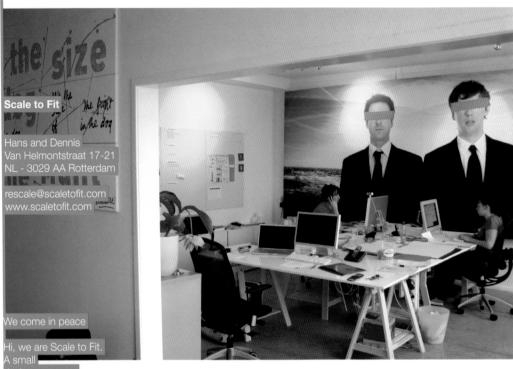

Hans and Dennis
Van Helmontstraat 17-21
NL - 3029 AA Rotterdam

rescale@scaletofit.com
www.scaletofit.com

We come in peace

Hi, we are Scale to Fit.
A small
design company
with great ambitions.

We started out
two years ago
but
things got serious
last year
when we both quit
our daytime jobs
and
started working
for Scale to Fit fulltime.

We even have an office
and a phone!
Can you imagine?
We get
most of our work
from
the entertainment industry
and that means
we get
to meet a lot of celebrities
and
go to fancy parties!

Woohoo, what a life…

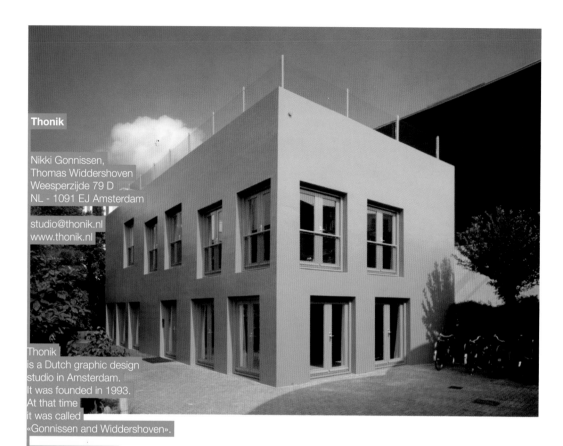

Thonik

Nikki Gonnissen,
Thomas Widdershoven
Weesperzijde 79 D
NL - 1091 EJ Amsterdam

studio@thonik.nl
www.thonik.nl

Thonik
is a Dutch graphic design
studio in Amsterdam.
It was founded in 1993.
At that time
it was called
«Gonnissen and Widdershoven».

The first three letters
of their first names
served to form the name
«Thonik» in 1999.
Thonik currently employs
nine people.
The studio designs
books
and company styles
and develops
communication concepts
and publicity campaigns.

Thonik's design method
is characterized by
radical clarity
and it is related
to that of
industrial designer
Richard Hutten
and architectural office MVRDV.

Text: Ed van Hinte, April 2004

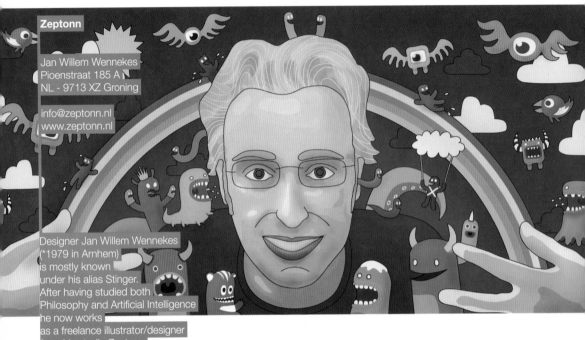

Zeptonn

Jan Willem Wennekes
Pioenstraat 185 A
NL - 9713 XZ Groning

info@zeptonn.nl
www.zeptonn.nl

Designer Jan Willem Wennekes
(*1979 in Arnhem)
is mostly known
under his alias Stinger.
After having studied both
Philosophy and Artificial Intelligence
he now works
as a freelance illustrator/designer
from his studio Zeptonn
in Groningen.
There he draws, sketches, thinks,
eats, drinks coffee
and wears lots of t-shirts.

As a one-man design army
he creates all sorts
of funky designs
ranging from t-shirts, posters,
logos, badges
and skateboards to books.
He loves drawing
imaginative things
while still endowing them
with an analytical twist:
look again and you will discover
there is more to it
than hopping critters
or wacky fantasy monsters.

He loves colours, simplicity,
street-art,
music, philosophy and
boardsports.

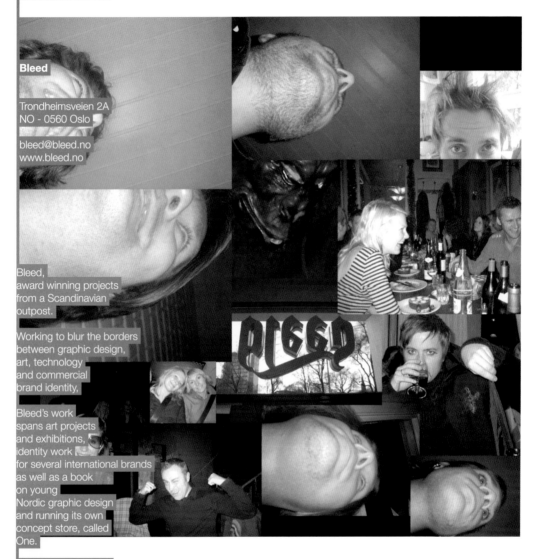

Bleed

Trondheimsveien 2A
NO - 0560 Oslo

bleed@bleed.no
www.bleed.no

Bleed,
award winning projects
from a Scandinavian
outpost.

Working to blur the borders
between graphic design,
art, technology
and commercial
brand identity,

Bleed's work
spans art projects
and exhibitions,
identity work
for several international brands
as well as a book
on young
Nordic graphic design
and running its own
concept store, called
One.

The Oslo based outfit
employs 14 people full time,
representing a mix
of cultures
and disciplines
to challenge today's conventions
around art,
visual language, media
and identity.

Bleeds seeks to add the edge.
And thus
to challenge the boundaries
of who, what and where.

Claudia C. Sandor

Oslo Collective
Rosenborggt. 16A
NO - 0356 Oslo

claudia@claudia.as
www.claudia.as

Claudia C. Sandor
is a graphic designer,
art historian
and art journalist.
She has run
the graphic design studio
Claudia since 2002.

Born in Montreal
to parents from
Norway and Hungary,
Claudia moved to Norway
in 1986,
where
she has been living since.

A main part of
Claudia's clients
come
from various
cultural industries,
especially from the field
of
contemporary art;
in the past year
she has been doing
a large amount
of book design –
exhibition
catalogues, a cookbook,
a book on art theory…

Her passion
is experimental typography.

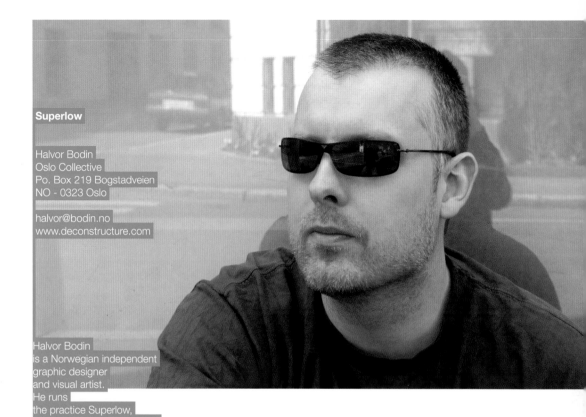

Superlow

Halvor Bodin
Oslo Collective
Po. Box 219 Bogstadveien
NO - 0323 Oslo

halvor@bodin.no
www.deconstructure.com

Halvor Bodin
is a Norwegian independent
graphic designer
and visual artist.
He runs
the practice Superlow,
in the studio Oslo Collective.

Bodin is known for working
with everything from
Black Metal bands
such as
Satyricon/Darkthrone
via corporate identities
to church altar pieces,
without any
irony or disrespect.
He writes regularily
for
the Norwegian
design magazine Snitt.
He is
one of the most
highly
awarded graphic designers
in Norway the last decade.

Bodin
is currently the Art Director
of .no magazine
together
with Claudia C. Sandor.

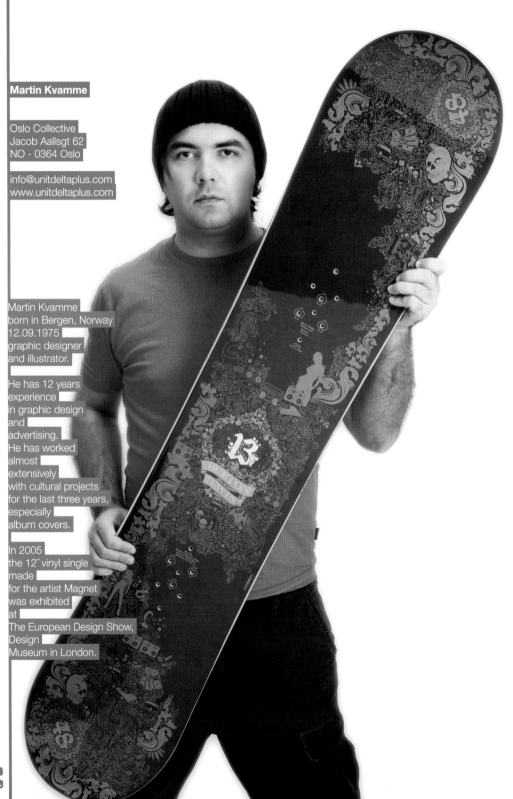

Martin Kvamme

Oslo Collective
Jacob Aallsgt 62
NO - 0364 Oslo

info@unitdeltaplus.com
www.unitdeltaplus.com

Martin Kvamme
born in Bergen, Norway
12.09.1975
graphic designer
and illustrator.

He has 12 years
experience
in graphic design
and
advertising.
He has worked
almost
extensively
with cultural projects
for the last three years,
especially
album covers.

In 2005
the 12″ vinyl single
made
for the artist Magnet
was exhibited
at
The European Design Show,
Design
Museum in London.

Trine + Kim

Trine Paulsen,
Kim Sølve
Hølandsgata 22 B
NO - 0655 Oslo

post@trineogkim.no
www.trineogkim.no

Trine og Kim
is
a design duo
working
and living in
Oslo.

TRINE OG KIM
OSLO, NORWAY

Portugal

—nada—

Rua Comandante Nunes da Silva
2, 1ºE
PT - 1300-140 Lisboa

nada@designedbynada.com
www.designedbynada.com

Our mark is no mark,

our label is no label,

our name is no name.

Information
and knowledge
are everything.

Making that obvious
is what we do.

MusaCollective

Raquel Viana,
Paulo Lima,
Ricardo Alexandre
Rua da Rosa No.14 E6
PT - 1200-382 Lisbon

info@musacollective.com
www.musacollective.com

MusaCollective
was formed in October 2003,
a Lisbon-based collective
of graphic designers,
with the main objective
to divulge
the Portuguese design
worldwide.

Initially
Musa is a design studio
(MusaWorkLab)
that decided to join
several artists/designers
in order to promote
the
new Portuguese talented
and
emergent young visual culture.

Musa is working
on
their own projects
like exhibitions,
books,
toys, participations
with international designers
and projects,
and working on their
commercial projects
like fashion and trendy clients.

Nuno Martins

Tv. Monte S. João
n° 200, 3°
PT - 4200-408 Porto

nuno@nunomartins.com
www.nunomartins.com

Nuno Martins
was born in 1979 in Porto,
where he lives
and works.
He graduated
in
Communication Design
by Faculdade de Belas Artes,
Universidade do Porto
and studied at the
Willem de Kooning Academy,
Rotterdam,
The Netherlands.

He mainly works
as a graphic and
web designer, areas
in which
he has been
several times awarded
with first place prizes
like
Oceanário de Lisboa Mascot,
Pavilhão da Água
do Porto Mascot,
Porto Digital
Logo Ideas Contest
and the
«2006 Papies» contest,
with the Ambar Website.

Paulo Arraiano

Sítio do Castelo
nº1, 1° Esq°
PT - 2750-314 Cascais

mail@pauloarraiano.com
www.pauloarraiano.com

Illustrator, designer,
founder of palm
(limited edition t-shirt
project)
www.palmshirts.com

Tries to bring to life
his supadreadlyfrendly
friends
ready to proclaim
the supa rights for more
colour
in the world

Art Director
and designer
for magnolia trend mag,
and slang urban culture
mag

stay.irie_peace_

Rui Almeida Vargas

Rua da Estação
nº32 - 2º DTO
PT - 2725-302 Mem-Martins Sintra

ruialmeida_81@yahoo.com
www.ruialmeidavargas.com

My name
is Rui Almeida Vargas
and
I'm very proud
to be a graphic designer.

I graduated
in 2004 in IADE –
Institute of Visual Arts,
Design & Marketing.

Actually I work
for Design Box,
an agency in Lisbon
where
I am free to explore
new materials
and
languages for some
of the
agency clients,
but
it is on the freelance
and
personal projects,
that I encounter
the satisfaction
to play with the design.

My spirit of living:
design, family, music.

I love apples
and
I love Apple.

Six Letter Word

Diogo Potes
Rua da Penha de França
Nº62 3dto
PT - 1170-306 Lisbon

slw@sixletterword.net
www.sixletterword.net

Born
in the seventies
in
the year that everything
happened, 1977.

I'm from Lisbon and
grew up
with skate, punk rock
and
heavy metal…

My references were
always very visual.
Skate
graphics and
magazines, music covers
and
artworks…
this resume how
and why
I became designer.

Never been a natural talent,
but graphics
always make me happy.

Spain

Astrid Stavro

Baixada de Viladecols, 3
Primero Segunda
ES - 08002 Barcelona

astrid@astridstavro.com
www.astridstavro.com

Astrid Stavro
was born in Trieste, Italy
in 1972.
She graduated with a First*
in Graphic Design
from
Central Saint Martins College
of Art & Design (2000),
and with a Distinction*
from
The Royal College of Art (2005).
After graduating from CSM,
Astrid co-founded
and directed
the design studio Pavlova.
After completing a Master
in Communication Art & Design
at the RCA,
she moved from London
to Barcelona
where she founded her own
multi-disciplinary design studio
in September 2005.

Astrid specializes
in typography,
editorial, and corporate image.
She is now venturing
into furniture design.
Additionally, she is starting up
her own publishing company,
specialized in books that
«drive librarians nuts
as they don't fit
under any standard
bookshop classification system».

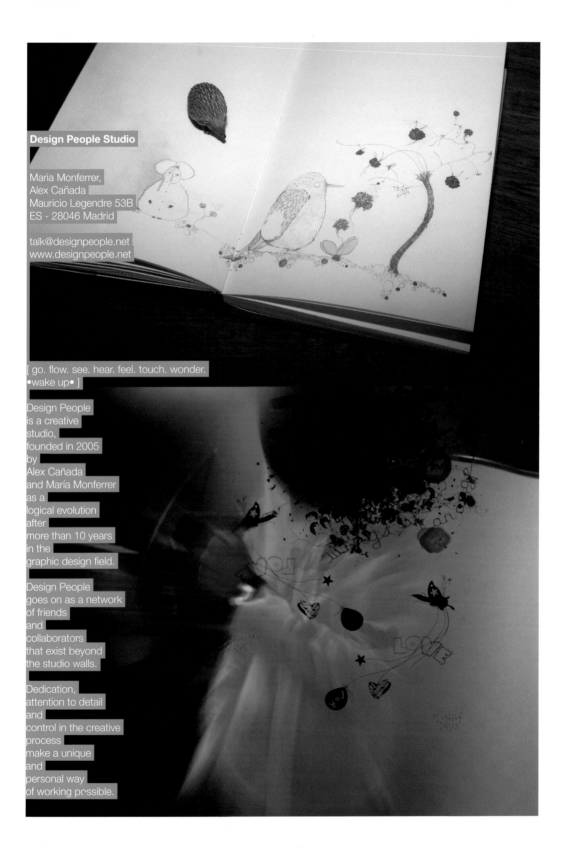

Design People Studio

Maria Monferrer,
Alex Cañada
Mauricio Legendre 53B
ES - 28046 Madrid

talk@designpeople.net
www.designpeople.net

[go. flow. see. hear. feel. touch. wonder.
•wake up•]

Design People
is a creative
studio,
founded in 2005
by
Alex Cañada
and María Monferrer
as a
logical evolution
after
more than 10 years
in the
graphic design field.

Design People
goes on as a network
of friends
and
collaborators
that exist beyond
the studio walls.

Dedication,
attention to detail
and
control in the creative
process
make a unique
and
personal way
of working possible.

Fiilin.com

Juha Fiilin
c/Palma de Sant Just 7
ES - 08003 Barcelona

juha@randomone.com
www.fiilin.com

Juha Fiilin
aka Fiilin.com,
a Finn living and working
in Barcelona since 1998.
Received
Master of Arts degree
from
University of Art and Design,
Helsinki
with a MA exchange studies
from the
Royal Collage of Art in London.
This training gave me
a strong background
in fine arts, photography,
graphics and film.

Involvement in wide range of print
and web projects
in various countries
taught me to keep on learning.

Currently I am focussing
in directing and designing trailers,
music videos
and title sequences
for film and television.

Martí Guixé

Calabria 252
ES - 08029 Barcelona

marti@guixe.com
www.guixe.com

«People kick themselves
for not having tried…» (Cantona)

Martí Guixé
comes from the background
of every good designer,
with an academic curriculum
to his credit
and work done
with famous firms.
But as revolutionaries today
are
born within the institutions
that trained them,
he revolutionises design
by working on living matter,
that can be transformed
and decomposed.
He analyses situations,
behaviour and gestures
in order to propose
radically effective solutions
with minimal ergonomics,
liberated from the image
of an idealized body
where technocratic perspective
tried to create
the right form.

As a visionary
he transforms things with his eyes
that observe them
and invents
the indispensable commodities
of the 21st century.

Meat Collective

Michael Romano,
Diana Aspillera
c/Montseny, 49 Bajos #1
ES - 08012 Barcelona

d.aspillera@meatcollective.com
www.meatcollective.com

We are Michael Romano
and Diana Aspillera.
Originally from California,
we moved to Barcelona
in 2004.
Diana is trained
as a product designer,
but found her home
in the visual medium.
Michael has been drawing
since
he could hold a pencil
and considers himself
more an artist
than designer.

Both view design
not as a job
but more as a lifestyle.
Although each has
a specialty,
the magic comes
through collaboration
which sometimes
includes
many other specialists…

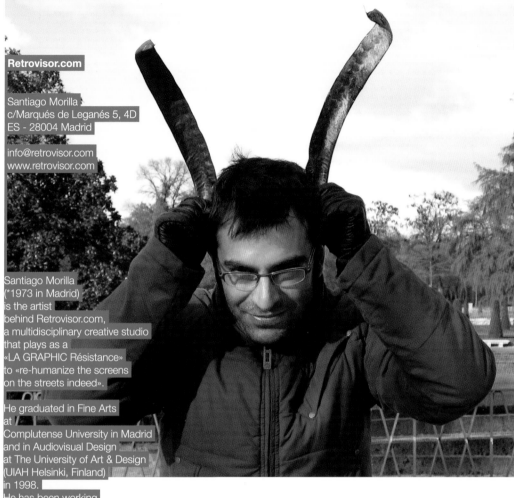

Retrovisor.com

Santiago Morilla
c/Marqués de Leganés 5, 4D
ES - 28004 Madrid

info@retrovisor.com
www.retrovisor.com

Santiago Morilla
(*1973 in Madrid)
is the artist
behind Retrovisor.com,
a multidisciplinary creative studio
that plays as a
«LA GRAPHIC Résistance»
to «re-humanize the screens
on the streets indeed».

He graduated in Fine Arts
at
Complutense University in Madrid
and in Audiovisual Design
at The University of Art & Design
(UIAH Helsinki, Finland)
in 1998.
He has been working
as graphic designer
and illustrator since 1999.
He declares
himself interested
in useless things
and illustrations
which turn into assignments.

Nowadays
he is working as illustrator
and art director
in advertising while developing
his own personal project:
a small independent publisher
called Mondadientes.com,
dedicated to collect and pop up
underground illustrators
in Madrid.

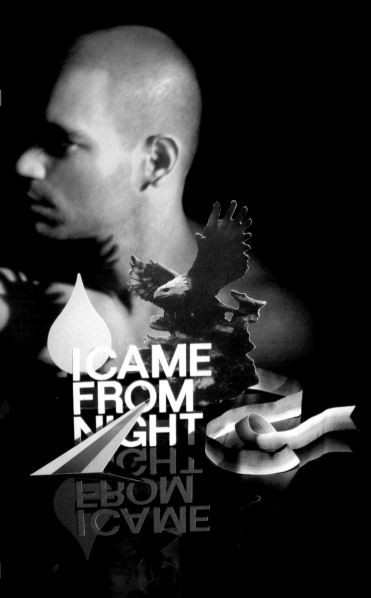

Serial Cut ™

Sergio del Puerto
Princesa 3 Duplicado Apto. 1109
ES - 28008 Madrid

info@serialcut.com
www.serialcut.com

Serial Cut ™
is a Madrid based studio,
established in 1999
by Sergio del Puerto,
working on a great variety
of project types although
mainly focussing on:

ART DIRECTION
Graphic solutions
working with a wide team
of professionals,
specialized in visual culture.
The main objective
is to provide clients
with a special, personal way
of communicating
their product.

GRAPHIC DESIGN
Branding, editorial projects,
record labels and web projects.

ILLUSTRATION
A versatile and experimental style
based on
the «cut&paste» technique:
a mix of vector shapes,
photo collage, pixels
and pencil strokes.
In most cases, typography
reinforces the idea
to generate more impact.

toormix

Oriol Armengou,
Ferran Mitjans
Muntaner 88, 2on 2a
ES - 08011 Barcelona

info@toormix.com
www.toormix.com

toormix
is a design studio based
in Barcelona.
Formed in the year 2000.
Seven years
accompanied
by customers
who understand
the value of design
and have put their trust
in us.

We have worked
with all kinds of people,
learning continuously
and facing up
to new challenges.
With strong value
in strategy, concept,
research,
and creativity,
toormix
works on projects
involving graphic design,
art direction,
brand creation, product
and publication design,
communication,
packaging,
websites and
interactive media.

Yvonne Blanco Studio

Yvonne Blanco
Moragas Nº4 Entresuelo 2
ES - 08022 Barcelona

studio@yvonneblanco.com
www.yvonneblanco.com

Yvonne Blanco Studio
is a graphic design initiative
based in Barcelona.
Specialized in the art field,
her main focus is editorial design.
She works preferentially
in catalogues
and other printed materials,
like posters or limited artist editions.
This has contributed
to foster challenging relations
with artists, art galleries
and museums.

With a passion for
monochromatic graphics,
white colour,
the sum of all the colours,
and alternative music
her studio is home
of an adventurous
and intense world of possibilities.

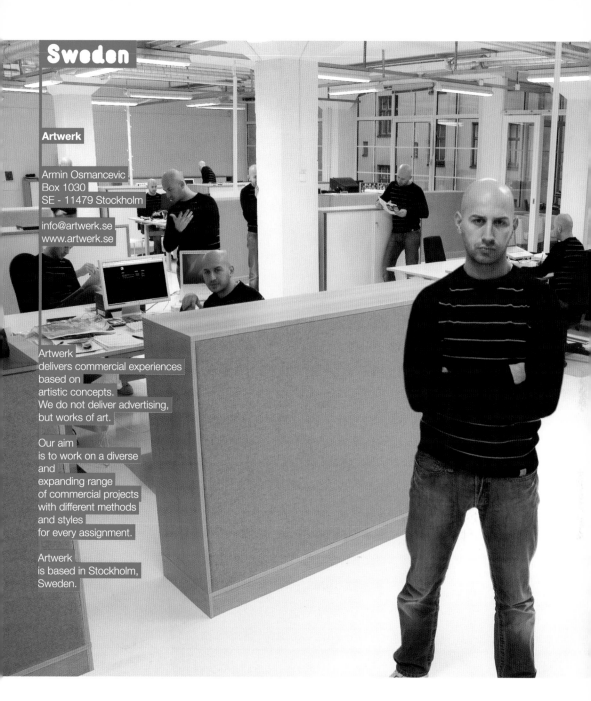

Sweden

Artwerk

Armin Osmancevic
Box 1030
SE - 11479 Stockholm

info@artwerk.se
www.artwerk.se

Artwerk
delivers commercial experiences
based on
artistic concepts.
We do not deliver advertising,
but works of art.

Our aim
is to work on a diverse
and
expanding range
of commercial projects
with different methods
and styles
for every assignment.

Artwerk
is based in Stockholm,
Sweden.

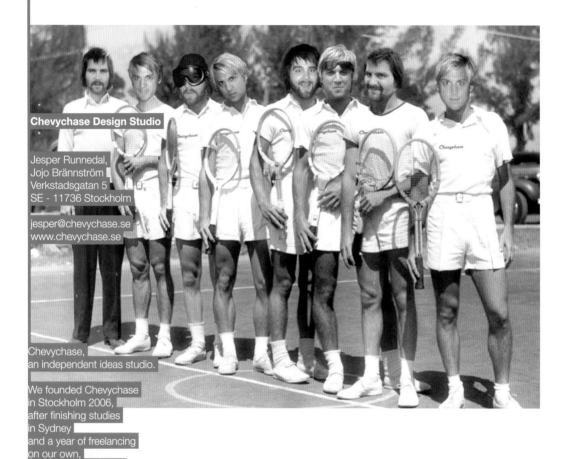

Chevychase Design Studio

Jesper Runnedal,
Jojo Brännström
Verkstadsgatan 5
SE - 11736 Stockholm

jesper@chevychase.se
www.chevychase.se

Chevychase,
an independent ideas studio.

We founded Chevychase
in Stockholm 2006,
after finishing studies
in Sydney
and a year of freelancing
on our own,
we merged into one –
Chevychase,
an independent ideas studio,
working within the field
of Communication design.

Our goal are satisfied clients,
and helping them with design,
ideas and strategy.

We love design
and we love to design
whether it is a brand identity,
store design, motion graphics
or a good old brochure.

We are a creative studio
whose united skill and experience
allows us to work
across a variety of medias
and clients.

Design for design's sake
does not concern us.

Emma Megitt

Bellmansgatan 8
SE - 11820 Stockholm

info@peeandpoo.com
www.peeandpoo.com

The cuddly toys
Pee&Poo were created
by Emma Megitt
as her
Master of Design project
in 2004
and have since
developed into a brand
including children
and adult wear.

INK Graphix

Mattias Lundin
Erikdahlbegsg. 5
SE - 41126 Gothenburg

mattias@inkgraphix.com
www.inkgraphix.com

Mattias Lundin
started designing record covers
and club flyers
under the name INK Graphix
in 1996.

In 1999 INK Graphix
was registered
as a business
and Mattias became
one of the biggest record
cover designers in Sweden.
He has done
several award winning designs
for Timbuktu,
Looptroop and others.

In 2002 INK Graphix
was nominated
for the Swedish award
Best Graphic Design.

Teresa & David AB

Teresa Holmberg,
David Castenfors
Sigtunagatan 6
SE - 11322 Stockholm

info@teresadavid.com
www.teresadavid.com

A design studio
based
in Stockholm,
and established
in 2001.

Theresa and David
have broadly worked
on
graphic identity,
motion graphics,
book design,
magazine
and illustration design.

Variety is important
to them,
not just to stimulate
a high level
of creativity,
but
also to prevent
getting stuck in
only
one certain style.

Their work philosophy
is based on
passion, fun, patience
and
dignity.

Zion Graphics

Ricky Tillblad
Bellmansgatan 8
SE - 11820 Stockholm

ricky@ziongraphics.com
www.ziongraphics.com

Zion Graphics
is
a multifaceted design
agency based
in Stockholm,
founded
by Ricky Tillblad
in 2002.

Zion's work
crosses over vast
disciplines
including corporate identity,
fashion,
interactive media,
packaging and print.

Switzerland

at-elier

Julien Notter,
Sébastien Vigne
Rue de la Servette 91
CH - 1202 Geneva

info@at-elier.net
www.at-elier.net

at-elier
is a graphic
design studio
established
by
Julien Notter
and
Sébastien
Vigne
in Geneva 2004.

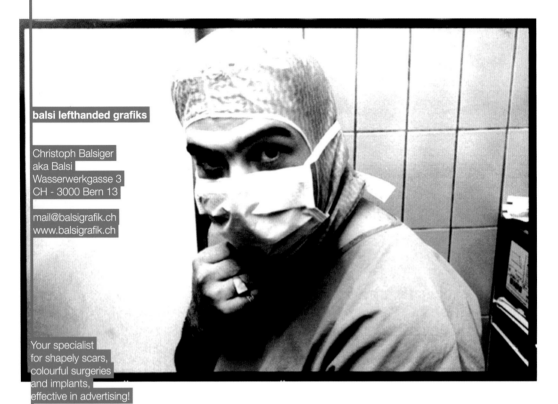

balsi lefthanded grafiks

Christoph Balsiger
aka Balsi
Wasserwerkgasse 3
CH - 3000 Bern 13

mail@balsigrafik.ch
www.balsigrafik.ch

Your specialist
for shapely scars,
colourful surgeries
and implants,
effective in advertising!

Balsi is a young atelier
for communication
and graphic design,
located in Bern,
the capital of Switzerland.

Balsi is always
challenging
and questioning –
searching for new ways
of understanding
the art of communication
and the language
of design
in its purest form.

Never satisfied…

In ductus we trust!

Glauser & Pietsch

5 Kingsland Passage/Flat 4
UK - London E8 2BA

www.dieterglauser.com
www.piets.ch

Dieter Glauser
(Swiss)
and
Sebastian Pietsch
(German)
have been working
on
various mainly cultural
projects together.

They are
currently
on a hiatus
working in
different cities,
different
countries
for
different companies.

Glauser in Zurich,
for Zimtstern
while
running his own
studio «I did».
Pietsch
is currently employed
by last.fm
in London, UK.

Photo: Elisabeth Real

I did — Dieter Glauser

Birmensdorferstrasse 221
CH - 8003 Zurich

idid@dieterglauser.com
www.dieterglauser.com

The graphic
design studio «I did»
was set up
by Dieter Glauser
in 2006
after he graduated
from the
Hochschule
für Gestaltung und Kunst
Zürich.

So far
it is based in Zurich,
and works
in various fields
such as
graphic design,
brand development,
art direction,
editorial design
and
image making.

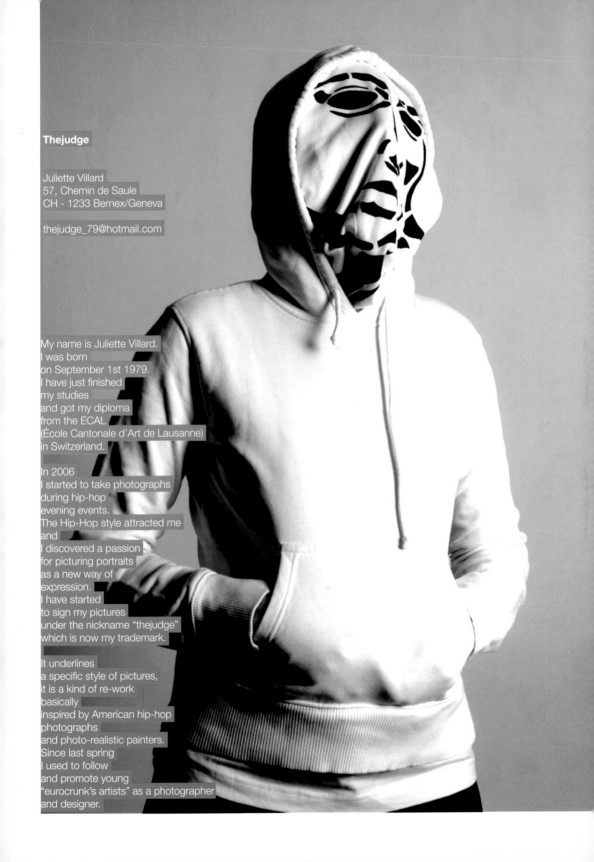

Thejudge

Juliette Villard
57, Chemin de Saule
CH - 1233 Bernex/Geneva

thejudge_79@hotmail.com

My name is Juliette Villard.
I was born
on September 1st 1979.
I have just finished
my studies
and got my diploma
from the ECAL
(École Cantonale d'Art de Lausanne)
in Switzerland.

In 2006
I started to take photographs
during hip-hop
evening events.
The Hip-Hop style attracted me
and
I discovered a passion
for picturing portraits
as a new way of
expression.
I have started
to sign my pictures
under the nickname "thejudge"
which is now my trademark.

It underlines
a specific style of pictures,
it is a kind of re-work
basically
inspired by American hip-hop
photographs
and photo-realistic painters.
Since last spring
I used to follow
and promote young
"eurocrunk's artists" as a photographer
and designer.

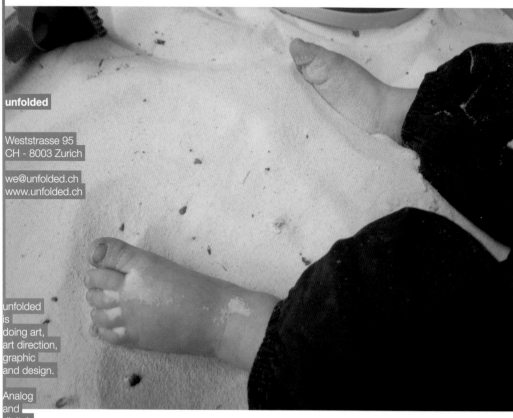

unfolded

Weststrasse 95
CH - 8003 Zurich

we@unfolded.ch
www.unfolded.ch

unfolded
is
doing art,
art direction,
graphic
and design.

Analog
and
digital,
timebased
and
timeless,
and
most important,
no
matter
whether print
or
digital: interactive.

Viola Zimmermann

Dienerstrasse 15
CH - 8004 Zurich

v@viola.ch
www.viola.ch

Viola Zimmermann
was born in 1962
in Biel, Switzerland.

After graduating
from the
School for Visual Communication
in Biel
(Kantonale Schule für Gestaltung),
she worked as art director
in various studios
in Berne and Zurich
before becoming self-employed
in 1994.

In 1997 she moved to London
to undertake postgraduate studies
in Communication Design
at Central Saint Martins
School of Art and Design.
She graduated with a Master of Art
and returned to Zurich
to work as director and head
of the design department
at the webdesign agency R.Ø.S.A.
In January 2000
she returned to self-employment.

Since 2001
she has also been a lecturer
at the HKB
(College of Art and Design)

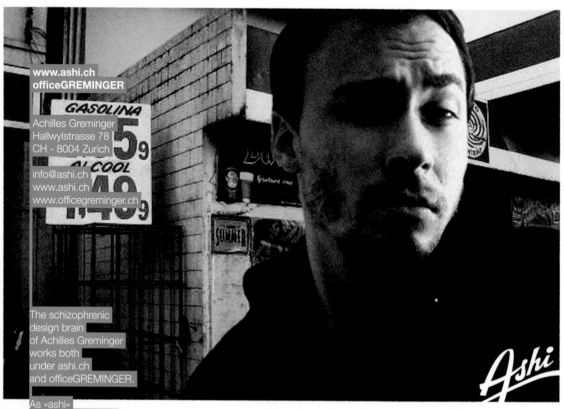

www.ashi.ch
officeGREMINGER

GASOLINA 5.9

Achilles Greminger
Hallwylstrasse 78
CH - 8004 Zurich

A COOL 1.49.9

info@ashi.ch
www.ashi.ch
www.officegreminger.ch

Ashi

The schizophrenic
design brain
of Achilles Greminger
works both
under ashi.ch
and officeGREMINGER.

As «ashi»
creates illustrations,
the graphic design part
is done by
«officeGREMINGER».

Mainly influenced
by the so called «retro» style
of the 1950's
up to the 70's
and
the music of those years.
What's Chuck Berry
for rock'n'roll,
Herbert Leupin
is for graphic design.

Some
personal heroes:
Jean-Paul Belmondo
for kissing
Jean Seberg
in «A bout de souffle»
and the Beatles.

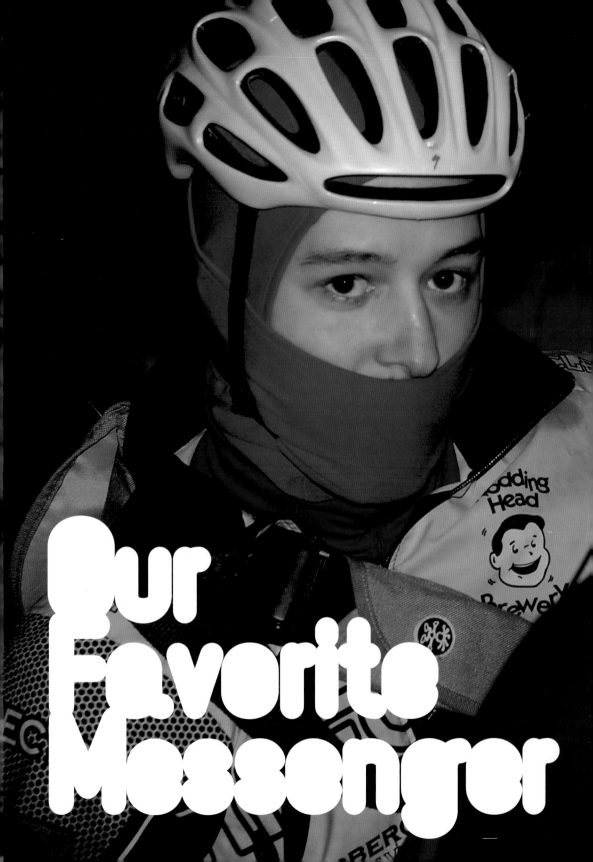

Our Favorite Messenger

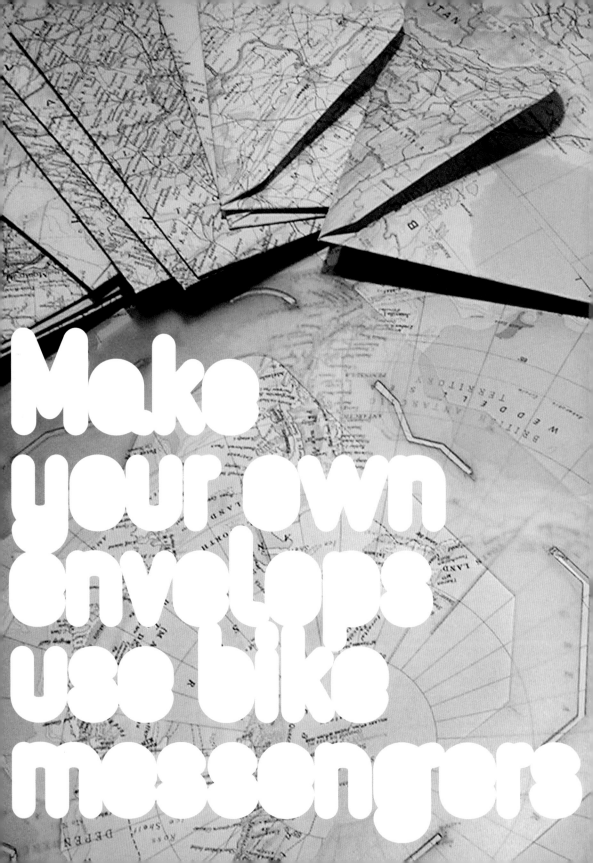

Make
your own
envelopes
use bike
messengers

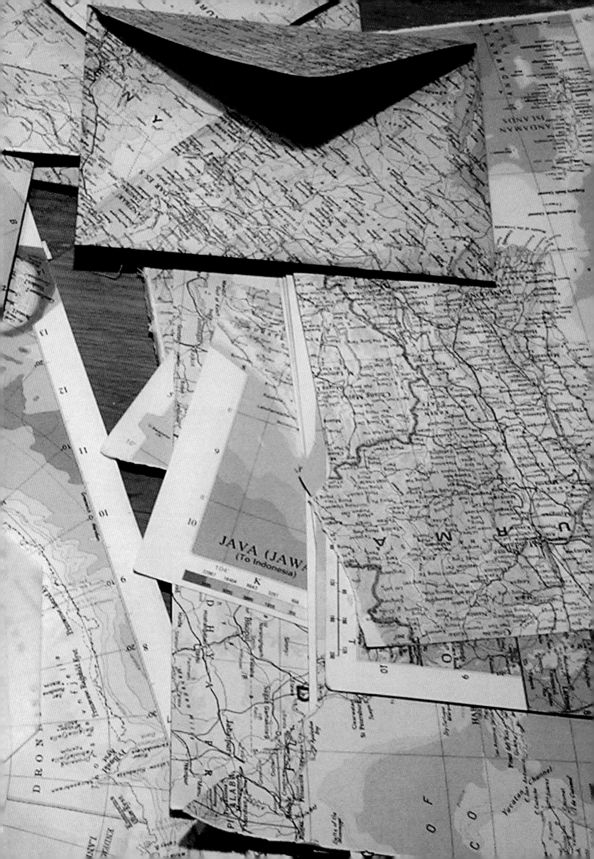

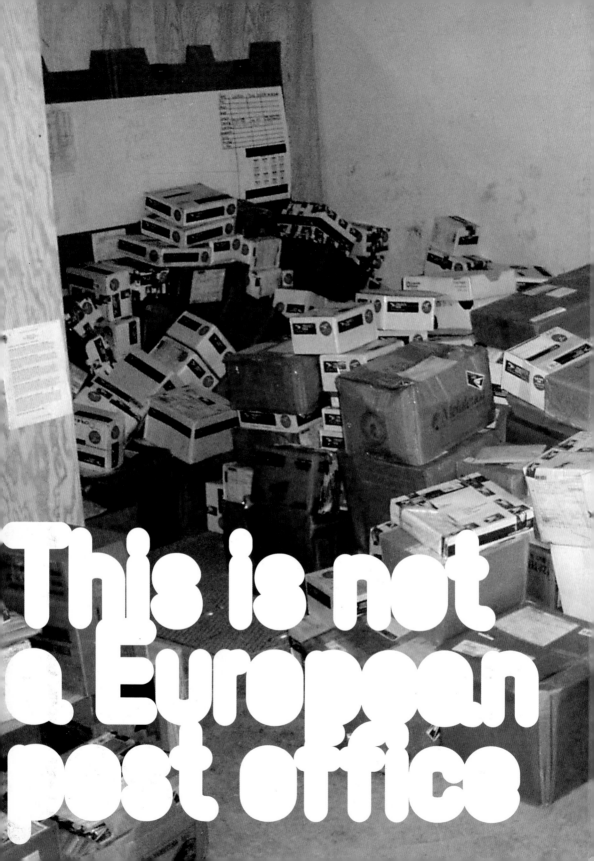

This is not
a European
post office